# EDGEWISE: A PICTURE OF COOKIE MUELLER

*"Why does everybody think I'm so wild? I'm not wild.
I happen to stumble onto wildness. It gets in my path."*

—Cookie Mueller, "Provincetown—1970," *Ask Dr. Mueller*

   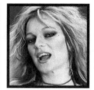  

Illustrations and design
in collaboration with
GWENAËL RATTKE

# EDGEWISE
## *A* Picture of
## COOKIE *M*UELLER

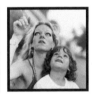

by CHLOÉ GRIFFIN

b_books

To Max and Sharon

# CONTENTS

# LUCK, LAUGHS, LUST

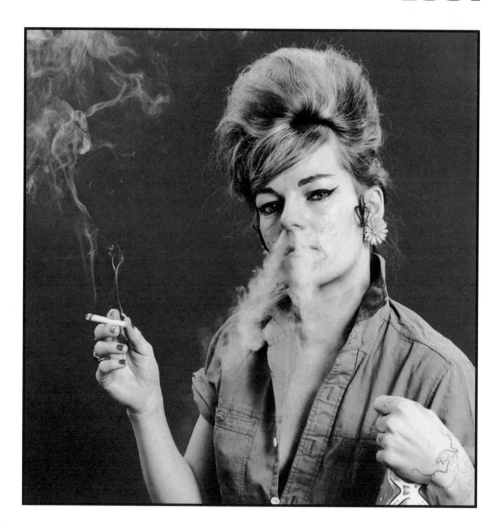

*Cookie, 1981 (Tobi Seftel)*

Cookie Mueller as Concetta in *Female Trouble*. Face caked in white makeup covering bad skin, three-foot-tall beehive, spit curls, liquid black eyeliner, luridly pale lips. She snaps, "I got a knife here in my pocket and I'm gonna cut you up after class." I see a girlfriend I wish I had known through the doldrums of high-school detention.

My first viewing of John Waters's films at 18 years old seared my imagination. The delinquent humor and the explosion of misfit glamour were obsessing. Their sensibility broke all the parameters of provocation I recognized, conformed to no familiar kind of rebellion. Finally these were the freaks I could relate to, models for unavoidable lunacy.

Eight years later, on a make-shift film set in a derelict storefront in Berlin, a friend hands me a book of short stories called *Walking Through Clear Water in a Pool Painted Black*, by Cookie Mueller.

I don't know what part of us falls in love with the voice in another person's stories, or why I felt something hinge in a mute, broken off part of myself when I read Cookie's words. But Cookie's voice opened up my imagination to new ideas, experiences, possibilities. I felt in her writing a fast desire to live bravely, hilariously and without compromise.

Through her absurdist observations, her shards of street wisdom and sharp-eyed images of her sometimes heart-breaking life, Cookie drew me in. I wanted to see for myself the characters Cookie wrote about: Shaggy, aka Sharon, dressed like a "cross between a blond Japanese Sumo wrestler and a gypsy fortune teller," and Sue Lowe with her "buck knife the size of her mini skirt." I wanted to find Cookie's "hillbilly beau monde." So I set out—without plan or practice—to look for traces, to pay some kind of homage to Cookie's life.

## NAVIGATIONS: TASHA HILL, 2006

It's a few months after reading *Walking Through Clear Water in a Pool Painted Black*. I'm in New York City beginning my search for Cookie.

The day of my first interview starts on the 48th floor of the Marriott Marquis in Times Square. I'm having cocktails with two girlfriends amidst a revolving floor and muzak, looking down on the yellow river of taxis and getting tipsy. I'm anxious, I have no idea what I'm getting myself into, whether it will be obvious what to do, what questions to ask. After another Manhattan I realize I'm already late for my meeting with the artist Billy Sullivan.

Jammed in downtown traffic heading toward the Bowery, I make conversation with the cab driver. I tell him about my ideas for the project. He says he knows who Cookie was, that I'm doing a good thing, that I should be proud of myself, keep up the good work. He adds that I should look into getting funds from Jimmy Carter, who gives away money for things like that. I thank him for the pointers and hand him a $2 tip, but he hands it right back and says, "Take yourself out for a coffee and give yourself a pat on the back!"

The next couple days lead me around unsure which direction to take. I receive a tip that Sharon Niesp, aka Shaggy, a close friend and lover of Cookie's, is living in Provincetown without a phone, maybe in someone's backyard. I also hear she's been working in a pizza place called Spiritus. So I look up the number and call. As the phone rings I doze into other thoughts, expecting no one to pick up. A chirpy girl answers. I ask if Sharon still works there and how I can get a hold of her. She tells me to wait a minute and the next thing I hear is a deep voice asking me what I want.

My conversation with Sharon is intimidating. She isn't expecting me, I'm not expecting her, and I say everything wrong. I ask her if I can talk to her about Cookie, if I could come out to Provincetown to see her—if only for a quick coffee. She tells me flat out she isn't into it and I

should talk to John Waters instead. Laboring, I tell her that my idea is not to take the expected route, that I just want to hear about who Cookie was from the people who knew her best. I make it plain that I am not a journalist or a practiced biographer, that I'm simply inspired by Cookie's stories. As I inch forward on the edge of my chair, Sharon suddenly comes around. We arrange to meet two days later on the pier in Provincetown.

The journey to Provincetown takes ten hours. First the Chinatown bus to Boston, then a ferry ride—three hours delayed—due to "Rough Seas." Midway across the bay, surrounded by complete darkness—no moon, no stars—rocked back and forth by ocean rollers, the wind beats on three passengers next to me puking over the railing, I feel like I'm being tossed into a scene in one of Cookie's stories.

As the ferry docks and I step onto the pier, I hear my name. It's Sharon, with her mess of bleached curls, standing steadfast in jeans, a big wool sweater, and big leather boots. As soon as we meet, I have the feeling we'll get along. As we walk over to her beat-up blue sedan, which is crammed full of belongings, she stops and looks me straight in the eye.

"Now what I wanted to say is, where I live now, up on Tasha Hill, is where Cookie lived the summer before she died," her deep voice frank and open. "The first time I met Cookie she said, 'You know Shar, I'm a great believer in timing.' And the timing is such that I haven't lived in this particular house since the '70s. And this is the house where we used to court, and it's where she lived the last summer before she went back to New York in September and before she died on November 10, 1989—as I'm sure you know, the night the Berlin Wall came down."

We spend the next few hours in a bar on Commercial Street talking about Cookie and ourselves. It's as though we know each other already and we're just filling in the details. Sharon tells me it's no problem for me to spend a few nights on Tasha Hill in one of the spare rooms.

Tasha Hill consists of a 19th century house, marooned in time, with a horsehair sofa, cobwebs and shells ornamenting its broken down charm. Surrounding it are pathways to scattered

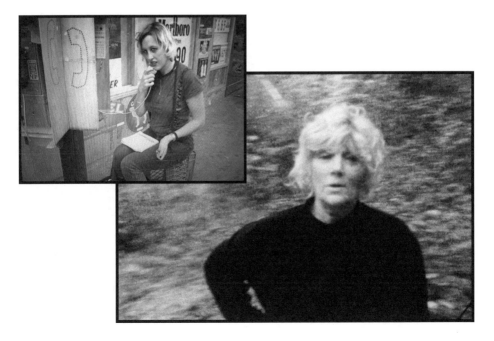

little wooden cabins. There's also a barn, which is home to ducks, chickens, rabbits, two horses, a couple of dogs, countless cats and some turkeys.

As we arrive, I hear crickets all around in the night air. Further back you can hear the moan of a foghorn. Sharon points me to the corner of the house where Cookie spent her last summer. In Sharon's little room on the ground floor of the main house, the soft lamps are on and the ghetto blaster is playing blues, the *Stars of the Apollo* album. A cosmos of books, textiles, pillows, stones, and pictures. On one of the walls is a beautiful photo of Cookie and Sharon embracing. A single pink light bulb hangs from the ceiling. We stay up late talking.

The next morning streaks sunlight over my sleepy eyes. I dress and have a smoke outside on the little stone steps that lead from my top-floor room to Sharon's. After a couple drags, Sharon comes out with coffee and toast. The morning couldn't feel better. Some rounds of coffee later we take a walk with Peg, Sharon's three-legged dog, and Turkey Joe, the big fat strutting turkey who's been kicked out of the coop for hassling the she-turkey, as Sharon tells me.

Hanging out with Sharon is comic and the real thing. Everything is fun with her, even if she complains that she's misery incarnate: driving around, cruising church sales, picnicking on the beach. Her tone is unmistakably her own and genuine. Tony, a fisherman in Ptown since the early '70s, tells me, "She's like a heart attack. She's shot from the heart. She'll show you the light and she ain't gonna want you for it."

At this point I still had no idea how far I would go looking for Cookie's stories. I was naive to how many days, and eventually years, of work this project would take. But certainly it was that naiveté, that spontaneity, that prompted me to follow these tales and clues, the scent of new friendship and adventure. Sharon trusted me and I felt a loyalty to make something from this trust and memory. Cookie's stories had taken me to Provincetown, and from there my desire to keep travelling was born anew by each person I spoke to.

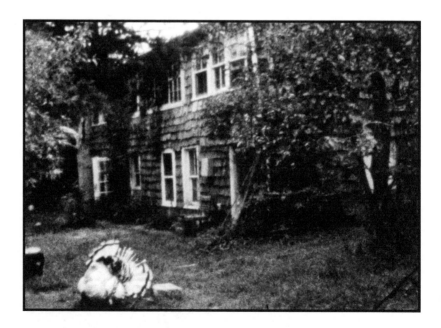

*Tasha Hill*

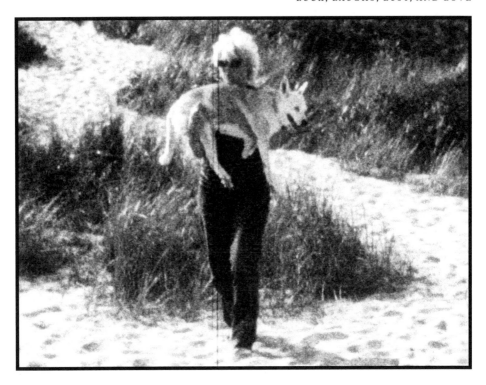

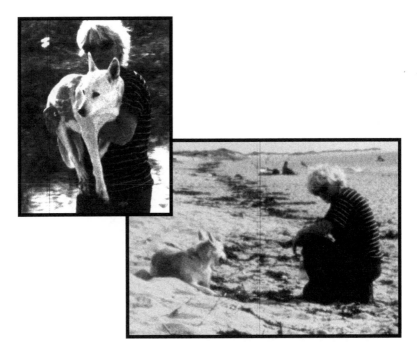

*Sharon Niesp & Peg on the dunes, Ptown*

Not long afterwards, I made it to Baltimore on the Double Happiness bus and was dropped off at the O'Donnell Street Cutoff truck stop on I-95. From there, I was picked up by Sue Lowe in her old, white Ford pickup and spent the next week sleeping in her leopard-print high heel closet with Dirtball, her cat. We went thrift shopping, smoked bongs, scrounged Value Village, drank way too much coffee, strutted the sidewalks of Fell's Point, and ate grits at Jimmy's Diner while watching a Miss Maryland photo shoot out the window. By the end of the week she was introducing me as her sister.

I interviewed John Waters in his home surrounded by his arresting art collection as he contorted himself marvelously in his chair, looking all of 10 years old. The real Chucky doll glared at me from the corner. I was a guest in Dolores Deluxe and Vincent Peranio's wonder house, stocked full of set props from Waters's films all the way from *Mondo Trasho* to *Cecil B. Demented*. Even the birdcage that imprisoned Edith Massey in *Female Trouble* grows vines in their chimerical garden. I had afternoon tea with Sue and Mink Stole, the "religious whore," in the after-surgery rehab room of a recovering Bob Adams, aka Baltimore's "Psychedelic Pig."

In New York I met with writer Gary Indiana at his house where a long talk about Cookie, nourished by return trips to the liquor store, led to us watching the whole of Michel Auder's two-hour avant-garde film *A Coupla White Faggots Sitting Around Talking,* then Andy Warhol's *Bad,* then an unreleased film starring Brigid Polk called *Fight.*

Again and again, these trips took the stories that had inspired me and made them breathe, talk, smoke, and come alive.

*Clockwise: Miss Maryland girls; AABus ticket; Sue Lowe's house; Sue in Fell's Point, Baltimore*

## FULL TILT

Cookie grew up in the suburbs of Baltimore and like hell wanted out. She writes that she felt alien to the "older couple in the living-room" and that she didn't have "anything in common with them except that we shared a few inherited chromosomes, the identical last name, and the same bathroom."

Voted "Most Expressive" at Catonsville High, Cookie doubled as a problem child. She was an out-of-place beatnik—the first one in her class—with every inclination to misbehave. She was also an avid reader with the teenage hope of becoming a writer.

After graduating in 1967, Cookie took a trip to San Francisco where she mingled with dead-beats and Satanists. She crossed paths with the Manson girls, and in her own words "wound up a drug casualty, not unlike a bag lady" and took a short breather in a mental hospital.

Back in Baltimore after shock treatment, Cookie won her way into showbiz. Her film debut was in John Waters's *Multiple Maniacs*, as Divine's bad-news daughter: a radical icon, twisting to '50s rock-n-roll in Spring-o-lator heels, topless in hotpants, her hair big and messy, bejew-eled with necklaces, bangles clanking up her arms, rings on every finger, with black nail polish on each bitten fingernail. She lisped her half-forgotten lines in a Valium-dimmed drawl, look-ing like an exploded star, brazen and maladjusted.

By 1969 Cookie made it to Provincetown, when dropouts and queers were still lying on its beaches and climbing its dunes. A one-cop town with a doctor who supplied amphetamines, Ptown attracted characters like Valeska Gert, a Jewish refugee from Berlin who opened a bar in 1944 called *Valeska's* and employed Tennese Williams and a 70-year-old midget named Mademoiselle Pumpernickel. It was still a town for lunatics. Cookie's Ptown gang teemed with crackpots, poets, drunks, and romantics. Here she gathered a family of fugitives around her, and her relationships deepened and took shape. On a sweaty dancefloor in a backwoods disco, Cookie found Sharon, one of the big loves of her life. It was nearby on the Cape that she gave birth to her son, Max, on a night when "Mongrels roamed in packs. The moon had turned to blood and the hungry hounds were howling for it in wild lunar lust."

During these years, Cookie practiced her art of storytelling. Her own life and the lives of her friends became the raw materials for her concoctions of myth and truth, the stories into which she wove her unique and indelible philosophies. Her ambition to write and get published, as well as an urge to be a part of an artistic scene, drove her to New York City.

Cookie's candor and clarity of spirit quickly brought her onto the stages and screens of un-derground theater and cinema. With her art column for *Details* magazine and witch-doctor remedies in *The East Village Eye*, she gave her readers glimpses into the most ragged fringes as well as the manicured elite of New York society. Cookie became known as the cure for a bad party.

Despite the struggles of supporting herself and her child by atypical means, Cookie man-aged to travel. Parading the Amalfi Coast one summer, Cookie fell in love with the Italian art-ist Vittorio Scarpati, whom she accompanied back to New York and married. They would return together every summer to Vittorio's hometown, Positano.

Wherever Cookie lived, however wild her scenes became, she always created around herself an orbit of friends and lives entwined with her own. Her connections were individual and in-tense, even if fleeting. Cookie was, a lover of hers told me, "like mercury, beautiful and quick but almost impossible to hold on to." She was herself an entire scene, a crackpot mother-figure, a lightning rod in dark times.

Cookie was just beginning to find her voice as a writer when she got sick with AIDS. She herself wrote of the lives stolen by this disease: "These were the kind of people who lifted the quality of all our lives, their war against ignorance, the bankruptcy of beauty, and the truancy of culture. They were the people who hated and scorned pettiness, intolerance, bigotry, mediocrity, ugliness, and spiritual myopia; the blindness that makes life hollow and insipid was unacceptable."

## FOOT CANDLES

The afternoon of the second day of my first trip to Provincetown, Sharon pulls up to a lumberyard and hollers out the window to a dark-haired, friendly looking guy standing at a distance. As he approaches the passenger's side, I ask her who he is and she says, "Max. Now give him your spiel."

I freeze. I hadn't thought about how to approach Cookie's only child with this project. I feel awkward and self-conscious. I tell him simply that I'd like to speak with him about his mother. His mood changes instantly. He looks away and mumbles he doesn't really have time. Sorry. Sharon pushes him with, "She's cool Max, talk to her." We arrange to meet after his work, he'll pick me up at Tasha Hill, and we'll go to his place in Wellfleet.

The drive to Wellfleet takes about 30 minutes and Max is silent almost the whole way while I talk non-stop, trying to ease his shyness and convince him I'm worth opening up to. We arrive at a little white house which has "Mueller" written above the door in black marker. Once inside, a voice comes from behind a brown blanket separating the kitchen from the living room: "I hear a woman, does that mean we're gonna get supper?" My first of many meetings with Max's childhood friend Yoko, a tattooed, rude-mouthed, but somehow charming Polish guy.

Max and I go into his bedroom for some privacy. The room is cluttered with children's toys. On the wall is a beautiful black-and-white photograph of his mother holding him as a child in a pile of fishnets. He tells me briefly the story of that photograph: how he had had his feelings hurt and had run to the pier and hid under the fisherman's nets and his mom had come and found him and comforted him.

Max pulls out photographs, drawings, and art books. He murmurs that he doesn't really know what to say or talk about in regard to his mother. I tell him not to worry and we can talk when he feels like it. While he's in the shower, I look over the pictures and items he has left of his mom. They seem sparse and treasured. I feel conflicted about how to enter into this person's life.

When Max gets out of the shower he gets a phone call from his four-year-old daughter, Razilee. He puts her on speakerphone. Her voice is bouncing with love and giggles and she pleads for him to pick her up tomorrow from school. Max tells me she is the most important thing in his life.

We head off to a restaurant for dinner. Awkwardness settles in again. I don't know how to bring up the subject of his mother and the conversation feels strained.

We finish our meal and decide to go for some drinks. As we're getting into the car, Max suddenly asks me if everything is all right, if "*it*" is going okay. Surprised, I ask him why he thinks there's a problem. "Because you sighed."

I immediately come out of my self-centered thoughts and assure him I'm having a great time. To myself I think how foolish I was to be so simple about this situation. The trust I need to develop with this person can't manifest over 90 minutes.

The Bombshelter is a typical northeastern small-town dive bar: wood paneling, beer neons, multiple television sets playing football, and a fine collection of old and young semi-conscious regulars. We order two whiskeys and start talking, mostly about ourselves, things we'd like to do someday, and how things are going at the moment.

After a few drinks we decide to smoke a joint by the pond. It's chilly outside and Max gives me his jacket. We sit and talk more, this time about his teenage years growing up in the early hip-hop scene in New York City. Max is easy to be with now, we've overcome our shyness and can sit in silence as easily as in conversation. He tells me he wants to show me the ocean side.

The dunes of the Cape on the ocean side at 1 a.m. feel like the edge of the world. Sitting on a little ledge in the sand, we look out toward the blackness in which a warm crescent moon appears. The night and water howl around us, it feels like a secret place. Max talks to me about Cookie. The moon reminds him of his mother's tattoo. He tells me about the one on his arm, a Nigerian symbol for mourning hung above doorways to signal the death of a beloved. He got the tattoo when he was homeless after his mother's death.

Over the following years Max, Sharon and I spent a lot of time together on the Cape and in New York. I came back several times to Provincetown and stayed on Tasha Hill in my own sunny little corner room. We spent afternoons with Razilee at the beach or swimming at the ponds or going for long walks through the red maple swamp trails. The comic nature of Sharon's and Max's banter became a familiar soundtrack while we cooked meals, watched movies like *Spider Baby*, and went for drives.

It was only after a friendship had developed over five years that I was able to ask Max the questions I felt I needed for this book. The delicate and cherished nature of his memories and thoughts about his mother has sometimes made his feelings difficult to convey. The trust and the times we spent together have made for a real friendship with the person who was the closest to Cookie, the biggest of her loves.

*Max Mueller in Ptown*

17

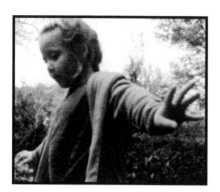
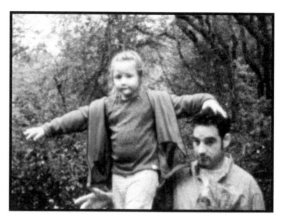

## PICTURES IN THE SMOKE

I began this work because I saw something in Cookie that I desired in myself. As I learned more, my relationship with her changed. She developed flaws and insecurities. At certain times, as the picture changed, I felt ready to abandon the effort of this work. So what kept me on? Perhaps it was precisely that: Cookie became a person, not just an icon.

Over a seven-year period I met and spoke with over 80 people who described the impressions Cookie left on their lives. It was impossible because of the wide reach of Cookie's contacts and the scattering effects of time, to interview everyone with memories of Cookie; there were people whom I did not reach, and others who chose not to be interviewed for the project. The interviews were almost always informal, going on for hours and sometimes even weeks. If the conversation began in a café, then it would end up in someone's home, and if it began at home, then it would turn into drinks afterwards. Even if we only spoke over the phone, a familiarity was recognized. I was not made to feel like an outsider.

What had initially intimidated and worried me about meeting people often ended up being an advantage. I didn't need to be a professional, it wasn't in the spirit of the subject. As Amos Poe said to me, "All we were about was being amateurs, inspired amateurs."

My decision to edit the interviews into a continuous conversation aims to echo the loose style of informal meetings and mixed recollections, like an extended dialogue of memory.

Recently I came across a letter written by Cookie describing her collection of short stories, *Garden of Ashes*, and I was struck by how perfectly it expressed my feelings about my own book. She writes:

*"All of the pieces here fit together the way weeds and flowers do in an overgrown eclectic garden. The thing is this garden is memories that are now sort of like ashes—the past seen after the flames, after it's made pure.*

*I also like to think of these pieces as messages from a place situated right on the borderline, in a sort of netherworld, perhaps right on the precarious edge between two uncharted lands..."*

Holding these memories in my hands, letting them speak longer to me, brought them closer to my life. At certain times I felt I was in some communing position, trying to distinguish the edge between two lands—memory now and the real past.

When I returned last autumn to Provincetown, seven years after my first trip, I was hit with a strange kind of familiarity. I walked down certain streets and it was almost as if I remembered

seeing Cookie there, sitting on a curb or bicycling by with her old tin bucket for a basket. I could smell the sea of 1973 on the wind, five years before I was born.

All these memories I experienced, they seemed so real and close. But of course, I was never there. I never met Cookie except in her stories, and in the reflections of her that come through the people she knew, who loved her.

I want this book to be a testimony to Cookie from those close to her, an homage to her life and what she did with it. This is not a definitive biography: there are myths and contradictions here as there were in her life and in people's memories of her. I have chosen to leave these in.

§

On the first weekend I met Sharon and Max, I had a dream in which Cookie appeared. I was lying under a tree with Max and the grass was damp from the dawn. All of a sudden, Cookie came down from the sky and hovered above us in a purple, blue, and black cape. Her hair was big and blowing all around her and her eyes were painted and fixed on me. She seemed angry and demanded to know what I was doing. Amazed, I told her that I wanted to put together a tribute to her and that she should trust me. I squeezed Max's hand; I was terrified. In the next moment, Cookie burst into shaking laughter and carried on as though her initial threatening demeanor was just an act. From there, we three took a walk through woods filling with light.

*—Chloé Griffin, 2014*

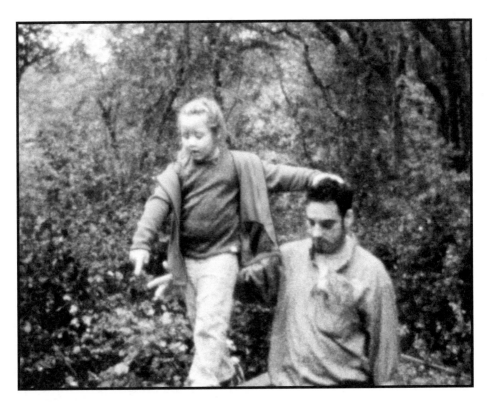

*All previous images by the author*

# The Anomalous Nobility

The Anomalous Nobility

Baltimore 1966-1969

## HIPPIE HARLOTS

*"I was always leaving. Every time I left I had a different hair color and I would be standing on the porch saying goodbye to the older couple in the living room. I didn't have anything in common with them except that we shared a few inherited chromosomes, the identical last name, and the same bathroom.*

*They would be protesting. Screaming. It became a tune, with the same refrain, and the same lyrics, 'If you leave now, you'll have no future. If you leave now, you'll be a bum.'"*

—Cookie Mueller, "Alien 1965," *Garden of Ashes*

MINK STOLE: I met John Waters in 1966. My sister knew John and she introduced us. I was in that group when Cookie showed up. Cookie had been a part of a whole other scene that I didn't know. I was introduced to all the counterculture that I had ever met through John.

JOHN WATERS: When I met Cookie she was living on Pleasant Street. She looked like Janis Joplin-meets-redneck-hippie with a little bit of glamour drag thrown in.

SUSAN LOWE: I was kind of a fag hag. John and I clicked over Tina Turner; we didn't like the Beatles, they were milquetoasts. We liked James Brown and something rockin' and damn dirty. We were called freaks, not hippies, because we liked hamburgers and I used to screw around with Chicanos and the hippies hated that. If someone called us hippies we retaliated because we weren't the brown rice type. We still liked high heels and makeup and the whole glamour bit—hippies didn't. They lived in flower skirts that went down to their ankles and preached *love*. They had babies that were flower children. Meanwhile, we were out fucking disco dancing with black people.

JOHN WATERS: Sue Lowe looked the way she did in *Multiple Maniacs*. Miniskirts with no underpants and pubic hair showing. Scary. Punk before there was such a thing. Hippie harlot. Mink was the religious whore. She wore black nail polish, and this was way before Goths. She used to wear rosaries... she always looked confrontational.

MINK STOLE: John, at that time, if I remember correctly, wore corduroy bellbottoms and striped jerseys, which were t-shirts, but we didn't call them t-shirts back then, we called them jerseys. They were long-sleeved. He had long hair, long stringy hair, and a moustache and he wore yellow aviator sunglasses. This was his almost-always look. He was very thin. He's long in the torso.

GEORGE FIGGS: We went around doing the most shocking things we could think of just to make people go, "Oh my God!" You know, if you could get a really good "Oh my God" out of somebody, then you'd won.

We were weirdos, and weirdos went downtown and hung out. We were in search of the Beatniks and there was a culture. It was 1964 and I had already been to that "I Have a Dream" speech.

JOHN WATERS: George always looked scary in a great way, he looked like the hitchhiker that you picked up in *Texas Chainsaw Massacre*, but he was handsome in a scary hippie way. He had long hair and wore scary thrift-shop clothes. We kind of dressed alike.

GEORGE FIGGS: Cookie and I were boyfriend and girlfriend back in the day. In the night of the day. Cookie made me vow that if I ever saw or looked at another woman she would kill me and I vowed that I would kill her if she ever looked at another man and we were completely serious. Haha!

It was a semi-political socio-cultural stewpot in downtown Baltimore. If you had long hair or looked different they would kill you or try their best. We were sorta like post-Beat, but Cookie was a little younger and she was more of a hippie. We all took lots of acid together and tripped and roamed around the city, freaking on people and stuff.

PAT MORAN: It was a whole different world in the United States at that time. There were two cultures: ours and theirs.

SUSAN LOWE: I met Cookie though Vince's little mistress, Dolores Deluxe. They had gone to high school together and were dealing LSD and pot. I met them and it was immediate, *immediate*.

DOLORES DELUXE: I lived with Cookie for a short while and she was just so filthy and gross that I had to get out. We lived in downtown Baltimore around the Lovely Lane Methodist Church, which is a little landmark. That lasted a matter of months and between her dog and herself, it was too gross for me to live like that. So I got out and I'm not sure what she did at that stage. She had her own world.

MINK STOLE: John and I met Vincent and Susan around the same time: 1966, 1967. Susan and Cookie hung out together. I was living at my mother's at the time. Susan had a place on Bond Street and she, Cookie, and I used to go out and get drunk and pick up guys and bring them home.

SUSAN LOWE: Take them out the back porch!

MINK STOLE: Yeah, I don't know... I think we were working really hard at being as bad as we could be without doing anybody any serious damage. We'd smoke grass, drink. I really felt like the little straight girl with those two, 'cause Cookie and Susan were diehards. And I felt like a little preppy thing.

SUSAN LOWE: Mink! That picture of us hitchhiking, you were wearing black nail polish and fishnet hose!

MINK STOLE: Oh, but that was a little later. I was trying hard to be a bad girl, and succeeding on some level. I had my share of larcenous moments and drugged-out moments. We enjoyed excess then.

DOLORES DELUXE: Everybody fucked everybody.

SUSAN LOWE: People did, that's true.

VINCENT PERANIO: Well, I didn't personally. You two did.

JOHN WATERS: From what I remember, I met Cookie when she won the door prize at the world premiere of *Mondo Trasho*, which we had in a church basement. The door prizes were ridiculous things, like rotting meat. And this one was a dinner for two at the Little Tavern, which was the sleaziest hamburger shop. You see it in *Female Trouble* for a second; Divine works at the Little Tavern. They had hamburgers for 30¢. They are long gone in Baltimore. Cookie won the door prize having just come back to Baltimore after being released from the mental institution in San Francisco.

MINK STOLE: Dolores had her committed.

SUSAN LOWE: Yeah, Dolores told me the whole story the other night.

*Drawing from a flyer for* Mondo Trasho, *1967*

## THE WHOLE STORY

*"Time stretched out and we waited through all the days in Haight-Ashbury. Knowing that we were the blessed ones in states of grace, we lived clean lives in preparedness and took drugs to kill time. We got ready with our backpacks and energy granola. We practiced astrology, yoga, levitation, transcendental meditation, astral travel, telekinesis, cabalism, prayer. We called on the spirits. We waited and waited, and hoped, but the world didn't fall apart. It was a big letdown."*
—Cookie Mueller, "Waiting for the New Age," *Garden of Ashes*

DOLORES DELUXE: It was the classic "Cookie's-mother-would-say-it's-all-my-fault-and-my-mother-would-say-it-was-all-Cookie's-fault" thing. Let me tell you right now: it was all Cookie's fault.

VINCENT PERANIO & SUSAN LOWE: Of course it was! Oh yeah, it could never be your fault.

DOLORES DELUXE: No, no, I mean I could take credit for having the true spirit.

VINCENT PERANIO: You were high school bad girls.

DOLORES DELUXE: And we went down a very typical road of taking drugs out of our mothers' cabinets—more her thing. Well, my parents wouldn't have had drugs in their cabinets; they were more religious. Cookie's was more the mainstream mom, more likely to have Valium in the cupboard. Her mother was nuts.

SUSAN LOWE: Her mother *was* nuts.

DOLORES DELUXE: But on the other hand, her mother was in a typical suburban, estranged, '60s relationship with her child, which we all went through. So we got split up. I got sent to Lansdowne and she got sent to Catonsville, which was more college-bound and academic. I got sent to where the greasers went, in the low-rent neighborhood. But when I was in high school, I would see Cookie on the weekends. She started hanging at the Pixie Pizza Parlor, which is where she always claimed to me she met John and that gang. She would say, "You wanna meet them down there?" But that was never what happened.

SUSAN LOWE: I introduced them.

DOLORES DELUXE: Well, honey, I'm sure it's all about you. We got back together when we were out of high school and went down to Ocean City. Ocean City is rural and it's a tourist beach area. We'd go out to the country and just pick corn in the fields and I think we did manage to feed off of some farm stand one time. You know, just being bad, not knowing how bad we were. Thinking we were going to live in a socialist society where everybody just shared everything with us. Ocean City was a place where you could pretend to run away. You could tell your parents you were getting a job like these nice kids, and then you could quit your job and hang out.

SUSAN LOWE: And be fucking on the beach and taking LSD and every fucking other thing you could imagine. It was the runaway place.

DOLORES DELUXE: I don't remember you being there.

SUSAN LOWE: No, I wasn't there then. But...

DOLORES DELUXE: Anyway...

VINCENT PERANIO: In Maryland, it was almost a tradition to go to your prom and then somehow end up in Ocean City.

DOLORES DELUXE: Well, that's one level of it, but that's not the level Cookie and I were participating in. We had already rejected the social mores of going to your prom and having dates and shit. We were well past that. I actually made my way west to San Francisco before Cookie did, because I hit up with another group of people—this kind of communal group—and Cookie came and stayed with us. We were at Page and Cole Streets, right near the Golden Gate Park, in the heart of the Haight-Ashbury district. And things that only went on for about a month seem like things I did for about a year, so the dates are hard. Surely that was five years of my life... oh no, that was just one.

VINCENT PERANIO: Surely it was '68 to '71.

DOLORES DELUXE: It was within two years of graduating from high school. Everything was a commune, because who had any money to pay the rent? Mostly you were running away from home. You had nothing, and you were hustling with no money. Luckily, there was a girl with a baby who we could take on the streets and panhandle with. Nobody had a job—are you kidding? There was drug dealing, but it was more about marijuana, LSD, and mescaline—you know, the recreational drugs of the hippie world.

Cookie and I didn't hang out all the time, but we went to concerts together and she was exhibiting her taking-forever-to-get-dressed thing even then. Mostly, I remember her really overdosing on drugs and not being able to handle them. I'm sure I was taking just as many, but she would act out. She would get just a little too stoned and then get physical with people and, well, we had incidents. I remember taking her to the clinic several times because she kept breaking into cars. I don't think it was with the intent to… I mean it was for esoteric reasons. I don't know how to explain it. She wasn't necessarily trying to steal, she was saving something. People were nuts when they were on LSD, mescaline, meth—take everything and take it all at once. We got on Manson's bus… we got off, it was parked on Haight Street.

I remember one night we had a pregnant woman in the house, she was actually a good Jewish girl who lit candles on the weekend. She centered the house, she was very benevolent. She was quite nice but she was getting a little "I'll hit you too," and one night there were baked potatoes left over, and Cookie was going around mashing baked potatoes in people's faces while they were sound asleep. People were sleeping all over the house, many in drugged-out conditions. And she was pouring water on them or something. I don't know, just weird stuff. In the end, we had to call the clinic guy that we had been working with when she was getting overwrought. He came, then he had to call some other guys, and it took four or six guys to get her down the steps, out the door, into the wagon, and onto the eighth floor of San Francisco General, which in the day was just full of everybody who had ODed like a crazy person on some psychedelic and wasn't quite over it yet. The psych ward in San Francisco was pretty open-minded; it wasn't like you were sending them to a snake pit or something. And I'm not trying to say she was the only one who had an extreme reaction. It was just a cycle then; it was bound to hit somebody in the house, someone was going to go crazed. She was just too much chaos for me, as a control freak.

VINCENT PERANIO: Dolores is a reactionist.

DOLORES DELUXE: I was trying to handle stuff. I didn't know to what extreme it would get to, so I wanted someone professional to handle it. I don't think of it as persecution. Cookie's mother had to come and get her. I guess I probably called her.

VINCENT PERANIO: Cookie was pissed. Cookie was really pissed.

DOLORES DELUXE: Well, I don't know. She actually wasn't acting like she was pissed. I think she probably came out of the worst of the shit knowing she could still manipulate. She was an actress, so I'm sure she started acting like, "I can get through this." We did have a memorable scene I always wanted someone to film: I'm in my little yoga moment in my

little sunlit San Francisco hippie room and her mother brings her to get her stuff 'cause she's taking her back to Baltimore or wherever they went from there, and Cookie comes into the room and whispers, "I hate you I hate you I hate you." I was like, "I totally understand, Cookie. I would probably feel the same way. I really don't know what to do and I forgive you. You can always be just as mean back."

So that was pretty much it for me and Cookie. I always tried to be gracious to her when I saw her and appreciative that she still associated with me in a room, because I know what she went through had to be a hideous experience. But I always felt that ended our relationship on the level of any kind of intimacy.

SUSAN LOWE: Oh, she always talked about you in a good way.

DOLORES DELUXE: I still followed her career in my own little way, was always glad to have known her once.

SUSAN LOWE: She was insane.

DOLORES DELUXE: I'm sorry I don't remember more; there were plenty of backseats of cars, drive-ins, and intellectual aspirations I can't even recall, which is a shame.

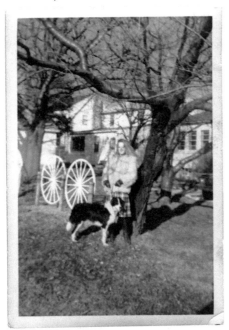

## A CRACKPOT GROUP

*"I lived there with my pet monkey who liked cockroaches. He used to scan the fabric walls for them. When he saw one from way across the room with his primate super X-ray vision, he'd swing the distance on the ceiling pipes and deftly scoop up the bug with one hand, pop it in his mouth, and swing back to the curtain rod window perch where he lived. He was a good pet.*
*There were always a few people living there with me, they floated in and out, but a pretty lesbian named Babette, who never wore a shirt indoors, and a homeless philosopher hippie named Nash were permanent fixtures on the sofa. We lived primarily on LSD, poppy seed buns, and cheap champagne."*

—Cookie Mueller, "Breaking into Show Bizz," *Garden of Ashes*

LINDA OLGEIRSON: After the San Francisco thing, Cookie returned to Baltimore and her parents apparently had a house that was next to a monastery or a retreat. Cookie asked if she could live there on their land and just not talk to anybody and apparently they allowed her to camp out on their land and pull her stuff together. Cookie was drinking a lot of water, because she believed that you are what you eat, so she was drinking nothing but water and walking around naked, thinking she was invisible. She also insisted that she was speaking fluent French, though she had never learned French.

PETER POMPAR: When Cookie came back from San Francisco, she went to live with her parents. I was going to university with her older sister, Judy. Anyway, Judy and I were getting along and we were sharing English concerns and one day we went to the house and this young girl came bounding down the stairs.

I was going out with Judy from the spring of '68 through the summer into autumn. I think Judy wanted a simple life; she was very different from Cookie. Cookie read a lot. I don't

know if she graduated high school. She was very fashion-conscious and had got into a cool scene in high school but I don't think academic concerns were hers. But for Judy it was 180 degrees different. Academic concerns were all Judy. She read, she was quiet, she got along with mom and dad, and she did what she was told. Cookie and I became close friends over time.

GEORGE FIGGS: I met Cookie where my band was playing. She came to one of our gigs and she liked me, you know, I was the lead singer and rhythm guitarist so I was up front and Cookie was dancing and I really fell in love with her. I think it was at the coffeehouse. And I think she was with Alan Reese! Because I remember seeing him there too. He probably had his eye on her. We hooked up that night—she went home with me. I lived on Bolton Street on Bolton Hill. Cookie lived with her parents in Catonsville.

Our band was George & Ben and we released a record called *Boa Constrictor & a Natural Vine*. I guess I would say we were ahead of our time. Our LP came out in 1968 on Vanguard Records. It did very well in West Germany. Kind of psychedelic music with a little bit of jazz thrown in. It was totally non-conventional. A few folk songs and there's other stuff on it that's just experimental bizarreness.

BEN SYFU: Oh yeah, at the Boar's Head, the coffeehouse. That's where we met Cookie, that's right. I think we were only 17 or 18 at the time. But I do remember Cookie.

GEORGE FIGGS: I remember Cookie had had an abortion. It was hard, I don't know how she did it, but she managed to get it done. Somebody from San Francisco. It wasn't mine. She might have gone out of state to have it done. Planned Parenthood had just started up and it became easier to get an abortion around that time. I think she had some trouble but I know she had it because I remember her crying about it. That was when we first got together, and it was something we talked about and she cried on my shoulder about it and everything and I fell more deeply in love with her.

I'd go out to Catonsville on the bus and get her and we'd come to the city together and go to all the places downtown. There was the Hardy-Har joke store, the head shops... In those days there was a little neighborhood that was full of hip establishments: music stores and junk stores. Pat Moran had her store called Divine Trash at that time. The original Divine Trash was in Baltimore on Read Street. It was the old Read Street scene. We used to go there and just hang out.

BOB ADAMS: I got acid from Pixie, from *The Buddy Deane Show*. *The Buddy Deane Show* is what the movie *Hairspray* is based on. So Pixie from *The Buddy Deane Show* brought me LSD. I wouldn't go outside; I was afraid to go outside. I thought, you can't go out in public on this shit.

GEORGE FIGGS: Bob's full nickname was the Psychedelic Pig, because we used to have acid parties at his house on Bolton Hill on Park Avenue and Sue and Cookie and all of us used to hang out there too.

BOB ADAMS: I was a disc jockey and spit would come out of my mouth and Leroy said, "You look like a pig, you look like a psychedelic pig," and that's where the name came from. I'd get all the records and stuff and we'd be at a farm or some place and I'd have wireless mics and broadcast. Everybody would be stoned, tripping and shit—even in San Francisco—I would go on the frequency where the main station was and walk down the street and interrupt whatever they were listening to and fuck with their heads.

BEN SYFU: I remember this one time—George and I were really young, this was during the Boar's Head time—we came back to George's and his guitar had been stolen. We were on acid and he was flipped out so he called the police and they were all over the place and taking notes and I was freaked out so I went to Bob's house on Bolton Hill and he was listening to Blues Magoos and Blue Cheer and just some really awful psychedelic music and I was tripping and I said, "Bob, I got a little headache," and so he picked up an oversized

two-foot box of Bayer aspirin and said, "Here, would you like an aspirin?" Bob was crazy, and still is, as far as I know. But he's great. We were all just very new friends at the time. I had just gotten out of high school.

GEORGE FIGGS: Bob lived there, Sue lived there, Vincent lived there, Eggy the egg man lived there, and everybody went to the Maryland Institute except me. I went to the Maryland Institute to sell drugs and find women 'cause I was a bad boy! I wanted to have fun. That was the Bolton Hill period because the Maryland Institute College of Art is in Bolton Hill so everybody lived near there. So they were all members of the class of '66. Vincent and Sue and a few other people.

BOB ADAMS: None of this was planned; everybody grows into the tree in different ways. I was hanging around the art institute because I got laid off and wanted to get drugs. See this is where it all mingles together, it just happens fast. It's pretty much like you go to a party and there's around 10 people there and then you know everybody.

GEORGE FIGGS: There was a time when Ben and I would go around with John Waters to Bob Applegarth's house and David Lochary and Divine would be there and we'd listen to music real loud and take drugs, what everybody else did, you know.

PETER POMPAR: In '68, Cookie was living in this little alley, three steps down from the street. She was dealing acid. I remember being there one time when two men in business suits showed up and dropped off suitcases. I said, "What's in the suitcases?" and Cookie said, "Acid. I'm involved in trying to bring down the price of acid in town." I was just a little straight boy in the crowd and we were just tripping friends. We would go to Loch Raven Dam—it's a dam outside of Baltimore—and she had great stories about witches living there that she knew. When I went for my draft physical, I came to Cookie's house and she was living with a monkey and a gay guy. I spent the night before my physical in her apartment and there were about 30 dif-

ferent people who tripped into the house that night.

ALAN REESE: That would have been '68 or '69. It was 4901 York Road, just above Cold Spring Lane. I had a basement apartment there and there were a number of people who lived there on and off. Mink Stole was a resident for a time—she got arrested in the bathtub there.

JOHN WATERS: It was a suburban garden apartment. I don't know how many people could have lived there, I just remember two rooms and upstairs lived Mum and Anna. Mum played the prison guard in *Female Trouble*.

ALAN REESE: Mum was this real heavy bull dyke that lived in the same building.

MINK STOLE: Alan Reese... I don't remember how I knew him, but I remember I was arrested out of that apartment. I lived in that apartment when we were making *Mondo Trasho*, because it was during *Mondo Trasho* when we all got arrested.

ALAN REESE: She was taking a bubble bath before going to work, it was early in the morning and without her permission the two police officers opened the door and walked into the bathroom with her sitting in the tub and she started screaming and throwing soap bubbles at them. Eventually they got out and she got dressed and had to go with them. They had issued warrants for all of them. It was written up about in the paper.

Looking back at my old journals, Cookie and I were only together for two-and-a-half months it looks like, in '69. I was with my high school sweetheart and then I met Cookie right before John's premiere of *Mondo Trasho*. She had a little attic apartment and I met her through mutual friends.

This is from my journal, March 18, 1969:

*"Zixobo," read by the illustrious Cookie Mueller. Very beautiful story written by the aforementioned Miss Mueller. Cookie: Pisces, the face of earth, thin lips. John Waters's* Mondo Trasho *premiered this past weekend, I saw it five times. Excellent. John (Leisenring), Cookie, and I went to the cast party. We got stoned out of our poor skulls and I stayed at*

*Cookie's. I stayed with Cookie twice in her attic and she stayed once with me. We bathed in my tub, smoked, and had some tea and honey. A euphoric bath. Parties, problems, and drugs, a lot of busts going on.*

I knew John Waters at that point already; I got thrown out of high school and was going to night school and John Leisenring and John Waters were lovers. John Leisenring and I were best friends in high school and then he met John and ended up playing the shrimper in *Mondo Trasho*. I loved Cookie but I could never hold on to her, she'd just slip away. She was beautiful and shiny and everything a man thought he could want except that you knew she was not going to stay in one place.

JOHN WATERS: We loved Cookie, how she looked and everything. She wore high heels, but she was very much a hippie then. Like a downtown hippie, basically.

MARINA MELIN: My impression of her was as a motorcycle chick, a little bit hardened. But as I got to know her through the years, she definitely softened up.

JOHN WATERS: Marina was Miss Paraphernalia. Full mod fashion: mini-skirts, *Story of O* dresses, Sassoon haircuts, lashes.

MINK STOLE: Cookie had really long hair, multiple rings, multiple jewelries; she kind of affected that beatnik mama bluesy atmosphere. Cookie had the look and the attitude and she had stories about having met Charles Manson, which may or may not have been true. None of us were there, none of us saw it. But she said that she did and very possibly she did. I mean, she looked like Janis Joplin and she had a monkey. She kept it at home. It was a small monkey, not an ape. I have a recollection of it being in a cage, like a parrot cage, but that's probably not completely true.

ALAN REESE: Yeah, that would have been it. I had a parrot and a monkey. A cinnamon ring-tail monkey, Mr. Bojangles... No, I think it was her monkey. I had a Mexican redheaded parrot named Finious and she had a monkey named Avery.

MINK STOLE: Alan was nice. He had a girl-friend named Alberta whom he later married. All I can remember about Alan, in the context of that apartment, is that he had either gerbils or hamsters.

ALAN REESE: April 4, 1969:

*Testing amphetamines and an anti-epileptic pill, for Johns Hopkins. They paid us $50 for seven visits. Everybody's takin' it. John, Cookie, and I took our first speed for the test yesterday, it was endurable to say the least. I started taking the anti-epileptic pills this morning skipping history for a cup of tea at an anarchist gathering which amounted to nothing to speak of.*

JOHN WATERS: I did the speed test with John Leisenring. You went in and you had to fill out forms: "I'm depressed, I'm not depressed," that kind of thing. Then they gave you amphetamine and then an hour later you had to fill out the same test. That's my memory of it. I took a lot of LSD trips but I think that was before Cookie. The main people I took LSD trips with were with Divine, Howard Gruber, Pat Moran, Mary Vivian Pearce, and Bob Skidmore, all at the Marlborough apartments.

MINK STOLE: Howard Gruber and Van Smith lived at the Marlborough apartments. It was near the Maryland Institute and it was where a lot of kids who went to the Institute lived.

MARY VIVIAN PEARCE: We'd wander around and go up on the roof. There was a group of us that would meet every Saturday night for a while. Somebody knew somebody who was working at Johns Hopkins Hospital, saying they got the real LSD-25. That was when they put a tiny, tiny drop on a sugar cube. I don't know how they figured out you're only supposed to have a tiny, tiny dose. That was high school, I guess we were about 18 or 19. LSD was still legal when we tried it—we didn't touch illegal drugs, of course [giggles]!

John and I go way back. We went to church together with our parents. We'd always meet in the back of the church. We'd sneak out and steal cigarettes from cars and go into the graveyard and smoke and gossip and then meet our parents when mass was over. My

parents thought he was a bad influence and his parents thought I was. That's when we started fake dating. We'd have somebody, a friend, come and meet my parents, because to go out on a date the guy had to come to my house and meet my parents and be told the curfew and all that stuff. So

we'd get a friend to just come to the door to get me and then he'd go to his real date and I'd go meet John and the group and we'd go out.

PAT MORAN: Divine came from the county. Actually, John, Divine, and myself were all county people, initially. John and Divine were from Lutherville, and I was from Catonsville. I didn't know Cookie from Catonsville at all, but I think we shared the similarity that we

thought it was the most *dreary* place in the world!

GEORGE FIGGS: There was a coffeehouse scene and I arranged for the first showing of a John Waters movie to the public in the coffeehouse I was managing. I would bring in all the other hootenannies. We showed *Hag in a Black Leather Jacket*, *Roman Candles*, and *Eat Your Makeup*. I was in *Eat Your Makeup*. I was the prince who kisses the model who models herself to death. I bring her back to life.

BEN SYFU: I worked the scare-o-chair. There was some sort of carnival with a tent and a lawn chair and someone sits in the chair and I rock it back and forth and side to side while this woman screams hysterically at the top of her lungs and then she gets up and says, "What a wonderful ride!" and then walks away.

*Cookie, Baltimore, c. 1969 (Bob Adams)*

GEORGE FIGGS: And then I was in *The Wizard of O.D.* John still has footage of it that he shows every once in a while at his Christmas parties. I played the Grassman. Pat Moran played Dorothy and had a little plastic duck instead of a dog. It never got off the ground; we only shot for about four days and then John gave it up.

BEN SYFU: For the flying monkeys John used flying junkies and the wicked narcotic agents.

MARY VIVIAN PEARCE: In *Hag in a Black Leather Jacket* I played a dancer. I do the Bodie Green. I wore one of John's mother's evening gowns. I guess the Bodie Green because we'd always get kicked out of CYO, the Catholic Youth Organization, for doing the Bodie Green, which was considered dirty dancing. It's a version of the twist but only instead of going side to side you did bumps and grinds. The Catholic Church considered it obscene.

GEORGE FIGGS: We used to sit outside Martick's café. John and I and Van and Bonnie (Mary Vivian Pearce), we were waiting for a beatnik to come out so we could buy some pot or have them get us some wine.

MARY VIVIAN PEARCE: Martick's was a little bit before Cookie. It was a bar and nightclub and Maelcum Soul was a bartender there, when people were still beatniks. I wasn't even old enough to go into a bar and we'd sneak in there and get kicked out within 10 minutes.

GEORGE FIGGS: Maelcum Soul was an artist and she used to tend bar in a nun's habit.

PAT MORAN: Martick's! Oh yes yes yes. More fun than anyone deserves to have! Maelcum Soul was my best friend. Every one of us was pretty much a renegade Catholic, for some reason. She died during the riots—not as a result of them but she died and then the riots came. Very peculiar. She died when Martin Luther King did, in 1968. She's buried at the old Bohemian Cemetery here in Armistead Gardens and for many years John and I would always go there for Halloween.

MARY VIVIAN PEARCE: We went to her funeral in 1968, during the riots. That was really scary. The riots were still going on and I was living with John on 25th Street. We lived in an integrated neighborhood, and so we had the National Guard right out in front of our house and we could see people going out and looting. Little kids were selling televisions for $2 and there was a curfew. One night I was working at the racetracks and we were on the way back to town and we could see the whole city in flames. I was with some guys from the racetrack, they were all black, except for me, so we just turned around and went back to the racetrack and I spent the night in the barn.

GEORGE FIGGS: Yeah, they burnt Baltimore and Detroit. Not the whole city. They burnt all the buildings on Martin Luther King Boulevard. The city was on fire back in '68. After they killed Dr. King, everybody went crazy and set everything on fire.

SUSAN LOWE: The whole of Baltimore city was usurped by army guys with guns and army trucks. I remember a girlfriend and I were going out to purchase some hashish and it was past curfew. It was pretty scary. I mean, we had to hide behind cars and shit. We immediately went back 'cause we got scared. We saw fire and heard shotgun shots out of high-rise windows. It was awful. And looting all over the place.

It was an exceptional time in American history. We grew up in postwar situations. Everything was TV, refrigerators, irons, and vacuum cleaners. All our parents cared about was how *clean* and proper everybody looked, and this sterile no love, no touching because it might be dirty or whatever. Everything was like *no dirt*. When black people saw us, because we were freaks, they would give us the thumbs up. It was the '60s, so it was all new: hippies living on communes and stuff, artists all over the place. It was quite a revolution, really. It was a cultural revolution in the United States. Civil rights, Martin Luther King, Kennedy.

Vince had started this whole commune in an old bakery in Fell's Point, South Broadway on the Docks, it was called Hollywood Bakery. I said to John Waters, "You have to come down to Fell's Point. You will go insane!"

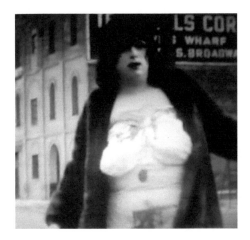

## FELL'S POINT:
## HOLLYWOOD BAKERY

*"Baltimore was becoming our oyster. World fame looked like it was right around the corner. We were up-and-coming celebrities, our ships were coming in, our stars of fortune were rising, we were blessed people in the most blessed profession, the best business in the world. The entertainment business."*

—Cookie Mueller, "John Waters and the Blessed Profession—1969," *Ask Dr. Mueller*

VINCENT PERANIO: There was not a tree in Fell's Point, and at the foot of Broadway, at the intersection, there was a huge rusted freighter most of the time and trains went right down the street. Nobody wanted to come here. It was dangerous.

SUSAN LOWE: It was industrial.

VINCENT PERANIO: It was the docks.

SUSAN LOWE: Whores, sailors, bull dykes, winos. That's all you saw. And the Greek mafia. Edgar Allan Poe died in Fell's Point. He used to come here to drink and fight.

GEORGE FIGGS: Fell's Point is a waterfront neighborhood. It's the wharf. The reason we went down was there were no yuppies there. There were Indians—I mean American Indians—prostitutes, scam artists, alcoholics, working types, seamen, and that whole thing.

BEN SYFU: And it was never Fell's Point then.

We never knew it as Fell's Point until much later. We always called it "the foot of Broadway," and it really was the slums.

PETER KOPER: The way you would enter the bakery was through a little alleyway. You had to know exactly where you were going, it was right off of South Broadway, and you'd walk down this narrow alley and then you would come to a big backyard and you'd turn left and then you'd walk up these stairs and then bingo you were in the bakery.

VINCENT PERANIO: We were eight graduates from the Maryland Institute College of Art. Everybody had their own bedroom, their own studio. We had common rooms, downstairs, where the big bakery ovens used to be. We set up a little theater and did little plays to amuse ourselves. We were artists, so it was just covered with paintings and all kinds of artwork and thrift shop furniture. It was an artists' commune.

SUSAN LOWE: Inside, Vince had turned all the rooms into period sets. He made a planetarium. He's brilliant. Like, this is the Victorian room and this is the Grecian room. It was just when second-hand stores were opening up, and we collected a lot of things from second-hand stores. There's one place that we always went, the Hadassah, that was downtown. Man, we would find beaded bags for a dollar, beaded shawls and all kinds of stained glass windows. I mean it was unbelievable this place. Vince and

*Above: Divine, film still from* Multiple Maniacs, *1970; right: Fell's Point local*

the others would make the trip to Hadassah a lot too and then there was an old Goodwill several blocks north on Broadway.

JOHN WATERS: All of us dressed in 1930s clothes because that's what our parents had thrown out. That was what was in the thrift shops. So Vince was always a thrift shop dandy, and I mean that in a good way.

PETER KOPER: In Baltimore in those days, all the whites had moved out of the city and it was just poor blacks left. The city was deteriorating. It used to be a really gorgeous, wealthy port merchant city but there were all these government programs to demolish all the old houses and a lot of people would go and just steal stuff. All the Maryland Institute people like Vince were immediately decorating their places with stuff they'd found out on the street. It was chock-a-block filled with statues, stained glass, old wicker furniture and art on the walls. It had a kind of a Victorian, LSD-inspired feel to it.

SUSAN LOWE: And it was huge.

VINCENT PERANIO: Yeah, it was 22 rooms for $100 a month. It was amazing. It would fluctuate between 8 and 12 people. If you were underground somehow, from out of town, you would make your way to our place.

PETER KOPER: The Hollywood Bakery was like a magnet.

JOHN WATERS: It was Vincent's first set really.

GEORGE FIGGS: It was like a cross between a Parisian salon from the 19th century and a hippie crash pad. Most of us were painters and sculptors and actors and filmmakers.

MINK STOLE: But this place was *decrepit*. There were huge gaps in the floor. I mean, to live there they had to be mountain goats. They had to jump gaps in the flooring to get from room to room. It was crumbling.

PETER KOPER: People from the literary crowd at Johns Hopkins University, among whom I was, and the Maryland Institute College of Art people. And into that scene—this young crew of acid-head artists and writers—stepped Cookie and Dolores.

I have photographs of Dolores from those

days: she had straight, wild red hair. No makeup. She was a little pudgy and wore plain hippie dresses—housedresses. She was just a plain girl from the suburbs and with her came Cookie. I distinctly remember Dolores making huge vats of soup for everybody at the Hollywood Bakery, and there were con-

stant parties where people would just come by. I remember a party once where everybody dressed like they were in the 1950s. I think Dolores had a poodle skirt on or something like that.

ALAN REESE: March 30, 1969:

*Cookie, Jerry, Sally, John Leisenring, and I went to a '50s party last night at the bakery on Broadway. What a night. Cookie, Jerry, and Sally got all '50ied up. Jerry looked like the most unpopular girl at school while Sally*

*looked like the one everyone took out for hand-jobs and for a fuck but the one they never talked of. Cookie had a ponytail with bangs, red lipstick, a French push-up bra, a white blouse tied in a knot to expose her middle, faded torn tight dungarees cuffed up to about an inch or two above her ankles and blue strap heels. She*

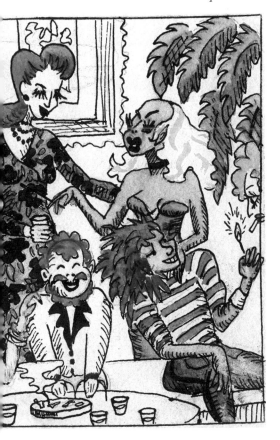

*took home the guys that the chick every guy at school wanted. The one who walked in a cloud of rumors. Still, there was no one to say he had had her.*

*Susan Lowe was the school slut, knife and all. Everybody was boppin' and drinkin' beer, undershirts with cigarette packs rolled in the sleeves, big lipstick marks on shirt collars. Came home and smoked some hash and drank some wine, floors began spinning like magic carpets.*

*Drawing by Cookie, c. 1972*

The only way I have any clear memories are looking back at these old journals. I was 19 at the time.

VINCENT PERANIO: It was a huge party house. Sue brought John Waters, Mink, Divine, Bonnie Pearce, David Lochary, and Van Smith down at the same time.

SUSAN LOWE: From downtown, where I used to live. Then I moved to Fell's Point and shared an apartment with a gay man, Paul Swift, the Egg Man in *Pink Flamingos*.

PAT BURGEE: I met all of them at different times. I met John at a bookstore; he sold me my first copy of *The Night of the Iguana*, when I looked like I was 12 and nobody would sell it to me but him. I was so amazed by them. I hoped that someday I'd get to know these guys who were so much more interesting than anything else.

JOHN WATERS: My set came from Towson and Lutherville: Bob Skidmore, Mark Isherwood, and Mary Vivian Pearce were the bad suburban kids, and we hooked up with the gay ones downtown because Divine lived there. He introduced us to David Lochary and all of them and they became my gang. The other gang was the Hollywood Bakery, and that was very much Vincent Peranio and Jim Thompson, Dee, Sue Lowe, and Dolores Deluxe. We sort of merged, but it was two distinctive groups. Next door to the bakery was Pete's Hotel, which is where Edith (Massey) worked. We would go to the bakery and then we would all go to Pete's Hotel because drinks were so cheap. Vincent and Sue were the ones who brought me to meet Edith.

MARY VIVIAN PEARCE: I'm not sure if Edith was born in Baltimore. I think she maybe came in the '40s or '50s and that's when she worked on the block. Have you seen the documentary *Love Letter to Edie*? I think she was a tap dancer and then a sitter. They'd hire women to hustle drinks, they'd call them B-girls or sitters. I went into a bar once and applied for a job as bartender and they said, "No, we need a sitter." "You need a babysitter?" [laughing]. Edith looked a little bit like Tallulah Bankhead. People called her Tallulah.

GEORGE FIGGS: Me and one of the Peranio brothers went over there and said to Edith, "You are incredible—what are you doing in here? Uncle Pete needs a barmaid across the street."

VINCENT PERANIO: We all knew Edith as a bartender long before her acting career.

SUSAN LOWE: John fell in love with her there. Pete's was all old, down-and-out merchant marines who were drunk in the bar every day.

GEORGE FIGGS: Oh yeah, we knew Uncle Pete. He loved us, he was like our uncle. He was like a very kind old Polish grandfather.

PETER KOPER: Upstairs at Pete's Hotel were single rooms for sailors. By 1967 the sailing industry had sort of collapsed, so the rooms were filled with derelicts, winos, and just homeless people. So was the bar; the bar was filled with drunks and some old ladies, so we took over the place. It was perfect for us. We drank Arrow Beer drafts for 15¢. The beer was awful, a step above urine. But it was cheap and got you drunk eventually and they had a great jukebox. I remember dropping acid and going in there hanging out with all the old winos, a different kind of LSD trip.

The first time I saw Cookie was at Pete's Hotel. She must have been 17 or 18, and I always found Cookie to be quite attractive, actually. She had this kind of damaged face but there was something attractive about it, very interesting face. She already had that sort of bird's nest tangle of dirty blonde hair, dishwater blonde hair. The fashion in those days was for women to wear a lot of bracelets, from elbow to wrists, so she had a lot of bracelets on and a lot of jewelry.

JOHN WATERS: Divine always hated Pete's Hotel, because he wanted to go to fancy places. He was never a hippie, really. His father used to say to him, "Why don't you go to a riot? Why don't you go to the political actions that they go to?" Divine just wanted to see Elizabeth Taylor movies and wear mink coats.

PETER KOPER: I remember there was a part of the John Waters crew that didn't mix with the Maryland Institute group; it was kind of the gay group. Like David Lochary, Van, and

Divine; people knew Divine and stuff but Divine didn't come to hang out. We knew who each other were, but it wasn't the kind of firm friendship with shared experiences that the people at the bakery and Pete's Hotel had. You have to understand, we were all taking LSD at that point, including John. That was our aesthetic. A lot of our acid trips were at the Hollywood Bakery. LSD is a drug that changes your perception, and it changes your perception for life. It kind of imprinted us; this was the beginning of the whole drug age. Nobody knew what any of this shit was, so we felt like astronauts or something, entering this strange world. Some people claimed it was Owsley acid, but it was chocolate acid. One of my first trips was with Vince and his girlfriend at the time, Cissie Ludlow, in Fell's Point. The waterfront was just abandoned factories, so we were tripping and walking through these glass-strewn sidewalks and into abandoned factories where we would be finding these pools of chemicals and go, "Wow, look at the colors!" We were walking through the Allied Chemical chromium factory. All that stuff was poisonous.

GEORGE FIGGS: The Home of the Blues was one of the reasons I hung out in Fell's Point. This guy collected 45s and had a six-foot-high file cabinet with five drawers filled with old blues: Muddy Waters, Howlin' Wolf, Skip James... Cookie would come. We would just drink wine, dance all night, and go for rides on the tugboats. The Home of the Blues was right on the wharf where the tugboats pulled up. We would yell to them from the windows and they of course could hear the music, because the music was blasting. The girls would yell out, "Hey, give us a ride!" and the guys on the tugboats would say, "Sure, come on!" and the whole bunch of us would come. They probably thought it was just going to be girls!

BEN SYFU: There was also a coffeehouse in front called the Flambeau. For the Home of the Blues, you would enter through the back alley. Mostly a folk scene at that time.

GEORGE FIGGS: In fact, that was kind of the basis for the Hollywood Bakery. Vince found the bakery because he had been coming to the Home of the Blues. We had found Pete's and the Hollywood Bakery was right next door, empty, so Vince got it.

MINK STOLE: The Home of the Blues was great, but I wish I had been more aware. The first time I went to Home of the Blues was before I knew any of these people. I don't know how I got there but I know I went with my sister. I'm not sure she would want to be quoted, so we'll leave her ambiguously as my sister. We somehow ended up there a couple of times when we were taking drugs, but I have no recollection of how we got there. I was probably just blindly following my sister around.

Back in those days, the acid was so strong that all I could do was sit around and admire the patterns in the rug, just sort of sit with a big grin on my face and go, "Look, paisley!" It wasn't particularly active.

PETER KOPER: We'd seen John's advertising around town on telephone poles and stuff. He used to show his early movies in church basements, so we kind of knew who he was. Then one day he showed up at the Hollywood Bakery and everybody came by to meet him and he immediately grabbed hold of Vince and Jim Thompson and all these other people for his next movie, which was *Multiple Maniacs*. It was *Multiple Maniacs* that everybody started with.

VINCENT PERANIO: My group of artist-friends became friends with them and Cookie, and then we all participated in *Multiple Maniacs*. That was the first film with John I ever did and I've done every one since then. Yeah, a Dreamlander, basically.

PAT MORAN: That was what John referred to as Dreamland Studios way back when, which was merely his apartment. Mostly I remember the Christmases at John's. There would be the whole Dreamland collective and everybody had been out to thrift stores, way before they were popular. I can remember all of us being there and opening up our presents. You'd have

presents for 25 people, but it probably didn't even cost $25 at the time. We were knee-deep in wrapping paper.

JOHN WATERS: Pat Moran was like *Beyond the Valley of the Dolls*. She liked to wear mod clothes, like Twiggy.

My first apartment was at 315 East 25th Street. You can see Bonnie walking out the front door in *Mondo Trasho*.

All the indoor scenes of Lady Divine's apartment were my apartment. Christmas

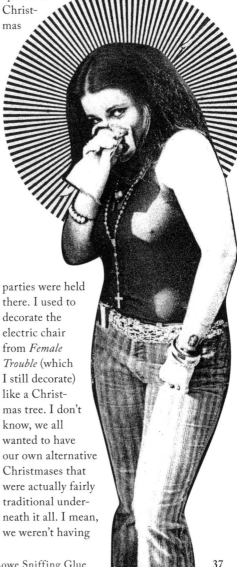

parties were held there. I used to decorate the electric chair from *Female Trouble* (which I still decorate) like a Christmas tree. I don't know, we all wanted to have our own alternative Christmases that were actually fairly traditional underneath it all. I mean, we weren't having

living *crèches* or anything, but we all bought each other presents and decorated the house.

MARY VIVIAN PEARCE: The early ones were on Christmas Eve. Everybody would wildly rip open presents at midnight. Finally John's parents said he couldn't have Christmas Eve parties any more because he was just too tired on Christmas day. The guests wouldn't leave until 5 or 6 a.m. Now they're catered, but the early parties it was no cooking: just potato chips and lots of whiskey and beer.

VINCENT PERANIO: Cookie had gotten an apartment a block away from us in Fell's Point on Bond Street. We all lived down in the Fell's Point area during that period when we were making *Pink Flamingos* and *Multiple Maniacs*.

JOHN WATERS: And Sue Lowe lived on Bond Street with Paul Swift, the Egg Man.

SUSAN LOWE: 839 South Bond Street. The trains would come up and down every morning and my window would be like *dee-hee-hee-hee* [shaking sounds and gestures]. I hated those fucking trains. Finally I broke the window when I couldn't stand it anymore. I looked outside and the train had fallen in and smashed all the cars. That always happened at least once a year.

JOHN WATERS: Bond Street is where you see Divine walking up the street in *Multiple Maniacs* when Howard Gruber and Sue Lowe are sniffing glue and they jump him and rape him.

VINCENT PERANIO: That scene in *Multiple Maniacs* where Divine is chasing the whole gang is really all of our friends from that period. We needed everybody we could get for that crowd scene, with Divine chasing as a monster. We did it on a Sunday morning right down the middle of Fell's Point: 60 people screaming, running around blocks.

DOLORES DELUXE: Well, nobody was there except the homeless ladies.

SUSAN LOWE: Or the old Greek lady.

VINCENT PERANIO: The Greek belly dancer. No one cared.

GEORGE FIGGS: I had known Cookie since high school, so we finally got together during the making of *Multiple Maniacs*, in which I played Jesus Christ. There's a great picture of me as Jesus Christ and Sue is spitting at me; she hocks a loogy and it's hanging off my beard—that's a really charming picture!

I was living with Cookie, she was my girlfriend. She was working on her first book, handwritten in a copybook with illustrations. I did some of the illustrations too. I sure would like to find that. She said, "I'm writing a book," before she ever had aspirations of being a writer. It was about what was happening, everybody in the scene, and how she felt about things and poetry. A kind of creative journal. It was funny. Cookie had a really sophisticated sense of humor and would play with your head. She would find out if you were particularly uptight about something and she'd go after you about it, force the issue.

JOHN WATERS: In *Multiple Maniacs* Cookie played Divine's Weatherman left-wing daughter, being at riots all the time. She and Divine got along great. It almost seemed like she was Divine's daughter in real life!

MINK STOLE: I thought I was the only one who played Divine's daughter. I have a lot of roles in that movie. I have one main role, and then multiple other roles. I'm the religious whore, I give Divine the rosary job. I'm also the tourist they shoot up in the tent, and I'm also in the riot at the end.

SUSAN LOWE: When John was a kid he was a puppeteer. He used to put on little shows with

puppets and they would all kill each other and have car crashes and he would perform them for kids' birthday parties. So we're his puppets for movies.

PAT MORAN: When we started to make movies it was the era of Jonas Mekas and Jack Smith and Warhol. It was underground films, but we knew that we could make films with peculiar subject matter in a sort of guerrilla fashion of filmmaking. Nobody was a professional. It was like whoever could show up on the weekends. Cookie was part of our ensemble.

BOB ADAMS: I lived across the street from Cookie on Bond. We used to have tea and coffee together in the morning—well, whenever the morning was; we weren't early risers. And then later I was living on a commune and

John asks, "Can I film a trailer scene at your house?" and I said, "Sure," and that's where *Pink Flamingos* was filmed: Phoenix, Maryland.

GEORGE FIGGS: I loved working on *Pink Flamingos* because I got to work with Vince and Van on the trailer. The trailer was like a character in that movie; it itself had a personality because we made it into this kind of living thing with Edie's playpen in the corner and Divine's room. Like when you shoot in a certain city and the essence of that city gets into the film.

JOHN WATERS: I knew Cookie was going to be in *Pink Flamingos* after she had been in *Multiple Maniacs*. When we made *Pink Flamingos*, she played the spy who worked for the Marbles.

eferred to by Mr. Waters as his celluloid ondo Trasho" is humorously "trashy" but d harder to swallow; a monster film. It director's own fanatical enjoyment and lled "freak element" of movie-goers who oy movies that appall them; a movie-going

Mink Stole, the topless tap dancer of "Mondo Trasho", and it is certainly her most flagrant performance to date. New additions to the cast are Cookie Mueller (who won last year's doorprize to the Little Tavern) and Rick Morrow as Lady Divins's faithful bodyguard. The entire cast consists of eighty people playing multiple parts.

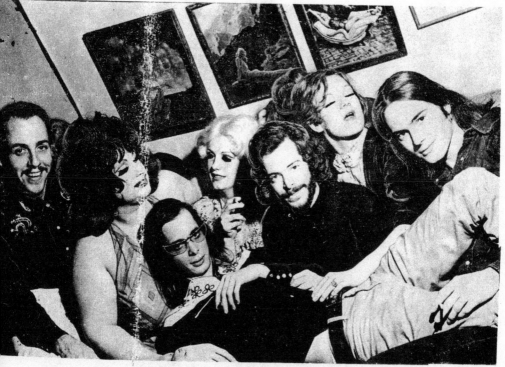

*David Lochary, Divine, John Waters, Mary V. Pearce, Howard Gruber, Cookie, Rick Marrow (Lawrence Irvine)*   39

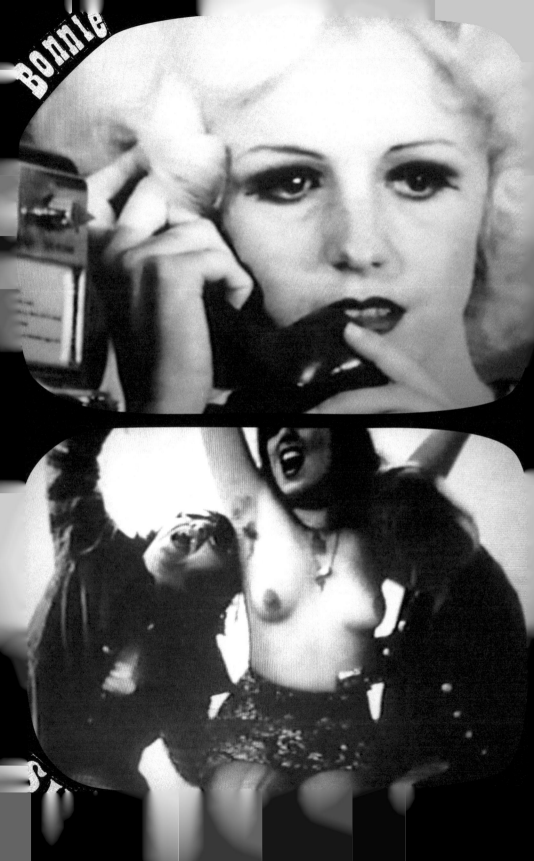

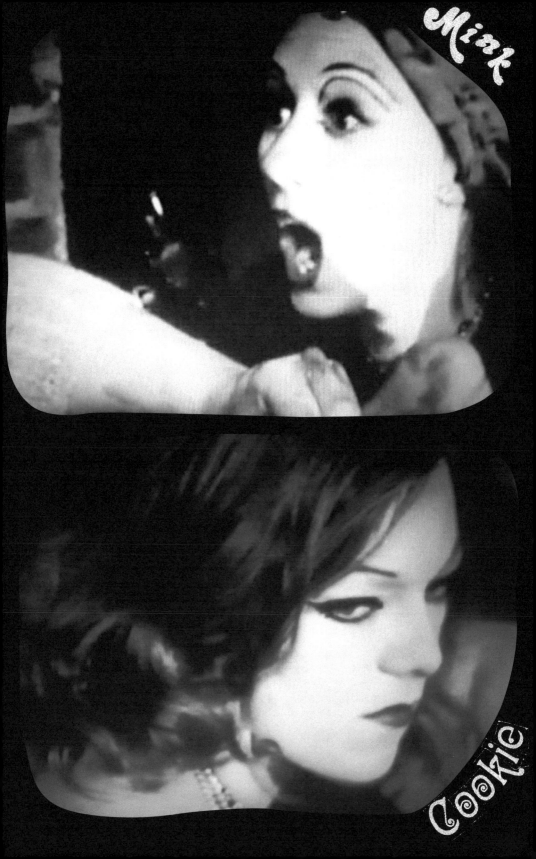

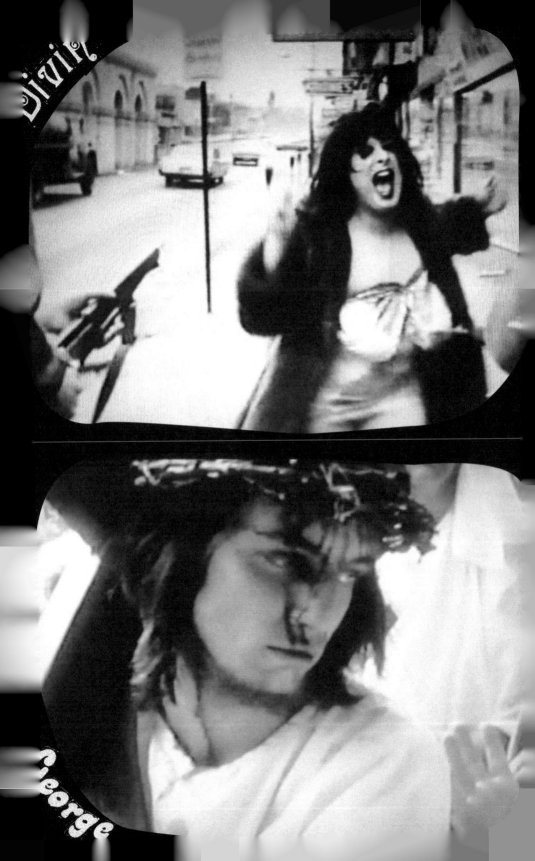

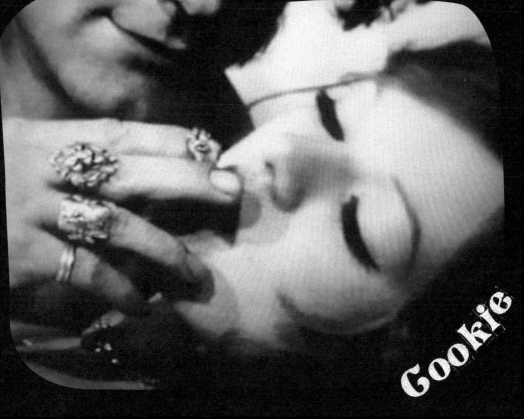

Cookie

MINK STOLE: I played Connie Marble. Connie and Raymond Marble were Divine's rivals for *the filthiest person alive*. Back then, Bonnie (Mary Vivian Pearce) looked like Jean Harlow, which is a description that she really hates, but she really did. She was blonde and gorgeous. She had her hair completely bleached out and curly. I think she wanted to feel that she looked more original than that. But there was a very strong resemblance, a very strong similarity. She wore bright red lipstick and she was slim. She was stunning.

MARY VIVIAN PEARCE: My hair was platinum blonde in *Pink Flamingos*. *Mondo Trasho* is in black-and-white, so it looks white. I used a toner called Champagne Ice. That's when I tried to make it look like a Jean Harlow hairdo. John saw to it that we didn't have roots when we filmed. There was always somebody to do my hair the day before we filmed.

JOHN WATERS: When we made *Pink Flamingos*, Mink and David had to dye their hair with Magic Markers and stuff.

MINK STOLE: A flame redhead. That really ultra-bright red was created for *Pink Flamingos*.

JOHN WATERS: David had blue hair. Nobody had ever seen that. They couldn't go out of the house with their hair that color. Yes, we got hassled.

MINK STOLE: But we knew that. We invited it. I get very impatient with kids who dress oddly and then get pissed off when people look at them. We knew people would look at us; we weren't stupid. I remember walking around San Francisco with Divine, she would be in a jumpsuit with a shaved head and no eyebrows, and I had the flaming red hair and God only knows what else I was wearing. Cars would screech to a halt! We possibly caused accidents when we went for a walk. But we expected it. We knew we looked extraordinary.

LINDA OLGEIRSON: I was living in Baltimore with my boyfriend, Jack, and Susan Walsh, Divine, and a woman named Pam. Susan and I went thrift shopping all the time and had these 1930s satin nightgowns that we hung around in all the time. Basically we never

got dressed, just to drink at the bars in Fell's Point. John used to drive up the back alley and pick up Van and Divine at 7 a.m. when all these blue-collar types were getting ready for work, and Divine would get out of the alley in complete drag, you know, fishtail dress, makeup, and all shaved, those eyebrows.

CHANNING WILROY: Interminable waiting. Show up at 6 a.m., sit out in some cold warehouse or country farmhouse all day waiting for your scenes to come along, and they wouldn't come along until the next day if they even came along then. Of course we didn't have catering so we'd all go to lunch in whatever outfit you had to wear that day. Sometimes the scenes would get fucked up and we'd have to come back and go through it all again because it didn't come out right on film or something electrical would go wrong. There was a lot going on.

LINDA OLGEIRSON: In *Pink Flamingos*, Susan Walsh and I get kidnapped by David Lochary, who has a baby factory and Channing is the inseminator.

CHANNING WILROY: I'm the one who kept the girls in the basement.

ALAN REESE: I have screen credits for *Pink Flamingos*. Alberta and I were in the human asshole scene; we were audience members viewing the performance.

LINDA OLGEIRSON: There was another scene that was filmed in John's house where Chan kept forgetting his lines and so in the film his face is all red because John made them start the take at Mink slapping him. So there was take after take after take beginning with a slap until he remembered his lines. John is a sadist.

ALAN REESE: The first film I was in was *Mondo Trasho*. I was in the insane asylum where Mink does a topless tap dance and gets gang raped.

MINK STOLE: Sometimes I wonder how John sleeps at night.

SUSAN LOWE: We didn't say no though, did we?

MINK STOLE: Yes, I did once. I wouldn't set my hair on fire! He wanted to set my real hair on fire. With a match! I'm not kidding. In

*Previous pages: film stills from* Multiple Maniacs, *1970; opposite:* Pink Flamingos à la carte

*Cecil B. Demented,* that was optically done! And Cookie never got fucked by a chicken in *Pink Flamingos!* That is such a lie. But yes, in the sex scene with her and Danny, there was a live chicken, and the chicken was between their two bodies, and she was really scratched. Cookie would never have said no.

JOHN WATERS: We fought when we were filming. Cookie and I bickered, always. We bickered like an old couple. She'd be late, which made me insane. Cookie could never be on time. But then she'd bitch at me. One thing for which she was right about bitching is that I wanted her to smash a TV set while it was on and film it while it happened. She called this place and they said it would be very dangerous and not to do it. She wouldn't do it, and well, she was right. My reality was a little...

CHANNING WILROY: Baltimore's where John sets all his films, the place where he gets all his ideas.

LINDA OLGEIRSON: Baltimore was such a small city and anyone who had a certain bend would find each other.

JOHN WATERS: Linda: very pretty, a good girl, really, from a very nice family. Like a private school girl turned *political*—a leftwing girl. She had the look of a radical feminist at the time, but not in a bad way... more like a yippie.

LINDA OLGEIRSON: It was during the antiVietnam War period. There was this newspaper called the *Baltimore Free Press* and all these people used to go to Cuba, you know, all these "middle class" white rich kids would work in a cane field and feel revolutionary, wear beards and talk about a revolutionary group called the Venceremos Brigade. I mean at the time it seemed cool but in retrospect it seems totally bullshit.

PAT MORAN: Once we started doing premieres in New York and Provincetown, all of us from Baltimore would stay with other people who lived there. It was always very tribal. We traveled in packs. Cookie was a big hitchhiker. So I think she used to hitchhike and we would always take the bus.

*Divine, Channing Wilroy & John Waters, c. 1970 (Nelson Giles)*

JUST THREE SLUTS

Cookie Mueller excerpts are taken from her story "Abduction and Rape—Highway 31, Elkton, Maryland, 1969," *Walking Through Clear Water in a Pool Painted Black*

COOKIE MUELLER: "They were just three sluts looking for sex on the highway," the two abductors and rapists said later when asked to describe us.

This wasn't the way we saw it.

MINK STOLE: Yes, it must have been 1969. You know the story. Well, my version's probably different. In Cookie's story, she had me wearing a ball gown, which is completely not true. I was wearing brown bellbottom jeans and a brown leather jacket.

SUSAN LOWE: I had black nail polish, miniskirt up to here, black lipstick. We were the punks.

COOKIE MUELLER: …and I, the blonde, was dressed conservatively in a see-through micro-mini-dress and black velvet jacket.

SUSAN LOWE: We were such sluts. We had taken three Black Beauties each and we had a big ol' bottle of wine on us.

COOKIE MUELLER: True, we were hitchhiking. True, we were in horny redneck territory, but we hadn't given it a thought.

MINK STOLE: We started out, I don't remember, might have been Memorial Day, might have been before that. The three of us got out on the road and were just getting short-hop rides.

COOKIE MUELLER: It was a sunny day in early June, and Mink, Susan, and I were on our way to Cape Cod from Baltimore to visit John Waters, who had just finished directing us in his film *Multiple Maniacs*.

When we told him we were going to thumb it, he said incredulously, "You three?? You're crazy! Don't do it."

MINK STOLE: Then a couple guys picked us up— we were still in Maryland. They promised to take us to New York, and we believed them.

SUSAN LOWE: We got in this car with these hillbillies because they had beer in the backseat. They looked like… oh, you know, greased-back hair or a flattop, maybe—farmerish.

*Drawing by Anton Garber*

COOKIE MUELLER: …Burgundy Mach 4 Mustang with two sickos, gigantic honkies, hopped-up and horny on a local joy ride.

MINK STOLE: The three of us got into the back and the stupid thing is that we put our luggage in the trunk. That was our mistake. And Cookie carried *everything* in her bag: an iron… I mean she was loaded down.

COOKIE MUELLER: For the twelve-hour trip, we didn't forget our two quarts of Jack Daniels and a handful of Dexadrine Spansules (they were new on the pharmaceutical market), and twenty Black Beauties. Aside from these necessities we had a couple of duffle bags of Salvation Army and St. Vincent de Paul formals and uniwear.

MINK STOLE: We started getting a bad feeling about these guys. I don't know how long we were in the car before we realized that they were never going to take us to New York, that they had no intention of taking us to New York and never had. What they intended to do, I don't know.

COOKIE MUELLER: There comes a time when even the most optimistic people, like myself, realize that life among certain humans cannot be easy, that sometimes it is unmanageable and low-down, that all people are quixotic, and haunted, and burdened, and there's just no way to lift their load for them. With this in mind I wanted to say something to Mink and Susan about not antagonizing these sad slobs, but right then the driver turned to me.

"You ain't going north, honey, you ain't going nowhere but where we're taking you."

These were those certain humans.

MINK STOLE: I don't know if they thought they could just ride us around, I don't know if they intended to rape us or kill us or what. I really don't know. Anyway, it was still daylight and we were in this town called Elkton.

COOKIE MUELLER: … smack in the middle of a famous love zone, Elkton, Maryland, the quickie honeymoon and divorce capital of the eastern seaboard.

MINK STOLE: At one point we went through a car wash. We sat in the car through the whole thing. We could have hopped out while the guys got out, but they were fucking with us already and we started to get scared and they knew we were scared and they were somehow getting off on that.

SUSAN LOWE: Well this is how I remember it: I remember seeing the same toll taker, and I'm going, What the fuck? And then we realized the guys were trying to make us lost and then one time we tried to pass a note to the toll booth—it was me because the toll booth was on the driver's side and I was behind the driver—and they caught us trying to slip a note. We were laughing because we didn't realize the danger at the time. We were high on Black Beauties.

COOKIE MUELLER: "We have knives," the guy riding shotgun said and he grinned at us with teeth that had brown moss growing near the gums.

"Big fuckin' deal," said Susan, "so do I," and she whipped out a buck knife that was the size of my miniskirt.

The driver casually leaned over and produced a shotgun and Susan threw the knife out the window.

MINK STOLE: Eventually they drove to some small rural house somewhere in the area of Elkton. There was a woman with a small child doing the laundry.

COOKIE MUELLER: She was wearing blue jean cutoffs and a T-shirt that said MARLBORO COUNTRY on it. She looked forty-five but she was probably twenty.

SUSAN LOWE: A hillbilly house that I have never seen before, except in pictures of Appalachia, maybe. It was in the woods. Mink and I were on the edges, so we jumped out but Cookie was in the middle and they drove off before she could get out.

COOKIE MUELLER: Mink and Susan got out but Mossy Teeth, El, grabbed my thigh and held me fast. Merle spun the car around and we took off, making corn dirt dust in all the faces of everyone who was standing there in front of the house…

I began to feel the mood change. As they were talking to each other I noticed that they sounded scared; El even wanted to get out and go home.

After a lot of fighting, Merle finally did let El go…

I have always been an astute observer of sexy women and unsexy women, and in all my years I've never seen a crazy woman get chased by a man. Look at bag ladies on the street. They rarely get raped, I surmised. And look at burnt-out LSD girls. No men bothered with them much. So I decided that I would simply act crazy. I would turn the tables. I would scare him.

I started making the sounds of tape-recorded words running backwards at high speed. This shocked him a bit, but he kept driving farther into the woods, as the sun was setting and the trees were closing in.

"What the fuck are you supposed to be doing?" he asked me nervously. "You a maniac or something?"

"I just escaped from a mental hospital," I told him and continued with the backward-tape sounds, now sounding like alien UFO chatter.

I think he was believing me, anyway he pulled off into the bushes and unzipped his pants and pulled out his pitifully limp wiener. He tried to get it hard.

For a second I saw him debating about whether or not he should force me to give me a blow job.

"Ya devil woman, ya'd bite my dick off, wouldn't ya?"

He tried to force his semi-hard pee-wee rod into me as he ripped my tights at the crotch. I just continued with the sounds of the backward tape as he fumbled with his loafing meat. This infuriated him. "I'm going to ask Jesus to help me on this one. Come on, sweet Jesus, help me get a hard-on. Come on."

He was very serious.

MINK STOLE: Susan and I got the woman to call the sheriff. He came and got us and took us to the station. Susan was drunk and passed out; she had tattoos on her belly and her shirt would ride up and, well, they just thought we were trash. We were beatniks, we were hitchhiking, and we deserved whatever we got. There was absolutely no sympathy. We described the guys to them, described the car. They had to have known who they were; it's a small rural town, but they denied all knowledge. So Susan and I stayed in the sheriff's office for a while, and during this time there was a jailbreak. Someone had pretended to be hurt in the jail cell and had gotten himself put in an ambulance and taken to the local hospital, and while he was there he escaped. So everyone in the sheriff's office was completely upset about this. They were all very excited about this jailbreak, and I remember there was this one really fat guy walking around in his Bermuda shorts. He had a two-gun holster and was yelling, "Leg irons! Next time we put 'em in leg irons!" So that was

going on while we were trying to get them to look for Cookie, trying to get them to pay attention to us and realize that we had a friend who was really in danger. I mean we had *no idea*; Cookie had disappeared with two guys. We were terrified!

COOKIE MUELLER: Not waiting to see whose side the Lord was on, I pushed his wiener quickly aside and threw open the door and dove out into the darkness. I ran faster than I'd ever run and I wasn't a bad runner.

As my eyes grew accustomed to the half-moon light, I saw that I was running into very deep woods. Aggressive brambles grabbed at my thighs, poison ivy licked at my ankles, and yearling trees slapped me in the face.

After a long time I decided to stop running, so I got under a bush next to a pile of rocks. I felt a bunch of furry things scuttle away. Rats or possums or raccoons, I guessed.

I laid there for awhile trying to see things in the darkness. And then I heard his voice.

He was far in the distance yelling, "Girl! Girl! Where the hell are ya?"

Did he think I was really going to answer?

As he got a little closer I saw that he had a flashlight and I got scared again. If his light found me there would be no hope. My white skin was very bright in the bluish flood of the half moon. I had a black velvet jacket on with a black lining, so I ripped out the lining in two pieces and wrapped one around my head and the other on my almost bare legs. Those brambles had shredded my stockings.

No light would bounce off me now.

I was awake for a long time and then I just fell asleep, sure that he had given up the search.

MINK STOLE: Eventually a cop showed up from Delaware and he had pictures of decapitated girls. He wanted to show us what happens to girls who hitchhike. Then they threw us out of the station and Susan and I were on the streets of this stupid little town—a hick, redneck, awful town, and we were walking and kids were throwing stones at us. I mean *children* are throwing stones at Susan and me! We have no place to go, nowhere to stay. We have money, traveler's checks, and we go to one hotel and they say they're full. Well, they couldn't have been full; there was just no way they would take us. It was getting dark, it was creepy, we had been walking for a while, and the town was very hostile. And then someone actually stopped and offered us a lift to a motel and we took it. I mean here we had just almost been kidnapped while hitchhiking, but we took the lift because we wouldn't have been able to stay at the motel without a car. It was like *nobody* wanted us!

COOKIE MUELLER: At sunrise, or thereabout, I woke up. I didn't even have a hangover.

I felt very proud that I had melted so well into the underbrush, just like Bambi. Without too much trouble I found this little dirt road and I started walking to the right.

All roads lead to Rome, I told myself.

MINK STOLE: So the next morning we

went back to the sheriff's office and it turned out that Cookie had found her own way to the state police station, the state police who didn't know she was missing! The sheriff's office had not even notified them.

SUSAN LOWE: It's funny, I remember telling Mink at some point in the morning, "Mink, I know it's going to be okay, I know she's going to show up soon, I know it, I know it, I know it. I have a good feeling now." And five minutes later she showed up. We knew Cookie was clever enough to do something. She hid in the bushes all night, then she found a road and got picked up by a forest ranger giving a bunch of school kids a tour or something.

COOKIE MUELLER: I told my story and they were really peaceful, sympathetic people. The ranger called the police station and I found out that Mink and Susan were there.

The ranger's wife liked me, I could tell, and they both drove me to the police station. When they let me off the wife kissed me and said, "I hope everything goes well for ya, honey. That's a nasty thing ta happen. Watch yasself round these parts, there's some hanky-panky round every corner hereabouts. I know. My husband deals with it everyday." Inside the police station the police weren't so nice, but they were patient with my story. They knew the guy. It was a small town.

"He was just released from Jessup's Cut," they said. "He's a bad ass for sure, always in trouble."

"His daddy's a religious man, though, had one hell of a religious upbringin'," one of them said.

Don't I know it, I thought. He believed the Lord would raise the dead even.

MINK STOLE: We called friends in Baltimore, who drove us to one of the Washington airports and we flew to Boston and then hitchhiked to Ptown. That's how we knew to travel —I mean that's just what we did!

SUSAN LOWE: Well, we knew there weren't that many hillbillies on Cape Cod!

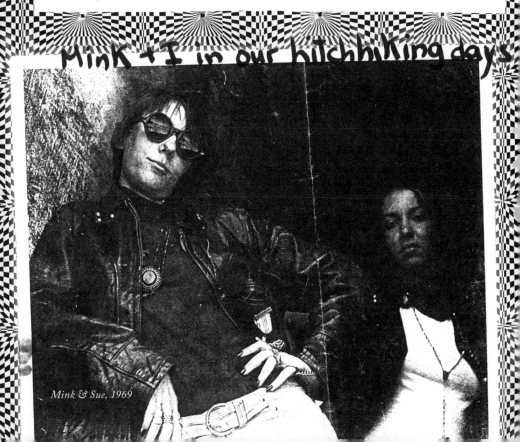

*Mink & Sue, 1969*

# The End of the World
# PROVINCETOWN
## 1969-1976

### FISH TAILS

*"Susan unscrewed a bottle of rotgut port, the kind laced with formaldehyde, and sat down at the kitchen table where black mollies swam in a blown glass oval and a potted hibiscus was folding up its red blossoms for the night. Mardi Gras beads at the window moved and clicked in the first timid breeze of the twilight. It was as if the rising moon had exhaled a cool sigh."*

—Cookie Mueller, "Tattooed Friends," *Garden of Ashes*

CHANNING WILROY: The crazy people came to Provincetown, the people who didn't fit in Cleveland or wherever else they were from. This was like a dumping ground for the ne'er-do-wells. We all got along quite well here. The town is very forgiving that way. Everybody's welcome here; you can be anything you want.

SHARON NIESP: I think Cookie came here in '69. It was before Charlie Manson did his little tap dance. And they all lived here during that whole period, all the Baltimoreans, just about.

MINK STOLE: Yes, it must have been 1969 when we all went up there. I had spent two summers in Provincetown already, and I actually spent a winter there too with this guy, Whitey. Last time I saw him 20 years ago he was talking about spaceships. I have no idea where he is

or what he's doing or if he's even still blonde. In Provincetown, 1969, we had a tiny little house, a living room, and the bed in the kitchen. It was not a very nice place, but it was cheap and there was a little attic that was extremely hot with a single mattress on the floor. That's where we would go for privacy, which meant either we wanted to be alone or we wanted to have sex. I had a job in this toy store in town. Cookie and Susan weren't working. I would get so angry; I was the only one working and I would come home from work and oh, the two of them would be sitting at the kitchen table with a big jug of wine and needles and ink and they'd be giving themselves hand tattoos and wrist tattoos and drinking wine and smoking cigarettes and *ahhh*. I would be so outraged. I'm sure the two of them were like, "Would she just shut up?"

SUSAN LOWE: I'd turn tricks and come home with my share of rent and Cookie would hustle at the bar. We drank, we hustled.

MINK STOLE: And I was real straight, with a job. But then Susan left that year and I got hepatitis. Cookie really came through for me. She really did, because I was basically flat on my back. I was bright yellow... oh, it was a real pretty look: black nail polish, bright yellow skin, and dark red hair, a very pretty look. Cookie took care of me. She brought me food.

She didn't cook, and by that time she may have gotten a job. There was a place in Provincetown we called the Fish Factory, which was a fish-canning factory, and everybody worked there at one time or another. I did, and I think she might have worked there too.

JOHN WATERS: They lived in this tiny little place on the corner, right down the street from my place on Mechanic Street. I lived with Mary Vivian Pearce, and John Leisenring. In Ptown, I always worked. In those days, I ran the Provincetown Book Shop. Cookie worked in the fish factory when she needed money. That's what hippie girls did when they needed some quick money—you could work there for a week. The fish factory is gone now, but they worked in a real factory.

MARY VIVIAN PEARCE: It was huge. We all worked together in one room—all the people who couldn't get jobs anywhere else: hippies and the Portuguese townies. It wasn't actually a factory, you just packed fish. It was hard, hard work. Just packing fish all day long. You had a 15-minute break in morning and then in the afternoon. After we got fired from all the boutiques and better jobs we'd end up with the fish factory. I think some years we went to the fish factory first!

My favorite job was weighing the fish tails.

You just weighed them and put them into different bins according to weight. You really stunk after working at the fish factory all day. I was at Peyton Smith's house one night making dinner and this other guest comes up, "Is Peyton still throwing those fish heads around for the cat?" "No, that's me, I just got off work." On payday, sometimes we would just go right to the bar after work and people would just move away.

If we showed up late, we got sent home. I remember one night we went out to the dunes and took some magic mushrooms and were late the next morning and got sent home. Cookie always thought that was hilarious: "We're going to get sent home *because* we're late!"

PEYTON SMITH: I met Cookie in Provincetown. I believe we were both 19. We were in Provincetown and wanted to go to some music festival in Philadelphia or somewhere south. I had a dog and Cookie looked the way she looked, so getting a ride out on the highway was not so easy. I mean, we were hitchhiking with a dog. Who goes hitchhiking with a *dog*? What were we thinking?

What was odd was that the cops ended up picking us up and forced us off the road somewhere way off in western New Jersey. Or maybe they drove us into Pittsburg or something like that. They were like, "You can't hitchhike anymore, but you can't get on the train either, not with a dog." They said, "Whatever, we just don't want to see your faces again." So we ended up getting a ride from the creepiest man ever because we were stuck. Oh my God, it's such a weird memory. Cookie was in the front seat and I was in the back with the dog, and she gives me this look to tell me to look over at the guy driving who's a *total* freak. He has flip-flops on with inch-long toenails going right over his toes! We were so appalled but we were forced to be with this weirdo! Why do I remember the man who drove us back to New York City's *toenails!* I just remember the irony of being unprotected in this situation—that the police forced us into—with this *really creepy* guy that of course Cookie handled beautifully.

I remember we stayed in my apartment. I think that might have been the first time Cookie had been to New York. I had my first apartment when I was 16. I would sublet it to

*Cookie at the Blessing of the Fleet, Ptown, c. 1970 (Greg Everett)*

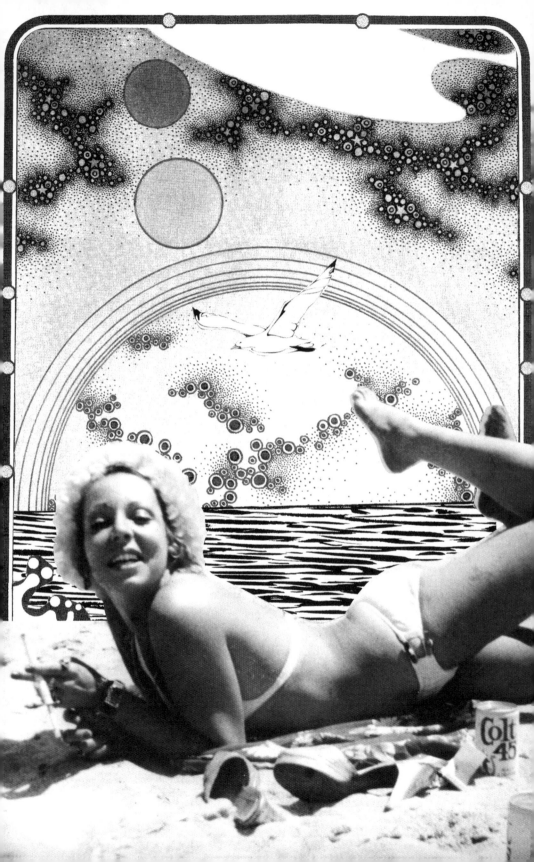

a friend when I went to Ptown for the summers.

MINK STOLE: Cookie and I would get together and go on these wonderful, long bike rides in Provincetown. We'd take sketchbooks and sketch in the dunes. I remember this one day where we took a long ride out in the dunes and Cookie and I took turns reading passages from *Dracula* to each other. There was a real kinship. I felt related to her. I felt she was more family than friend. We did kind of grow up together.

We had a band. It wasn't called anything— it was with these two guys, Jeff and John. I can't remember their last names. They were a couple. This was in the winter of '70 and '71. Vince (Peranio) played accordion, Cookie played harmonica, there was a drummer— might have been Cookie's boyfriend; Cookie always had somebody—and Vince and I were backup singers. Jeff and John were lead singers. We had two performances. One was at the Town Hall and the other was at... oh, I forget. Cookie had brought some blackberry brandy and I was drinking it. I was and still am a really easy drunk. I get very tipsy very fast. So we were drinking, and the stage was basically a platform, not a stage, and I was tripping off it. Cookie was very sweet. She'd come up to me and whisper, "I think you're singing flat," and I'd be like, "*Shut up, Cookie.*" I didn't need to know that; I was perfectly happy thinking I was fabulous. You know, Cookie liked to get a little dig in here and there. We did that show and the one at Town Hall and we never got paid and we never did another. Bands that last a minute and then are gone.

MARINA MELIN: We all summered in Provincetown every year and I came to know Cookie more and more. I lived with her and Divine and a man named George. I actually lived there with Chan before Cookie moved in.

CHANNING WILROY: It was in the East End. It was in a house with Divine and Spider— you know Spider? Spider lady, George Tamsitt is his real name. Divine and Spider rented a house that had a shop called Divine Trash.

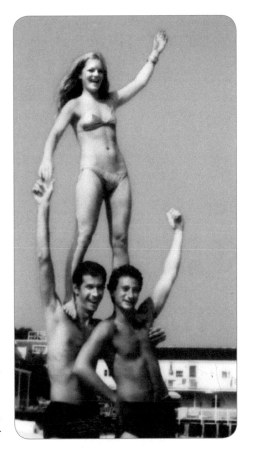

It was a big house. They lived upstairs and Cookie and I lived in the cottage in the back. The shop looked great. Divine knew how to dress everything up, but it was just trash stuff you'd find here and there: old clothes, furniture, knick-knacks. But of course it flopped on its face because it was in the wrong part of town, way down in the East End on Bradford Street. Near where the theater building was. It didn't matter, it was great.

ALAN REESE: This is from the summer of '70, July 24:

*After* The Mummy *was over I lay down to sleep but found myself unable to succumb. I dressed and went out to watch the moon. I took my bike, winding up at Cookie's. We talked awhile and Marina woke up and we decided to go watch the sunrise, so off we went to*

*Highland Light. Next we drove around Truro. Cookie suggested we breakfast. I squeezed oranges while Cookie and Marina prepared coffee, pancakes, and eggs for us. Cookie left for work soon afterwards. Marina and I sat and talked. Glenn (Divine) woke up and appeared in a Jackson Pollock psychedelic nightgown. He began talking about the Tina Turner concert in Hyannis and I bicycled home.*

MINK STOLE: One Christmas, Cookie and Divine chopped down someone's tree and stole the lights. Divine wasn't having any little stick with tinsel on it. It was a lit Christmas tree and they chopped it down and brought it home! Cookie was fearless—she would do anything.

JOHN WATERS: It was a fully decorated Christmas tree from someone's front lawn, a real one. The next day they saw that it was the sheriff's. That's the story I heard—that they were really freaked out.

MINK STOLE: Vincent and I had three large twigs. We had no money for Christmas ornaments so we hung my rhinestone jewelry on the branches.

SUSAN LOWE: I did that with my stripper outfits!

MINK STOLE: That was the winter that Cookie, Divine, Vincent, and I were there. Linda was there with her boyfriend of the time. Vince and I had them over for dinner and I smoked marijuana, which I never did a lot, and made a meatloaf that I took out 15 minutes after I had put it in because I had no sense of time. So we ate raw meatloaf! Everyone was trying to be polite... bloody meatloaf.

VINCENT PERANIO: When I lived with Mink, she was the high school secretary in Provincetown and I had a leather shop, making belts and sandals and things.

LINDA OLGEIRSON: I would work at the library—assisting, shelving books—all winter. They were fun winters. We would have wonderful Thanksgivings and Christmases where we'd go thrift shopping in Boston and get wonderful presents for everyone.

Divine in Morning Attire    *Linda Olgeirson & Howard Gruber, Ptown, c. 1972 (George Fitzgerald)*

## JUST LIKE THAT

*"I was in pain in the maternity ward of the Hyannis Hospital, but this wasn't plain pain, no; this was the kind of pain that for reasons of sanity, the mind doesn't allow a woman to remember. It was relentless, unbearable, hideous, appalling, horrifying. I was undergoing internal gut-ripping tubal-wringing, organ-stretching, muscle-pummeling, bone-cracking. I was the grand martyr. Prometheus knew no pain like this. Lamaze had lied."*
—Cookie Mueller, "The Birth of Max Mueller,"
*Walking Through Clear Water in a Pool Painted Black*

MINK STOLE: That winter of '70 and '71, Cookie got pregnant. We were begging her, *begging* her, "*Please* Cookie, do not have this baby." We begged her to have an abortion, because we just thought she wasn't ready… and she wasn't. She and Earl never lived together. When she got pregnant it was all about *her* baby, it was not about *their* baby. I don't think she ever asked anything from him as I recall.

EARL DEVREIS: I'll tell you everything I know about Cookie, which isn't much. Her and her acting troupe there with John Waters, they appeared in Provincetown and they were this odd group of actors and they just bounced around. There was only one place to dance, Piggy's, so we all ended up dancing there.

JOHN WATERS: Piggy's. That was the big place for a long time, the best place.

PEYTON SMITH: I was the DJ there for a couple years. It was like a roadside place—a road that had nothing on it. It was such a wonderful time because it was so completely open. In town there were really gay places where you didn't feel comfortable mixing. But Piggy's was not like that. We went every night.
I was a mother during the day and my friends —they would babysit and I would work at night. Dennis Dermody used to babysit.

DENNIS DERMODY: I also DJed at Piggy's. I remember on the anniversary of JFK's assassination I blended in his inauguration speech with

"Shotgun" by Junior Walker & the All Stars. Piggy's was a mixed bar and that's what made it great. It was where people went in the winter and then they would go and have sex in the graveyard. It played rock and soul; people would dance all night. And now it's someone's house! It was the first bar I ever went to, before I even moved to Provincetown. I went one winter night and I remember seeing David Lochary and all those people dancing. I didn't know them and I thought, wow, these people look great. This is my kind of bar, this is fabulous!

VINCENT PERANIO: At that time in Provincetown, there was this Puritan law that you could not dance on Sunday. So you couldn't dance after Saturday night at midnight and you couldn't dance again until midnight on Sunday night. They had a town meeting during the winter and all of us got up and voted out the 200-year-old Puritan bill of no dancing on Sunday. It was the little Baltimore contingent and the little gay contingent. Of course Cookie was in there. And to this day, you can now dance on Sunday in Provincetown.

EARL DEVREIS: They were just an odd, *odd* bunch of people with dyed hair and they were way ahead of their time—their dress and body makeup and facial makeup all the time—way ahead of their time.
I started dancing with Cookie and Cookie liked the way I danced and I liked the way she danced so we danced all the time. One day she came up to me and said, "I wanna have a baby and I want you to give me a baby." I didn't pay much attention to that. I thought she was just being odd, I guess. Three or four months later, she shows up in Provincetown in January of 1971—most of the people leave in the winter—and says, "Come give me a baby." Just like that. *Just like that.* So we went to my place and had sex all day and night and I never saw her again for three or four months until the spring I guess. Then she says, "Hey, I'm having a baby, your baby." And she laughed, she thought it was so funny. I was like, "*What?!?*" I was taken aback. It had never happened to

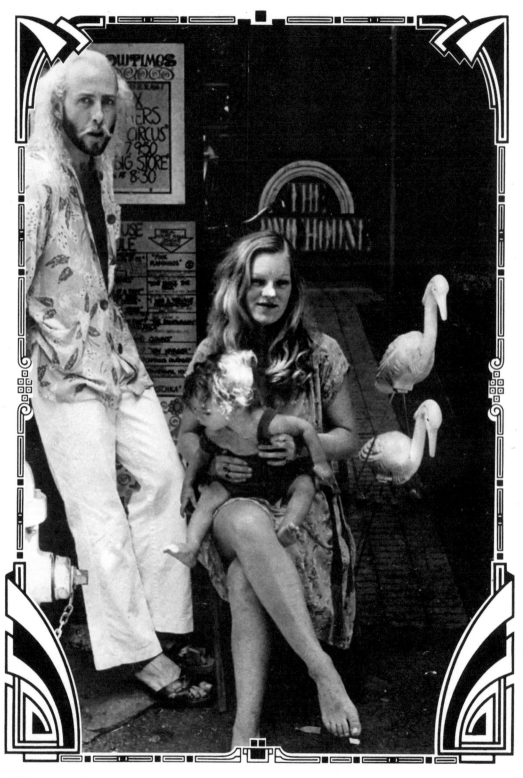

60      *David Lochary, Cookie & Max outside The Movies, Ptown, 1971 (Gary Goldstein)*

me before. And that was it. She thought it was rather entertaining and humorous what we did, you know, make a baby just like that. She had it all planned.

SUSAN LOWE: You know what Cookie told me? She said, "I don't know, I just liked the way he looked 'cause he was exotic!"

MINK STOLE: Earl had slightly Eskimo eyes, you know, slightly almond-shaped.

SHARON NIESP: Yeah, a Mulakan. Earl's father was born in Aruba and he's a mix of German and Aruban—they call them Mulakans. So he's like West Indian but very light skinned because they're mixed with Germans. Mulukans are mulatto Dutch-Indonesian/black Dutch-Indonesian. And his family is very beautiful.

MINK STOLE: You know, Earl was okay.

SUSAN LOWE: Nobody knew him, really.

MINK STOLE: Cookie's little secret. Cookie always had little secrets, secret things going on, stuff she didn't always talk about. Not that she was secretive, it was just that she didn't tell everybody everything. And she had different groups of people that she hung out with. One group didn't necessarily know another group. Earl, he wasn't really a townie but he was sort of a townie type. He had lived in Provincetown a long time and there was always a disconnect between the townies and the not-townies. We were the not-townies. There were two major types of townies: the Portuguese—you know, the fishermen with the fisher boats—and then others: the artists, the writers, and the businesspeople. There was a fairly strong artistic community. Earl was sort of a Portuguese townie, but he wasn't Portuguese and he wasn't even a townie. But that was kind of his slot as far as the non-Portuguese townies were concerned.

SHARON NIESP: He had a joke store and a UPS service combined. Ship 'em in, ship 'em out. He was a drummer and a smuggler and a joke-store owner. That was Earl the Pearl, the Wizard of Cod—that's what they called him. Yeah, he was with all the straight guys in town, the old-timers, the old Provincetown crowd.

EARL DEVREIS: Yup, joke shop. Halloween, that kind of thing, which turned into a great little business with my lack of businessship. I let it go—again that irresponsibleness. I just got tired of doing it and it started fading and fading until it was gone. And that's the way I was, man.

SHARON NIESP: 1971, September 25. Cookie was with Earl for a split second, and that split second was all it took.

EARL DEVREIS: I never heard about the birth until later. Somebody told somebody and then somebody else told somebody and they told me. In fact, I can't even recall seeing her pregnant. I can't recall her sitting there with her big belly at all. That's why I was taken aback. I was like, Oh no, me? What—I? Me? And she thought it was humorous. Every time she would see me like that she would laugh like hell. She had a nice smile and laugh about her, always nice to be around, nice woman. Max looks like her. He don't look like me at all.

MINK STOLE: She wanted to name Max "Noodles"—she did. And the hospital refused to put it on the birth certificate. So she had to name him Max. And he actually is the baby Noodles in *Pink Flamingos*, which was the fall of '71.

DENNIS DERMODY: I'm glad Max was not Noodles. Noodles Mueller?

LINDA OLGEIRSON: Her mother was going to pursue legal action to declare Cookie an unfit mother and have the baby taken away. Her

*Baby Noodles*

mother thought her friends were leading her astray. I think Cookie basically told her that she would kill her if she came to take Max away, and I don't think they spoke after that for a long time. I think her mother was religious, born again, and didn't get Cookie at all. Didn't understand her, didn't like her lifestyle, thought she was this and that, and from a parent's point of view, I guess she was, but she couldn't see her creativity.

PEYTON SMITH: Cookie had been pregnant before, but she terminated the pregnancy. I think she really regretted that first termination. I think she even wanted that child but the guy she was with was totally not into it, so I think the second time she was just, "I really want a child, doesn't matter who the father is."

EARL DEVREIS: She wanted my sperm, and she got it and we got Max. Funny story, but it's true, true, true. Often when I talk about it with people it's like, "What an odd thing," you know. But that's ahead of the time. Like there's a lot of women now who want to be single and have children, one child anyway, so they choose whoever the hell they want to give them the baby. She chose me. Tall, dark, handsome guy who liked to dance.

SHARON NIESP: In one of her books, Cookie talks about when she was out in the Haight. There was this big black van, and the girls in there saying, "You'll like Charlie," but she figured it was five girls to one man so... see ya! Just think: she could've been in prison with an X carved on her forehead. And Max would've been a twinkle in Charlie Manson's eye! Could be worse, could've really been a mess!

ALAN REESE: There was gossip that I had gone and spent a night with Cookie in Ptown. Alberta, my wife, had followed me and found my bicycle outside of Cookie's house. Cookie and I were inside and she was calling to me and we were both like, "What do we do, what do we do?" Somehow that story got passed around.

And then there's something that I've only told Bob Adams. Cookie came to me one day and told me she was pregnant and that she thought

I might be the father. Alberta and I were about to move back to Baltimore and I just didn't know what to do. I was already married and I didn't have children. Even as a dishonorable 19 or 20-year-old womanizer, I still felt I was an honorable person and I certainly didn't want to leave her alone with a child. I was really torn. Then she came back the next day or a couple days later and said that she didn't expect me to have any responsibilities at all, that she planned to raise the child. Then a few days later she told me she was certain that it was this other guy Earl. So I was just [sighs]. Then we moved back to Baltimore.

MARINA MELIN: Cookie and I became closer and closer and I eventually lived with Cookie when Max was born. Max was kind of like a mystery child: one didn't know what was going to happen or how it would be, but Cookie definitely wanted the child.

## STRAIGHTEST GIRL IN TOWN

*"I had two lovers and I wasn't ashamed."*
—Cookie Mueller, "Two People—Baltimore, 1964,"
*Walking Through Clear Water in a Pool Painted Black*

SHARON NIESP: In Provincetown I was doing the Spiritus thing. Spiritus Pizza: it's a big hangout where all the showgirls go after the show. I was basically the only one who worked it when it first opened. In the morning I would make all the pizza dough and get the place open. They had this beautiful old jukebox that would play this beautiful tune "Laura," a jazz standard, and Cookie would ride by with Max on this old bicycle. She had an old tin pail as a basket and she'd ride with Max on the back in a baby seat. He had long hair then with old Popsicle sticks and gum and leaves and twigs

*Cookie & Max, Ptown, 1976 (Audrey Stanzler)*

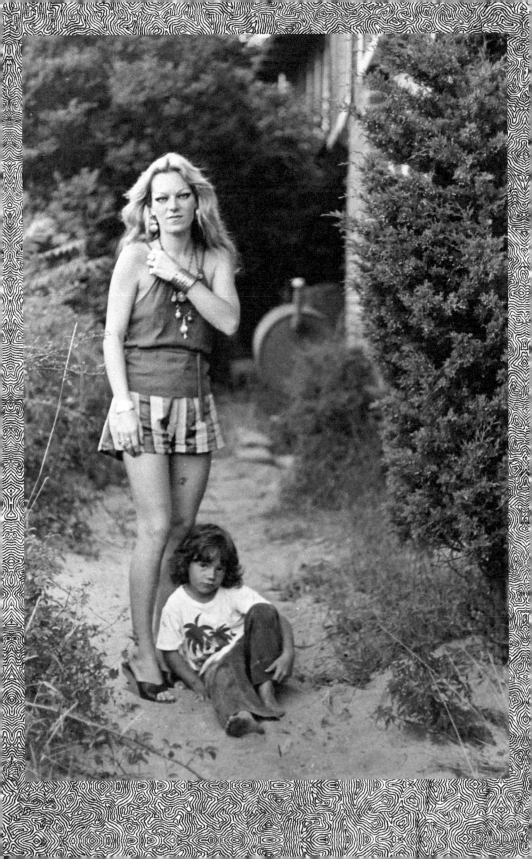

hanging out of his hair because he used to like to roll around and play in the dirt. He hated to have his hair washed; it was like *bloody murder.* I thought those two needed help. [laughing] Cookie always had heels on; she always had Spring-o-lators held together with safety pins. And her hair was always wavy. I said, "Oh my God, I love these people." She'd stop the bike and I'd give them something to drink—coffee or Coca-Cola. I'd always give Max a slice of pizza.

DENNIS DERMODY: When Sharon fell in love with Cookie we were like, "Oh, no!" God, we were a little worried about where this was going to go.

SHARON NIESP: Straightest girl in town. I mean, I was ahead of her. But I would just marvel at them when she would ride by on Commercial Street, taking Max to daycare. I'll tell you about our first date: we went to the dump. I had this old '57 faded-salmon-colored Cadillac with big, huge, bulbous fins. She loved the car. I probably bought it because I knew she'd like it. So one afternoon I'd gotten out early from Spiritus and she said, "I gotta go up the Cape to Orleans to the fabric store." I said, "Alright, I have this car, you wanna drive up?" Of course, she had to drive. She was a pedal-to-the-metal kind of girl and this car really wouldn't go over 40, but if it did, it would pick up momentum; it was like a ship. We smoked a joint and went to the dump in Truro. We found some fur dice and hung them on the mirror thing and went shopping in Orleans.

DENNIS DERMODY: Sharon was so bent out of shape about Cookie. I would come home every night from working at Piggy's or some bar and she'd be sitting on my bed playing the soundtrack to *Picnic*, talking about how she was with Cookie that day and didn't know how it was going. The early parts of the romance were rough—it was rough on all of us. She'd go, "Cookie moved the plate over here, what does that mean?" That kind of stuff.

SHARON NIESP: We had these two friends, Warren and Tutter. Warren was a tall, black, skinny guy with little dread things that stuck

out and Tutter, Tony Genola, was his friend. Really tall and skinny, too. Warren used to court Cookie; he used to call her "buns," since she had nice ones. "The Schwarzen" Cookie used to like calling them. That was her favorite word, the only word of German she knew. They looked like two skinny gangsters, they really did; they were quite a pair.

ANTHONY GENOLA (TUTTER): We were the farthest thing from what you would think of as a gangster. I never stole from anybody, we never got in fights, all we did basically was get high and chase women.

JOHN WATERS: They were great. Their story was like the movie *Going Places* starring Gérard Depardieu and Patrick Dewaere. They were hippie-debonair-cool-cats. They were very handsome and they dressed great, but they were definitely a little bit illegal. Something

about them was scary to some people. Not to us, we seemed to be quite comfortable with people like that!

TUTTER: We were pretty far out, actually. We spent one whole winter wearing a ladies suede bathrobe with a belt and felt slippers in Manhattan.

WARREN LESLIE: I met Tutter in Provincetown the summer before I met Cookie. He was a hippie freak from Massachusetts.

TUTTER: I was one of the first people with really long hair. I had it three inches below my waist. Allen Ginsberg and Gregory Corso and Lawrence Ferlinghetti and all those guys, that's who I read when I was a kid. So I went to Ptown and I'd go to Norman Mailer's parties and I'd be something new and crazy.

JOHN WATERS: They were two straight guys who hung out with gay men and weren't closet queens. They got every cute girl. I mean, they really did well in the sexual department.

WARREN LESLIE: The first time I met Cookie, she was just a little hippie chick sitting on the curb on Commercial Street, just sort of staring off into space. We said hi.

TUTTER: When I met Warren I was kind of eyeing his girlfriend and he was eyeing my girlfriend: that's how the friendship started. We actually broke up with them and ended up hanging around with each other for the next 40 years. Everybody thought we were gay except John, he knew we weren't. I hit on every girl in John's movies. I slept with a lot of them, but never with Cookie.

MARY VIVIAN PEARCE: I met Tutter in 1964 and I was so impressed because he had a tattoo. In those days, people just didn't have them like they do now. He was in the Navy and had a tattoo of a mermaid that moved when he flexed his arm. So of course I fell in love with him immediately.

TUTTER: Mink never wanted to have anything to do with me. Bonnie's a hot ticket. She used to work the racetracks. She's hysterical. I was going to Bonnie's and Marina Melin's houses. Marina was very beautiful. Now when she sees Warren in New York sometimes she runs away from him.

WARREN LESLIE: Max was two years old, that's when Cookie and I started. It was '73, and Cookie lived in this little place on Railroad Ave. Railroad only had two little houses, and Cookie's was one of them. It used to be where the old railcars would come and pick up the fish and take them to civilization; that's why

it was called Railroad, but there was no railroad anymore. She lived there with Max and her dog, Frank.

DENNIS DERMODY: Warren and Tutter were great. They were such interesting characters. They were stars, kind of. They just had a really great look: one was the skinny white Bohemian and the other was this cool black guy. They took the town by storm. They were really close to Cookie and Sharon. They were dueling over

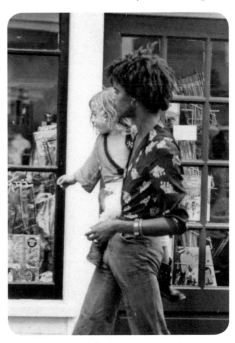

Cookie, and that made Sharon so much more paranoid. I would find her sitting on my bed nibbling a pierogi and smoking a cigar, being a nervous wreck.

SHARON NIESP: Warren was courting her more, I was courting her less. In other words, they were more intimate. He would go out the front door and I'd come in the back door.

WARREN LESLIE: I lived with her that spring and summer. That was a crazy, crazy summer. That was the summer that Gregory Corso came to town. Oh man, he was a piece of work. Tutter crashed with us a lot. The next thing I knew, Gregory was sleeping on the

*Warren Leslie & Max, Ptown, 1973 (Audrey Stanzler)*    **65**

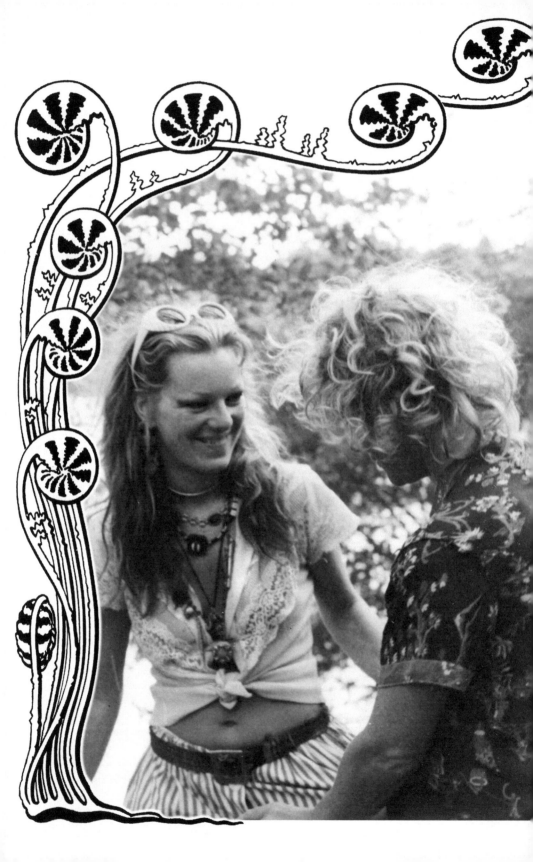

couch and Sharon was sniffing around. That was when Sharon first decided she was in love with Cookie—that was pretty hilarious.

SHARON NIESP: I was always leaving her things on the step. She'd say, "Sharon's always leaving me great stuff on the steps. I always go home and there's a little surprise." So I was swimming in the pond one day and I got a big pond lily with a really long, tubular root. Years ago, when Ptown was Ptown, you could go down to the wharf and the fishermen would give you a couple of fish from their catch. They thought it was bad luck if they didn't. This time, I wrapped the root around the fish and had the lily coming out of its mouth. I wrote a note: "Hey Cookie, pass by or something, Sharon." Warren and Tutter went to her house and erased my name and put their name on it, one of those little things they did. I went over that night and she was cooking it up and she said, "Sharon, come on in for dinner; look what Warren and Tutter brought me!"

So for that summer and maybe a little bit longer, Warren was courting her and I was still leaving fish or anything else I thought she would appreciate on the doorstep; a little weed, you know.

WARREN LESLIE: There was one night when we tried to have an orgy. Cookie decided she was going to do both of us, so we're lying there in bed and I think Sharon was there too and all we could do was laugh. It was just too funny; it was like the biggest non-orgy in mankind. Nobody could do anything, it was too goofy. Anytime anyone would start something, we'd burst out in hysterical laughter. We were all really good friends by that time and we'd already been through enough orgy scenes to know where those lead—nowhere.

SHARON NIESP: I'll tell you exactly what she did the first time we went home together. We were in the parking lot of Piggy's. We used to have so much fun; we used to get ripped in the parking lot with weed, right, and then go dance and sweat until 1:30 a.m. Back then, everybody used to just hang in cars afterward for a while, because it would get so sweaty in the bar. It was the greatest place.

Okay, so we were in Piggy's and she was hanging out with Warren at that time. I was leaving the bar and heading for the door and she goes, "Where you going?" in that voice, that really velvety, smoky, bourbon-laden, Lemon Hart 151 rum voice. I said, "I dunno, just going." So she said, "Come home with me." I asked where Warren was and she said, "Oh, he's around." So we walked out of Piggy's, and I don't know if this was like a test, but we walked out and there's a big swamp with bullfrogs... she walked me through the swamp and said, "I'm gonna take you through it; it's kind of muddy." I had to take my shoes off. She took me through the brambles, through the bushes, up through the trees, and we walked all the back roads until we got to Railroad Ave, where we slept on the floor. Max was on the couch. Warren and Tutter were in the next room. They got drunk and passed out and we put a blanket on the floor and just slept. We didn't do anything; just slept on the floor together. Spooning, I guess they call it.

First thing I remember in the morning, with a hangover, is Max jumping off the couch and squealing and running out the door with poop coming out of his diapers. He thought it was so funny. I said, "Where's he going?" and she said, "He does this every morning. He loves it." So she had to get up wearing her coral apricot slip and her Egyptian makeup down to here, Cleopatra eyes hanging under her cheekbones, and chase him up the street to the back of the market. All the people were coming in for their newspaper and coffee in the morning and there's Max, squealing, with poo coming out of his diapers where all the Cape Cod old-timers and people up from New York are at their oceanside summer cottages, dainty precious cottages. He was a little bowlegged two-year-old; she would drag him back and he wouldn't want to go.

WARREN LESLIE: Somebody would wake up and feed Max and change his diaper or try to potty train him—that was either Cookie

or myself—then do stuff with him and take Frankie out for a walk. Slowly, the rest of us would come to life in the afternoon. We were late risers. Then we'd try and put our money and heads together and figure out what we were going to do about food, and then we'd need something to drink so we'd figure that out. It was your typical poor artist's life: how we were going to get drunk, how we were going to get high, how we were going to feed the kid, how we were going to take care of the kid. Max and I were really close.

SHARON NIESP: And then Gregory Corso would come over with a bottle of Flame Tokay wine at 9:30 a.m. That's when the liquor stores opened.

TUTTER: We met Gregory Corso because he had a whole bunch of opium he had stolen or gotten somewhere in New York. He was drunk all the time; he used to walk around with a bottle of Parma wine, a very cheap Italian wine that usually comes in gallons. He was very smart, like a walking encyclopedia. He could tell you anything about anything. He taught himself in jail, he just read and taught himself. He read classics, everything. He was supposed to introduce me to Burroughs, but that never happened. That was my big dream, him being one of my drug heroes—hell of a role model for a young man!

WARREN LESLIE: When Gregory Corso showed up it was insane. He was totally drunk out of his mind all the time and doing the most obnoxious things you could ever possibly imagine, 24 hours a day. I'll never forget when we took him to the nude beach. We were the only ones with clothes on, and he's got his two bottles of really cheap port wine. You have to walk down this little path to get to the beach and there would be a little old lady with her little beach gear and he'd say, "Oh, I'd love to suck your cock," in this loud, obnoxious voice and if there was an old guy, he'd be, "Oh, I want to eat your pussy." And then there'd be a bunch of gay men and women playing nude volleyball on the beach and, oh God, that's all he needed. He would just go off. He was

out of control, but he never got arrested. They banned him from some bars, but he would always go back. He was like the town asshole and everybody loved him. He was just ridiculous.

TUTTER: Warren and I used to walk downtown with Max. Max would have on a cowboy hat, cowboy boots, and diapers, and he would say things like, "Fuck this. Come on guys, what the fuck?" because he would listen to us, which wasn't very good. We'd probably get arrested today—detrimental to childhood or something.

WARREN LESLIE: None of us worked. Cookie sewed for people; I think that's how she supported herself. Tutter and I were basically deadbeats, maybe we dealt a little on the side just to have some food money. We just sort of survived. You could go down to the pier and get fish for nothing, and Cookie had a great little garden, so between those we were pretty set. When we went out, we didn't have to pay for anything because Cookie was a mini-celebrity and I was already a legend. People just wanted to have us there in the bars. A lot of people came just to see us go nuts.

I was helping Sharon court Cookie by the end of that summer. I knew I wasn't going to be there after the summer, and I thought somebody had to be with her. She was that kind of person: she had a great independent streak, but she needed to be cared for. I hope that isn't weird to say. She was the kind of woman who, if she didn't have to worry about the mundane things, could really be creative. As I was leaving, Cookie was like, "No, don't leave, we'll go to Brazil, we'll go here, we'll go there." I was like, "Cookie, I don't have any money, I can't do it," and there it was. I can see Cookie and Max and Frank at the end of Railroad Ave with the wind blowing and the sun setting, waving at me as I'm getting in the car. Straight out of a great B-movie.

CAROLINE THOMSON: Cookie and I had a fling from September until whenever she and Sharon got together. We did performances; we did a mad performance of *Lady Godiva*, a musical

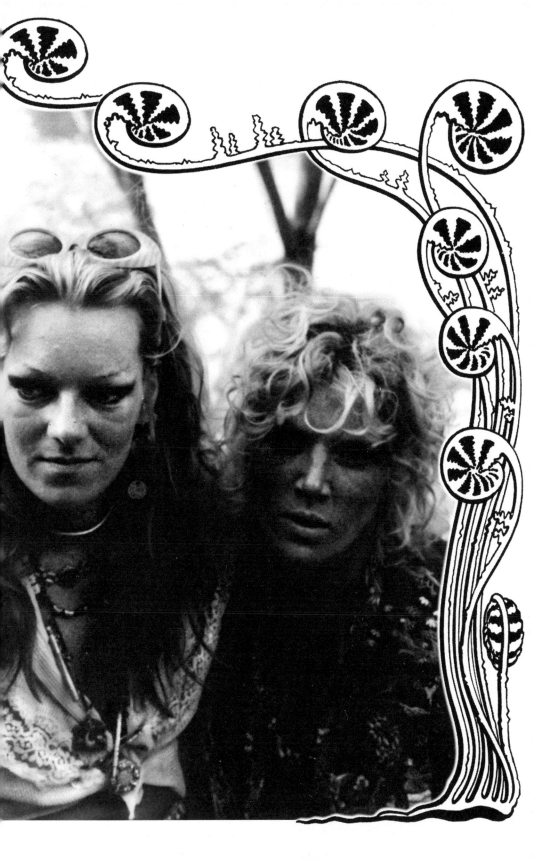

by Ronald Tavel. It was at Piggy's. They made a papier mâché horse for Cookie to strip on. Naturally, she was Lady Godiva and I was one of the chorus of singing nuns. Sharon was Sister Veronica or something like that and she stole my bloody wig just as we were going on so I had steal someone else's. I wore spikes and a G-string under my habit and kept flashing everyone, which wasn't in the script, and the chorus had these funny lyrics. Like instead of "Guadalajara," we'd sing "Guadalawhora, look at the whore." Cookie would be stripping very slowly and saying funny things and she had a long, long wig. She made a perfect Godiva.

We would meet up a lot, but it was always in public, going from one bar to the next. We wore spikes, we recognized each other as something familiar. We would talk a lot and make things; I wore a lot of jewelry and she was making hers. We finally made the plunge, but Sharon was on the lookout for Cookie by then. One night we were dancing at the Crown & Anchor and Sharon was inside and Cookie and I were outside. I asked how we were going to escape from Sharon. There was this huge chain-link fence that we somehow managed to get over. It was quite high, but with our drinks and high heels we got over, and then spent most nights and mornings together from then until October.

The bars would close at 1 a.m., so we'd get on Cookie's bicycle and bundle up Max. It would be freezing and she'd put him in the front of her bicycle basket and I'd sit on the back and we'd go all over town looking for after-hours parties. But she treated Max very well. They got food stamps in those days, and she always cooked him the best food and when he was very hyper she would give him black coffee and he would calm right down; she had all these little tricks.

MINK STOLE: I remember being in the apartment on Railroad Ave and Cookie would lock Max in his room at night so she could go out. She did that all the time. When we were begging her not to have this baby, it was because this was exactly what we were anticipating. She fed him and she bathed him, but as far as the daily maintenance of quality living for a child, she wasn't good at it.

LINDA OLGEIRSON: We would go out dancing at bars in Provincetown and Cookie would latch the top of the screen door so that Max wouldn't be able to open the door. It was just a little latch that if anything happened, he would be able to break it. If there was a fire, it wasn't like he was trapped in there, but that was her babysitting. He'd be asleep, she would latch the door, leave, and I don't know if he would wake up at night and feel alone and be scared or if that was okay with him. But knowing children, I'm sure it wasn't such a comfortable feeling.

EARL DEVREIS: She would say stuff to me sometimes like, "You're the father, you should take care of him. I'm getting tired, I need a break." I said, "Cookie, hold on a second, that ain't part of the deal." It was never my style to be a father. No, I was not a father at all to Max. My lifestyle was loose and I liked being loose. I didn't like responsibility much. I tried a couple times but it was too much for me. I had an apartment and I said he could come, but then all of a sudden I couldn't do it. I'd have to be home at a certain time to cook dinner for Max and da da da. Not my shtick, honey, not my shtick. When he was older I could take care of him, but when he was a little boy, I was undisciplined, I was just bouncing around. I wasn't going to beat on my chest and be super dad, that's not my style either. So I faltered in that respect. But that's the way I was.

CAROLINE THOMSON: During the time I spent alone with Cookie as lovers, funny things always happened. Gregory Corso was a really funny guy, a wonderful man with a marvelous sense of humor. One morning he arrived at Cookie's—we were still in bed—and he was leaning over with a big grin and shiny eyes, and he had an emerald for Cookie and a sapphire for me. I said, "Where did you steal these from, Gregory?" and he said, "From the gods, for my two goddesses."

*Cookie as Lady Godiva, Ptown, c. 1973 (Ron Illardo)*

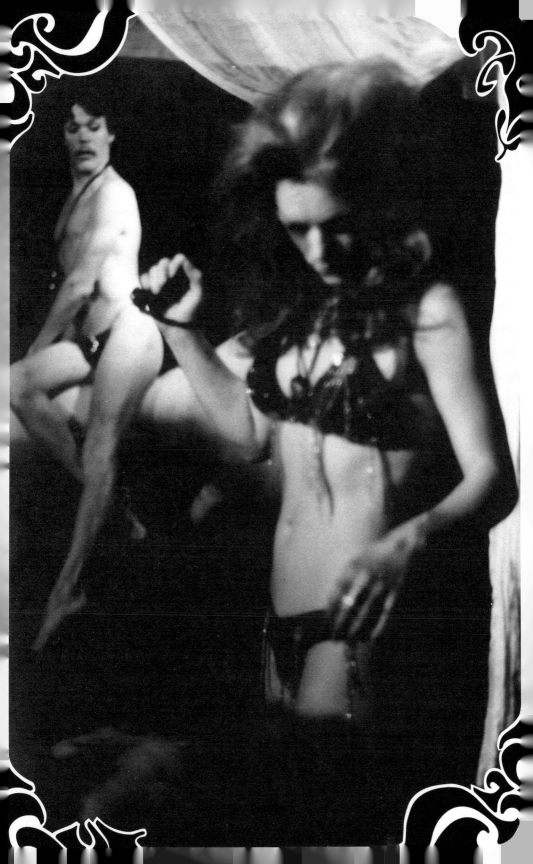

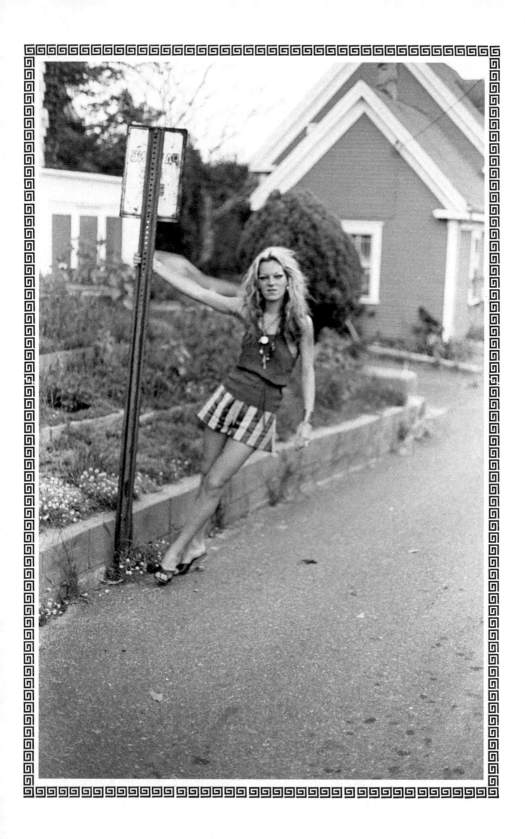

Then the next morning he arrived with a bottle of Tequila Gold and a drawing of the hieroglyphic for the scribe for me to tattoo because he was a scribe, but he had drawn the brush upside down by accident. The next day he noticed, and it was too late, but he said it was okay because he was a retired scribe.

And then of course the time when I tattooed Cookie, people wanted to come and see her getting tattooed. I was a tattoo artist for years, the old way, and she thoroughly wanted a hooded falcon. I sort of knew what a hooded falcon looked like, but she didn't bring any pictures, so she sort of drew one out, and drawing wasn't really her thing. Not only that, but people kept putting things under our noses, some kind of powder which wasn't conducive to tattooing; it was kind of speedy, so I kept tattooing the same dots over and over. Everybody was talking and having fun so I kind of got the outline done, but it was never totally completed. Normally I did my own tattoos; I would feel people out and give them what I thought they should have. The tattoo was on her left wrist. Every dot takes ages in the old method. I used three needles which makes a kind of triangle where they all meet. I was taught by my teacher-lover, Vali Myers; she gave me my first tattoos in the '60s, then I tattooed my mouth. I'm from New Zealand so it was very influenced by Maori tattoos.

DENNIS DERMODY: Caroline and the Positano gang... the witch, Vali Myers, who lived in Positano. Caroline was a disciple of the witch and had her face tattooed.

SHARON NIESP: Yeah, Caroline and Cookie had a little affair before I kicked down her door—it's an old country expression.

## FEMALE TROUBLE ON MILL RACE ROAD, BALTIMORE

*"In the world there are many brave people: those who climb Mt. Everest, those who work in Kentucky coal mines, those who go into space as astronauts, those who dive for pearls. Few are as brave as actors who work for John Waters."*

—Cookie Mueller, "Pink Flamingos," *Walking Through Clear Water in a Pool Painted Black*

GEORGE FIGGS: We'd know when John wanted us for filming. We would just constantly stay in touch with him by phone or by letter or by word of mouth. Someone would be going to Baltimore and you'd say, "Are you going to see John? Ask him when he's going to be ready." The word went out. That was when I was on the road still with rock-n-roll bands. But I came back to Baltimore for whatever filming was happening.

PAT BURGEE: I got involved with George Figgs—we were a couple for a really long time, and we were married for a while—so I pretty much married into the group in the early '70s. That was when I really started to know everybody on a regular basis. In '73 I moved into the house that George was living in, a funky backwater part of Baltimore that really looked like several centuries had passed without it being noticed.

JOHN WATERS: New Hampton. And it still looks exactly the same. That's where we filmed the stations of the cross scene in *Multiple Maniacs*. It was really housing built for the people who worked in the mill there; it was very low-income housing and now it's been yuppified some. It's really old, *really* old.

PAT BURGEE: It was October of '73. I moved in, and there was Cookie, Max, Susan Lowe, her husband, her daughter Ruby, and a guy named Wayne Storm, whom we all knew from the Institute. It was a place where we could all live and live comfortably, sort of outside of the focus of the rest of the culture. When I moved in there, it was the same time that Cookie and

*Cookie, Ptown, 1976 (Audrey Stanzler)*

Max moved in because Cookie was down here for *Female Trouble*.

JOHN WATERS: It's the apartment where Daddy Earl lives in *Female Trouble*, where Mink comes to find her real father and it's Divine. That was George Figgs's apartment, with the boar head on the wall.

GEORGE FIGGS: I carried that boar's head on my lap from New Hampshire on the train.

PAT BURGEE: Cleaning wasn't big on anybody's agenda. The lights were kind of low in there, so nobody ever had their attention drawn to whatever was going on in a dark corner. When I said that we lived there with about eight people, we also had about seven dogs, so there was a lot of the sound of things licking themselves. It was like we had two societies: the canine one and the human one.

GEORGE FIGGS: Mill Race was like a stone-age commune. We had a fireplace and reggae or blues blasting all the time. We had band rehearsals there. When Cookie moved in, we weren't *together*, like, sexually anymore, but we were very good friends.

MARY VIVIAN PEARCE: I also dated George Figgs. Of course, George Figgs dated everybody.

GEORGE FIGGS: I also lived with Sue Lowe for a year. As a matter of fact, I have a history with most of the Dreamland girls except Mink! I was kind of a rounder and a rascal.

MINK STOLE: I don't like being one of a list.

PAT BURGEE: I would go into a party and look around and think, every woman in this room has screwed my husband. It's a very incestuous lot of people, so trying to keep up on who was sleeping with who was impossible.

GEORGE FIGGS: Sue had another boyfriend then who was living there too, Dave McLean. I was good friends with him. Dave and I were kind of the men of the house. We kept the cars running and the fire lit. Things were looser, people were less possessive. It was like, let's not have chaos and crap in our own house.

PAT BURGEE: Imagine marrying into a really tight Irish-Catholic family. People eye you for a while, so you're not really integrated for a length of time. Not being fully integrated let me be more observant, and it was a pretty fascinating group of people to watch. Sue was grouchy and funny, the dominant woman in the group. I mean, you did more or less what Sue wanted to do. She was pretty much the one that was running things—she and George. They clashed a lot. And God, crazy George... God [laughing].

George was attractive in his own way. He had dark hair and a broad forehead and he had these deep-set, very languid, very attractive eyes. George has a cleft palate, but it wasn't unattractive or anything, it just added to the intrigue of his face. He had a very intense look and was a very intense person. Extremely thin, very, very, thin. Wiry. George was like a feral dog that would come in and wag his tail and sit by the fireside but if you try to touch it, you might get bitten.

I wore eye makeup, but I wasn't as flashy as the other gals. I was really quiet, very young and definitely somewhat intimidated by all these characters because they had really strong temperaments and personalities and I didn't. I was a small woman, very svelte, a little bit boyish looking. I just wore kind of leggings and a black top, but I looked odd as well. We were so tribal, but within that there were variations on a theme and I was definitely the somewhat darker, somewhat grimmer side of them.

GEORGE FIGGS: My first wife! I love her, she's a wonderful person, a sweetie. When I came back from the road to Baltimore and formed a band she was the bass player.

PAT BURGEE: The house had bare wood floors with old, really deteriorated rugs on them. Real pretty, but kinda dirty and really, really cold. Max's nose ran all winter long. This little guy was close to the floor with just dirt underneath, wandering and crawling around on this really cold floor. So he was sick most of the time. He wasn't talking a whole lot yet. He liked cartoons on TV so he'd say, "Toons, ma! Toons, ma!" all day. When he was hungry, "Noodles, ma!" and she would cook him

up a batch of noodles. So he lived on cartoons and noodles most of the time. He was a cute little kid with completely crazy, matted, honey-blonde hair that you couldn't possibly get a comb through. Every possible kind of thing stuck in it. You'd look down and he'd have a candy wrapper stuck in his hair. He was the cutest little nut.

BOB ADAMS: I have the best picture of Max as a little kid. I mean he looked like a little dirt ball. Everybody in those days looked so dirty, Susan and David, her husband and the kids, everybody had dirty feet and faces; we all looked like dirt balls, little scrub buckets.

PAT BURGEE: Max was a little two-year-old, something like that. He could toddle around. He used to climb up the steps to a room that was pretty warm that had a stove and the old fireplace in it. He would climb up that freezing cold stairwell like a little puppy: one foot and then one hind foot.

Cookie didn't sit around and think, oh God, this damn kid. She adored him and was as sweet as she could be with him. She would

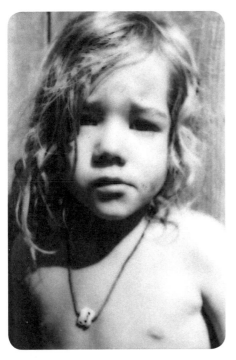

*Max, c. 1973 (Audrey Stanzler)*

figure out Cookie ways to deal with being a mom. And she leaned on the rest of us, leaving him with us, things like that. Or she would just toddle off with him and it was the cutest thing: Cookie in one of her outfits with Max looking like Max looked, hand-in-hand walking up the dirt road that led into the city, chattering away with each other. They kind of had their own little language that they talked in that the rest of us couldn't completely understand, but Cookie always understood what he wanted. It was a Cookie style of mothering and it wouldn't have been anything that any mother at the time would have recognized as appropriate, but it was far more appropriate between the two of them than other people realized.

GEORGE FIGGS: John's Christmas party is always the biggest event of the year for us, our big social moment where we all get together. Back then it was like if you didn't make it to John's party, it was really a drag. Max was sick on the night of one party. He was still a baby and Cookie was going out of her mind because she couldn't go to the party. She was crying and everything and I said, "Look, I'll stay with Max, okay? It's not gonna kill me to not go to this party." So I took care of Max until they got home because I loved Cookie, I really did. She was one of the loves of my life that I'll never forget.

PAT BURGEE: Cookie and Max lived in one little room. They had a mattress on the floor. They weren't planning on staying; they were just down here for the film, so it wasn't heavily decorated or anything. Mostly clothes. The two of them just slept in there and Max had the run of the house most of the time. When Cookie wasn't around he stayed in the room a lot.

He wasn't precocious but he wasn't deeply shy either. He wasn't like the two-year-olds that demand your attention but the two-year-olds that are there with the adults, part of what was going on in the room.

GEORGE FIGGS: I don't think she really took to motherhood quite as intensely as Max

probably needed, but she did her best. Believe me, she did her best. She was always worried about him. He got sick a lot. As far as circumstances could allow, you know, she was a good mother. But we were in poverty—we didn't know where our next meal was coming from.

PAT BURGEE: Cookie and Max were more like playmates than they were like mother and son, even though Max needed a mother more than a playmate. She loved him dearly, but her concept of mothering… well, it was her own.

JOHN WATERS: Cookie was Concetta in *Female Trouble*.

clatter through the rooms. And those women, Cookie, Susan Walsh and Divine, they looked exactly, *precisely* like the women who were in the bathrooms in the school when I would go in. I'd be the little thing creeping in to pee and wash my hands and they would be looking like *get the fuck outta here*—you know— *don't penetrate.* It was so evocative, it was such a clean, clear photograph of what your own life had been like. I was blown away by the accuracy of it.

Although other people weren't living intimately with the people in that film, I was. I

CHANNING WILROY: *Female Trouble*, most of us who have been in his films agree—even John does: that's his *pièce de résistance*.

PAT BURGEE: I love *Female Trouble*. There's a scene in the bathroom where the girls are smoking, it's so real, it's *so* bloody real. The bathroom is totally accurate to that period of time when we were going to school. We were all going to school in old buildings that were really crappy and stinky and the heat would

was watching them, and the movie was just so truthful to who and what everybody was. The edges are really blurred for me! That's what our rooms looked like. Vince exploited the contemporary look to make it look crazier and more intense but all our rooms had that kind of feel, a set-like feel. The blending of the real and the artful is just so tight.

JOHN WATERS: I mean, in *Female Trouble*, that was their real hair; nobody was wearing wigs.

*Divine, Susan Walsh & Cookie, film still from* Female Trouble, *1974*

It wasn't like on the set of the new *Hairspray* or a movie now where they have wigs. Then it was real hair, teased like that. They had to work with those hairdos, live in beehives.

GEORGE FIGGS: In *Female Trouble* I was Dribbles. The first hairdresser in the line. It was me, Eddie Peranio, and Paul Swift, bless his soul—the Egg Man, he was Butterfly. He was the third hairdresser; we were the hairdressers in Le Lipstick Salon.

I remember the crew coming and setting up at Mill Race. It was usually two lighting people and the DP, because John wasn't shooting anymore. At first John was DP, John did all the shooting, he did everything, but by that point it was a small crew.

Shooting it was a blast, *blast*. It always was. We looked forward to John's next movie like triple Christmas. And the more extreme thing John had you do, the more uncomfortable it was, the better you felt about it because it was kind of like when Divine says, "Who wants to die for art?" her line in *Female Trouble*.

PAT BURGEE: That fall was spent mostly going out and doing things on John's film. And then at one point they came in and filmed in the house for the scene where Divine comes out to meet her father and knocks on the door and it's Earl, played by Divine as well. Earl rapes her. She rapes herself.

MINK STOLE: And I play Taffy, Divine's daughter. I kill my father, who is also played by Divine.

GEORGE FIGGS: It was great shooting at the house. It wasn't an inconvenience. I was born inconvenienced. I'm a wild person, not a regular, straight person. I was overjoyed, I wanted them to come back and shoot more. I had another set-up upstairs, a bedroom set-up, that I wanted them to use for one of the scenes. They almost did, but something better turned up, so we used that. Everybody had something to say about it. John listened and then did what he wanted.

MINK STOLE: If we were shooting, everybody was gone. We didn't have big crowds of people sitting around in the living room watching us work. It was completely professional. There was no fooling around. Film was expensive. I mean, we had a good time, it wasn't a prison camp. But if the camera was rolling, it was quiet. We were there to work. We weren't partying and oh yeah, let's smoke a joint. There was none of that.

BOB ADAMS: You remember in *Female Trouble*, remember Ernie? Edith says, "I have someone for you to meet, Gator." That's me, Ernie. In *Hairspray* I'm the car salesman at the auto show.

GEORGE FIGGS: Bob is one of the family, one of the Dreamland crew. He was thin then, with curly hair, like in *Female Trouble*. Edith delivered that wonderful line, "Heterosexual life is a twisted life, please find a nice gay man!" so then Bob said something like, "You're rough trade, baby."

PAT BURGEE: Bob was very fast-moving, very fast-talking, broke into a laugh every third word. You always knew that Bob was there; you could hear his laughter echoing straight through the house.

That was the cool thing about living with those folks: every now and then a circus would arrive and it would not be about the normal things of life, what's for dinner or who paid a bill. It was about the interaction of this group of people who were really creative and funny and terrifically delightful to be around when everybody was having a good moment. Everybody was a little bit sharp in those days and some of it had to do with the drugs they were taking. George was quick to have a good time and quick to get angry. There wasn't a complete happy family going on there; there were eruptions and irritations here and there.

GEORGE FIGGS: They weren't "I'm gonna kill you!" arguments. They were like, "I'm gonna kill you!" without really meaning it. We had a kind of ennui. You'd forget about the argument the next minute if there was something else to do. We weren't fractious. We had a sense of humor; you knew there would be

a resolution, it wasn't an "I hate you forever" type of thing.

PAT BURGEE: They'd have horrible, *horrible* arguments that you'd think, in any other context that those people would move to the opposite ends of the world to *never* see each other again, and then it would be completely over. They'd be laughing about it. It was like swimming in dark shark infested water except the sharks would bite you and then they'd take it back!

GEORGE FIGGS: Cookie didn't argue a lot with people. I mean, if she had a problem, she would let you know it, that's for sure, and in no uncertain terms, but she was a sweetheart.

PAT BURGEE: She'd always try to get things calmed down, try to talk people out of their tempers, and she was good at it. Then she and Max would just go disappear.

She was very empathetic in certain circumstances and that set her apart because empathy wasn't the thing you were looking for when you were hanging out with the Dreamlanders. Cookie had it and she was free with it. And then she could get on the other side too, and trash something about a situation that she thought was stupid. But the minute she saw pain in somebody, she responded to it. That was the mothering aspect about her: she responded when she saw pain, she got in there with it. "Oh hon," you know.

I *loved* Cookie. She was the warmest person living in that house. That pack of women could be very tough to get along with but Cookie wasn't. She was very sweet and absolutely crazy. And *scattered*, all directions at once. We all kind of flirted around what Sue wanted. Every once in a while we'd decide that we had to clean up and there would be this flurry of dusting for a few minutes and then Sue would sit back down and have another cup of coffee and the flurry would continue around her for a little while and then just die away and everybody would be sitting down and drinking—back to the norm, which was a lot of lounging.

GEORGE FIGGS: Susan was just like me,

Cookie, and Divine: we're mentally ill. That's why John loved us so—we were all totally nuts... and I still am! We all had little corners of our minds that didn't match with the rest of the world or, sometimes, with each other. We dealt with it, we dealt with it. We took a lot of acid and smoked a lot of pot.

PAT BURGEE: In the early days of John's sets it was hard to tell the difference between life and the set. It was so similar! In other films, and in his later movies, you know the line between the guys who are working on something and the actual film itself, but in those days, I mean, where's the edge of the set? Are they in costume or not? Who knew? It was a deep merging. I'm a painter, and it was like being caught inside the painting as you're painting it. There wasn't a line keeping everything distant from everything else: that to me is what's so powerful about John's films. They were an *extension* of the reality we were living, not a commentary on it. John understood everybody around him so clearly. He's such an observer. He would write according to who these people were, so when they act something they're not purely acting, they're chosen because that's how they are.

PAT MORAN: If you're attempting to cast a giant, it's always better if he's 6' 4" than if he's 5' 1". John knew all of our characters and how we were and how we interacted, so being a writer director I'm not certain that he didn't write certain roles, and he did, for certain people, so he wrote, whatever Cookie played, he wrote it with that in mind.

PAT BURGEE: Mink used to have meltdowns, for instance, the most extravagantly wonderful meltdowns. If you watch the first part of *Desperate Living* where she goes crazy as Peggy in her bedroom, that's tailored to the way that Mink would go berserk, and it was so wonderful! The Cookie that you see in John's early movies... that *is* Cookie. That is so clearly an aspect of Cookie that he lifted out. It's like taking the color straight out of the tube without any mixing.

But the shooting depended on so many things going right, and most things went wrong, so it took a long, long time to get those things done. Everything would get set up and ready to go and then something would go wrong and it wasn't like anybody had a lot of money they could throw at the problem, they just had to reconfigure and so it dragged out for a long time.

Cookie was in an awkward situation then. She didn't have a lot of money and I'm sure she really wanted to go back to Provincetown. We were all prone to depression so you could see any one of the group just fade off every once in a while, and Cookie did too.

When we were living on Mill Race, I got pregnant and I was not happy to be that way and of course I was sick all the time. I was going down to Planned Parenthood to set up getting an abortion and Cookie was heading down on the bus too, so we took the drive down together. It was good to talk to her about being pregnant. I didn't get what I might have gotten from some of the other girls, like, "You asshole, how did you let *that*

happen?" So we're on the bus and this really creepy-looking Baltimore guy gets on and sits next to us on the other side of the aisle... *yuck*. Then he looks over at us and by about the third block he was beating off, which happened on the buses of Baltimore. There were people on this bus, old women and they're looking over and you can hear their tisking and it's like, oh Geez, that's disgusting! Cookie said, "I'll fix it." I'm like, "Well what are you gonna do?" and she says, "You'll see," and she takes a couple seconds to get it together and then she leans over and she vomits on it. She *vomits* all over the guy—it really spoiled his pleasure. I said, "How the hell did you do that?" and she said, "I can vomit at will." She's the only person I ever met who could vomit when she felt like it. Of course, now *we* were more disgusting to the old women on the bus than he was after that, but dear God, that was hysterically fucking funny. And oh man, there have been so many times since that I've wished I could do that, 'cause if you just kind of fake it, it's not the same.

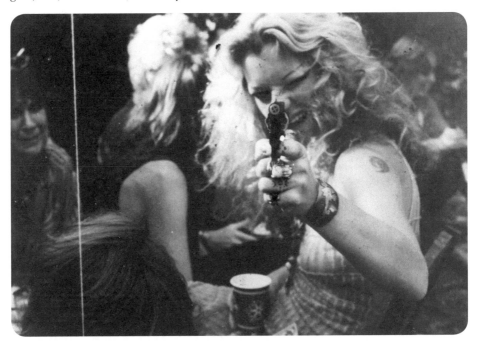

*Cookie at a picnic, c. 1974*

## BEING PISCES

*"Being a human being isn't easy, what with all these insatiable physical, emotional, and intellectual desires.*
*If the ultimate goal in life is to be happy then you have to admit that one-celled creatures have it all over us. Little germs are probably always happy. They are superior, they don't sing the blues. Think about that the next time you bring out the disinfectant bottle and start scrubbing them away...the happiness of germs is something terrifyingly enviable."*

—Cookie Mueller, "Fleeting Happiness,"
 *Garden of Ashes*

SHARON NIESP: Cookie came back to Provincetown late '73 going into '74. I kicked down her door and she's never been the same. By Thanksgiving, Warren got out of the picture and I started coming in the front door. I was at a Thanksgiving dinner at this house on Bradford Street where friends of ours who are now passed away used to live. I was lying on the floor because I had eaten so much, I couldn't move. Cookie came over to me and said, "Why don't you just move your furniture into my house? Might as well, you're there every day, anyway." So that's the way I moved in with her.

I helped her move into Brewster Street from Railroad Ave and it was *freezing* in the winter. We lived in this loft area—a long space with a canvas hanging where the skylights used to be. You'd wake up and there'd be snowflakes on your forehead because of the windows. It was such an old place. We had this old fireplace that would heat up the whole place and this armature we could cook on and this big witch's cauldron. We used to cook soups and stews and we had a lot of parties there. My birthday's in August and we'd have *huge* parties; sometimes the floor would shake there'd be so many people there. We'd get bushels and bushels of oysters and mussels—we'd go out and just pick them up when it was really

clean here. You'd get all kinds of oysters and clams and mussels and steam 'em up, and tons of liquor and tons of pot. We always had great parties.

SUSAN SCHACHTER: I met Cookie at Sharon's birthday party. It was the first night I met the two of them. Sharon and I were sitting outside in the back and everyone else was inside and then the police raided the party. The girls were all dressed in this Daphnis clothing and it was really quite amazing. To me it was all very visual, I was doing a lot of hallucinogenics at the time. But then the cops came and that ended that.

CAROLINE THOMSON: Everybody seemed to be doing acid. They'd go up the Cape and see this doctor who gave out Valium and maybe some speed. But it wasn't heavy stuff.

EARL DEVREIS: Everybody knew everybody, and when one guy came in with 500 pills, everybody knew about it, everybody was sharing. I had weed and connections with New York and Boston, and I happened to know everybody, so I was a good connection.

MARINA MELIN: One summer when I was with Cookie before we had all settled in New York, she and I took some MDA and went bicycling along the dunes. It was like we were spending no energy; it was as though we were angels flying above the earth.

PETER POMPAR: The amount of magic going through that town... it was madness. Everybody was fucking everybody every fucking night. There was no being totally straight in Provincetown. Well, some of the fishermen held out somehow, but I know some of their wives didn't and were sleeping with other women!

SHARON NIESP: We had this old kerosene heater in the front room. We'd turn it on and then go out at night and come home loaded and forget to turn it off. You'd wake up in the morning and it would be all flooded with kerosene. And then we'd have to go get sand and soak up all the kerosene. It was totally illegal. It was really sort of a horrible place. We stayed there for two years.

*Cookie's astrological chart*

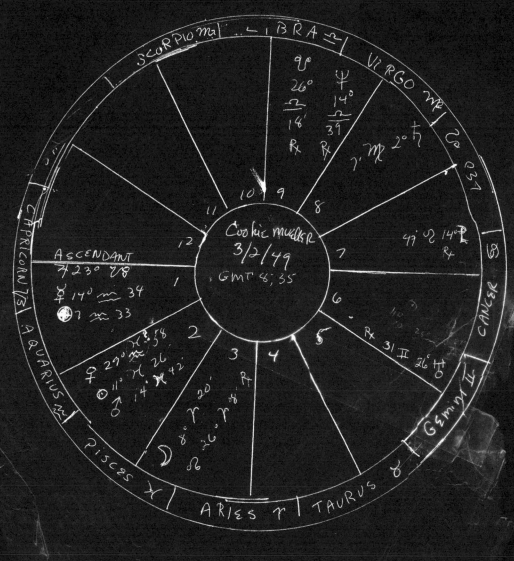

astrological chart
by cookie

MAX MUELLER: My memory of the Brewster Street apartment is probably a bit distorted. Being so small it just seemed really, really huge. It was a two-story with a big living room, a kitchen, and a couple bedrooms upstairs. High ceilings.

The bathroom was covered in postcards. My mother told her friends to send postcards from wherever they went, so the walls were covered in postcards on top of postcards from all over the world.

When I was a kid, I liked being in the woods and climbing trees. Down at the end of Brewster, it used to just go right into the woods, so I would play down there. I remember there was this old tree across the street from my house, some kind of fir tree, an evergreen of some type, and I used to climb up it all the time. It's something in my genes, tree climbing.

I had some friends who lived on the same block and some other friends who lived down by Saint Mary's on the harbor but I kind of always liked to be by myself. I would go down to the wharf or the beach. I don't know... a loner child.

PETER POMPAR: Sometimes I would babysit Max. The house was just above the cemetery and Cookie would steal flowers from the cemetery for her apartment. She always had flowers.

When I first came to Ptown, I was very down and she helped me get a job and let me stay with her. I knew Cookie from Baltimore, and even then she had the most alive and cherished air. She and I believed in magic. I never even kissed her; she was just somebody who was fun to hang around with and play with. And she was very caring. Then the apartment above her became free for a month, so I stayed there. She took me to my first nude beach. I don't think I was as exciting as some of her other friends, but I was doing something the others weren't: I was hitchhiking and traveling around the country. I was the guy down the road who'd show up all of a sudden.

SHARON NIESP: Here's a little story about what happened early on that touches on how she reacted to things emotionally, being Pisces or whatever. Max was like three, right, and so we took him to the aquarium in Boston. So we're walking around, looking at the sharks. Max loved the aquarium because of living in Ptown. We came upon this window people were standing around and we didn't know what they were seeing. They were going, "Ewww, look at that—isn't it ugly!" and the kids were like, "Oh, mama! Oh, mama! I'm scared of it!" So after they all left, we went up to the window and it was an octopus, a poor little octopus, all curled up in a ball. Max said, "Those people hurt its feelings," and Cookie said, "I know, Max." So we all got up to the window and Cookie was going, "Isn't it beautiful, Max?" and Max was saying, "This is really pretty, you're really beautiful." And then, I swear to God, on the ashes, the octopus straightened out like this and pressed itself against the window and showed itself off, and not only that, but its little baby that it was hiding opened right up, too. They both put their tentacles on the window and were showing themselves off. And Max was touching the window and he and Cookie started crying. She was really cool like that. There she was, weeping against the window: she had her face up against the glass and you'd see this little black makeup trail trickling down, because she had those Cleopatra eyes.

MAX MUELLER: When I was a kid my mom used to read me *The Story of Ferdinand*. It's about a peaceful bull. He used to like to just sit under a tree and smell the flowers while all the other bulls were fighting and locking horns and such. And then one day a bullfighter is looking for a bull, for the most fierce bull. So all the bulls are fighting and trying to show off that they're the toughest but Ferdinand goes back to his spot under the tree to smell the flowers. But then he sits on a bee and the bee stings him and he goes absolutely berserk. So the bullfighter sees this and takes Ferdinand to the bullring. But when people are throwing flowers into the bullring he just sits down and smells the flowers. All the bullfighters come

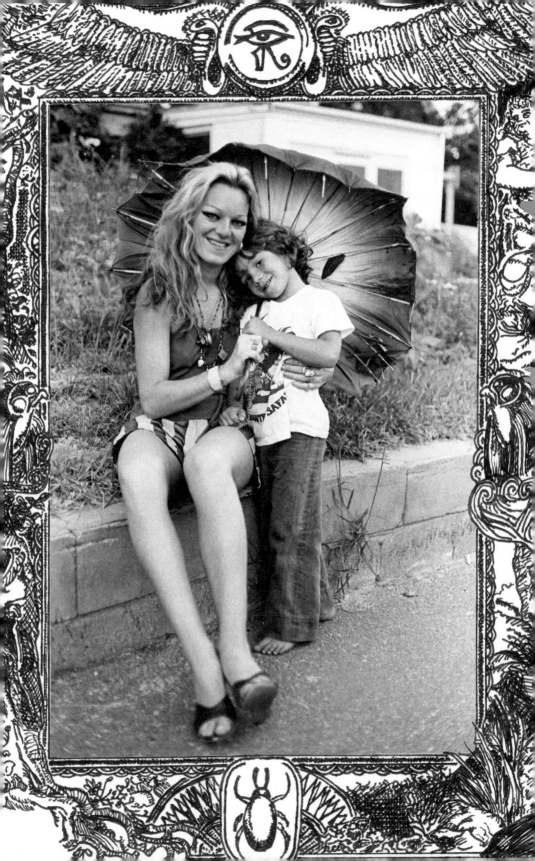

in and none of them can get him to do anything, they can't get him angry. So the main bullfighter takes him back to his field with the flowers and lets him be, smelling flowers. That was definitely one of my favorite stories.

SHARON NIESP: Another time, we went to an alligator farm in Florida and there was this huge turtle; it was so huge, and it was in the sun, and it was panting and panting, trying desperately to get out of the sun. People were laughing, going, "Ha ha, look how slow it's going!" So—and I can't believe this, but Cookie really did do it—she felt so bad for this big, 125-year-old turtle that she threw herself on it. She jumped over the gate, got on top of the turtle, covered up his head, and gave him water. Max started crying immediately. Cookie was crying too, saying, "The poor turtle, everybody's laughing at him, he's gonna die!" Max said, "No Cookie, he's not gonna die," and everybody in the whole place started weeping. All the parents. All the children started crying, "Mommy! Mommy! The turtle's gonna die!" Then everybody in the alligator farm standing around the 125-year-old turtle started to weep.

I swear to God, the whole alligator farm. Everybody was cryin' and weepin'. Max was cryin' and weepin', the kids were cryin' and weepin', the parents were cryin' and weepin'. It was like… have you ever seen those James Brown shows where they try to get James Brown off the stage and they put a cape over him, but he won't get off the stage? He keeps playing and he keeps throwing the cape off and then he goes back on the stage and performs and starts weeping, and then his assistant comes back and throws the cape on and says, "James, we gotta leave now"? So I say, "Cookie, we gotta leave now. Cook, the turtle's okay." "No, he's gonna die, we have to get him out of the sun." So we both had to take this huge turtle and guide him into the shade—and we did it. And all the people felt really bad about themselves; they felt like real fucking creeps. That's how she was with animals.

MINK STOLE: Cookie did have the best dog, Frank, a Border Collie. I loved Frank, he was a fabulous dog. The very first time that I was going to see Cookie on Railroad Ave., I couldn't find it and I was getting frustrated.

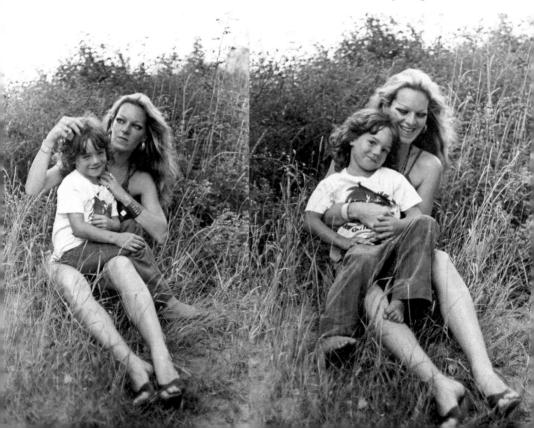

I was wandering all around and then I saw Frank out in the neighborhood and I said, "Frank, take me to Cookie," and he did! I followed him through backyards and we went Frank's way to his backyard. It was so cool. Frank was a cool dog. He really was.

SUSAN LOWE: What happened to him, do you remember? Because he didn't have a very long life, did he?

MINK STOLE: I don't remember.

SUSAN LOWE: And then she got Beauty, who lasted for a really long time.

MINK STOLE: But Beauty was Jackie Curtis's dog.

SUSAN LOWE: Was it Jackie Curtis's dog?

MINK STOLE: Jackie Curtis died, and I think she inherited that dog.

SUSAN LOWE: Yeah, Cookie knew everybody.

MINK STOLE: Everybody. But Frank was a cool dog.

SHARON NIESP: One time Frank ate all of Divine's hash. Cookie was away having Max in the Hyannis hospital. Frank was staying with Divine and ate all of the hash. Divine was so pissed off that he took him to the ani-mal shelter. When Cookie came back from the hospital she was like, "Where's Frank, where's my dog?" Divine was like, "Well, Cookie, he ate my hash so I put him in the dog pound." And she was like, "No! Frank!"

MAX MUELLER: Frankie was my favorite dog. He was so cool. He used to lick my face all the time. Dogs always love sticky sweet kids. I used to tie him to the belt loop of my pants and then one time he saw a squirrel or something and he just went for it and he dragged me up and down the block literally.

SHARON NIESP: Frank was always running away and the dog officer would always bring him back. Once he was missing overnight and Cookie was hysterical. He came back the next day carrying a clothesline with everybody's clothes on it! He had big, fat person's Levi's and shirts, a woman's slip, and little kids' clothes on the clothesline with him. He had his own little adventure.

MAX MUELLER: He was always getting in trouble, going out of the house and fighting other dogs. Or he'd knock up the female dogs.

*Cookie & Max, Ptown, 1976 (Audrey Stanzler)*

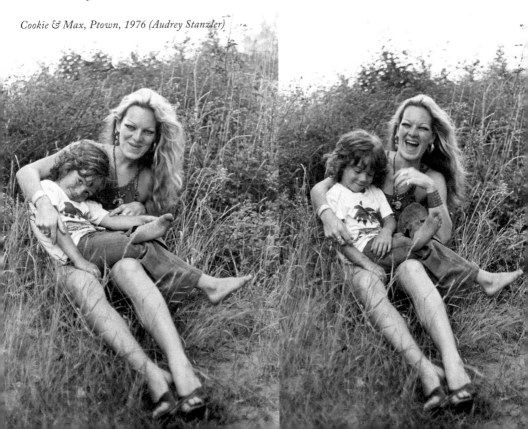

SHARON NIESP: They arrested us one time. Billy Fields, the dog officer, came to the door and Cookie answered the door in a slip all hung over with her makeup all hanging down. And he said, "Dorothy"—her name was Dorothy Karen—"Dorothy, please put some clothes on. I have to take you to jail now because of Frank." She got dressed, and they took her down to the jail and arrested her. They put her in and then I had to go and bail her out for $5. She had to stay in jail for a couple hours until I woke up from my hangover. So she did her time in jail.

MAX MUELLER: Frank got sick and died. After Frankie was Ralphie. Ralphie was a toy Collie.

SHARON NIESP: And our cat, Speidel. We used to see this commercial on TV, right, and it was for the Speidel twistable watchband. Max used to love the commercial—it was on through the '70s. So Max used to twist Speidel around like this—not hurting him; you could do anything to him, you could carry him upside down. He just loved to be gently manhandled, so we named him Speidel the Twistable Watchband. He was a great little cat. He was like a grey tortoise, a Tabby or whatever—I don't know, but he looked like a watchband.

JOHN WATERS: Cookie and Sharon had a night in Ptown once a week, the first punk or new-wave night. They played that song by Elton Motello, "Jet Boy, Jet Girl." "Ooh ooh ooh ooh, he gives me head." They played that over and over when it came out. They were the producers of that night.

SHARON NIESP: That was at the Crown & Anchor. It was like an old hotel with a bar in the front with a piano and an outdoor patio. The Backroom was where everybody went dancing and played pool. It's called the Backroom at the Crown & Anchor. It was a really cool hotel in downtown Ptown, center of town.

PEYTON SMITH: I worked about three years as the DJ at Piggy's, then I went to the Backroom. We would all go to the Backroom after that. I played disco, hello! We were this gay enclave, so record people wanted to start this whole movement of music in Provincetown, Key West… these were the very good places for this music. Record executives would bring me music to play and would bring artists like Donna Summer to meet me at the Backroom.

JOHN WATERS: We also went across the street to the A-House disco.

MARY VIVIAN PEARCE: The A-House was the bar that we liked to hang out in the most. At that time they had a jazz band.

TUTTER: Warren and I were more into Jimi Hendrix, the Manhattans, Otis Redding, shit like that. Wilson Pickett, Al Green, the Temptations, the Stylistics—the Philadelphia sound as opposed to Motown. But Smokey Robinson was always our favorite. I was a fabulous dancer, I used to win dance contests in the Navy. I'd hang around with all the black guys and beat them. We'd drive to this black strip club about 150 miles from base and jump up on stage and do James Brown impersonations. I was 18, one year away from being in Catholic high school. The prostitutes loved me—cute little white boy. One girl called me the Fred Astaire of Provincetown.

MAX MUELLER: I remember Warren and Tutter, they used to teach me tai chi, they were both masters.

DENNIS DERMODY: Max was a sweet kid, always. I took care of Max one weekend when Cookie and Sharon went away. I think they left me $1 for food. But I remember taking him to *Creature From the Black Lagoon* in 3D at the Metro theater in Provincetown and he was really scared but liked it.

MAX MUELLER: I saw *Jaws* when I was four or five, when it came out in the drive-in theater. My mom brought me! It was filmed at Martha's Vineyard right here on the Cape. So sometimes my mom and I would go to the ponds, but I stayed away from deep water, I was just always terrified of a shark attacking me. My mom loved swimming. She was a certified lifeguard.

DENNIS DERMODY: Cookie introduced me to John Waters. She was the one who said, "I have

THE END OF THE WORLD

a friend you are going to get on really well with, because you guys have the same books." I had seen *Pink Flamingos* and I was writing a novel. It never worked out; it was called *Spider Eggs.* It was about a serial killer and it was good. I mean, I thought it was, and Grove Press was going to publish it. It was funny; when I met John there had been a murder in town. This girl was found on the beach with her head smashed in and her hands cut off so they couldn't identify her. She still has never been identified. But in the book I had written, there's a scene where a guy cuts off somebody's hands, so John was convinced that I was the killer, since he didn't know me well. He would run up to me and say, "Look, I know you have the hands, so I'll pay you 25 bucks to show me!" That was kind of how we met. I was like, "Just leave me alone, I didn't kill anybody! And don't start that rumor!" The chief of police was so obsessed with the case that he reconstructed her head years later—that finally fixed the dental thing, but they still never found out. It became his obsession. That's why Norman Mailer wrote that book *Tough Guys Don't Dance.* It was about that crime.

PEYTON SMITH: Dennis would have a movie-thon on his birthday. Three or four movies in a row, horrible movies!

MAX MUELLER: My mother took me to a lot of movies. We would always go to Dennis Dermody's night at the Whaler's Wharf. I remember his laugh. That was the first place I saw movies that you wouldn't see in normal theaters, like John Waters's films, Russ Meyer's *Faster, Pussycat! Kill! Kill!* Dennis loves horror movies.

DENNIS DERMODY: It was called "The Movies." It was the balcony of what once was a bigger theater in Whaler's Wharf. It was only during summer and I changed movies daily—mostly art house and classics and midnight movies on 35mm projectors. Movies like *Walkabout, Harold and Maude, Persona, 1900, Badlands, Death in Venice, The Decameron, Amarcord, Thundercrack!, Flash Gordon, El Topo.* Tourists came, townies, ev-eryone—it was always packed. I managed it through the '70s until 1981 or 1982 when I left for New York for good. Every summer around Labor Day I had a private birthday screening party for friends. I would get two 16mm and 35mm films from collectors, movies like Ed Wood's *I Changed My Sex!* or Paul Bartel's *Private Parts,* and other movies like *The Legend of Lylah Clare; Motor Psycho; The Wild, Wild World of Jayne Mansfield;* and Doris Wishman's *Deadly Weapons.* Cookie came to all of those parties with Sharon. Those were a blast. John's movies would play at midnight.

JOHN WATERS: Originally, the Ptown premieres were in the art cinema. I rented the movie theater and I would have to pay the percentage that I owed for each seat and I would sit up on the balcony with a projector. We would go out on the street and hand out fliers. They were big events in Provincetown. They were local premieres but they sold out. We had them right up until the last movie I did, with the stars themselves giving out fliers on the street to promote them.

EARL DEVREIS: They were way ahead of their time. Their styles, clothing, the Madonna look... they had that Madonna look down 20 years before with the high heels, red lipstick, black lipstick, eye makeup, teased hair, all that crap. I remember one day Cookie came up to me and said, "Let's dye your moustache *blonde!*" So all of a sudden I have this blond moustache. Now I'm Caribbean, and in the summer I'd be almost black from lying on the beach and swimming. It was kind of odd, but the girls liked it. Now I see people doing that kind of thing, so, way ahead of her time.

There were a few good-looking girls in the acting troupe who were straight or gay or whatever the hell they were, but the fellows would be hitting on them all the time, trying to worm their way into the group. But they pretty well stayed to themselves and lived together and did odd things, probably. Social deviants, I guess you call them, but people just looked in awe and accepted them.

87

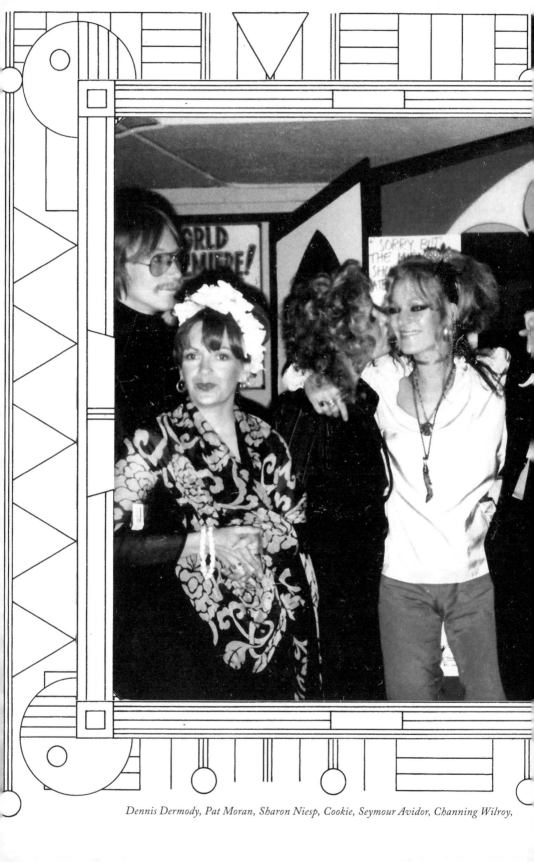

*Dennis Dermody, Pat Moran, Sharon Niesp, Cookie, Seymour Avidor, Channing Wilroy,*

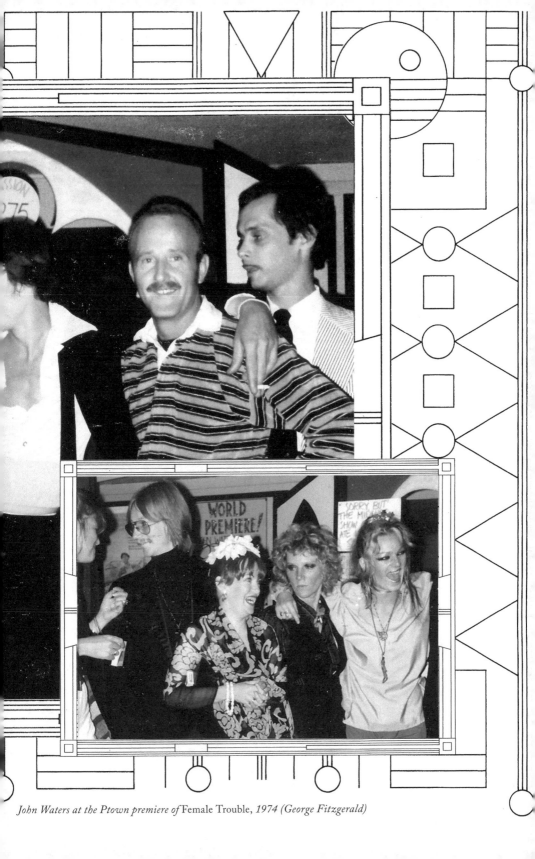

*John Waters at the Ptown premiere of* Female Trouble, *1974 (George Fitzgerald)*

## THE B.B. STEELE REVIEW

*"Edith did get into show biz, on stage as a dancer in strip joints. She danced her way across the country, hitchhiking, hopping freight trains. She once owned her own bar in Kalumet City, Illinois, and she was a madam in a place in Talihana, Oklahoma, that used a hot dog stand as a front. She was one of the sweetest women, she fed the stray cats, she brought American cheese and Wonderbread sandwiches to the bums on the street. She could barely afford to do this. She wore her dark hair in a forties' poof in the front, the back hung down almost to her waist; she wore the same dresses she'd worn in the forties. She had warts on her nose, there was a large space between her front teeth, she hardly ever drank, but when she did she was funny, she had a thick Baltimore accent, and she was everyone's mother confessor."*

—Cookie Mueller, "Edith Massey: A Star,"
*Garden of Ashes*

BEN SYFU: It was 1975 or '76, and it started because there was a period where everybody was waiting for John to make another movie.

*Edith Massey*

I was working with Frank Zappa and I also wanted to try some independent producing—it's easier to do here in Baltimore than it is in New York. John had an injury, a street injury, he was assaulted by someone and was put out of commission for a while, so there were a lot of people here saying, "Why don't we do something together?" Someone asked me to produce something called "The End Of The World Revue," which I put together with Susan, Edith… well, actually I wrote it out as a parody on drag shows. It got a very good response, so we decided to play more shows.

SUSAN LOWE: I played rhythm and blues—that's what I liked. Ben Syfu and I were living together, and we thought, let's do a band. Ben is the most brilliant musician I have ever known. He played with John Lee Hooker, Roland Kirk, and he was a studio musician in New York during the '60s and '70s. So we started to rehearse. We were sounding good, so we thought, wouldn't it be great to have a cabaret with Edith Massey singing songs like "Fever"? She was tone deaf, so everything was wrong.

PAT BURGEE: She had a voice like Shirley Temple on crack. It was a grating little innsy tinnsy voice that crawled up the back of your neck.

DENNIS DERMODY: I went on the road with

*Susan Lowe*

*All photos are taken on the occasion of a performance of The B.B. Steele Review, Ptown, c. 1975*

those idiots and my job was to dress Edith. She sang standards like Peggy Lee's "Fever" or "These Boots Are Made For Walking" by Nancy Sinatra, then I'd cart her offstage and change her outfit, then the girls would come out and sing old rock-n-roll and rhythm-and-blues stuff—like The Bells, you know. Then I'd ship Edith out in another costume—like Dorothy in *The Wizard of Oz* with a little fake dog—and she would sing "Somewhere Over The Rainbow" with that snaggletooth!

**GEORGE FIGGS:** I wrote the song "Tina and the Weasels" for Edith.

**SUSAN LOWE:** Edith would wear pigtails and it brought screams from the audience. I'd be singing Nina Simone, so I'd have my chanteuse outfit on. Sharon did Tina Turner. We loved changing our outfits. We rocked the show. We always packed the house. They loved us, because they thought we were all drag queens.

**BEN SYFU:** Sharon, Cookie, and myself were pretty much the vocal and musical part of the group. Susan was… I guess the personality of the group, you might say. And Edith was basically the star, they all were there to see her. The B.B. Steele Review is what I called it; everybody else called it Edith's show.

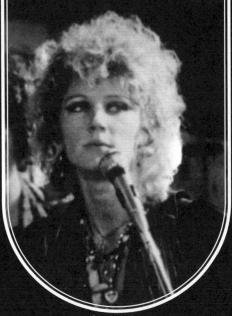

*Sharon Niesp*

**SHARON NIESP:** [Looking at photo] Look at us, look at the way we look. Like pirates! [laughing] What were we thinking? Look at the hair, oh my Lord! See, Cookie had really good bone structure for film and movies—and the big eyes, which was total makeup.

**BEN SYFU:** Chris Mason did the makeup and the hairstyles and Dolores Deluxe did some of the costuming for the show. Chris has now passed on. But Chris also did hairdos, makeup and some costuming for John in his movies, along with Van Smith.

**SHARON NIESP:** Edith would do "Rhinestone Cowgirl" and come out in a big ball gown. Sue would sing "A Fool In Love" by Ike and Tina Turner and I would sing "Daddy's Home" by Shep & The Limelites, a doo-wop group. And "Beat Me to the Punch" by Mary Wells.

**BEN SYFU:** Cookie, Sharon, and I did "Town Without Pity." Sue and I had a version of "That Old Black Magic." And other old standards that we updated and discoized or just rocked. "Lipstick on Your Collar." Edith read poetry about her dogs and cats.

**SHARON NIESP:** Cookie would do back-ups and we would all do back-ups for Edith. We would all switch. We all did solos and back-ups for each other, so Cookie might have done a solo.

*Cookie*

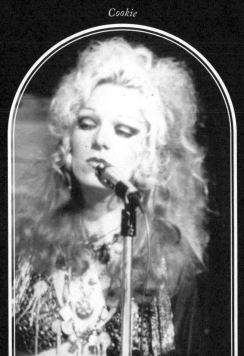

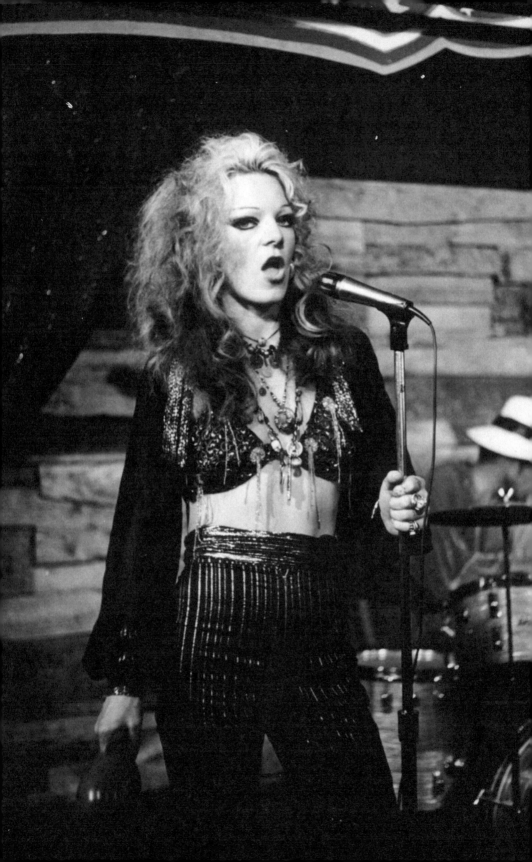

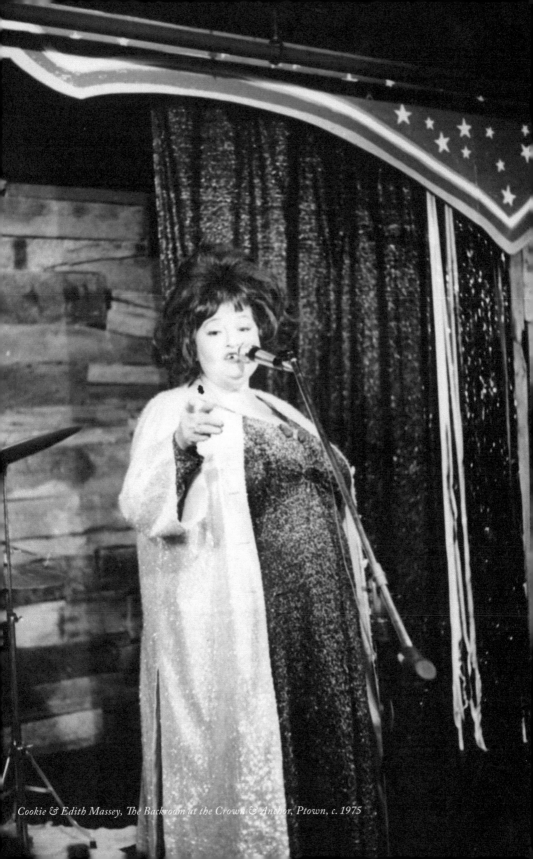

*Cookie & Edith Massey, The Backroom at the Crown & Anchor, Ptown, c. 1975*

I think she did— or maybe she didn't. The girl couldn't sing, really. It was a perfect relationship: I couldn't write and she couldn't sing but we both could dance really well!

**BEN SYFU:** There was one show where Edith was carried out in an egg. She was carried out by bodybuilders in an egg where she erupted out of the egg. And there were two other women on stage, dressed in black and they had hairdos that were in the shape of an egg on top of their head and at some point in the show, Susan and another girl, I forget who, who was planted in the audience, ran up on stage, grabbed the two girls by the hair and threw them off the stage and yelled, "We're taking over the show, motherfucker!" to the audience and then went into a version of James Brown's "Night Train", which Susan sang. And on

*Ben Syfu, Sharon Niesp, Sue Lowe, Cookie & Edith Massey.*

cue, her compatriot, who was holding a gun, jumped out of a white jumpsuit with Day-Glo pasties and a Day-Glo G-string and danced along with Edith and Susan as they took over the show and the band played "Night Train."

JOHN WATERS: They were hardly slick musical revues, but they certainly were pictures of feminine aggression and Edith Massey's clueless, wonderful beauty.

PEYTON SMITH: They were so bad and so wrong. They were just fabulous.

SHARON NIESP: Nan Goldin made a photo button of The B.B. Steele Review. She took a Polaroid of us and then laminated it to a little button. That was her first job. I had one that was me, Cookie, Sue, and Edith Massey all crammed into the button. I had it for a really long time and I had a lot of

others" people wanted it because they were Edith the Egg Lady freaks.

MAX MUELLER: Edith the Egg Lady, my godmother. I remember their shows but I was bored. I was young and didn't understand it. I remember one time at the Backroom at the Crown & Anchor I got auctioned off; I guess I was being a brat or something. My mother, Sue Lowe, and Sharon auctioned me off. They were like, "Anybody wanna buy Max?" and the crowd was like, "Yeah, yeah!" and then they started carrying me off when the auction was over.

I really freaked out. It was a big joke, but I thought I was being really sold to some freaks in the audience, for good! Pretty funny. Everything's so serious when you're a child; you don't know the significance of a joke.

DENNIS DERMODY: What a crackpot group! Sue was dating some guy at the time who was in *Desperate Living*. He was great because he sort of protected me. Anybody who would hassle you,

*as The B.B. Steele Review, Ptown, c. 1975*

he'd beat the shit out of them. I liked him—Kenny, I think his name was—he's the one in *Desperate Living* who says, "You can lick my royal hemorrhoids you fat pig!" That was Sue's boyfriend at the time when The B.B. Steele Review was in full swing. Kind of scary, but very sweet.

SUSAN LOWE: Kenny Orye. He owned a bar in Fell's Point and used to run guns to Ireland. Chucky was our 16-year-old bass guitarist, and he kept up really well. Our little boy that we corrupted to death. We were a cabaret, really, and we did all different kinds of things. Spanish-orientated birdcalls, crazy shit. And then we would break into James Brown. I used to get on the train with all these instruments; nobody had a car. We had so much fun. We drank ourselves stupid.

BEN SYFU: We'd get around by train, car, bus, hitchhiking, any way we could. We also were in very different parts of the country, so it was a very difficult show to put on. But the musicians were wonderful. Cookie and Sharon, you couldn't have two better front people right there. And Susan gave the show kind of an exotic feel to it. And Edith just, you know, brought Fellini into it.

SUSAN LOWE: We never made a penny. We drank it up and or bought pot or whatever, so it was hard to travel without any funds.

But it was more fun than I've ever had in my life.

BEN SYFU: It was a little before its time too, because I dressed everybody up in very elaborate hairdos and very flashy costumes. At the time, people just didn't see that sort of thing. They were used to Jefferson Airplane and rock bands, they weren't used to seeing a *show*. And I know that someone from the B-52's was there and started emulating some of the things that we did as far as the costuming and appearance and show were concerned.

SUSAN LOWE: The B.B. Steele Review played Max's Kansas City. We asked them if there was anywhere we could rehearse and they said we could rehearse there; we could have a bar tab. Wrong! We got *fucked* up. We went on stage and fucked it up.

DENNIS DERMODY: I remember that night so vividly: it was the weekend when Connie Francis had been raped in a motel. It was a big shocker story back then, and one of Edith's songs was Connie Francis's "Where The Boys Are." Edith's wigs were always stuffed in an old newspaper bag; they were always crooked and you could never fix them before you sent her onstage. So I was doing Edith's Connie Francis wig, and it was a mess and I was having a really hard time trying to get it in order, so I told her to say when she got out there, "I really had a

hard time at the Howard Johnson's last night!" So she went out and said it and they all went crazy. She said it totally innocently and everyone roared. Cookie came running in, saying, "You told her to say that, didn't you!"

SUSAN LOWE: Then Edie walked off the stage because she thought I was upstaging her. I said, "Edie, it's my band, you know." She was drunk, and she used to get nasty when she was drunk. We had been drinking all day and we were all a mess, so anyway, that was the end of The B.B. Steele Review.

DENNIS DERMODY: I remember Jayne County was going on after us and even she was shocked. She stood back and looked at all those characters on stage, Edith singing "Where The Boys Are"... It was just the weirdest!

BEN SYFU: Everybody liked it. The owners of Max's came up to me and said, "You know, people actually stayed and listened; normally they walk out." I was flattered by that because we were playing music at the time of punk rock, which was very loud and deafening. It went against the grain of everything that was being done at the time.

SUSAN LOWE: We played for about a year in Provincetown, every season. We played the Backroom of the Crown & Anchor. They loved us there. Edie went on to sing in a punk band after she was with us and sang a song called "Punks, Get off the Grass."

BEN SYFU: We played in a theater in Fell's Point, Baltimore, and we played in CBGB's and other venues. We did a lot of advertising and apparently a lot of the advertising was torn down I guess as mementos or something like that. It ran for approximately four or five months and we got some very good notoriety and then John was ready to do his next movie. I believe it was *Desperate Living*, because he asked me at the time if I could score it and I couldn't because I was back and forth doing other work.

## DESPERATE LIVING

*"Actors know scenes like these make stars."*

—Cookie Mueller, "Pink Flamingos," *Walking Through Clear Water in a Pool Painted Black*

SHARON NIESP: The first time Cookie took me to Fell's Point in Baltimore, I never wanted to leave. Everything wasn't built up with concrete and cement; it was wood. Old wooden benches and wooden piers and there was a lot of land that wasn't even touched yet. It was a really windy day and old bum pants and plastic bags were flying through the air. It was like their little haven. Everybody used to live down there. The first time I saw Fell's Point, I just wanted to move there, just wanted to stay there. Edith Massey had a thrift store, Edith's Shopping Bag.

*Opposite: Edith Massey & Sue Lowe, c. 1975; above: Edith Massey & John Waters, 1976*

MARY VIVIAN PEARCE: It was just a thrift store where she'd dump clothes. People would give her stuff to sell. Once I was in there, shopping, and took off my sweater to try something on. She didn't have a dressing room or anything, and before I knew it, a girl picked up my sweater and bought it! Luckily, I caught her. Edith didn't know and I said, "Hey, that's my sweater, you can't sell that!"

SUSAN LOWE: Edith would be sitting here: "Can you buy me a loaf of white bread? Suzy? Oh, hi, little birdie. Hi, ugly. Want some pizza? Well, you hafta go to Mortsville." She couldn't say Mortville.

MARY VIVIAN PEARCE: Oh yeah, she was a sweetheart. Her shop in Fell's Point would be open until maybe 8 or 9 p.m. and people would hang out with her for a while before heading out to the bars. People didn't buy a thing, they'd just talk to Edith.

SUSAN LOWE: Jean was Edie's comrade, she was retarded and homeless, and she'd always wear a lot of eye makeup and just stared at people and hardly ever talked. She was there with Edie all the time. She bathed in alcohol. Now isn't that interesting? I guess if you don't have a bathtub...

SHARON NIESP: I remember John Waters was really mean to Edith one time when they were making *Desperate Living*. She was sitting up on her throne as Queen Carlotta and her little feet didn't even touch the ground and she couldn't remember her line and John would say, "Edith, you have a mind like a sieve. If you don't get this next take right I'm going home and I'm drowning all your kitties." That's what he said: "I'm drowning all your kitties!" She used to feed all the stray cats in Fell's Point. She'd feed all the cats and all the bums from her little store—give them baloney sandwiches. Oh God, what a sweet lady!

PAT BURGEE: The first time I ever met Sharon, I think she came down for a John party. I didn't think I was ever going to get to know that sullen little creature over there with the blonde hair. I mean, she was just, *don't get close to me*, but during *Desperate Living* I really got to know her.

PETER KOPER: I bought a 26-acre farm north of Baltimore because it had all these barns and a real Victorian house that was attached to a log cabin. It had two streams and a spring; it was kind of its own little world in a valley. I wanted to live in the country and I needed someplace to quietly deal dope, so this was the perfect hiding place. John asked if he could use it as Mortville in *Desperate Living*. I had a long driveway and they built Mortville along the driveway. Vince used some of the barns as backdrops. He would attach window frames to the side of the barns so it would look like a lot of buildings. He built Queen Carlotta's castle, which looked kind of like Disneyland. I was one of the goons in that movie.

GEORGE FIGGS: We were naked in the nudist camp in Mortville in 30-degree temperatures. You could see your breath! We had to stay naked for a long time and it was drizzling. We didn't care.

MINK STOLE: In *Desperate Living* there's a scene, it was a nighttime scene and I wasn't in this particular scene but I was on location. It was bitter cold and the scene is where the residents of the town are storming the castle. They've killed the guard and they're going to go in. Everybody, *everybody* has coats on. Everybody has coats on except for Cookie, who would not wear a coat because she wanted to look hot. Meanwhile, she's got one arm tied back because in the movie she's got a flipper, but she's in this little outfit; I guess it's a bra and one-legged pants.

JOHN WATERS: She played the lesbian with one arm.

SUSAN LOWE: It was freezing, I remember.

MINK STOLE: It wasn't like they were pretending it was summer.

SUSAN LOWE: Our breath was showing!

MINK STOLE: Right, see, so it really has everything to do with Cookie wanting to look hot on film. It had nothing to do with that scene. But I give her credit. She wanted to look hot and film is forever, and you know, you get over the cold weather.

MARINA MELIN: I think there was a sense of

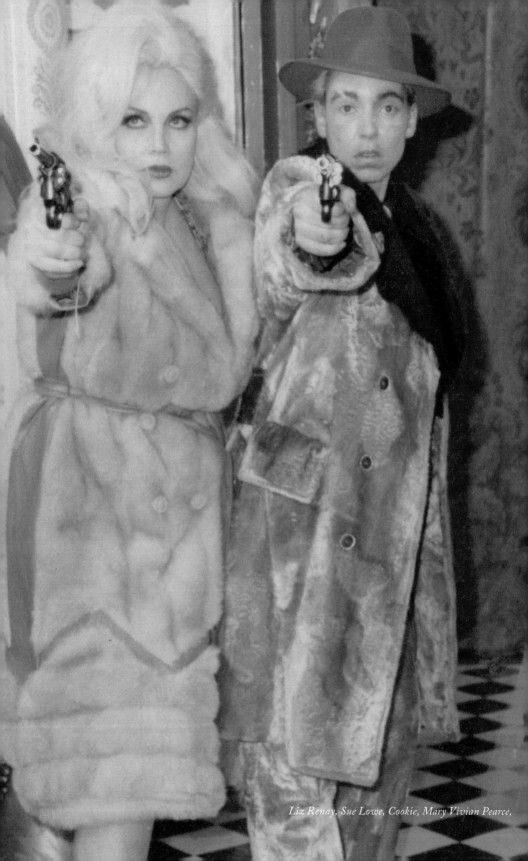

*Liz Renay, Sue Lowe, Cookie, Mary Vivian Pearce,*

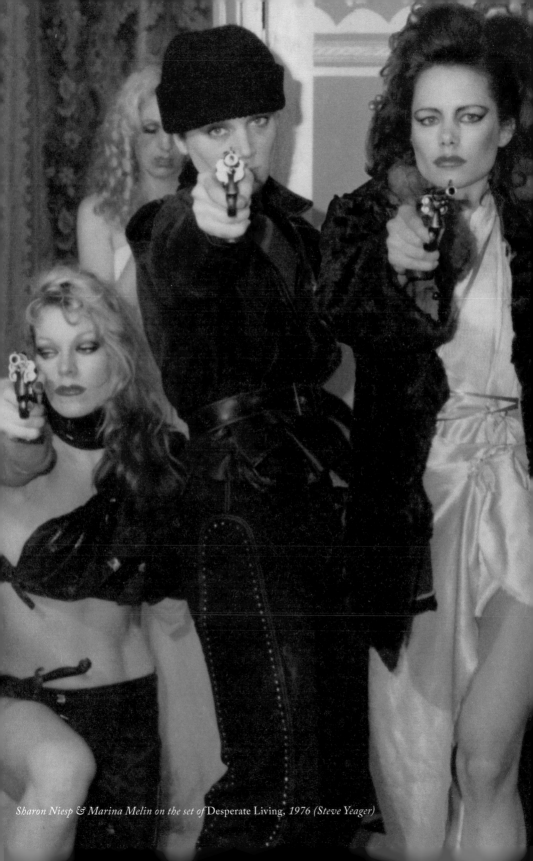

*Sharon Niesp & Marina Melin on the set of* Desperate Living, *1976 (Steve Yeager)*

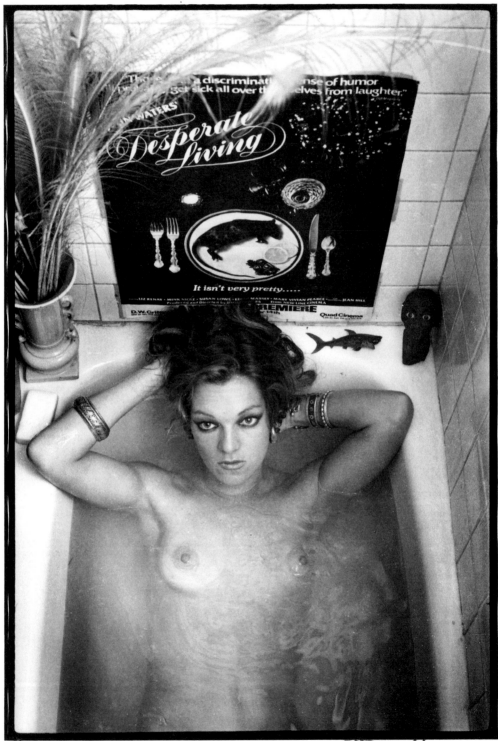

Cookie Mueller - Actress
NYC Oct 26, 1978

competition though, and certainly I think Mink was the most competitive, but given the fact that Cookie, Sharon, and I were somewhat insecure—just kids, really—we definitely wanted to try to look our best.

MINK STOLE: No, it didn't make any sense to feel competition. I didn't feel any. I mean who would I be competitive with?

MARINA MELIN: The outfits were wonderful—Van Smith, a wonderful character, a very sweet person. He did all the makeup, too.

JUDITH PRINGLE: I worked with Van on *Desperate Living,* getting all the people out to Mortville and putting underpants on their heads and dirt on their faces! We'd drive around to all the thrift shops and start collecting clothing and then when it was time to be on the set, they brought in busloads of people to be the residents of the town. I would just be there with Van and it was just all very casual.

CHANNING WILROY: John was out to make a spoof of everything that America held dear, every stupid piece of shit that America thought was just wonderful, like American apple pie, and he did it and he did a great job. None of us thought about it at the time. I mean, these were home movies! None of us dreamed that *Pink Flamingos* would be the sensation that it turned out to be. It was a long uphill thing; it took a long time. We were just having fun being in a movie that we'd get to see in some church basement and that, we thought, would be the end of it. Not so.

SUSAN LOWE: We weren't successful then, we started trends. We never made a penny, we scratched our way to the bottom in John's movies, but we were the originals and we made him. What would he do without us? He treats us good.

VINCENT PERANIO: It was fabulous; we were playing the most outrageous stuff and laughing at it all.

SUSAN LOWE: Laughing at ourselves.

JOHN WATERS: We lived our wild youth, certainly. It was, when I think back on it, more like a political action almost—terrorism against taste or something! That sounds highly flatulent now. I wasn't thinking that then,

but it wasn't made like regular people making a movie. It was my friends and I had a camera and I put them in it. It wasn't like anyone knew at that age they wanted to be actors. Nobody ever sent me a headshot or anything. How I ever got it together I don't know.

PAT BURGEE: One day when we were sitting around stoned out of our minds, I realized that it was exactly what it was like to sit around in the late 1800s in one of those salons. These were those people who were generating something that was going to become a norm, but here was the seed of it. And, oh my God, it's as prosaic as this? And it is. Prosaic in the sense that there were cups and saucers sitting around and wine glasses and cigarettes. It's real, you can touch it, it's right in front of you, it's living and breathing. You watched it being a very cohesive, tightly-knit situation that if you live long enough, you'd also watch disperse.

## SKULKING IN THE DEPTHS OF DRUNKEN DEPRAVITY

*"There is a little hill right outside Provincetown where everything opens up big and wide, the sky, the bay, the sea, and the dunes. From this point you can see the end of the world, or at least the end of America, the very last tip of the Cape jutting into the Atlantic. It's called Witch's Knoll because supposedly it's where the old broom riders met to toil and trouble over their bubbling brew on full moon coven nights. It's the windiest part of the Cape and the wildest."*

—Cookie Mueller, "Divine," *Garden of Ashes*

DENNIS DERMODY: Sharon was friends with the Boston group. Nan Goldin used to hitch-

hike down from Boston every week with David Armstrong and would make these photo buttons. They were such a great couple. Nan was so pretty and David was the most beautiful boy you'd ever seen, and he used to drag in those early days—punk Cockette-type stuff. He was just ethereal. They were so much fun.

DAVID ARMSTRONG: I was going to the Museum School in Boston and Nan and I would go to Provincetown from the summer of '73 straight into the '80s. We got an apartment on Commercial Street and all the Baltimore people were there. We didn't know them yet. We had seen *Pink Flamingos*, and I think we met John Waters first. We met Cookie through Caroline Thomson. Cookie was living on Brewster Street with Sharon. There's just a lot of intersection. Nan and I had gone to this weird, free hippie school and then I left there to live in this commune in Cambridge. I knew Sharon from Cambridge because she was friends with a lot of people we knew.

DENNIS DERMODY: Sharon knew all these cult people—they were very scary. They were like Mansonites. They lived in a lighthouse in Boston and were involved in these bank robberies. The lead man was arrested and was killed in jail. He was really gorgeous—he was picked up from the street by Antonioni for his only American movie, *Zabriskie Point*, which was made during the early '70s, the counterculture period. He wanted to do a cult hippie movie. Mark Frechette and Daria Halprin, the stars, became members of this cult that was on Fort Hill. The cult was run by this wild guy, Mel Lyman, I think his name was, and he did a newspaper called *The Avatar*, a big counterculture newspaper they handed out in Boston.

PHILIP-LORCA DICORCIA: My brother had a shop in Provincetown—used clothing; they used to buy it by the pound. He knew Cookie's whole scene. I think the '70s was kind of an age of innocence. I don't think being gay was a lifestyle choice in those days. It was probably quite liberating to go from suburban Massachusetts to Provincetown, and all of those people, as far as I can tell, are the products of extremely liberal childhoods. So I don't think there was any kind of release from repression, but I think there was some sense of relief in the common aesthetics and sexuality that were probably a huge part of what attracted people to Provincetown.

PETER POMPAR: Provincetown also had the history of a lot of avant-garde artists and theater people. We felt Ptown was the one right place to be. Henry David Thoreau walked into Provincetown from Concord. Kurt Vonnegut, some of his stories take place in Ptown. Annie Dillard, I ran into her in Ptown one time and she thought the world of the place. Mailer's novel *Tough Guys Don't Dance* takes place in Ptown. Jesus Christ, you read that and you wonder where the hell the place is—you can't tell whether it's at the end of the country or the hills of West Virginia. A lot of great writers came and spoke—Edward Albee, people like that. I was walking down the street one night and Anthony Perkins was walking in the opposite direction.

DAVID ARMSTRONG: Cookie was definitely one of the reigning divas—or *the* one. That time was really fun and crazy and it's still lingering. That's what's most interesting to me about Cookie: there was this lingering background of having been part of the hippie counterculture. But part of the whole thing had been this idea of being very anti-everything. I mean, for one thing, a disdain for money. Our goal was not to work, not to have a job where you had to work, and everybody made it happen without any money.

EUGENE FEDORKO: We all pretended like we didn't have any money because we were all in the hippie ethic. Mostly we had an underground economy that involved marijuana and LSD. Cookie and I used to play poker and I remember one time she lost and she had no money so she paid me with marijuana. My boyfriend and I, we paid our rent money in weed. We paid 3 ounces a month in the wintertime and then when May rolled around our landlord came up to us and said, "We have to raise your rent to 9 ounces because it's the summer season."

*Newspaper clipping*, The Provincetown Advocate, *c. 1976*

SHARON NIESP: Cookie had welfare and I had disability. I was working at Spiritus also, and then I had to go for a review or something and Monique Yingling, who is a big lawyer now, wrote a letter to disability saying that I cannot accept even a minimal amount of responsibility because I just would go in a corner and cry in the fetal position.

JOHN WATERS: It was hard, you had to hitchhike to Hyannis to get welfare.

SHARON NIESP: Cookie collected aid for dependent children and I collected crazy money, and that's how we survived. And what else did she do? She raised some beautiful, fat tomatoes.

JOHN WATERS: Once I remember the newspaper called *The Provincetown Advocate* back then had a picture of Cookie sitting at the Vauxhall, which was kind of like the hippie biker bar. She was just sitting there, but they ran a headline—SKULKING IN THE DEPTHS OF DRUNKEN DEPRAVITY—and she sued.

DENNIS DERMODY: She got a big lawyer, like Melvin Belli, somebody really big. Then when he found out she was in *Pink Flamingos* he was horrified because they were suing for defamation. But she won.

JOHN WATERS: It took forever, because she probably *was* skulking in the depths of drunken depravity! That's pushing it, but she did sue them. I think she probably got a couple of thousand dollars, which was a lot.

DOUG ASHER-BEST: I didn't know Cookie well, but of course was well aware of her. I worked with her briefly one winter, dishwashing at The Mews restaurant. Stuck in a cold, dank basement with the dishes coming and going. We talked mostly about books. She was a big reader. She didn't stay at that job long. I forget why, but my main impression was that she was one of those rare, truly grounded people who can somehow turn on the fabulousness when needed. I always felt that way about Marilyn Monroe, too.

*The Provincetown Advocate*

That Old Cape Cod Pastime

:ulking In The Depths

f Drunken Depravity

SHARON NIESP: That was before me, when she was a dishwasher at The Mews. She had to do the big pots, and she told me she just got sick of cleaning one, so she just threw it out. She went around back to the bushes and buried it in the sand! This is when David Lochary, who was *the filthiest person alive*, would throw ducks over the fence to Divine who would catch them and they'd go home and have duck for dinner almost every night.

DENNIS DERMODY: They all lived together, oh God! But when I got to Ptown, Divine had been kicked out of town. She had a shop called Divine Trash and somebody was going to sue and then she did a real

stunt—she rented the whole apartment and then had yard sales and sold all the furniture from the house outside the house that wasn't hers to sell. Just like everything in the house, she sold it. And the woman went *crazy* and then they put a warrant out for Divine and she had to run out of town. So when I was living in town, Divine came back to do *The Neon Woman* and *Women Behind Bars* and all the Tom Eyen plays, and she had to pay a big fine to come back to town!

SHARON NIESP: We had a black Volvo sedan with a red interior—we loved it. Cookie found license plates on the street and kept them under the sink, so whenever we'd get a car she'd just take the plates from under the sink and put them on the car.

DENNIS DERMODY: They really were all criminals! [laughing] Did you ever hear about one of Ptown's notorious characters... she was really crazy. Oh my God. She went into a Howard Johnson's early in the morning, went up to the bar, and said she'd like a drink and they said, "Sorry ma'am, we're not open to serve till noon." She said, "Oh really, I can't have a drink?" So she went back out to her car, got a hair trigger bow and arrow, came in, stood at the doorway and said, "Now can I have that drink?" And she was never arrested! God she was scary. I remember I was sitting with John and she drove up and screamed at Sharon, "This is Total War!" It was so funny. We were laughing for hours, and John put it in one of his movies.

TUTTER: One day she went to school and told the people to get their kids out of school because the aliens were attacking Ptown. She's quite a story; she should have a book of her own. She used to write letters to Mick Jagger and all sorts of crazy people.

SHARON NIESP: And Sister Dawn... she's an old-time Ptown fixture, she was around in the '60s with all the psychedelic rock painters. Sixties hippie, post-psychedelic, acid-crash art. Pre-apocalyptic. She was wandering the streets just cursing: fuck this, fuck that, fuck cops, fuck everybody. She wasn't on the right medication.

DENNIS DERMODY: Cookie's favorite film was *Splendor in the Grass* with Natalie Wood and Warren Beatty. It's about a young girl who goes nuts when she doesn't have sex and she goes into a mental hospital. Natalie Wood is wonderful in it. It's written by William Inge, who wrote all those early '50s plays—*Picnic, Bus Stop, The Dark at the Top of the Stairs*—those kind of plays, but Cookie loved *Splendor in the Grass*. Her favorite scene was when Natalie Wood goes crazy! The scene where she loses her mind and gets out of the bathtub naked and starts screaming... Cookie loved that one!

SHARON NIESP: Yes, Natalie Wood, we all went to see that movie. It was condemned by the Catholic Church for reasons of decency, it's one of my favorites. *The Green Pastures* is also one of my favorites, where the little kids all float on clouds and fish all day and the men get five-cent cigars and the women get big beautiful hats and the minister tells the little children in school what heaven is like. It's really a great movie. Dennis gave it to me.

LINDA OLGEIRSON: Every summer the carnival comes to town. It's really a dive carnival, basically the stone addicts and drunks who work them. Cookie was at the carnival and invited all the carnie people to her house for a party afterwards. But when she got home, she realized that she didn't have any hors d'oeuvres for everybody, and the thing is, Cookie was like a housewife. She liked being a hostess. When people were at her house she always liked to make sure that there was something there to eat or drink, so she took crackers and spread canned dog food on them and pretended it was *pâté!* And everybody thought it was delicious and nobody knew.

EUGENE FEDORKO: She always got into trouble. I remember one time I think she owed her dealer some money, and she went swimming in the bay and got the money all wet. She didn't realize she had it in her pocket. So she put it in the oven to dry it off and then forgot it was there because she was so

They Really Were All Criminals!

stoned and all the money dried up into this crisp, brown nothing! It was always antics like that.

MARY VIVIAN PEARCE: If Cookie was there, it's always a good time, whether it was a party or making a movie, or the fish factory.

PETER POMPAR: Sometimes in the wintertime when I was subleasing her place, people would knock on the door and say, "Cookie said it's okay if I stay here, is it okay?" and I would say sure so people would come and

do that." She always could. She was dazzled by glitz. *She* was glitzy. I never saw Cookie where she didn't have three different outfits on at the same time. Always.

PETER POMPAR: And she had a face. She wasn't pretty, but she was so alive that she drew people to her. She really did.

CHANNING WILROY: She was a very interesting character, one of my favorite people. Cookie was a thinker.

PETER POMPAR: When I finally had a yard

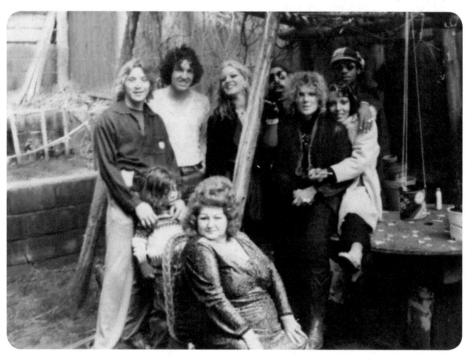

go and I didn't even know who the hell they were. There's a bit of Truman Capote to her. I remember being in art galleries in Baltimore and someone hearing I lived in Provincetown and saying, "Oh, do you know Cookie?" She just knew a fantastic amount of different kinds of people. That was a part of her world and that's why it was great to be around her. She would have so many ideas and would take ideas on.

CHANNING WILROY: Cookie would try anything. She didn't know the meaning of "I can't

sale because I was leaving the place, I asked Cookie, "What do you want me to do with all the things that are yours?" She said, "Just get rid of them." So all I did was mention to a few people that I was going to have a yard sale and get rid of a few of Cookie's things, and then her old friends—all these older, tattooed women—showed up and Cookie's stuff was all gone by 9 a.m. In years prior, I would see her with this dress, and then a couple of years later she wouldn't have the dress anymore but I would see it on somebody else

*Brewster Street backyard, Ptown, c. 1975*

at Piggy's or the Backroom. And that dress would be passed around three or four times over the years.

CAROLINE THOMSON: There was a great wish-fulness to Cookie, I found. A longing, a sort of restlessness. And in 1976, that's when they all left. Cookie, Sharon, and a lot of people all went to New York. I think it was an es-cape. There wasn't much happening here and the winters were dreadful. I had talked to her about New York and the parties, and she

New York and places like that. It was hard to get into that, and you need to if you're going to succeed. I mean, there's no other way to do it. That's why John was always such a good role model, because he was so driven from when he was 10 years old. He knew what he wanted and he was not going to stop. He just keeps going.

SHARON NIESP: It was so fun here, it was the greatest, totally different than how it is now. Kids now are doing the same thing that we

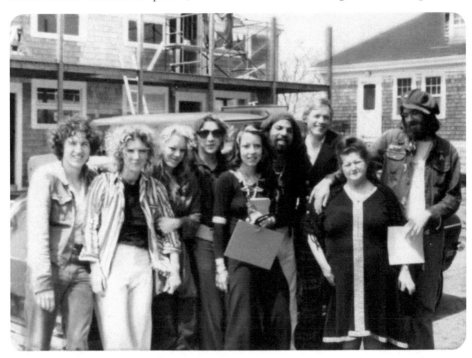

hadn't yet found exactly what she was search-ing for, which was to be acknowledged. She had her charisma, and anything would go for her.

SHARON NIESP: It was very fun here then, but she had her ambitions that couldn't come to fruition here.

DENNIS DERMODY: It's hard living in Prov-incetown while wanting to advance and achieve. That was completely zapped out of us. It was just that we didn't give a shit. And everybody else was so driven, especially in

used to—history repeats itself—but the atmo-sphere was different. It wasn't as money-ori-ented.

PETER POMPAR: Cookie and I, we'd just sit somewhere and talk and of course it was the magic that drew us to Provincetown. It was only fame that took her to New York. She knew New York was the town she had to make it in.

SHARON NIESP: We moved to New York and that's when everything just went "*Boom.*" Ev-erything just expanded.

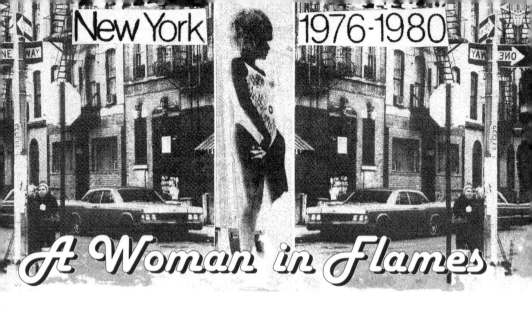

## INSTANT COFFEE

*"It seemed so inane... convulsing there on a dirty dynel shag pad on a 'stage,' which was usually nothing but a flimsy fly-by-night platform the size of a dinner table, while stone-faced male loners sat in a circle around it, clutching their overpriced drinks, watching intently this twitching female flesh parcel.*

*No, that wasn't for me. I just danced. On two feet."*

—Cookie Mueller, "Go-Going—New York and New Jersey, 1978-79," *Walking Through Clear Water in a Pool Painted Black*

DENNIS DERMODY: The exodus. They all moved, they really left. The winters were getting harder and harder to get through in Ptown and the rents were going up. New York was kind of poppin' then, and it was fun to be there—and cheap. There was a lot of innovation going on.

MICHAEL OBLOWITZ: New York in '76–'77 was really an underground city. Most of the well-to-do had fled the city. The city was going through a real recession and there was a darkness to America that made it attractive to us. It was an America in decline; it was the punk rock era. It was flooded with people who were anti-hippie and anti-capitalist, an un-derground post-Andy Warhol scene. Nihilists, people like that. There were lots of other people who were tuning in and dropping out and going to live in the country or Hawaii or Oregon or Vancouver, but there was a whole other school of people going into the dark, uninhabited parts of the city like downtown Manhattan, which was a kind of graveyard of skyscrapers.

ERIC MITCHELL: New York was a magnet. It just seemed so decayed and adventurous and people wanted to be here. There was garbage everywhere. People who had more money would move to huge lofts and people who didn't have so much would move to small apartments that were crap and the landlords would say, "You want the apartment or you don't want it?" They wouldn't even ask you anything. "Alright, first, last, and security. If you don't pay the rent, I'm kicking you out." Then you write a check for $330, alright, okay, and then you'd get the keys. We were just hearing about CBGB and how the culture was basically changing. It was no longer the hippie stuff.

SHARON NIESP: Everybody lived the way they could—they lived simply, they lived in tenements in the Lower East Side, they squatted, they did this and that, and they always did their art and they always got out and did films. We lived on Bleecker. When we first

moved there, the rent was $435. Now it's $1,500, easy, for that place.

LINDA YABLONSKY: It was a railroad apartment, which is a typical tenement apartment in New York. They call it a railroad because it's one room after another in a long line, with a couple of alcoves off the airshafts.

JOHN HEYS: It was sagging in the middle! Ha! It was *sagging* in the middle—believe me, it is not an exaggeration. Cookie was on the second floor. Above her lived one of the best, most fantastic actors in the history of New York theater, Ron Vawter, one of the original members of the Wooster group with Willem Dafoe and Kate Fawk and Peyton.

The bell was ringing constantly, with Beauty, the dog, barking. The configuration of the apartment was such that there were two doors on the landing and the right door went into her living room and the left door opened to the kitchen. She was forever changing the house around, but the front room basically stayed the same. That had the two windows facing Bleecker Street. She would sew drapes, so she always had new window treatments. Or a throw to put over the couch, which was—everything was—found. Then in the middle you had to walk around her huge double bed and negotiate the corner of the bed and her bureau, which was stuck in the corner. Then you went into this tiny hole, the bathroom, that you stepped up into. There was no window. You stepped down and you walked into the kitchen. Then there was the other door I spoke of from the hall; you could go in and out and then you walked into the last room with two single windows and the fire escape: that was Max's bedroom.

MAX MUELLER: My room was mostly a mess. I stayed in every room in the apartment. First I had the room

in the living room, so my mom had to go through my room to get to the living room. Then I had the room off the kitchen when she got tired of walking through my room.

PATRICK FOX: It was late 20th century Bohemian, but completely. It was a Bohemian salon at *fin de siècle* New York. At that point we really didn't know that we were like Berlin or Paris in the '20s. We knew that we were in this amazing time—we had Jean Michel Basquiat and Keith Haring and all the art, all the music. New York was cheap enough that kids could move there and create. And they did. Yes, we'll take your rubble!

Cookie had paintings from all her friends: an Alain Jacquet, she had a Kiely Jenkins, she had a Arch Connelly, a small painting by Bill Rice, she had graffiti art, she had neo-surrealists, she had artists from the '70s. She had all these small, very personal pieces. She had a couch that needed the stuffing fixed. Cookie would have people stand up for a second so she could adjust the horsehair, the springs, jute strapping and twine, and then wad up fabric from below.

JAMES BENNETT: Her apartment always looked fabulous—lots of tchotchkes all over the place. I remember she had stuffed animals, like a squirrel on a branch, and lots of cool stuff, always changing.

RICHARD HELL: She had strange little pop

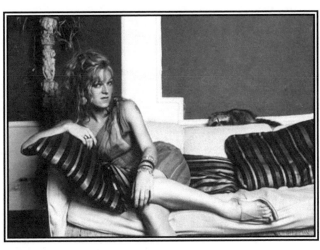

*Cookie, NYC, c. 1978 (Marcus Leatherdale)*

AIR CONDITIONED THEATRE★★★★★★★★★★★★★★★★★
★★★★★★★★★★★★★★★★★

LIVE NUDE revue

DESIRE

LIVE NUDE REVUE
5 XXX MOVIES 25
COLOR

LOVE

DANCING

SHOW

VIOLATED LOVE

FREE-FREE

SECRET FILM

SEE IT AS IT IS!!

ONLY AUTHENTIC
ADULT SHOW PLACE

MOVIES
IN COLOR

25¢

culture tacky cool stuff that she picked up, too. All of her furniture was from the street, but was still semi-elegant.

PETER KOPER: ...skulls, scarves over lamps, very hippie romantic décor. People's paintings, and I'm pretty sure some fairly valuable stuff but you know she'd tack them up with thumbtacks and put holes through the stuff.

PATRICK FOX: She had an alligator skin hanging on the back of her door, this beautiful... crocodile skin maybe. Cookie would also make her clothes, so there would be things hanging on the wall that would next be on her body.

STEVE BUTOW: She had The Clapper—you know, clap on, clap off—and when her dog would bark the lights would go on and off! She was the only person I knew who ever got one!

LINDA YABLONSKY: She did a lot of unusual things to earn a living, like topless dancing. That was the way for a lot of young women to earn a living without being a prostitute: to dance in bars, waitress, receptionist, or work in sex clubs. But she really took it seriously as dancing. She took dance classes while Max was at school a few times a week, just to keep herself in shape, and then of course you'd have to drink a lot and get kind of high in order to be able to do that for eight hours.

PEYTON SMITH: We worked together in topless bars. We both worked for this company—she did first and I started because she did. You worked in different places every night. You didn't work for a club, you worked for the company that hires the dancers, so the guys get to see different dancers every night. I didn't like it at all.

JOHN WATERS: Cookie used to go to New Jersey and go-go dance but she didn't ever want us to come. Once in New York we did—but the people who ran the place were mad when hippies came in to see her because we weren't buying bottles of fake liquor. It was in Times Square, some horrible, sleazy place. She didn't have to do tricks or lap dances in the back or anything. Or if she did, I didn't

know it! I don't think she did. Cookie was a go-go girl. And many of the girls I knew did that then. To me, it was no big deal.

PEYTON SMITH: I remember Cookie going with me to buy the G-string that I was going to wear for dancing the first time. It was *horrible!* Cookie and Sharon telling me which kind of G-string I should wear, you know, as if I was trying on a dress or something. I remem-

Your first catalog carries a FREE gift offer valued to $9.00.

Allure!

ber Cookie telling me which style was better because my hips were like this or that.

LINDA YABLONSKY: I would go and hang out with Cookie in those days. A lot of people would go and drink at these bars because our friends were working there. Billy's on 9th Ave. was where a lot of people I knew worked. Another one was called Nancy Whiskey Pub in SoHo. This was way before lap dancing.

MARINA MELIN: I could never type. To find a job in this city you really had to type. So I couldn't find a job and Peyton said she was working in a topless bar as a bartender. They would sometimes tease the customers and take off their tops behind the bar but she said, "Come on Marina, you can make lots of money doing this." So I ended up working as a bartender in a topless bar. But I never took my top off.

PEYTON SMITH: The Nassau Street Bar was a bar where you would have four bartenders scantily dressed, bra and panties type of thing. I think Cookie worked there. I know Marina, Nan, and myself did.

MARINA MELIN: Anyway, the funny thing was that all the girls I worked with—Nan Goldin and Peyton Smith of the Wooster Group, and this other woman Nancy Reilly who was a playwright and actress—were all

really talented people. When I started I was so naïve. I was in my thirties and was shy to begin with. I just wondered, what do these men want?

JOHN WATERS: In New York people knew who Cookie was because of *Pink Flamingos*, basically. It was a good calling card in those days to launch her into the Bohemian society of Manhattan!

PAT MORAN: *Pink Flamingos* mostly sat on the shelf. I remember John dragged *Pink Flamingos* around in his trunk. He was going to New Orleans and trying to show it. John had taken it to New Line Cinema and it sat on a shelf for over a year. I remember he came to all of us and said, "I'm afraid we all put a lot of time in this and nothing's gonna happen and no one's ever gonna see it." New Line was new and had acquired *Reefer Madness*, which was playing in the Elgin Theater as the midnight show. The night started with *El Topo*. Then they stuck *Pink Flamingos* in at the Elgin Theater at midnight and the next night there were lines around the block. That was the beginning of John's notoriety.

AMOS POE: When they released *Pink Flamingos*, it was so cool. I remember the first time I saw it I was like, whoa, awesome, these people are nuts.

MARK BAKER: Aren't they amazing? One time Cookie, Divine, my mother, and I were in this limousine going uptown and I think someone had slipped us something. Divine was being consoled by my mother that his mother would get in touch with him soon. We all went to the opening of *Female Trouble*. It was horrific, really, but laughably horrific to realize afterward, oh my God, that man lives with me! Divine lives with me!

STEVE BUTOW: The night *Female Trouble* opened in New York, we were at our friend Seymour Avigdor's loft—he's no longer with us, but he was a very good friend of ours. Seymour was in *Female Trouble*. He's the lawyer at the end, Divine's lawyer. We were all getting ready—it was a little rushed—and Cookie was like, "God, I'm so tired."

PETER KOPER: I'm telling her to hurry up and she says, "I want a cup of coffee." I say, "We don't have time," and she had this freeze-dried coffee, a hard instant coffee, Folgers or something. So she lays out a pile of freeze-dried coffee, takes the razor blade we've been using to snort up coke, chops up the coffee, snorts up a couple of lines of it, and says, "All right, I'm ready to go!" Off we went!

STEVE BUTOW: All night long coffee was dripping out of her nose.

PAT MORAN: I do remember the premiere of *Female Trouble*, which Cookie was very prevalent in. We were in New York and we were all staying in everybody else's apartment. We woke up to a *blizzard*. There was snow all over the ground. But we sailed in and the scene went on and it was packed. That was probably Cookie's biggest role. *Female Trouble* is my favorite.

MARK BAKER: I met Cookie through Divine and John Waters. Divine was staying at my loft on Elizabeth Street in what was called NoHo. I had this really great duplex loft and I was flying high on the throes of having the title role of a big Broadway musical revival of a musical they said wouldn't live, *Candide*, Bernstein's musical directed by Hal Prince. Cookie was a doll. She was hilarious, she was gregarious, my God! I was from a small town in western Maryland and she was from the big city of Baltimore.

DENNIS DERMODY: All those wackos were coming in. Great theater—really weird shit—and the clubs were fun, and, you know, it was dumb to be in Ptown. Why would you sit and look out at a shrub on the beach for 10 months when you could actually go to movies?

JAMES BENNETT: Charles Horne and I came to New York and had a theater business. We did a musical called *Eva Braun*. We did *Restaurant*, a musical that was sort of based on all our lives in Ptown, working in restaurants and wanting to be something else. That played over on 18th Street in 1980. We had a show called *Dogs* that got as far as off-Broadway. The first review said, "Bring a newspaper," because it

was shit. None of it was any good. We had a kind of sloppy theater feel. I wrote the music and songs and Charles wrote the book.

Cookie was always around, and we always wanted to work with her, but she always had her own things. Her things were always a little higher-caliber than ours. Well, not higher-caliber, but she got more notice. She just had that natural click to her.

RICHARD BOCH: She's iconic. Even in the Village in the '70s Cookie stood out. Initially I knew Cookie as an actress in John Waters's films. I moved to Bleecker Street a few blocks away from her in '76 or '77 and Cookie wound up on my radar because we were hanging out at the same places and we had a lot of mutual friends, Linda Yablonsky and Sharon. With Cookie, there was everything going on: the great beauty thing in a very different kind of way to the wild bad girl thing. You know why she stood out? Because she reminded me of the girls I knew in high school who wore a lot of makeup and had their hair really blond and wore skirts that were really short. She was channeling that. I would see her on the street but I only knew her well enough to say hi but not to really engage. She was never aloof. She always made eye contact and she was right there when you said hello to her. And it was only a matter of time before we saw each other on a regular basis at Mudd Club or One U.

WALTER STEDING: I remember seeing Cookie on Spring Street. She was wearing just some tiny pieces of raw leather sewed together. At first I didn't recognize her and I thought, "Who are these people? What world do they come from?" Then she waved to me and gave me her great big beautiful smile. She overwhelmed me with joy at the realization that "these people" were me. It was *our* world and we were beautiful freaks.

SHARON NIESP: When we got to New York, it was all about having fun, hanging out in clubs, but being serious at the same time. One night Cookie said, "This is like a job, being out and about."

MINK STOLE: When Cookie was in New York she wanted to be a club girl. Cookie was a wonderful writer and a wonderful artist and she had all kinds of talent and she really wanted to express it and really wanted to be an "on the scene" gal. She really, really wanted that. I remember going to Studio 54 together and we didn't get in. I was like, "I'm not standing here and humiliating myself. I'm going home." Cookie was begging and pleading. She really wanted to be inside Studio 54. It mattered to her in a way that it never mattered to me.

STEVE BUTOW: The night Studio 54 opened, it was like the *Day of the Locust*. Everyone in town was invited to go. We couldn't get in because it was just so crowded, and everyone was on some kind of guest list from somewhere or something. So a lot of us were on the outside—the way Studio 54 always was—they kept people on the outside to attract more people. It was frantic. I was saying to Cookie, "Let's go around the back and see if we can get in through there." It seemed that she was ready to climb the building just to get in! I think eventually she did get in, but I didn't. I just ended up sitting on a parked car with a friend of mine, watching her.

PETER POMPAR: She told me she went behind and shimmied up some pole and climbed in the back way. She did it with her little granny shoes. She wanted to be included in things.

MINK STOLE: Cookie wanted to be an A-lister, and eventually she was.

SUSAN LOWE: We'd come up with Cookie to Studio 54 and they'd be, "Yeah, come in." They got to know her—she was there every night.

MINK STOLE: Cookie wanted to be…

SUSAN LOWE: Cookie wanted to be famous.

JAMES BENNETT: We all followed Cookie to New York to become stars.

PETER KOPER: These were the cocaine days, the battle of New York. If you wanted to get into these clubs, you usually went at midnight and stayed until dawn, hitting after-hour places that were kind of cocaine secret places. You had to knock on a door and say a word or they'd look at you and let you in. These were

*Following pages: Divine entering the NYC premiere of* Female Trouble, *1974 (George Fitzgerald)*

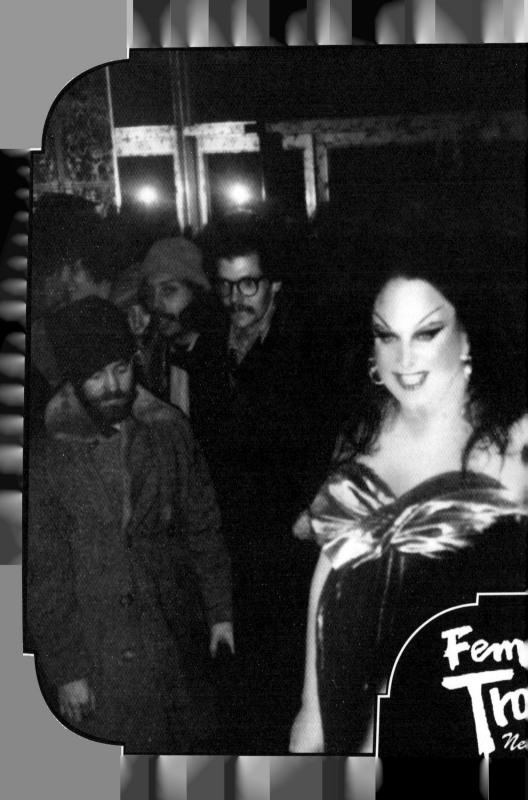

York Premiere

*Seymour Avigdor*

*Mink Stole*

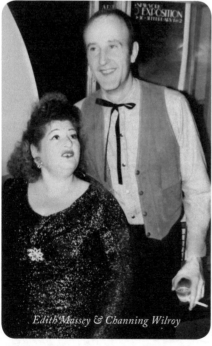

*Edith Massey & Channing Wilroy*

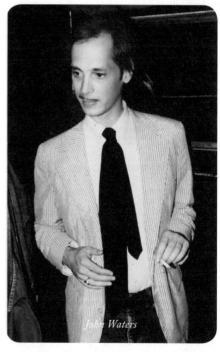

*John Waters*

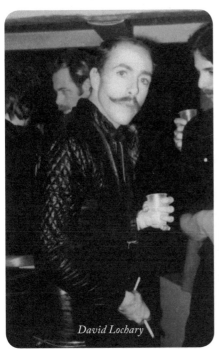

David Lochary

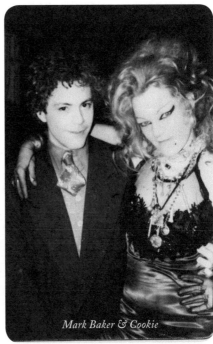

Mark Baker & Cookie

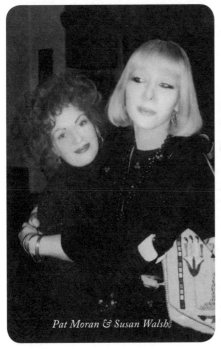

Pat Moran & Susan Walsh

DIVINE RETURNS!

bars that would stay open after 4 a.m., like co-caine speakeasys. People would snort coke off the bar and the bars would sell coke from behind the bar as well as drinks.

LINDA YABLONSKY: The Mudd Club, which opened in '78, was a big gathering place. We were all regulars there. Cookie, Sharon, and I preceded this by going to Studio 54 and another disco called Xenon that was its big competitor. And we went to a club called Hurrah, which was actually more of a rock bar, uptown. This was during the MDA years. We would drop MDA and go out dancing all night, so that sort of preceded the art world downtown scene. We saw each other regularly because we were neighbors and we both wanted to be writers.

RICHARD BOCH: Cookie came to the Mudd Club a lot with Sharon or Linda. She came with Tom Baker, the Warhol star who was best friends with Jim Morrison. He was in Warhol's film *I, A Man*. He was a big burly guy and really good-looking. They hung out a lot. After Mirielle Cervenka died, I used to see her with Gordon Stevenson, also with Gary Indiana. She would come with everybody and she would often come alone too. She was comfortable enough with herself and with the Mudd Club to just show up by herself knowing that I would be at the door. Cookie didn't pay to come in. People like Cookie made the Mudd Club what it was.

ERIC MITCHELL: The Mudd Club wasn't like Studio 54. Mudd was an icon of a certain downtown period, and what is so strange about the Mudd Club is that it only lasted about three years. It was a very short-lived thing. I think that's where I met Cookie.

There were several little groups and hers was the Ptown gang. It was Cookie, Sharon, David Armstrong, Nan Goldin, Billy Sullivan. I was part of a group that was James Nares, John Lurie, a woman named Becky Johnston, and Patti Astor. Basically, in each group you would have these really forceful characters—women—that would be like the head of some gang. It was kind of a rarified underground scene. It

had that kind of punk-art feeling, and Steve Mass, the owner, would always organize theme parties. They would have New Wave bands, like the B-52's. The CBGB punks looked down on the Mudd Club because Mudd appeared to be more elitist—more "art"—so you didn't see so many CBGB people coming to the Mudd Club. The No Wave crowd would come. It's usually associated with music like James Chance and DNA and Lounge Lizards and Mars and some movies were made around that. And that's where I fit in. So anyway, Cookie was one of these strong women at the club. You

would go there every night and meet painters and musicians and famous people. Or, people who were famous at the time would show up because they wanted to see what that scene was like—it had a kind of surrealist aspect to it. You felt that the people—the customers—were really the entertainment.

RICHARD BOCH: It was a small club in a six-story loft building on White Street two blocks below Canal. Tribeca before it was Tribeca. It was the ground floor, the basement

was the coat check area, there was a second floor, and then eventually a third floor.

The second floor was more VIPish, sort of limited access. There was dancing, live music, and DJs: David Azarch and a woman named Anita Sarko, but David really was the main DJ. He'd play everything from the Sex Pistols to the Supremes. The Ronettes to the Village People. With a heavy emphasis on '70s rock—Roxy Music, the Talking Heads, the Slits. It basically brought rock-n-roll back to the dance floor.

CHI CHI VALENTI: I met Cookie at *The Batman Show* opening, which I think was actually the

first thing that ever happened at the Mudd Club, before it even became a club. It was that arts group, Colab, which was a Lower East Side collective that put together amazing shows. The Colab people were always political. It's the whole art world that Cookie was a part of. Certainly people like Amos and James Nares and Jean-Michel and people like that. Cookie wasn't a member of Colab—they were sort of the more serious part of our generation, really Cookie's generation.

LINDA YABLONSKY: I remember Cookie once did a performance at the Mudd Club—it was for a skit someone arranged. She got all dressed up with a monkey-fur coat and feathers and she and Sharon were singing.

RICHARD BOCH: She did some readings there with people like Gary Indiana or Max Blagg. You'd have a bunch of people in there anywhere from ages 15 to 55 and then all of a sudden these downtown crazies would get up and the music would stop and they'd start reading poetry. The Mudd Club could handle that, it allowed it to happen.

GARY INDIANA: I took a lot of pictures of Cookie in drag. Kathy Acker and I were asked at one point to do a performance at the Mudd Club where we would project slides of our former boyfriends and read letters to them that we had written. I had a lot of letters I had written to boyfriends, but I didn't have that many pictures of them, so I called Cookie up and said, "Would you like to pose as several of my former boyfriends?" We went to William Coupon's studio, and she had two costumes. One was kind of manly—*Playboy*, kind of a smoking jacket—and the other was a *Hustler* kind of picture.

RICHARD BOCH: She also did some performance pieces with Francine Hunter. Francine's events that Cookie appeared in took place around the time I started working there: the early spring of 1979. They were very offbeat, kind of camp performances, with sort of that Andy Warhol bad-acting aesthetic, and I don't say that as a slight. It was almost like a calculatedly bad Andy Warhol acting aesthetic. It was all stuff I loved, and it's part of the Mudd Club legend, those performances.

Cookie for me is a thread that runs through the two-year course that I worked at the Mudd Club. There's everything from her being sympathetic and giving me a hug and a squeeze when she arrived because she would see the door was so insane and I was just out of my mind outside to seeing her in the bathroom two hours later when she's reapplying some lipstick or just staring in the mirror and fluffing her hair.

*Above and opposite: Cookie, May 1979 (Billy Sullivan)*

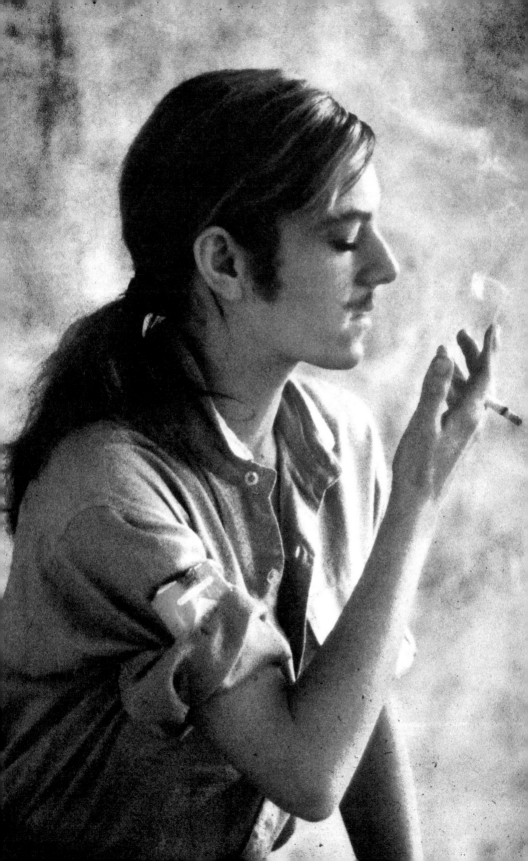

JOHN HEYS: When she came into a room—it didn't matter where it was, a little tenement apartment or something more glamorous like a nightclub, although sometimes these nightclubs were dives—she had an incandescence. You just felt it. And she was a fantastic dancer. Everybody I knew from Baltimore was. The real American dance, the old East Coast style. If you lived in New Jersey, Philadelphia, New York, Baltimore, this lindy or jitterbug—it gets called different names—we would call it *American Bandstand* style.

SCOTT COVERT: My relationship with Cookie was about dancing. We would go dancing and it was a way of exercising almost, just dancing every night. You met a lot of people on dance floors.

STEVE BUTOW: Cookie liked the people I hung around with. I had a little group of friends who were not connected with John Waters. Well, I had hustler friends. In my twenties I was a hooker. I mean, I still had my job, but it was just mad money and all my friends were party boys. We were very popular, so she would hang out with us, and being in fashion, I knew a lot of models. Warhol was friendly with all of us because he was always kind of in awe of John Waters and his gang—he found them very interesting. I knew Warhol a little bit; he took pictures of me one time. I worked for this agency called Adams Athletes. A sleazy, sleazy pimp ran it, this gay guy. It was fun. Most of the time you didn't have to do that much!

LINDA YABLONSKY: She was sewing, doing drugs, dancing, raising her kid, and galvanizing everybody around her with this energy. She was no innocent, but there was some kind of naiveté appeal that was completely honest. She didn't pretend to be anything other than what she was.

AMOS POE: There was no sense of artifice, yet at the same time there was a lot of *joie*. She really dug deep.

SARA DRIVER: I was about 10 years younger than Sharon and Cookie, so I really idolized them. I would always say to Jim (Jarmusch), "God, you have to put Cookie in a movie," but we just never got to it.

ERIC MITCHELL: I always thought Cookie was an actress because I was introduced to her as an actress. People would say she was an actress from the John Waters movies, and I had seen them, but I didn't remember seeing Cookie. She didn't really need that to validate herself.

BRUCE FULLER: When I met her I had no idea she was the Cookie in the John Waters's movies. I was like, "That's *you?*" And she was like, "Are you kidding me, that's the reason why most people want to be friends with me!" I said, "The John Waters Cookie doesn't really look like you, you're so much more pretty."

AMOS POE: I don't think she considered herself an actress. I think she considered herself an artist. I'm not sure, but if she considered herself any one of those things, it would be a writer. At different times she would consider herself different things. Cookie was everything in a certain way. Her sexuality for example was the most fluid of any girl I'd known. She was so natural, so unbelievably natural.

## THE DIFFERENCE BETWEEN A HACK AND AN ACTRESS

*"Everyone wanted to be a star. Everyone, all over the world, wants to be in the movies. It's modern human nature, a new biological urge, a twentieth-century physiogenesis. People feel compelled to be on the screen."*
—Cookie Mueller, "John Waters and the Blessed Profession," *Ask Dr. Mueller*

RICHARD HELL: I met her in 1978. We were working on a movie together called *Final Reward*. It's a horrendous film, except it does give you a feel of that moment just because of the cast, a roll-call of the downtown nightclub scene: Teri Toye, John Sex, Bill Rice, me, and Cookie—she played my girlfriend, but in this

*"Cookie as my ex–boyfriend," NYC, 1980 (Gary Indiana)*

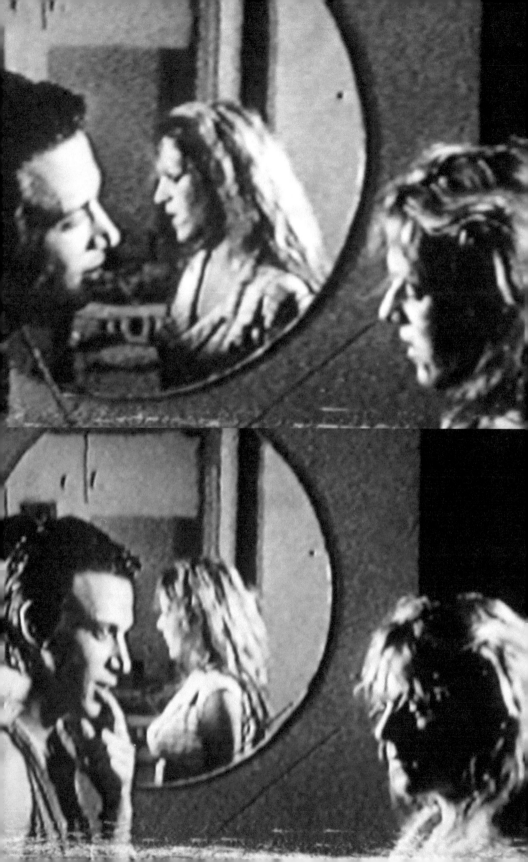

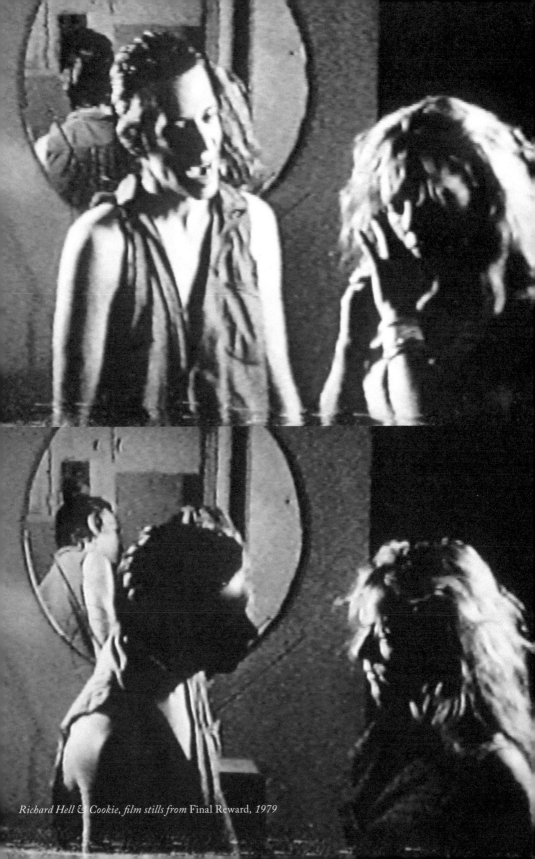

*Richard Hell & Cookie, film stills from* Final Reward, *1979*

exaggerated, Hollywood-diva style. It's definitely a good picture of Cookie's presence.

RACHID KERDOUCHE: *Final Reward* was basically a story of a guy coming out of jail who's trying to feel alive and look for his ex-girlfriend. I was looking for a blonde. And I had another girl, but she couldn't do it so I spoke to Richard Sole, the keyboard player for Patti Smith, who said to me, "Why don't you talk to Cookie Mueller?" She was more than what I was expecting. I wanted a simple blonde girl, just a girl who was blonde. When I used Cookie, I realized I could have a real person, in the sense that she could re-write the lines.

The scene with Cookie and Richard Hell was easy because they were friends. I had a scene where she has to remove a little bit of her clothes and Richard beat her or something. She was very professional. She understood.

RICHARD HELL: The scenes are pretty funny. She's like a masochist and I'm whipping her. She has some great scenes with Teri Toye, too.

RACHID KERDOUCHE: I remember having coffee with Cookie and seeing the tattoos on her hands and wrist. I recognized the tattoos because my family is Berber and my mother has tattoos on her face and fingers, so for me it was kind of strange because it was like a flashback to my mother.

That time was the beginning of something— you had Eric Mitchell, Amos Poe, Beth and Scott B, and then later you had Jarmusch and Spike Lee.

AMOS POE: Eric Mitchell's *Underground U.S.A.* is a beautiful film about an underground movie star who sort of goes to pieces. Patti Astor plays the main character. Great role. Yeah, it's like a masterpiece.

ERIC MITCHELL: I think I must

have met Cookie in '78. I was going to make this movie and I gave her a part as my girlfriend. She appears at the beginning of the movie and at the end—she's kind of like a bookend for this character. The way those projects were made... you'd write the movie in about a couple of weeks. There were people around and they would become the material that you worked with. I had Taylor Mead, Jackie Curtis, René Ricard—because the movie is about fading movie stars. It's a portrait of a "has-been" from the '60s who is living through the '80s, and because everyone once thought they were so wonderful and intelligent, pretty and talented, they would live through that fantasy life. So it was a cautionary tale, a moral tale. Patti Astor's character is based on Edie Sedgwick. She's not being hired for movies, she's still got some money, but she's living with René Ricard who is her servant or confidant, and she goes to a psychiatrist and she drinks and takes drugs and blah blah blah. In the end she just dies.

LINDA YABLONSKY: Cookie had a very pronounced lisp when she first arrived in New York. She got some professional instruction and managed over the years—it took a while—to get over the lisp until it was nearly gone.

PAT MORAN: She wanted to be an actress and we used to say, "But Cookie you have a speech impediment!" and she'd say, [with an affected tone], "It doesn't matter..." And it didn't with us.

MARK BAKER: That incredible lateral lisp of hers! She had some comic mastery in the way she would say stuff!

AMOS POE: I used to see her around, and I was a little intimidated by her. When I began writing *Subway Riders,* I started to think of who would be the best person for the character Penelope, and I thought, it's got to be Cookie Mueller. So I finally got the courage to go up to her one day, probably at the Mudd Club. I was just shy, and I thought she was a little wild. But she was friends with a lot of my friends, and finally I just introduced myself. It was one of those things where a person's façade or look is a little more intimidating than they are, because she was the most normal girl around, really. She was just natural—she wasn't posing, she wasn't putting on airs or wearing clothes that she didn't feel comfortable in. I asked if she would do my film, she said, "Yeah, absolutely," and we became really good friends. We were very close starting from '79. In those days, I was looking for something else. It wasn't necessarily that you could act or that I knew you were great in films—that wasn't really what I was about. I knew Cookie could do it. I had hung around enough with her that I knew that she was cinegenic, which is very different than photogenic. Some people can be photogenic but not cinegenic and vice versa. Everybody in *Subway Riders* was pretty much cast because I either wrote the parts thinking of them or wrote them when I met them. I knew that they could bring something else that I couldn't even think of. That was always the kind of collaboration I liked. You write a character in a certain way, like your imagination of that person, and if they're artists, they bring something to it that you didn't expect. It's definitely a combination of fiction and nonfiction. It's like playing out a fantasy, but then you use the reality to make the fantasy go even further.

BETTE GORDON: When I made *Variety* I fashioned characters in the movie around real people. So Nan Goldin plays herself more or less as the bartender at Tin Pan Alley. Tin Pan Alley was a very cool bar on 49th Street where we all used to hang out. The reason we liked that place was because it took us out of the art world and put us right smack into Times Square where it wasn't all artists. It was a combination of drug dealers, hookers, artists, musicians. The people in the bar scene were the people who hung out there anyway, Cookie being one of them. I wrote Cookie's part for Cookie.

RICHARD HELL: They did that in Hollywood in the '30s—people were there for their personal style.

BETTE GORDON: The voice Cookie uses in my movie, it was so *her.* She was just like, "Well I don't care if he doesn't want me, you know, I'd go after him. I'd go for it, I'd follow him." "You'd follow him?" "Yeah, of course I would. Who cares what other people think, if I want to do this or if a guy wants me… I go for it." I was friends with Nancy Reilly who was in the Wooster Group and I did a little Super-8

UNDERGROUND U.S.A.

COOKIE MUELLER

study of people talking about their porn fantasies, and then with Kathy Acker, the queen of using sexual language, we wrote the screenplay. Kathy was friends with Cookie.

MICHAEL OBLOWITZ: I did a great scene with Cookie in a film called *King Blank* where she plays a stripper dancing in this bar called the Pussycat Lounge that was an actual bar way downtown in lower Manhattan, right by the World Trade Center. There were a bunch of old lofts and bars on this street. It was almost surreal, like a European street in the shadow of this gigantic futuristic building that soared above us. People like Philip Glass and Dicky Landry had lofts on this street. I had this little apartment on top of the Pussycat Lounge. The scene is with Rosemary Hochschild, who became my wife; she's talking to this really perverted guy played by Fred Neumann, from the Blue Minds and Cookie's behind them, dancing this incredibly erotic dance just about totally naked. It was the sexiest scene in my film.

GLENN O'BRIEN: Cookie also plays a stripper in *Downtown 81*. I was the writer and producer and Edo Bertoglio was the director. It was a funny scene, it was in a topless go-go bar. It's kind of a complicated story about my friend Walter's band who's playing at the Mudd Club and the bass player is a topless dancer and then one of the other musicians, another girl, comes into the topless bar to pick her up from work and Cookie is the girl whose supposed to replace her in the shift and she's late so there's kind of a big scene, and Steve Mass who owns Mudd Club plays a drunken customer and he's harassing her and coming on to her and he's really drunk and Katherine throws a drink in her face and then Cookie comes in and she's like "Oh hi hon, sorry I'm late" and she just kind of chills everything out.

BETTE GORDON: Not only was she wonderful and easy to direct but she also came on the set to help do styling. Cookie came over and did Sandy's hair, she wasn't ever a prima donna, she'd jump in and be like, "Let me help do her hair," or, "I'll do her makeup." That kind of spirit of helping out is what really characterized cinema in the late '70s and '80s.

MARK BAKER: Cookie would lure me into these crazy projects. She'd say, "Oh hon, there's this woman named Susan Seidlman and she's going to be doing this first movie of hers called *Smithereens* with this darling girl named Susan Berman and Richard Hell's gonna be in it and I already got you a part, all you have to do is call her."

I remember I used a fake name in the credits because the movie was non-union. I gave myself the name of Roger Jett cause I thought it sounded like Joan Jett's cousin. I was playing a punk with sprayed red hair.

Cookie played a very glamorous woman in a wheelchair in the movie-within-the-movie where Susan Berman and Richard Hell go to the movies on St. Mark's and see Cookie in a bad horror movie.

MICHEL AUDER: Cookie plays in my movie *A Coupla White Faggots Sitting Around Talking.*

There was a play on Broadway at that time that was kind of famous called *A Coupla White Chicks Sitting Around Talking* so we took the title and replaced it with faggots. The film was shot sometime between 1979 and '81. The film is very low quality. It was shot on video. At that time, I didn't have any equipment so it had to be transferred all the time. I don't mind the quality.

The film was shot in the apartment of an artist-friend, Jack Youngerman. He's dead now, he was married to Delphine Seyrig, a French actress. It's all his art in the film. When he saw the film and he realized we were putting down art, he got very upset. Our friendship was broken.

Gary Indiana, Taylor Mead, and Alice Neel are in the film. I have an amazing scene with Sharon but it was cut out. She's the black-faced maid. She speaks with a Southern dialect. It's really a good scene. I pulled it out because the film is not so political and it was taken the wrong way and I didn't want to deal with it. I should have left it, but I didn't have any kind of interest to argue about it. I saw it the other day and it's the best scene. It was screened at the Kitchen. It played four or five times.

I felt I was lucky to have Cookie play in the film and she always made me feel that she appreciated my work.

GLENN O'BRIEN: We started becoming friends around '77. We got along really well. We have the same birthday, March 2nd, and we often had birthday parties at the same time.

In 1978, I started *TV Party*. It was a public-access television cable show in New York that ran till 1982. Chris Stein was the co-host, Amos Poe was the director and Walter Steding was the leader of the TV Party Orchestra.

Cookie was in the Heavy Metal show, in *TV Party*. She comes on and talks about a blood test she did and about what metals are in her blood, toxic ones like cadmium and all this stuff. She goes on and on about it, it's really funny.

AMOS POE: None of us were doing anything professional. I mean, what is professional? Everybody's an amateur at one point. You can do great amateur stuff and you can do bad professional stuff. All we were about was being amateurs, inspired amateurs.

ERIC MITCHELL: In some ways, the movies we were making were a form of appropriation, because already in '75 we thought there was nothing new, so we might as well re-do things and use those frames to do something that was yours. Don't concern yourself with plot, just use that grid of the past and then make it the present.

JOSEPH CACACE: I saw *Pink Flamingos* and became one of those fans that wouldn't leave somebody alone. I kept sending Waters letters and I finally called him and went to Baltimore, where I showed him some of my stuff at his apartment. He actually invited me there— this was probably 1981—and I became very interested in the other people that were in his films. I was doing this trilogy of short films called *Trilogy of Loneliness*, non-narrative films that are supposed to achieve a mood of loneliness or dislocation. I thought Cookie would be good for one of the characters. But I never thought she would do it. She had a listed phone number and I just called. We met in a bar. I remember I bought her a bottle of Moet champagne. I couldn't afford to pay her, so that's what I gave her and she agreed to do it.

*Taylor Mead, Eric Mitchell & Cookie, film stills from* Underground U.S.A. *1980*

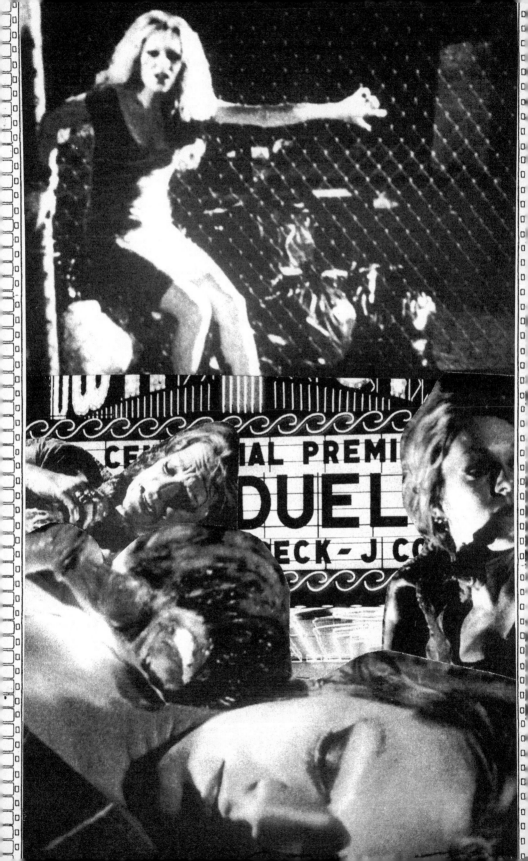

Essentially, she portrayed somebody, not necessarily a real person, that appears in the living space of somebody who is troubled. You could say that she was there either to comfort him or to inspire him to kill himself, depending on your interpretation. She could be hard-looking but when she spoke in a normal conversation she had a soft voice and a kind of underlying warmth that you certainly never saw in any Waters film. That's what I liked about her. She looked like a hard-ass, but she wasn't.

She honestly seemed very tired. I remember her napping in my friend's bed while we were getting ready. She seemed to have been having a difficult time. I don't know what was going on in her personal life; I certainly wouldn't have asked her. We spoke a few times subsequently. One time it was very odd: I called and she basically yelled at me on the phone, like, "I don't have time to talk to you right now!" She hung up and then two days later called me back and apologized. The film was shown at the School of Visual Arts a few times and she told me she wanted to come see it but she didn't. She never saw the film.

After being with her for a few days, I honestly thought she would make a very interesting mother in a film. I thought it might give her the opportunity to show people that she wasn't just a caricature.

GARY INDIANA: I fell in love with her the night I met her and I never stopped loving her. She was at a play, *La Justice* by Kenneth Bernard, and I just looked to Sharon and said, "She's the one." She is the *one*. I had to know her, and from then on I wrote plays only for Cookie to star in. I only did theater for Cookie to be the center of, for years. She was like a woman in flames—she was something like I'd never seen before in my life. Not just a beauty, but the freedom that she had about herself, that extraordinary freedom. I loved it so much, I craved it so much, and I wanted us to be collaborators to the end. And we were.

JOHN HEYS: Gary knew these people in the literary circle from Saint Mark's Church and the Bowery Poetry Project and the poetry marathons on New Year's Day where Cookie, Gary, Taylor Mead, Ginsberg, and on and on would read. I knew Gary from The Bar Bar, and then he just said, "I've written this play for you—would you like to do it, would you like to play Roman Polanski?" I thought, yeah, why not, and then thought, fantastic—Cookie as Sharon Tate.

GARY INDIANA: I wrote a play, *Curse of the Dog People*, that Jack Smith was originally in. He rehearsed the role of Inspector Bidet. This is why we didn't do *Curse of the Dog People* with Jack Smith: because we left the theater one night and Cookie said, "I can't wait for him to make 20-minute entrances any more. This is ridiculous. This is a chamber piece, it's not big enough to have Jack Smith hijack it." We were fed up because this little chamber piece that was really very exquisite kept getting turned into a Jack Smith psychodrama—like how long was it going to take Jack to come out and give his line, how long was it going to take Jack to come out and perform his role?

We would never have done *The Roman Polanski Story* if Cookie hadn't gotten so sick of watching Jack Smith trying to pull himself out of the doorway. She had the balls to say, "Okay, it's Jack Smith, so what?" There wasn't one director in New York that would have fired Jack Smith. You would *never* fire Jack Smith. But we fired him.

So then I said, "What do you want to do, Cookie?" and she said, "Something bigger." I said, "Something like *The Roman Polanski Story*?" and she said, "Why not?" We went to the Peppermint Lounge later that evening, and when John Heys walked in, we both looked at him and he looked exactly like Roman Polanski and Cookie grabbed him by the forearm and said, "Gary's just written the most brilliant play you can imagine—*The Roman Polanski Story*—and we want you to star in it." And he said, "Well, when can I see the script?" and Cookie looked at me and she says, "Tomorrow morning." And I had to go home and swallow so much amphetamine—I wrote the whole fucking script in one fucking night. And that's how that happened.

BILLY SULLIVAN: Cookie as Sharon Tate: brilliant. That was a walkthrough for her, it was just natural. I thought that's what Sharon Tate would be like at home.

GARY INDIANA: Cookie played Sharon Tate, she played Anjelica Huston, she played Polanski's mother, she played so many parts. Everybody did. The only person who played the same role all the way through was John Heys as Polanski. Sharon was all over *The Roman Polanski Story*. Sharon played about ten roles. She was amazing in it and Cookie was amazing. Amazing. She was always game, she never flagged. We rehearsed for months and months in every conceivable place, and her and Sharon would come in and have fights that would take up half of the rehearsal time, but when she was on, she never missed a mark.

JOHN HEYS: And she slapped me really fucking hard every night. There was a scene where she slapped me in the face. The opening scene was my head in her lap, where she would always cue me on my lines, 'cause I was so nervous I would forget my lines.

MAX BLAGG: Gary was trying to direct this group of lunatics. They used my loft for rehearsals, and Cookie had this huge fight with Sharon. The girl I was living with at the time was a conservator at the Metropolitan Museum. She had this incredibly rare pot—some Mesopotamian pot, or I don't know where it was from—but it was near the bed and those two were having a fight on the bed. It didn't get destroyed, but almost.

JOHN HEYS: A rudderless ship... Gary wrote a really good play and had an incredible cast of characters. Sharon gave a true tour de force performance. It was the one and only time the world saw Sharon in a skirt. As Ingrid Darmstadt. She was so fantastic and Taylor Mead and Chris Cap were in it.

SHARON NIESP: Gary had me as Ingrid Darmstadt, assistant to Leni Riefenstahl. I was fucking all the soldiers in the Wehrmacht

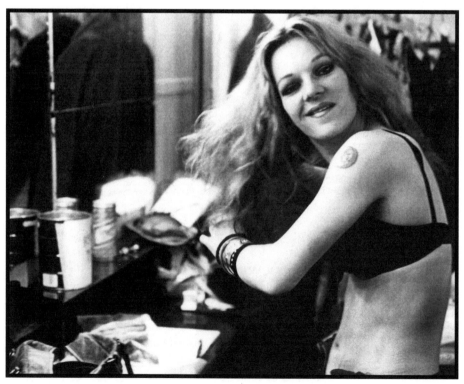

*Cookie backstage, c. 1981 (Sheyla Baykal)*

getting information for Leni Riefenstahl's movies. There's also a scene with me as a Valkyrie with horns. I come out in long braids with all this animal fur on me, smoking a cigarette and *screaming* like a female Hitler. While I came out he played the music from this old German opera, then he switched to Wagner's *Ride of the Valkyries*. I'm just ranting and raving and smoking a cigarette. He said, "Just rave and rant, make up a language." And then there's John Heys sitting in a wheelchair with a lightbulb doing one of those Polish jokes.

MAX MUELLER: I remember seeing my mom get stabbed on the floor and thinking, wow that's kind of heavy! She made a pregnant costume for Sharon Tate and she gets thrown on the floor and her stomach gets cut open. She designed it so that they reached in and pulled out feathers. They decided to go against the blood and gore and go for feathers.

GARY INDIANA: Cookie could be the most insane person that you ever met and the most professional, too. You know, she never fucked around with me. Ever. She knew what I wanted and she knew how to do it. She knew how to deal with other people's bullshit, because there was a certain amount of crap, although I must say, everybody was very professional. She knew when she had to be onstage, she had this instinctive idea about how to present herself and position herself, she knew how to cross

the stage. And if I told her, "You have to move over here," I never had to tell her again. Cookie directed herself. If I gave her one direction, she completely took it, and not only

took it, but understood it. You see, that is the difference between a hack and an actress.

JOHN HEYS: It was great, except we were all freaked out because somehow a man nicknamed Bela Box showed up. I can't tell how Gary Indiana found Bela Box, because he was in five or six Play-House of the Ridiculous Plays—lets say until approximately '72—and then got busted for dope and was in prison. We say "upriver." He was sent upriver to Sing Sing but then out of the blue he appeared.

*Poster for the stage production of* The Roman Polanski Story, *1981 (Jon Mathews)*     **135**

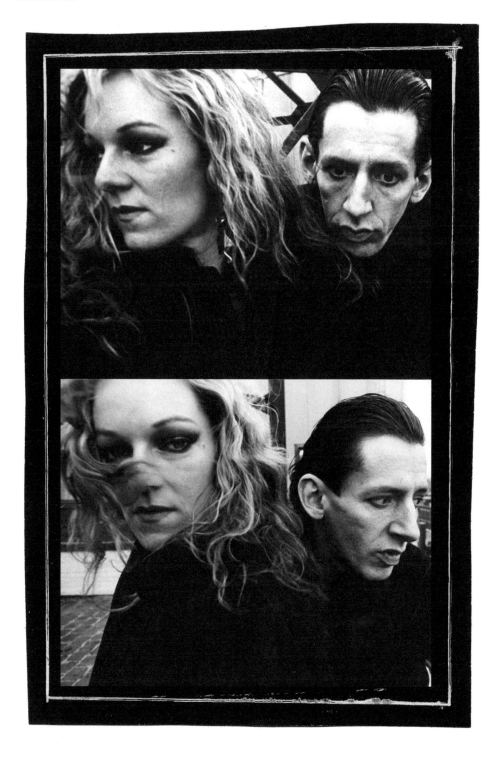

*Cookie & John Heys, NYC, 1981 (Allen Frame)*

GARY INDIANA: He was brought in as the AD to oversee rehearsals when I wasn't available. He was a friend of Kevin Bradigan, who recommended him. I had to be in Paris during two weeks of rehearsals and came back with broken ribs from a car accident. I discovered that he'd re-blocked the entire play behind my back. This created endless confusion and Cookie, I recall, was particularly livid about the way he barked orders at everybody. I had to put it all back together.

JOHN HEYS: At the beginning we had an actual script. The play had been cast, the engagement had been set at the Wooster Group's Performing Garage, but the rehearsals became totally chaotic. Bela Box came in and the feeling was, a) nobody liked him, and b) everyone thought he was no director. He came out with this drill-sergeant mentality and this was how he was trying direct people like Taylor Mead and Cookie Mueller and myself. It was not possible! It was just not possible!

GARY INDIANA: He did help choreograph the tango scene at the end, and he really did solve a lot of problems with that, but he was otherwise a pain in the ass takeover and I should have fired him the first week. The cast detested him because he acted like Mussolini when I wasn't there. He also stole all the soundtrack material I had borrowed from Jim Jarmusch, some of it very rare recordings of Antonin Artaud and the Nuremberg Tribunals.

SHARON NIESP: Gary just came back and revamped the whole thing. And I remember people coming twice to see it. In fact Susan Tyrrell, a great actress—she was nominated for an Oscar in *Fat City* and played in Andy Warhols' *Bad*—she came several times to see it and could be heard laughing in the audience. She brought people and really enjoyed it, the concept of it and the whole performance of it.

PATRICK FOX: I became good friends with Cookie during Gary Indiana's *Phantoms of Louisiana*—I believe that was in 1981. The play was a murder mystery, and Sharon and I were supposed to be the hired hands, and

really we would've been black, except we weren't. I was 22 years old, and my brother and I played the same role. Gary would be backstage and would randomly say, "Okay, you do this scene," because really Gary had a crush on both of us and couldn't decide how to work that.

SHARON NIESP: I was Coretta Kierkegaard, the white trash family retainer who thought she was a black lady. Coretta like Coretta Scott King.

PATRICK FOX: She was the kitchen help and I was the yard help, Buck. It was staged at the Wooster Group's Performing Garage. Bill Rice was in it, Taylor Mead, Cookie, Sharon, Allen Frame, Donald West, Mary Lemely, who was an artist and the assistant of Carl Apfelschnitt. She did these incredible costumes. I think Vicki Peterson may have been in it. Betsy Sussler was in it. Ross Bleckner did the sets. They were these incredible sort of optic vortexes of squares or circles that were done on enormous pieces of paper— maybe 12 feet, hung by wires—that would be shifted back and forth to create this plantation in the Deep South. Then in the middle of the play there was a dream sequence that was Oscar Wilde's *Salome* performed in its entirety with Cookie in the title role. That was sick to do an entire play within a play. It's no wonder that the rehearsals went on for seven months.

GARY INDIANA: Cookie was absolutely angry that I gave the main part to Mary Lemely. Mary had designed all the costumes for the previous play, so I couldn't not give Mary a part. So I wrote a special play, which was a condensed version of Oscar Wilde's *Salome*, for Cookie to do. But Cookie would come in clanging with bracelets and making all this noise and was just a horror.

SHARON NIESP: Oh, I loved it! Gary would have a nervous breakdown about it! She wore these bracelets and you could hear them [howling with laughter] she was Salome and she was supposed to come out and do the dance of the seven veils and she and Gary

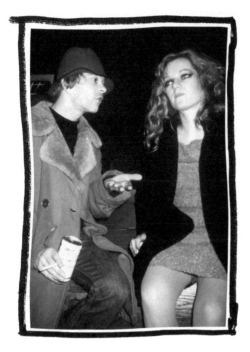

had a fight over these goddamn bracelets that kept clinking every time she'd move her arm and they had a big fight about it!

GARY INDIANA: On opening night, she sent a letter through Allen Frame saying she was having a nervous breakdown and she couldn't do it and I had to do the part and I did *not* like doing Salome.

SHARON NIESP: She quit right during the performance and Gary came out in a tutu as Salome. He came out and did the dance and then he would go right up to the people and sing, "There's No Business Like Show Business" really loud right in their face! He performed Salome and she walked out; she was mad that he yelled at her about her bracelets. *"God damn bracelets, Cookie!"* And you could hear them backstage clinking and clanging!

GARY INDIANA: Cookie worked with a lot of people, not just John Waters and not just me. She had enormous range as an actress; she didn't just play bubble-headed roles. She pushed me around a lot, but in a really healthy way. She was a very sensible person and she had her head screwed on. She liked

to have a good time, she was a good-time girl, no doubt, but when it came to acting, when it came to doing something, Cookie was incredibly disciplined. She took what she did very seriously, and if she didn't feel she was right for it, she would leave.

MARK BAKER: I think she was very aware of her individuality as a performer. I don't think she thought of herself as Eleanor Dusa—the famous actress not unlike Sarah Bernhardt—she didn't fancy herself someone like that. She thought she was more of a persona, a personality person, but she certainly was well aware of her sense of being able to develop an interesting character from material.

GABRIEL ROTELLO: She brought the same charisma to her stage presence as she brought to her daily life, but it wasn't so much her being an actress as much as being a person just dripping with charisma. Whether she was acting or just hanging out, she just brought herself to everything she did and was so striking that your eye just naturally gravitated towards her. She was pretty much just always the star of everything that she was in.

MARK BAKER: She and I wrote some things together, a play about Edgar Allan Poe, he of course being a strong solid poetic son of Baltimore. We made it look terribly authentic with clothes from the costume collection. It was all 19th century clothing that was kind of tattered and we had some wonderful actors from all over the place: the

New York scene, the off-Broadway scene, the underground scene, couple of singer types, because we had some incidental music that we wrote.

JOHN HEYS: *The Edgar Allan Poe Story*—another prestigious theater, the Dance Theater Workshop. Robert Applegarth—who was really a prince of a man, a sweetheart, one of the

early people to die from HIV—was the manager there. He was an ex-lover of Mark Baker, a fantastic actor. In *The Edgar Allan Poe Story* I played a character named Fanny Osgood.

MARK BAKER: The central protagonist was this marvelous guy, Byron Thomas, who was so like Poe and was so drunk the night we did the tech that we had to send everyone home. Cookie played Mrs. Shelton, a rich Virginia widow who admires Poe and his sense of the macabre and tries to seduce him over her husband's coffin, which was a wonderful vignette.

SHARON NIESP: I was the corpse. Cookie was dressed in black widow's clothes and she and Mark had a huge fight about it. I was Mr. Sheldon, and she had to throw herself on the coffin and go, "Oh, Mr. Sheldon, Mr. Sheldon, oh," with that little lisp and I had to lay there motionless and not laugh! "Oh, Mr. Sheldon, don't tell me you've gone, your spirit's gone." Some shit like that.

MARK BAKER: Wonderful. It was all community theater, New York style, with total ideas. We found this common vision that perhaps to other people seemed at worst random and at best

detailed. The only thing I had any reservation about was that Cookie ran away to the Berlin Film Festival and met Udo Kier. That she could just like walk away from it while we were in the midst of it. She was like, "Well baby, this is an opportunity to go to the Berlin Film Festival." So I had qualms and issues and all that but when she got back it all fell totally into place.

JOHN HEYS: Mark and Cookie wrote the script and we rehearsed a really long time. Again, a talented cast but there were conflicts with the direction.

SHARON NIESP: They argued a lot about this and that but they respected each other greatly. They butted heads about little things, details, but in the end they came together on the whole production.

MARK BAKER: When we wrote together it was like easy ice skating—we just did it. It was easy for us to collaborate and write all these personages that were not us. Cookie was very facile and had great mental acuity and she was really in the moment. I always anticipated some sort of fun with her, you know like the childhood friends you remember that were so winning, she was very winning.

I think we performed it about six times, or nine, and we got good coverage. We were never reviewed or anything but we were favorably mentioned. Years later when I

worked with Peter Sellers, the Pittsburgher wunderkind opera director, he became very enamored by the *Edgar* project. When he ended up the artistic director of

Together at Last: Cookie & John Heys, *1981 (Ken Tisa)*

the Kennedy Center he optioned our work and we both got a chunk of money—you know to keep it in the bay so no one else did it—well, no one else did it and neither did he. He spent all the money and went to Stuttgart to the opera or something, so that was kind of hilarious but at least we lived on that money while we knew we had some sort of commodity.

SHARON NIESP: Cookie just lit it up when she came on. You'd say, "Who's that?" She and John Heys used to do the Chin People—that was great.

JOHN HEYS: Cookie and I wrote a piece called *Two Chin People*. Rolf von Bergmann, who is dead now, was this crazy Berliner who arrived in New York and went everywhere on roller skates—this mad queen. He managed this fantastic space, Café Schmidt on Broome Street, and he asked Cookie and I to do a performance, *Together at Last: Cookie Mueller and John Heys*. The flyer was a picture of the royal family of Morocco.

MARK BAKER: This thing at Café Schmidt with John Heys... he was a trip. They devised something, this poster, a Xeroxed photo

of Moroccan royalty and it said, "We are not drag queens." They were a riot. Very star-ward and stoic. It was uppity as I recall.

JOHN HEYS: We came up with two parts, and the second half of the show was *Two Chin People*, before *Saturday Night Live* did it. Our heads were upside down and that's all you could see. Then we put false hairpieces over our chins, drew two eyes and nose, and had this conversation. My name was Romeo Tanghole—only Cookie could think of names like this—and Cookie's name was Sculptrina Fagioli. I think it's a combination of Baltimore sickness and Cookie dementedness!

MARK BAKER: Yeah, she was pimp, she was so hilarious. The mistress of reinvention. She demanded a kind of enthusiasm, even when she had great doldrums. There was enough going on to make them interesting as opposed to dull and gloomy.

JOHN HEYS: There was a rehearsal where I said, "Look, we're not going out partying and we're not going out dancing. We're rehearsing for Chin People and *really* I've got to draw the line here and I want you at 6 p.m. at my house or your house." She was always late and I just blew up and said, "Forget the whole fucking thing" and then she'd cry and apologize. Cookie would have spontaneous crying things over little mini-dilemmas.

GARY INDIANA: I wish I could have kept going with the theater company, but it was clear we weren't going to get financed. But everything Cookie and I did together was golden. She freed me to do things that I wouldn't have done otherwise. It wasn't a simple, uncomplicated kind of love. We argued all the time, but Cookie made an enormous difference in my creative life. She did. Because Cookie knew what was bullshit.

# BERLIN STORIES

The following is a recollection of true experiences of an American in West Berlin.

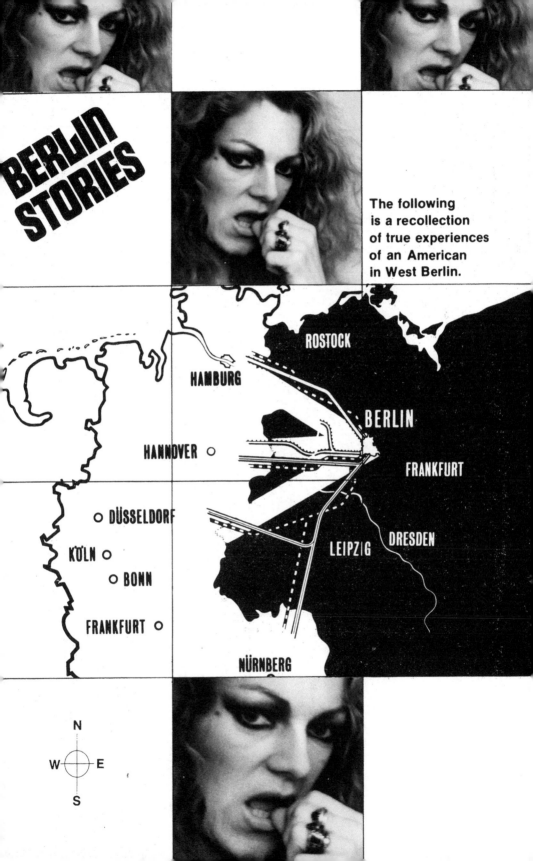

ROSTOCK

HAMBURG

BERLIN

HANNOVER

FRANKFURT

DÜSSELDORF

KÖLN

BONN

LEIPZIG

DRESDEN

FRANKFURT

NÜRNBERG

N
W E
S

# Eine Amerikanerin in Berlin

Cookie Mueller excerpts are taken from
"The Berlin Film Festival—1981"
*Walking Through Clear Water in a Pool Painted Black*

COOKIE MUELLER: The whole time we were flying across the Atlantic I hadn't been nervous at all about my personal stash of drugs that I was carrying inside my overly padded bra.

AMOS POE: The Berlin Film Festival, that's where we premiered *Subway Riders*.

COOKIE MUELLER: I had a part in this film. It wasn't a bad part, and I wasn't too horrible in it; the film itself was okay too, although not by any American standards.

AMOS POE: I was traveling with Cookie and my girlfriend Sara. You had to fly to Munich and then to West Berlin on Pan Am or whatever it was. It had to be American, British, or French.

COOKIE MUELLER: That sounded pretty good to me. Besides, German films were probably better than any other in the world at the time. Fassbinder was tossing his genius around. Herzog was busy influencing all filmmakers in the rest of the world and Schroeder was doing both, but to a more select audience. I wanted to see the stuff hot off the Steenbeck editing machine, fresh in the can, the films that might never get to America and maybe I could get some film work. Maybe. If I hustled. But I wasn't counting too much on that possibility. I suspected that I wouldn't have a lot of time to think about work... too many festival parties... things like that.

Basically I just needed some live European exposure.

All I had to do was get through the customs.

AMOS POE: When we got off the plane from New York in Munich, it was like 6:30 or 7 a.m., and I had forgotten my hat on board. It was this really weird plastic police hat. You know, white vinyl rim with black leather.

COOKIE MUELLER: ...his quasi-Nazi motorcycle hat...

AMOS POE: It was a crazy hat and I was wearing leather pants and a leather jacket or something. We didn't look good, the three of us. Sara looked great, actually. I looked a little retarded and Cookie looked wild.

COOKIE MUELLER: The beer-belly bunch at customs were eager for us. They thought they might have some fun because we didn't look like any of the other passengers.

AMOS POE: There were two lines: one for connecting flights to Berlin and one for customs, and we took the wrong line. When we got there, there were around 15 Gestapo-looking border guards and they looked at us coming down the empty hall and these guys just swarmed us. Basically they started looking through all of our stuff. I wasn't carrying anything because that's ridiculous. Why have anything on you when Berlin is just full of stuff? At the moment they're looking through my girlfriend's camera bag, I looked at her, thinking she was going to be cool because she was the least druggy person around, and *she* looked nervous. They reach into her bag and there are 20 rolls of film and they pull out one canister and in it was pot.

COOKIE MUELLER: Unfortunately for her, customs people have been hip to the Tri-X canister scam since the great marijuana days of the late '60s. They went right for it, found it, and then the place was alive. Suddenly a flurry of dogs and cops were circling in. Dobermans in S&M gear and aging uniformed Hitler youth cracking their knuckles like butchers snapping baby chicken wings gathered around us

*Cookie on the set of* Subway Riders, *1981*

while visions of gas chambers danced in our heads.

AMOS POE: So now they got the dogs, the whole thing was full of cops, and they immediately arrested my girlfriend. I looked at Cookie and *she* looked nervous and I was like, oh my God, no…

COOKIE MUELLER: I proceeded to melt into the Formica flooring. A puddle of sweat formed around my feet; after all, I was carrying hashish, cocaine, MDA, and opium, of course in small amounts, just tads really, but the variety was sure to turn heads once seized.

AMOS POE: "MDA, cocaine, heroin, pills, everything, you know. I have a drugstore in my bra!" Cookie said to me. "Shit, should I confess?" I said, "No Cookie, don't confess, never confess, let them beat it out of you, don't confess." She was like, "Maybe they'll be lenient with me and only give me 10 years." I said,

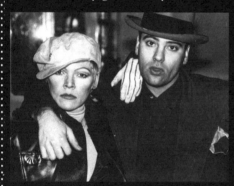

*Susan Tyrell & Amos Poe, 1982*

"Cookie, you can't spend 10 years in jail. *Don't confess!*"

COOKIE MUELLER: I wanted to confess, throw in the towel, but the whimpers stuck in my throat. My vocal chords froze in terror and I could only smile like Louis XVI on the guillotine gangplank. With the marble grin of an idiot, I stood there, goose pimples of horror rising on my flesh as the buxom bulldyke cop in full torture drag appeared…

AMOS POE: They brought in this policewoman, and I said, "Cookie, they're going to take you in there and strip-search you, and I think they're dykes, so what you should do is take off everything but your bra and be standing completely naked in front of her and at the very last second, take your bra off and just whip it into the corner. They'll be thinking of something else—they can't help it—just reverse the order of bra and panties. Bra last! Trust me on this one. It's the only way."

COOKIE MUELLER: In the private room, I began to disrobe. Employing cold-weather habits of fashionable bag ladies, and to cut down on the bulk of my suitcase, I was wearing most of the clothes I brought: tights, leg warmers, over-the-knee boots, a dress, two sweaters, a vest, a leather jacket, various fur pieces, and a long black coat. It was hell for her. She had to painstakingly inspect every item. She fingered every hemline, felt every bulge, probed the hairs on the endangered-species fur. She even dismantled my spike heels.

One can only imagine the state I was in. A more stressful situation was difficult to conjure. The sweat was ridiculous.

Remember now that the stash was in my bra. It was no sloppy job. Back in New York I had carefully sliced open one of the seams above the gargantuan tit pads. Between the boob-contoured double foams I had deftly placed in a plastic Ziploc bag—all the personal needs of an underground film star.

Right before I removed my bra I realized that this big woman was watching me very intently. I was but a slip of a thing at the time, certainly unwieldy and so top-heavy with those huge fake knockers.

I took off the bra and my pitiful boobs hopped out. They must have looked pretty sad compared to the bra and all its womanly glory.

She looked at my chest, and she looked at the bra, and I noticed a hint of female compassion there. She felt sorry for me, sorry that I should have exposed my secret to her. My secret of little tits.

In deference to me, in pure sympathy, and not to humiliate me any further, she didn't touch the bra.

AMOS POE: 10 minutes later Cookie comes out of the room and she's jumping up and down. So now what happens is they say Cookie and I can go on to Berlin, but my girlfriend has to be deported back to New York via Paris. So I say to Cookie, "You go ahead and I'll stay with my girlfriend until this gets sorted out."

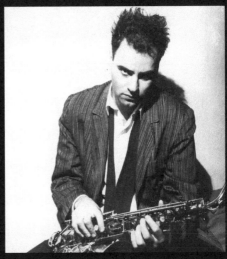

*Amos Poe on the set of* Subway Riders, *1981*

So I had to catch the last plane to Berlin. I'd been up forever. I get to the hotel, I go to the desk, "What's your name, blah blah, oh, your wife is up there and she has the key." All right, so I go up there and the door is open, but I can't push it open because Cookie is lying on the floor, face down, passed out. So I finally get in and go, "Cookie, are you alive?" She's like barely breathing and I take her fully clothed into the bathroom, turn on the shower, and put her in the cold water. She comes out and she says, "I thought they were gonna check my bra again in Berlin, so I ate everything that was in my bra on the plane from Munich." So she had all these drugs in her. When she got

*Polizei und Hund*

145

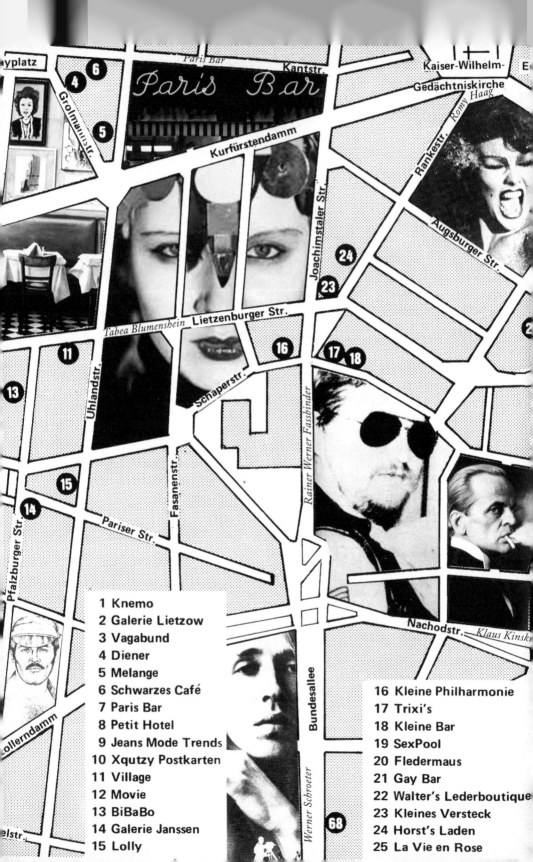

Paris Bar

Kant str.

Kaiser-Wilhelm-
Gedächtniskirche

Paris Bar

Grolmanstr.

Kurfürstendamm

Rankestr. — Romy Haag

Joachimstaler Str.

Augsburger Str.

Tabea Blumenshein — Lietzenburger Str.

Uhlandstr.

Schaperstr.

Fasanenstr.

Rainer Werner Fassbinder

Pariser Str.

Pfalzburger Str.

Bundesallee

Nachodstr. — Klaus Kinski

ollerndamm

Werner Schroeter

1 Knemo
2 Galerie Lietzow
3 Vagabund
4 Diener
5 Melange
6 Schwarzes Café
7 Paris Bar
8 Petit Hotel
9 Jeans Mode Trends
10 Xqutzy Postkarten
11 Village
12 Movie
13 BiBaBo
14 Galerie Janssen
15 Lolly

16 Kleine Philharmonie
17 Trixi's
18 Kleine Bar
19 SexPool
20 Fledermaus
21 Gay Bar
22 Walter's Lederboutique
23 Kleines Versteck
24 Horst's Laden
25 La Vie en Rose

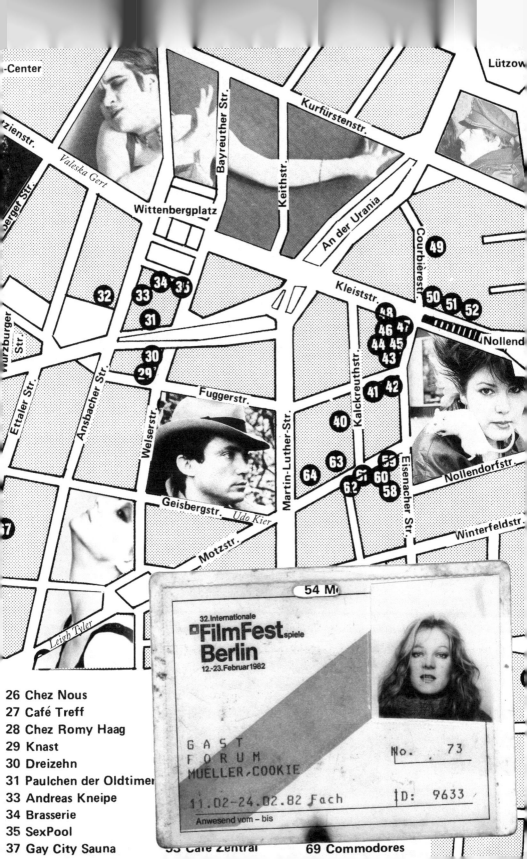

-Center

Lützow

Kurfürstenstr.

Bayreuther Str.

Keithstr.

An der Urania

Courbièrestr.

 \-zienstr.

Valeska Gert

\-berger Str.

Wittenbergplatz

Nollend

Nollendorfstr.

Kleiststr.

**32**
**33** **34** **35**
**31**

**49**

**50** **51** **52**

**48**
**46** **47**
**44** **45**
**43**

Würzburger Str.

**30**
**29'**

Fuggerstr.

Welserstr.

Ansbacher Str.

Ettaler Str.

**41** **42**

Kalckreuthstr.

Martin-Luther-Str.

**40**

Geisbergstr.   Udo Kier

Motzstr.

Winterfeldstr.

Eisenacher Str.

**64**   **63**

**59**
**61**
**60**
**62**   **58**

**7**

Leigh Tyler

54 M

26 Chez Nous
27 Café Treff
28 Chez Romy Haag
29 Knast
30 Dreizehn
31 Paulchen der Oldtimer
33 Andreas Kneipe
34 Brasserie
35 SexPool
37 Gay City Sauna

53 Café Zentral   69 Commodores

to the room she fell on her face—she had this bump on her forehead. I was like, "Cookie, you took all that stuff? At once?" She goes, "Yeah, oh my God," and then suddenly she's really awake, and she goes, "What time is it?" It was around 12:30 a.m., and she said, "There's a party we gotta get to—come on!" "Come on, Cookie, you're dead." But I had to drag her, wet clothes and everything, to this party.

COOKIE MUELLER: I met all the German film stars, people I'd always wanted to have beers with: Udo Kier, Bruno Ganz, Klaus Kinski, and the German filmmakers, the ones I'd mentioned before. I was in Aryan heaven.

UDO KIER: The first impression was of course that she was funny and intelligent and a great person. We were introduced at the Paris Bar, which was—well, it still is—a restaurant where everybody went after the films. She knew me from Andy Warhol's movies and she liked me; I mean she liked the movies. We exchanged addresses and she sent me an article she wrote about the festival in Berlin where she met me.

COOKIE MUELLER: I became fast friends with Udo Kier, star of Warhol/Morrissey's *Dracula* and *Frankenstein*, star of Fassbinder films, and I fell in love with Tabea Blumenschein, a woman who was Berlin's underground celebrity film queen. I spent a lot of time with Udo and Tabea at Tabea's home when we weren't at a screening of a film during the day or at a festival party at night.

UDO KIER: She met Tabea because Tabea made movies with Ulrike Ottinger during that period which were very—over the top

*Tabea Blumenshein als Junger Vogel, film still from* Die Betörung der blauen Matrosen, *Sylt, 1975*

is the wrong phrase—very avant-garde, very different. Tabea was an amazing woman. I haven't seen her for many, many years, but I loved Tabea because she was always totally… I think cool would be the right word. She was blonde, wore a lot of makeup. I mean, she was very similar to Cookie and maybe that's why Cookie liked Tabea. When I went out with Tabea in Berlin she would dress totally different than other girls. Very, very independent, and I think that's why Cookie liked her.

AMOS POE: Cookie met this German girl who she ended up having an affair with at that party. An actress, really beautiful, and then she ended up staying with her, so I was at the hotel the whole week making phone calls to my girlfriend in Paris, and then I left the morning after the film screened.

COOKIE MUELLER: Three days before the end of the festival, I ran into Udo at the festival headquarters.

"You better get out of your hotel room and move the rest of your things into Tabea's, Amos has left the hotel room and gone on to Paris. There's some problem with your bill," Udo said.

"What do you mean… some problems with the bill? The festival pays the hotel bill," I said, but nevertheless I had visions of going to the gas chambers again.

UDO KIER: And then the bill was very high and she had to climb over the wall and leave.

AMOS POE: Cookie came back to the room to get her stuff and they said, "Well, here's the bill for the phone," and it was like $1,000, and she said, "You know what, that's not my phone bill." They told her she couldn't leave, so she went back up to the room, tied some sheets together, climbed out the window, threw her bag down, and climbed over a bunch of walls.

COOKIE MUELLER: …I threw my heavy bag over the wire mesh fence and scaled it, ripping my blue leather skirt up to the hip on the barbs at the top, while the fence wobbled with my weight. I jumped down and then looked at the wall. What the hell was I going to do? I could use the ivy plants to climb the wall only if they were older plants with thick vines.

I quickly did some horticultural investigations and figured the vines were just old enough, so I threw the bag over the side. That took a few tries, and when I finally got it over I didn't hear it hit the ground on the other side for a very long time. That wasn't great. Once I was on top of the wall, where would I be?

I started up the vines and halfway I had to take off my boots and throw them over. It was easier in stocking feet.

AMOS POE: She almost climbed over to East Berlin.

COOKIE MUELLER: While driving to Tabea's flat, I was thinking about how I was going to strangle Amos Poe when I got back to the States.

"Cookie, what happened to you?" Tabea asked, laughing, as she let me in the door. She was frying up some sausages while the music of Wagner was blaring on the radio.

"I just climbed the Berlin Wall."

Inherited

CHROMO-SOMES

BALTIMORE

1949-1967

# Inherited Chromosomes
## BALTIMORE 1949 - 1967

 DOROTHY KAREN MUELLER

*"At home in the quasi-country lands of Baltimore County I would spend idle summer months in the woods behind my parents' house. In these woods was a strange railroad track, where a mystery train passed through a tunnel of trees and vines twice a day, once at 1 p.m. and then again in the opposite direction at 3 p.m. I would climb a steep hill which sat right on the tracks and I would look down into the smokestack and always the black smoke would settle on my white clamdiggers."*

—Cookie Mueller, "My Bio—Notes on an American Childhood," *Walking Through Clear Water in a Pool Painted Black*

JUDY (MUELLER) HULL: As a child, Cookie was always so inventive. She came up with these great ideas for games. We played cowboys and Indians; I was always the Lone Ranger and she was Tonto.

We both loved animals: dogs, cats, horses, baby birds. We had a dog that was part Chow and part Irish Setter. When Cookie was about seven, my mom bought her a baby alligator. One day my sister decided to put it in the bathtub. Unfortunately the water was too cold for it and it didn't survive the experience.

JAMES BENNETT: I saw home movies of Cookie when she was a little girl. She showed them on the wall at Bleecker Street one day on old 8mm film.

MAX MUELLER: They're on the beach at Ocean City. There's a party at the house. You know, normal things. It's a silent film. She's really young in the film. She was small. It was the '50s.

JUDY (MUELLER) HULL: Our mom came from a really poor family and wanted more than anything else to raise herself up out of that and almost reinvent herself. She didn't want to see herself as poor.

She was born in North Carolina and her dad was a waterman, had a boat and fished. Her mom was 15 when she got married to my grandfather and they had 11 kids. My mom was the fourth in line. They moved to Baltimore when she was, I don't know, maybe five or six.

Our grandmother died when I was about 12. We would go over to her house and she never had any toys. Her house was really small and as a child I remember my impression of it was that everything was grey. Just no color. She looked so different from my mom; she never wore makeup, never did her hair. She just wore housedresses, she was really poor, and it was like a different world.

SHARON NIESP: I met Cookie's mother a couple times when we went for Christmas to Catonsville, which is a suburb of Baltimore where everything looks the same. The mother

152        *Previous pages: the Muellers' Christmas, Catonsville, 1951*

gave us the master bedroom to stay in, and in the morning we had to get up and everybody always had to be active. You always had to be active in the Mueller house—no time for rest. She made us march around the Christmas tree!

MAX MUELLER: Christmas day was a traditional thing. Stockings and a tree. I would get Star Wars stuff and books and video games. It would be me, my mom, Sharon, my aunt Judy, her husband, and my cousin Ike. My grandmother was always nice. She always fed me a lot. She used to give me the old school candies, ribbon candies... and marzipan. I couldn't stand it, but she always used to give it to me.

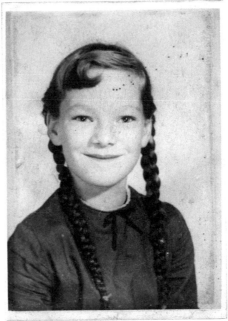

SCOTT COVERT: Cookie, Max, a friend, and I went to Baltimore together, a day trip. We went to Cookie's mother's house to pick up her grandmother's desk. Her mother was selling the house she grew up in. She was a sweet old lady, a dear lady. Really nice and smart, the wisdom of a woman, a homemaker. Very keen that way, a survivalist. It was a nicely kept house and garden.

JUDY (MUELLER) HULL: Our dad was born in Baltimore, and his family had more money. He was an only child and his mom died when he was nine. His father remarried and his stepmother was never very warm. He was quiet and private. My mom was the one who was real outgoing. She had a lot of friends and she was the one who always would plan the parties. He enjoyed making the drinks and he always went along with it, but was a fairly shy guy.

I wondered sometimes... he was nine years older than my mom and he had a job, a good job, when they married. Sometimes I wonder whether—I don't know if I should say this—she really was in love with him or if she just wanted to make herself over again, start afresh, away from her family. Because what she became was entirely different from her own family.

It was a time where people were becoming more affluent after the Second World War and they were buying houses and having kids and they wanted to see themselves as a part of a new generation. Having more money and being able to buy a car and have a lifestyle that was pretty glamorous.

MAX MUELLER: My grandfather seemed old and a little feeble. He always used to take me down to the basement where he had a train set with all the little parts, the buildings and town stuff.

JOHN WATERS: Cookie's father had a terrible accident and he died. The emergency brake went off in the car and it ran him over or something hideous.

SHARON NIESP: Cookies' father... he didn't say much. He sat and watched TV and read the paper. Cookie's sister Judy lives in Annapolis and is married to a former corrections officer. I guess they go sailing. She's a very gentle and sweet person. The mother was a very glamorous Southern belle when she was young. Then, unfortunately, Cookie had an older brother who one Easter Sunday didn't go to church with them and was climbing a tree and fell and died. The mother just completely

went grey. I saw home movies of her before and after and she just kind of shut down or something.

JUDY (MUELLER) HULL: Michael was seven years older than I was. He was 14 when he was killed. Cookie was the baby in the family and sometimes he felt like she got left out, and my mom would say, usually to me, "Stay with your sister, make sure your sister goes with you, make sure you take her to play," and sometimes I would be like, "I don't wanna take her"—you know how little kids are—and my brother would scoop her up and say, "Come on little Cookie."

It was terrible. My mom said it was the worst thing that ever happened to her in her whole life. That nothing else was ever as bad as that.

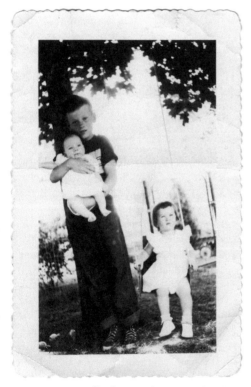

PATRICK FOX: Cookie used to say that her mother used to say, "If you're depressed, dye your hair."

SHARON NIESP: Cookie's name was Dorothy Karen, but her sister couldn't pronounce Karen, so they nicknamed her Cookie.

MAX MUELLER: Her brother used to call her Cookie. That was how she got her nickname.

SHARON NIESP: Cookie never really got along with her mom. But then of course the lifestyle that she wanted to lead, her mother didn't approve of it. She used to call John Waters Beelzebub. "Beelzebub called you today, Karen."

JOHN WATERS: She called me Beelzebub because she found the script from *Pink Flamingos* that said, "Cookie fucks a chicken." Well, I don't blame her. Later, I don't think she hated me because I had some kind of success. That, unfortunately, makes you even madder, when people only like you because of that. I had success *because* Cookie fucks chicken! It wasn't like suddenly I became a Mormon! I think the mother was perplexed, too, since Cookie really didn't include her. The mother knew nothing about Cookie's life, basically. Or Max, or anything.

JUDY (MUELLER) HULL: I know this sounds really lame but I never saw my sister's apartment in New York until after she was sick. She had never invited me and I thought maybe she thought I would disapprove of her lifestyle or something. I don't know why she didn't. I guess we just had different lives. And I never even asked to go or anything. My mom would

tell me things like, "She's living in Provincetown, she's in New York, she's gone to Italy."

DOLORES DELUXE: I remember Cookie floating

that "My sister's a lesbian, it's a family crisis" moment, but I remember hearing later that she got married—to a man. Which doesn't say that being a lesbian and being married to a man aren't compatible, I'm just saying that it was the classic, "Oh, your parents are scrooges and my parents are scrooges and we just want to have fun and do what kids do and they're not letting us so now we're just going to have to leave them behind because they live in a boring suburban world." I didn't know her parents that well and I only met her sister once.

GARY INDIANA: Having come from a quite similar background myself, I know Cookie did the best she could with what she had to operate with. Cookie's family was an incredibly straight, punitive family. They didn't like anything she did—you can see it all in John Waters's early films. They weren't the worst people in the world, but she wanted something else, she always wanted something more, to break out of that niche of the family.

JOHN WATERS: This is a terrible story, but

Cookie told me when she went for Christmas her mother said, "Well, stand up when you open your presents. No wonder you don't have any money!" Everyone else was sitting down and she had to stand to open her presents. That kind of thing is funny in a movie, but not in real life!

JUDY (MUELLER) HULL: My mom was a real—let me see how would I describe her—she was really the dominant one in the household. She had certain things she didn't want us to do and certain things we could do and I always toed the line and my sister would rebel and fight her and do the opposite. She did that her whole life, pretty much.

The first day of first grade, my mom had done her hair and put it in braids, and she had her nice dress on—a pretty dress, all ironed—and she got on the bus. When the bus came home that afternoon, Cookie wasn't on it. My mom was like, "Oh my God, where's Cookie!" Well, an hour later, here she comes, and this is when my mom was getting ready

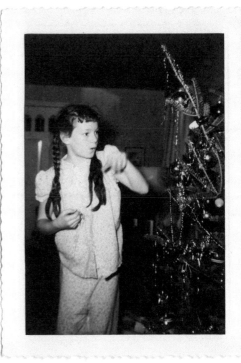

*Cookie's father, Baltimore, c. 1935*

*Cookie, c. 1959*

to call the police. She had decided to walk home by herself, and her hair was all out of her pigtails and her dress was dirty and wrinkled. She was fine, she had just decided she wanted to walk home, that's it. So she did. That was her, you could probably define her by that. If she decided she wanted to walk home, that was what she was going to do.

LINDA OLGEIRSON: One time, we all drove down to Baltimore from Provincetown, and Cookie calls her parents from the Jersey Turnpike to say she was on her way home and would be there in a couple of hours. But when we got to her house, her parents had left. She had to break into her own house. And we were all saying, "Just come with us," but she

said, "No, I'm sure they'll be back soon. I'll just go and ask the neighbors if they have a spare key or something." She had called to say she'd be there and now all the lights were off, the door was locked... I just thought that was so sad. We should have taken her with us

and not left her on the front lawn, but I think she found a window and crawled in.

GARY INDIANA: Her parents were not sympathetic, and it's not so unusual for an American family to be dysfunctional in that way. In fact, it's the normal thing.

JUDY (MUELLER) HULL: When Cookie was younger, my mom always, it seemed to me, admired her and inspired her and encouraged her to be creative and to pursue her ideas and her activities and her creativity. Then, when she started to get more rebellious—around 12, 13—that's when my mom and dad had a hard time with her. It would drive my dad *nuts*. He became really exasperated. My mom felt like she had no control over her at all. Every day would be a blowup.

*Left: Cookie, c. 1958; top right: Cookie at 16yrs old, 1965; opposite: Cookie, c. 1962*

**Baltimore County High Schools**
**EXCUSE FOR TARDINESS**

*Karen Mueller 10 K*
(Name of pupil)

I was tardy_____ minutes on_____Date_____ A.M. P.M.

The reason for the tardiness was_____

'65 MAR 3 AM 9:12

Excused?_____Vice-Principal

The last teacher signing will take up and return this excuse to the office for filing

Period                    Teacher's Signature

BEBCO 16-58

## CATONSVILLE HIGH

*"For appearances, we were best girlfriends, both of us with our combustible hairdos, sprayed with lacquer and teased high as possible. We wore the tightest black skirts... so tight that they hobbled us... black stockings, white blouses with ruffles at the neck and cuffs, pointy bras underneath and five-inch spike heels. With these shoes, and the hair, we were the tallest people in the school. Lesser women than we would have become acrophobic. We made people dizzy when they saw us."*

—Cookie Mueller, "Two People—Baltimore, 1964,"
*Walking Through Clear Water in a Pool Painted Black*

ROBERTA BLATTAU: Catonsville, at that time, was mostly middle-class and upper-middle-class families, predominantly white, but we did have a small black population. So, Catonsville High was predominately a white middle-class typical high school.

ERIC LAFON: We were friends, we would hang out together. We smoked pot. When flower power came out in the '60s, like the tie-dyes and things like that, she would be the first to take that and add to it, to be a little more outrageous. *Very* free spirited. She didn't care about ethnic background, race, if you were a nerd or a bookworm. It was all the same to her, she always just looked at people for their personality and how they treated her.

JUDY (MUELLER) HULL: I remember she always felt sorry for the underdog and for what most people in those days considered abnormal. She was obsessed with the idea of dwarves.

ROBERTA BLATTAU: We had a creative writing class together. She was very quiet. Everybody knew her but I don't know that there were a lot of people who were really close to her. She was kind of introspective.

ERIC LAFON: She was not extremely popular across the board because she was what you would call a little bit odder than some people, especially in the '60s. It was a little bit tougher than it is nowadays as far as being a little bit different from other people. So a lot of people didn't approach her. She might have been a little bit shy or coy or something. A lot of people didn't get to know her because of the way she dressed and the way her hair was— her hair was just always wild and free.

JUDY (MUELLER) HULL: She wore her hair in a

# Catonsville is . . .

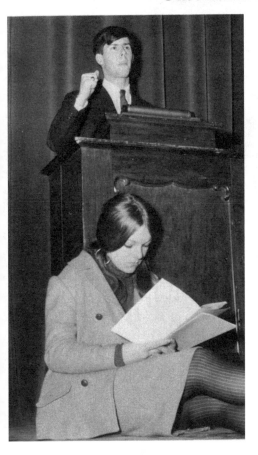

. . . a sweep of lines, blended in brick and ivy.

. . . trees withstanding the passage of time.

. . . a summit view of the city, beckoning, promising.

. . . a call to curiosity, a key of knowledge.

. . . committee conflicts amid extracurricular endeavors.

. . . bell, bustle—the rampage reaction.

. . . confrontation: thought and expression.

. . . friendships resisting time.

. . . "Invincible '67" flashing the invincible ring.

. . . fate shaping a date.

. . . a thousand talents, a thousand clowns.

. . . a personal encounter.

NIEL GORDON MILLER. College Prep; National Honor Society; sembly (10), Publicity (11), Decorations (10, 11), Social (11) mmittees; *Gargoyle*; band (11), orchestra (10), woodwind quintet , 11, 12); Varsity tennis (11). "Dan" . . . swimming, tennis, logy, chemistry, soccer; future—college.

HARD GORDON MILLER. College Prep; Student Council resentative (11); homeroom president (11); Decorations (10, 11) mmittees; gym assistant; J.V. basketball (10); Varsity tennis (10, 12); J.V. soccer (11); basketball intramurals (10). "Richard" . sports, photography, sports for youth; future—college; engi-ring.

BERTA LOIS MILLER. College Prep; homeroom secretary (12); d Committee (11, 12). "Robbie" . . . writing, sewing; future—onsville Community College . . . *I don't believe it!* . . . Champs . Amechie's.

SHEILA MARIE MILLER. General. "Sheila" . . . dancing, art, sports; future—secretarial job, night school . . . *Paint it black!*
WILLIAM JOHN MILLER. General. "Bill" . . . girls, cars, guitars; future—Air Force . . . *Let it all hang out!*
VINCENT JAMES MILLS. General. "Vince" . . . drag racing, scuba diving, girls; future—U.S. Coast Guard . . . *Paradise!*

PAULA FRANCES MIRABILE. Senior Council representative; Band (12), Special (12), Kay-Card (10, 11, 12) Committees; basketball intramurals (12). "Paula" . . . music, gardening; future—Catonsville Community College.
DEBORAH ANN MOORE. College Prep; National Honor Society; girls chorus (11), "Debbie" . . . art, guitar, skiing, boating, dancing; future—college.

GARY LEE MOORE. College Prep; homeroom treasurer (12). "Gary" . . . folk music, cars, boats; future—college . . . *Right!*
RHODA JEAN MOORE. Commercial; J.V. basketball (10); J.V. (11), Varsity (12) soft-ball; basketball intramurals (12). "Rhoda" . . . water skiing, bowling, horseback riding; future—college.

PHEN JOHN MOREA. General. "Steve" . . . cars, girls, good s; future—undecided.
ORAH GAIL MORGAN. College Prep; National Honor Society; dent-Council (12), Junior Council representatives; homeroom vice-sident (11), Kay-Card (12), Athletic (12) Committees; band (10, 12), orchestra (10, 11, 12); G.A.A.; J.V., Varsity hockey; J.V., sity basketball; J.V., Varsity softball. "Debbie" . . . music, rts, sewing; future—college.
RISTINE LOUISE MORNINGSTAR. College Prep. "Chris" . . . sing, boating, happiness; future—registered nurse.

KAREN ANN MORRIS. College Prep; Social Committee (10); girls chorus (10), choir (11, 12); stage crew (11). "Karen" . . . horse-back riding, swimming, animals; future—veternarian.
LINDA LEONA MORRIS. College Prep; homeroom vice-president (10), chorale (10, 11, 12), choir (11, 12), girls chorus (10). "Linda" . . . dancing, singing, writing; future—beautician school . . . *No matter how great you become, there is always someone greater.*
MARY ANN MOTSKO. Commercial; homeroom secretary (10); G.A.A.; J.V. (10), Varsity (11, 12) volleyball. "Mots" . . . swim-ming, skin diving, dancing; future—junior college; airline stewardess.

# . . . privileged

KAREN DOROTHY MUELLER. College Prep. "Cookie" . . . people, writing, art, modern jazz; future—college . . . Champs . . . Amechie's . . . *Really nice!*

JASCA ROSE MULLEN. College Prep; National Honor Society; Student Council representative (12); homeroom president (12); orchestra (10, 11, 12); basketball (12), volleyball (10, 12) intramurals. "Jackie" . . . politics, music, sports; future—undecided . . . *Smile if it kills you, and you'll die with a grin on your face.*

DIANE FRANCES MURPHY. College Prep; National Honor Society; Senior Council representative; Decorations (12), Refreshments (12), Favors (12) Committees; Drama Club. "Murph" . . . knitting, art, swimming, science; future—college; premedical.

PAMELA JOAN MURPHY. Commercial. "Pam" . . . cooking, sports, outdoors; future—photographer; work . . . *All right!*

RONALD MICHAEL MURPHY. College Prep; J.V. (10, 11), Varsity (12) soccer; J.V. basketball (10, 11). "Murph" . . . sports, metal work, wood work, cars; future—college; work . . . *Girls come to boys who go after them.*

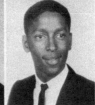

JOHN DAVID MURRAY. College Prep; National Honor Society; homeroom treasurer (11); Social (11), Program (11) Committees; band (10, 11, 12), orchestra (12), dance band (12); J.V. track (11). "Dave" . . . football, music, cars, science; future—college . . . *Oh, yeah!*

PATRICIA ANN MURRAY. Commercial; assembly monitor (12); volleyball intramurals (10). "Pat" . . . swimming, dancing, music; future—secretarial work; stenographer.

CHARD LEE NASH . . . College Prep; J.V. wrestling (10); rosse intramurals (10). "Rick" . . . hunting, cars, guns; future unior college; State Police.

BERT MICHAEL NEUBERTH. College Prep; Varsity football ); Varsity track (10, 11); basketball (9, 11), football (9), soft-l (10, 11) intramurals. "Bob" . . . girls, cars, football; future M.B.C.; Johns Hopkins University; electrical engineer.

BORAH ANN NEUS. Commercial; Social (10), Tickets (10) mmittees; Drama Club. "Debby" . . . music, dancing, drama; ure—secretary.

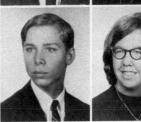

ENISE JOAN NEW. College Prep; basketball intramurals (10). enise" . . . water skiing, snow skiing, horseback riding; future unior college; nursing.

MES THOMAS NICHOLS. General; basketball intramurals. om" . . . stereo testing, pool, cars; future—college; Air Force.

BERT LEWIS NICHOLS. College Prep; Social Committee (10, ); Folk Club. "Bob" . . . stereo, swimming, movies; future— llege . . . *RIGHT!*

72

beehive; do you know what that looks like? My sister would do her hair up like that, and she always wore *a lot* of eye make-up and she wore white lipstick, or really pale lipstick, which was the fashion then. This is probably '61.

ROBERTA BLATTAU: We wore short skirts and long hair was the style, straight long hair. I was just talking to my girlfriend who knew Cookie, and her memory was that she and Cookie both wore thick black eyeliner. She remembers Cookie telling her that the reason why she wore the black eyeliner was because she thought her eyes were too small for her face, just like my girlfriend's!

ERIC LAFON: She'd have ribbons in her hair and hold it back sometimes... well, not ribbons but scarves and that kind of thing. Always a bright color. She was always on the edge with design and things like that. She was comfortable in her own skin that way. You either accepted her or you didn't, and if you accepted her, that's fine she'd accept you. If you didn't, that was fine with her too.

ROBERTA BLATTAU: The local hangout was an old drive-in restaurant called Champs. It's not there anymore, it burned down.

ERIC LAFON: People on roller skates would come to your car; carhops, they called them. Every Friday and Saturday night that was what everybody did. You'd drive around in a constant circle.

DOLORES DELUXE: Champs and Varsity. I think Champs was the one where we all acted out in cars.

ERIC LAFON: We had this place across the high school called "the cottage." It was an old carriage house, a tiny stone building. That's where everybody would go to cut class. We'd go and have a joint or something. Sometimes there'd be something going on at Dinky Dollars—you'd pay a dollar or two and got a draft beer and a band would play. We weren't old enough but we always went anyway. We saw Paul Revere & the Raiders there for a buck. That was a pretty good deal.

ROBERTA BLATTAU: I'm sure she probably dated but I don't remember her having a steady boyfriend at school or anything.

*Cookie at Catonsville High library, c. 1967*

JUDY (MUELLER) HULL: I remember she had an older boyfriend and she was real serious about him. I always questioned these guys she was with. I was not experimenting, even at that point at my life. I mean I was about 16 and she was 15! And she was already into that by the time she was *13*. Well, I don't know where she met this guy. I don't think he was from school. He was about 16, older than she was.

Do you remember those pictures of Marlon Brando in *On The Waterfront*? He didn't look *that* bad, but he dressed kind of like Jimmy Dean. She always liked guys like that. He was a dark-haired rendition of James Dean, I'd say. She liked guys who were a little bit tough looking. I remember she really liked Robert Mitchum. She liked these actors that to me were like *urhhgg*. She always liked these tough guys.

ERIC LAFON: She knew a lot of guys in school. I know she knew Jack Lippincott. Jack came from a family of means in Catonsville and he died right after we graduated. I think it was heroin that killed him. We had a couple friends like that, Barry Hughes was another one. He kicked the habit and then some guy comes up one day and says, "Hey, I got some of this really good stuff," and of course he was a weak type of guy. Whatever he had, it was bad and it killed them both. I don't know if Cookie did that stuff. It was generally after the fact that you found out that kind of stuff because people were kind of closet users. I know she smoked pot because we did that together, but other than that I couldn't tell you.

JUDY (MUELLER) HULL: She was really smart and really bright and she could write—she always wrote poetry for the magazine. That was where she excelled, but as far as her other studies, she was always sort of a free student. Sometimes she would hook school and I'd have to write notes for her. I would forge my mother's handwriting and write a note saying she was sick! I remember doing that quite frequently when she was a teenager!

ERIC LAFON: She always talked about poetry. I think she wrote some back then but I'm not sure. I seem to remember she liked Emily Dickinson quite a bit.

ROBERTA BLATTAU: They had certain categories that they would chose someone for: "best looking," "best dressed," "most athletic," "most artistic," "most creative," "most likely to succeed," that type of stuff. They would nominate people and then the whole class would vote—a senior class of 540 students—so it was definitely a select few that got it. She got "most expressive."

DOLORES DELUXE: Cookie was very good at mythmaking. She knew that was a part of what she did. To recreate and reinvent yourself, to get to the level that wasn't in the suburbs of Catonsville or Arbutus—eternally in the subdivision. So whatever you did, you put out your legend, because you knew people wouldn't pick you for *you*, they would pick you for this image you could create. It was branding. She was the first person who realized that. We knew about branding and we started to try and do that. Cookie was extremely successful at it in the end. We would walk down the hallways, being in trouble in the junior high, and she would make herself so amused that she would be peeing herself in the hallways. She was the first person I met who just freely peed themselves when they thought something was funny or when they wanted to. It was a part of her—"I'm not going by any rules."

*Cookie's senior yearbook sleeve, 1967*

Cookie Mueller

Karen
One of the nicest
girls I have ever met
at CHS. Best of luck
to you in the future.
Beverly

Cookie,
Best of luck
to you. Well anyway I think
that when you kicked
you know who that's
when we got real
close. And I'm
happy for all of it
it was the most
beautiful thing.
Love,
Diane

Cookie
To a real
cool chick
Lots of luck
always.
Pat.

Lots of luck
to one of the
hippest spacepeople
I know. Hope
to see you a lot this
summer. Phil '67

To Cook
Goodluck
to you & yours in the
future & find the answers
so that you can tell me!
Keep the faith!
Foxhole "68"

Hi. To a real nutty
& clever. Always nuttiness.
Have a swinging summer
and keep cool.
Be good.
Love ya
Sandra
'67

Cookie a real kid.
I'll never have a
sweeter girl than you.
I love your luck
this past year
Ed. because you deserve
it. Always remember
me & our wild Phys. Ed.
Class. Lots of luck always.
Sue '67

DEADLINES

&

New York

1981 - 1988

# DEADLINES
# &
# DIVINE
# DISTRACTIONS

## HOLIDAYS ON BLEECKER

*"All his loyal friends were there, the famous, the infamous, the washouts, the successful rogues, and the types who only have fame after they die. They were the representatives of the New York alternative subculture, the people who went to sleep at dawn. And never held a nine-to-five job because they were too odd looking, or sassy, or over-qualified."*

—Cookie Mueller, "Sam's Party—Lower East Side, NYC, 1979," *Walking Through Clear Water in a Pool Painted Black*

STEVE BUTOW: We didn't see our families—either they were defunct or they lived far away—so we would have big holiday parties together. We were all each other's families.

LINDA YABLONSKY: Every year Cookie would have this Christmas party. She was one of the few people at the time with a child—nobody in our crowd had children, even if they were in couples, and a lot of people were. She was the one with the home, so she had the Christmas party with the tree decorated and lots of presents and a big crown roast or a turkey. Sharon did a lot of cooking and we would have this enormous feast—100 people would come to her party, during which a lot of cocaine was consumed.

JOHN HEYS: I mean, 100 people. How it was possible, I don't know. One of the events of the year,

one of the grand soirees, the *crème de la crème* of downtown. And Francis Ford Coppola.

SARA DRIVER: Francis Coppola came and nobody cared. There wasn't that star thing that there is now, that celebrity thing.

JOHN HEYS: All these people, from Jim Jarmusch, to blah blah blah, whoever—they were there. And Cookie would just, you know, appear out of a packed crowd of people with this tray and on the tray were just like little hors d'oeuvres of cocaine with a straw and you partook of it if you wanted to.

SHARON NIESP: Cookie had a big silver tray and on one side was MDA and on the other side were various different things. She said, "Should I take the whole tray out there? I don't know, what do you think, Shar?" I said, "Yeah, go ahead, it's a party."

AMOS POE: She had a fucking tray of it, like a mountain of powder, and she walked around with it. There were straws all around it and she was offering it to everyone. I'll never forget this. It was very strong stuff; you really didn't want to take very much. You didn't want to take *any* really, but you had to be a good guest.

SHARON NIESP: So nobody really knew what they were taking and everybody had already eaten huge racks of lamb with little crowns on it and big turkeys with sweet potatoes and sweet potato pies. Cookie brought the tray out and everybody was like, "Oh yeah, ha ha, *snort!*" They

*Cookie, Peter Nolan Smith & Klaus Nomi, c. 1979 (Anthony Scibelli)*

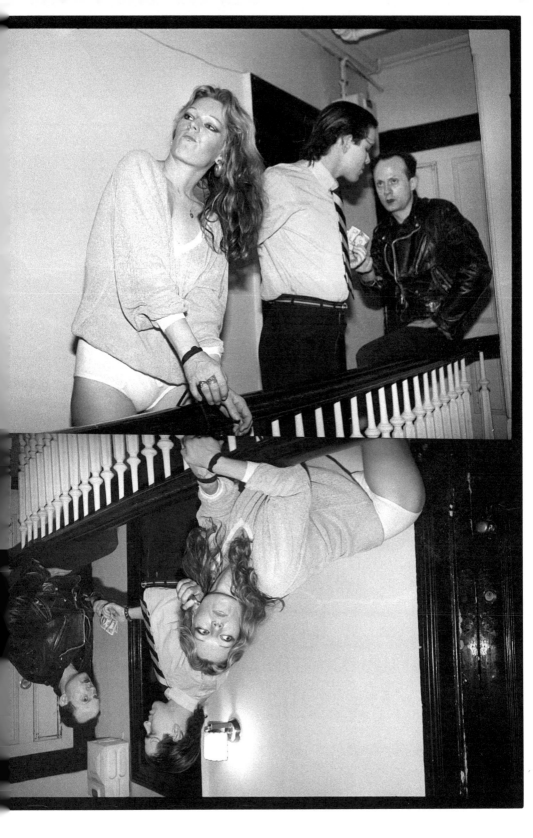

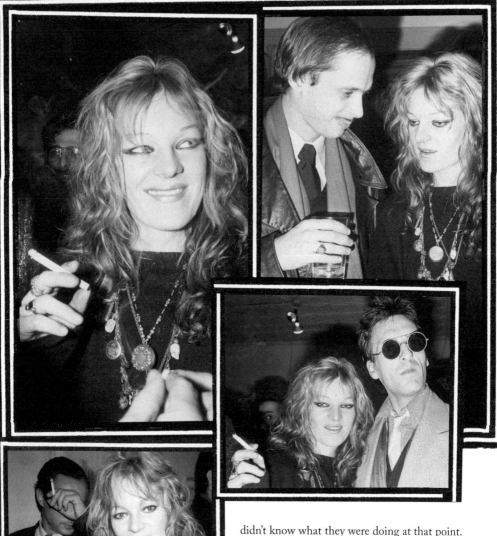

didn't know what they were doing at that point. I think it was Eric Mitchell…

ERIC MITCHELL: So I go into this room and there was this mountain of white powder and I had no clue what was going on. I didn't know whether it was coke or something else, but I started snorting it and, well, fine, nothing much happened. Then slowly it started to happen, so I took some more, and after a while somebody mentioned that it was MDA. So here I'm on the original Ecstasy and had never taken it before. Then all of a sudden it was the apartment of love—people were just looking at each other and feeling this vibe. The way Cookie did it, there was nothing secretive about it. It was just

*Clockwise from top left: Cookie at a party; Cookie & John Waters,*

there for anybody. So I took more, I took more, I took more...

AMOS POE: Eric just filled up his entire brain and walked into the living room and said, "Hey Amos, did you try that stuff? That stuff is great!" Then he puked all over the whole room.

ERIC MITCHELL: My body went into a total convulsion and I vomited everything on the Christmas tree.

SHARON NIESP: Eric Mitchell threw up on Francis Ford Coppola's blue suede shoes. He threw up on his *suede* shoes!

ERIC MITCHELL: I just remember Cookie reacted totally cool. She went, "Oh, don't worry about it hon." but for all the other people it was a total downer. It just went out of me like a cannon. I was not accustomed and I had taken too much—did anyone else tell you this story?

AMOS POE: That was Eric at parties—oh my God.

SHARON NIESP: Steve Mass came in a three-piece suit, and after he left we found his jacket, his vest, and his overcoat. It was a blizzard, the biggest blizzard New York had seen in years. I mean real big, high snowdrifts, and Steve Mass walked out in his shirt he was so loaded, ha! Cookie saw his stuff and went, "Oh my God, he's gonna die in a snowdrift!" So we all had to go out at 4 a.m. and try to find him and nobody could. Turns out he did get a cab and got home, but he had just walked out in the snow blindly because he'd had so much champagne, so much wine, so much vodka, so much everything. Every holiday was wonderful there.

DENNIS DERMODY: I would start running when those things would start happening. I would see Robert Mapplethorpe in full leather regalia... I was scared. I like it on a movie screen, but not in reality. Too much insanity in one small space. And Gregory Corso hung out at Cookies all the time. I couldn't stand him, he was a big loud drunk.

LINDA OLGEIRSON: Gregory Corso was a gentleman. One time we were all hanging out at Cookie's and I was living in lower Manhattan and Gregory Corso took the subway all the way downtown with me to escort me home and then got on the subway and came all the way back.

DENNIS DERMODY: Udo Kier was there a lot too. He would come over and stay for a really long time. One time he came up to John and said, "Why don't you use me in one of your movies?" and John said, "Because you don't have a Baltimore accent!" Udo was like, "I could get one" and John would say, "*No* you can't!"

JAMES BENNETT: Udo Kier... I remember him saying, "I can be a hillbilly" [in heavy German accent].

DENNIS DERMODY: It was a colorful group. But I can't imagine Max growing up in the middle of it.

SHARON NIESP: Cookie just included him. At the parties on Bleecker, Max would work the coat check. He would have his little white jacket on, and people would tip him—ones, fives, and twenties if they were really loaded. "Hey, there you go, kid, here's $20!" One time it was 5:30 a.m. and we couldn't find him. We're frantically looking all over the house—did he wander off? Did he go home with somebody? He was under the coats. He had fallen asleep on the bed, passed out under a big pile of coats. Snoring.

MAX MUELLER: Oh yeah, they were pretty wild parties. I would be the coat check *and* the bartender. It was fun and I made a lot of money. Drunk people like tipping. I must have been like 10, 11, 12 years old because after that point I was a little too old. I started getting into my own things, I wasn't too involved.

STEPHEN MUELLER: They always reminded me of old-movie parties like in *My Sister Eileen*. They were village free-for-all parties. And one time Cookie was desperate, she thought she might have to move. Because we had the same last name, I was supposed to pretend to be her husband or something so she could get another apartment. I guess she didn't have any credit, but I didn't have any either so I don't know what good it would have done.

ERIC MITCHELL: You'd have these people who are really famous and very successful just there at Cookie's. I think it was not only the party, but she was also the connection.

MARINA MELIN: Friends of mine—top

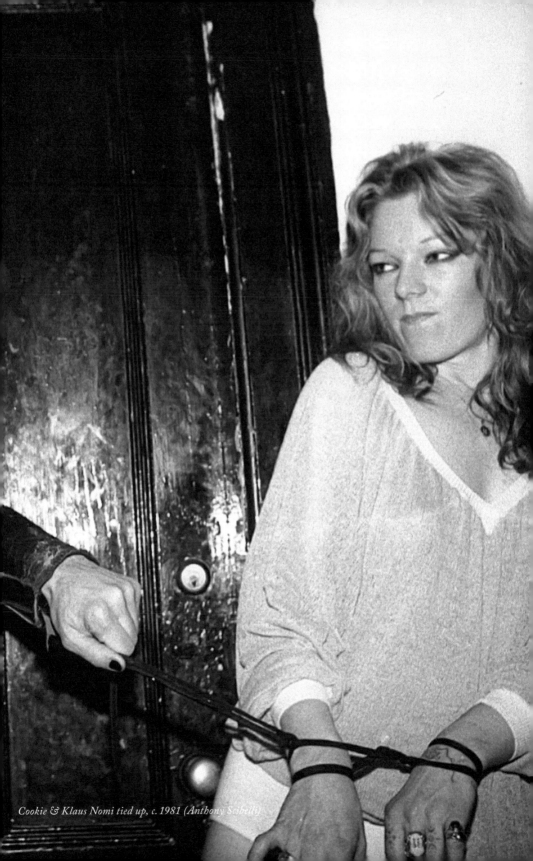

*Cookie & Klaus Nomi tied up, c. 1981 (Anthony Scibelli)*

designers in the fashion field—knew Cookie and were going over to her apartment to buy drugs. I never knew this. Everybody was high all the time and I didn't know that, either.

MARCUS LEATHERDALE: I met Cookie at her apartment in New York when I was about 25. We were buying pot from her, I think. I went there with Robert Mapplethorpe. You could always get what you wanted at Cookie's.

DAVID ARMSTRONG: She really had a salon ambiguous streak, and that was really a part of it, because it was a place where you could go and buy coke and it was always really fun. From 1980 on, she was supporting a lot of elements that she wanted, and was always trying to strike a balance.

LINDA YABLONSKY: She really turned it into a scene. Wallpaper and chandeliers and artwork—her own and other people's—because she was taking artwork as trade for the coke.

JAMES BENNETT: It was funny, I knew two people who dealt coke and they got it from the same source, but the coke you got from Cookie was always so much more fun than the coke you got from the others. It was the exact same stuff, but it was just because of the atmosphere.

MICHAEL OBLOWITZ: Someone told me if I wanted to get some drugs I could get them from Cookie. Of course I wanted to get some drugs, so I got them from Cookie. We became really friendly, we just got along well and I always thought she was really sexy and mysterious. She would wear black leather and even though I was really young I could tell just by meeting her she was into really hardcore stuff and it fascinated me. And she was friends with Max Blagg, the poet. I would come over there and we'd hang out, we'd party, we'd do drugs. And she was always writing. She had somehow crossed this bridge between decadence and poetry; she was like a female Rimbaud.

DENNIS DERMODY: I used to come up from Ptown every fall for the New York Film Festival and stay at Cookie's apartment on Bleecker Street and go to all the films.

That was during the big Fassbinder years, when those movies like *Despair* and *In a Year With 13 Moons* were playing in film festivals, and I remember one day she said, "Oh, a German dude is gonna buy some MDA and I'm leaving it here." I said, "I hate doing that stuff. I'm just here to see movies!" She said, "He'll just pick it up, it'll be fine, it's already been taken care of, we're going out." So the doorbell rang, and it was Fassbinder and his friend. He was here for *Despair* I think, and he was too paranoid to come upstairs so he sent up his friend, who I recognized from the movies. I said, "Oh my God, you're the guy who played the cute boyfriend in *Fox and His Friends*," and he said, "We just finished making *In a Year With 13 Moons* and it's gonna be great." Fassbinder was too uptight to come up the stairs—he was hiding down the hallway. But then he showed up at the film festival the next day as high as a kite, and I said, "Thanks Cookie! It's your rotten MDA!"

## MOTHERHOOD

*"I have a twelve-year-old son, who I believe has taught me the most."*

—Cookie Mueller, "Cookie Mueller," *Garden of Ashes*

JOHN WATERS: Some would maybe balk at Cookie as a mother. Sometimes she was a little bit lax about getting him to school on time. Max used to sell coke to Fassbinder downstairs. He was in *Pink Flamingos* as the little baby in the pit. He certainly had a very untraditional upbringing, but I think it made him a gentle person. I think Cookie did the best she could. She really loved him. They were touching together.

MAX MUELLER: I was freaked out by John's films. I was about four when *Female Trouble* came out.

SHARON NIESP: There's a story about when Cookie was at John Waters's house for Thanksgiving or Christmas and she put him in a drawer to sleep. She put Max in an open drawer, all comfortable, and John was like, "Oh my God!" and John's grandmother from the old days said, "You know, in World War I we quite often would put our babies in the drawer. There was nowhere else to put them."

JUDY (MUELLER) HULL: Cookie would bring Max for Christmas. He was very quiet and he was never any trouble. He was always really sweet actually, never a brat or anything at all.

JOHN HEYS: I would attribute Max's attitude or his behavior, his outward comportment let's say, to the fact that he lived in this small apartment with Cookie. The normal living situation was the doorbell ringing constantly, Cookie dealing coke, the phone ringing constantly, and there was Sharon's presence, the dog, so many people, some of whom would drop in just for a visit, others to pick up and go, others to stay and do blow. So this was all just like a regular thing for him, I think.

PATRICK FOX: He would integrate, but he would also isolate in his room to some degree. It didn't seem like he was particularly comfortable around a lot of it. I mean he was a kid, he was really young at that point.

MAX MUELLER: See, I didn't know anything about that business until I was older, a teenager, like when I started smoking pot and realizing what drugs were.

MARK BAKER: I remember one time in the early '80s—and I don't want to spill this too badly because I'm writing a book called *Celebrity Table Talk* myself—Max called me up and said, "Hey, come on over," and I can hear Cookie screaming in the background. So I did, and I remember Max took me into the back kitchen and said, "Mom's cooking," and she's there cooking spinach with this really odd look on her face. So I asked her what's up and she said, "I think Keith Richards is dead in the living room!" She thought she might have killed Keith Richards accidentally! Probably some illicit substance that had gone hideously awry!

PETER KOPER: Max was surrounded by all kinds of crazy people. That household was *chaotic*, let's put it that way. But it was not for want of loving Max, it's just that she was incapable of normal behavior. Cookie never wore a watch, she didn't know what time it was. That was Cookie. It's this side of her.

MARK BAKER: He was darling and rambunctious but shy. Very good-natured, always minded his mommy. He could get into mischief just like any young boy. He had some cowboy motif clothing, you know like really nice plaid shirts and suspenders and there was a little cowboy hat every once in a while. Really great head of hair. And he loved the dog, Beauty, who was around for years. It's ridiculous to say he had a normal childhood in the structure Cookie was working with, and yet he did.

MAX MUELLER: I remember a birthday party when I was in the fourth grade. I had my friends over and we would run around the house with little plastic fake guns.

PETER KOPER: Beauty was always with her, Beauty and Max. She smuggled Beauty around in a purse a lot. So Beauty would be sticking her head out of some kind of big satchel or purse that Cookie was carrying around. She didn't really walk Beauty; I'm pretty sure

*Cookie cooking, 1980 (Billy Sullivan)*

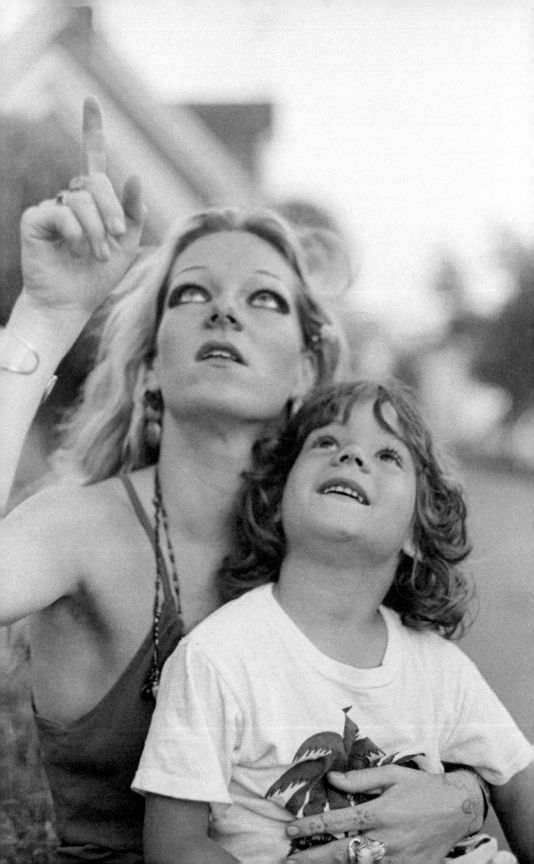

Beauty probably just shat and pissed in the apartment. She loved Beauty.

JOHN WATERS: I came to stay at their apartment in New York and found their dog dead there. It was July 4th and we couldn't get the dog removed. Gary Indiana and I are sitting there with a dead dog! That's a story that seems like it would be in one of her books. I got there and it was just dead! And then we couldn't get rid of it—you can't get a dead dog removed on July 4th weekend. Try it. I think we just covered it and left it for the weekend or something hideous. It was too big to fit in the freezer.

MAX MUELLER: We got Beauty from Jackie Curtis. She was raised in a bar so she loved beer and pretzels. After Beauty died we got Topo, which means mouse in Italian.

SCOTT COVERT: I have a wonderful story about Topo, Cookie's last dog after Beauty. When they first got him, Max brought him up on the roof because he used to take Beauty up there. So Max took Topo up there and Topo jumped or fell off the roof. Cookie was in the shower, and Max starts screaming downstairs and Cookie calls me—she lived above Ottomanelli, the butcher shop, and I lived above DiSalvio, the bakery. I went flying over there to see Cookie in her bathrobe with soap in her hair, looking for her dog on Bleecker Street. Ottomanelli actually came out and said, "Your dog is dead in the back," and we went flying into the back. Cookie screamed, "Topo!" and the dog jumped up and ran to her. I felt I had experienced a miracle when I saw that. That's a true story about Cookie Mueller and that's how things always were around Cookie Mueller.

SHARON NIESP: Cookie would say, "Anything that lives in here has to make it on its own or forget it." And she had a lot of plants, she loved plants. She had fish and an aquarium—what a drudge. It was always like, "Oh, God, I've gotta clean the fish tank."

PETER KOPER: So she had this kind of domestic structure. Sharon was the father, Cookie was the mom, Max was the kid, and then there was the dog. Perfect suburban family!

SUSAN LOWE: He had a very interesting life as a child, I think, because Cookie took him to a lot of weird, good things. He traveled around with Cookie, and I kind of wish his father was more in the picture, because Max was around a bunch of hags like me, Sharon, and Cookie all the time.

MAX MUELLER: I didn't have any friends when we moved to New York. I was really young and always scared and needy. When I was seven, eight, nine I just never wanted to be left so sometimes I would have temper tantrums until she would take me with her. Just stick me in a pile of coats someplace and I'd be fine. I'd sleep.

EARL DEVREIS: She never really asked me to be responsible for him until he was old enough to be on his own, and then I would happily let him live with me. He could take care of himself then, I'd just give him money now and then, whatever.

MAX MUELLER: I can remember this one time, I was maybe like 10 or something, and there was a boxing match. Gerry Cooney, the Great White Hope, was fighting for the heavyweight belt or something and I put on such an extreme temper tantrum when she was leaving that finally she just gave in and brought me along. When we got there the fight was over already. He won in the first round, knocked the guy out. She was not happy.

The big thing was that I hated being left alone. It happened so much. But one of the worst times was when I was maybe nine years old. I woke up in Amos Poe's apartment in the East Village. I guess they were out filming, maybe *Downtown 81*, and she didn't have a babysitter. I had fallen asleep in the cab or something and then I woke up in this strange apartment and was just there for hours. I remember finding myself really angry, it was the first time I got *really* angry. I broke some stuff in his apartment and slammed the door and screamed and yelled and cried. It was at that point when TV is the big babysitter. I remember trying to watch TV and just being confused.

*Cookie & Max, Ptown, c. 1976 (Audrey Stanzler)*

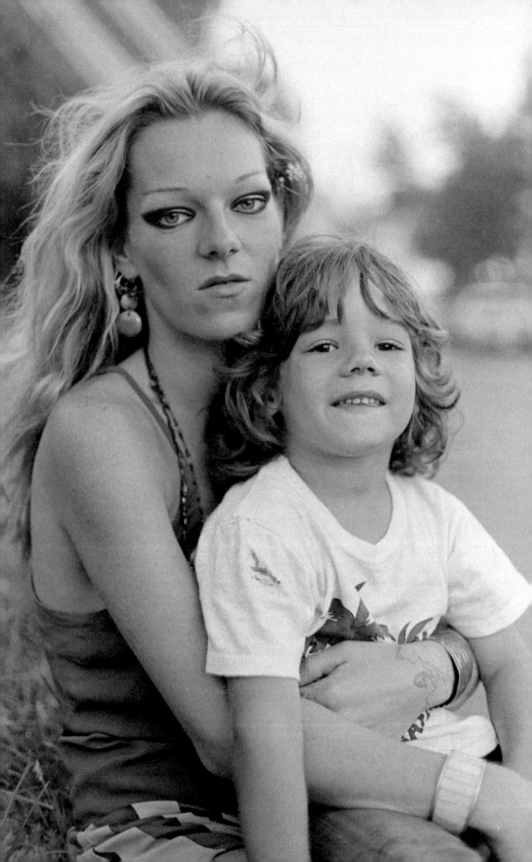

JOHN HEYS: Max was always… cool. I seldom use that word but I'll say cool in the sense that he was easygoing. When one went to visit Cookie or pick her up at night to go out or on the rare nights when we'd stay home, Max was in his room in the back watching television. He was never obtrusive, or… unobtrusive is not the right word because he was her son, she loved him, he loved her, Sharon loved him, he loved Sharon. In the summertime when Cookie went to Positano, he went to Provincetown and stayed with his father.

EARL DEVREIS: She would send him up when he was of age and she would come up and spend time in Ptown too. She had a lot of friends there and it was a nice place to live, the water and everything. He would work with me when he was like 14 or 15 in the joke shop. I don't think he really liked it, though. Ptown is a fun place, and it's a drag to have to go there and work.

MAX MUELLER: My dad came up with this great idea—I still think it's a great idea. He would make wands. I used to make them, too. He'd take a wooden stick with a stiff cardboard star and he had this super fine glitter, you would dip the star in glue, then sprinkle it with glitter, and then add some ribbons and feathers and put it in a bag. Five bucks. People would just go crazy for them. Don Juan's Magic Wands. He was Don Juan.

BRUCE FULLER: She wanted to do something nice for Max before he went to live with the father for the summer in Provincetown. She made me get a car to take Max and his friend to that amusement park Six Flags. We went through a safari ride where you take the car through an animal park and we entered the baboon part…

MAX MUELLER: …And there was an RV ahead of us that had a ladder on the back, so the monkeys were just *all over it.* There were like hundreds of them hanging on it. And there were monkeys all over our car too, and then we heard this tearing noise.

BRUCE FULLER: The baboons were peeling the vinyl rooftop off the top of the car. The park rangers had to come and bat them off! And

when we got through the thing the car was wrecked—they had peeled the top off and I had to bring it back to my friend! We were almost arrested two times that day; Cookie took off her top on a ride so she could get a suntan on her breasts. Just a very funny day. By the end I think we were thrown out of the Six Flags community!

STEVE BUTOW: I remember Max as a child, we would go out to Fire Island and spend the weekend there. Cookie, Sharon, Max, Richard Turley, myself, and a bunch of other people. We'd also go out to the Hamptons, South Hampton and one time we stayed in this huge house because Richard Turley knew the gay guys who were redoing this mansion. It used to be Baby Jane Holzer's mansion and it had something like 150 rooms! Everyone had their own bedrooms and it had an elevator and its own beach and we didn't have to clean up. We'd have big meals and drinks, as many as you could get!

JOHN HEYS: I just remember warmth and love between Cookie and Max. A little bit stronger and more overt on her part because she was his mother. And from Sharon, also. He was a bit shy maybe, but on the whole I think he handled the whole thing really well. That environment… I never could have handled it, it would have driven me crazy.

PETER KOPER: She wanted to take care of Max and the dog Beauty. She wanted to be a mother, she did try to be straight and keep a schedule and wake up on time and get him to school on time, but it was largely Sharon who was doing all that.

SHARON NIESP: Many times I would get him up for school and we would go to the Sheridan Square diner and all the drag queens and hustlers would be in there from the night before and they'd say, "Oh, are you Cookie's son?" And of course he was little Noodles in *Pink Flamingos*, so they'd go, "Look, it's little Noodles," and he'd be eating his breakfast and I'd be eating my breakfast and I'd be like, "Come on Max, you gotta go to school." He was going to P.S. 41 right near our house, but a lot of

times Cookie just couldn't get out of bed, so I used to get him up and get him to school and everything. But a lot of times I couldn't, so he didn't even go.

LINDA OLGEIRSON: His lateness or complete absence from school was glaring. Cookie wasn't getting up at 7:30 a.m. to make sure that he was out the door. There was negligence insofar as she really felt that he should get up and go to school on his own, but kids can't do that. He wasn't built that way. There are very few kids who are so self-motivated that they're going to get themselves up, get their own breakfast, and get to school on time.

JAMES BENNETT: Parenting skills weren't exactly her forte. I remember one time, it was after midnight, I think Max was 14 years old, and we were going out to some club. Cookie left a note on the door: "Max, do your homework and go right to bed," and then she just went out.

MINK STOLE: You know, Cookie was probably the worst mother I ever knew. She was not a good mother. And I can't be the first person who said that. The problem was that Cookie didn't make sacrifices to be a mother. She didn't want to have to give up any of her social life to be a mother. She wanted to have the baby and still live the life of a non-mother. And unfortunately Max suffered from that. She incorporated Max into her life without changing her life. He had to accommodate her rather than her accommodating him. She loved him, I completely believe that she loved him. But if it was either sleep late because she felt like it or get up and get Max to school, she'd sleep late.

MAX MUELLER: Going from Provincetown to New York was a huge adjustment. After P.S. 41 I went to intermediate school, I.S. 70, which was from 6th to 9th grade. It was such a big school and some of the kids… it took some time getting used to.

In 9th grade I started getting into a lot of trouble for cutting school. They didn't expel me, but they suspended me a couple times for fighting, and one time I brought some stink bombs back from Provincetown and threw them in science class.

EARL DEVREIS: Cookie never kept me informed about Max as far as school. She would say Max was being bad and misbehaving, and of course Cookie was the one who was undisciplined also. Max never had an iron hand over him, so he could pretty well do whatever the hell he wanted whenever he wanted to do it and nobody ever said nothing.

MAX MUELLER: I liked to do what I wanted to do, but I had to listen sometimes. My mom took it easy on me. Sometimes she would take my TV away. That was my punishment. She'd just rip it out of the wall and stick it in the living room.

JUDITH PRINGLE: Max was a real New York kid. He always had his friends over. I don't know a whole lot about his life as a kid but their relationship wasn't contentious in any way. They really seemed loving.

MAX MUELLER: When I got arrested she was really pissed at me. I was 14. She was just like, "What the hell is going on?" She was crying and really upset that I got mixed up with a bad crowd. I met my graffiti friends from I.S. 70 when I started there in 6th grade. We were into hip hop and it was the beginning for a lot of that old-school. Run-D.M.C. had been out for a little while and they were alright, but KRS-One was always one of my favorites. Public Enemy…

We'd hit the trains. We used to steal paint and then go hit the layups and a couple of yards too. I'd hang out with older kids who had the graffiti experience. My tag was MASE and our crew was R.S.S., the Romp Stomp Squad. We all lived in the same neighborhood, so we went together. We spent a lot of time in Washington Square Park and the basketball courts on Houston Street. Washington Square Park was cool, it was still wide open. There was drugs, gambling, and fights all the time. The criminal element and such. We would hang out, smoke weed, and drink beer.

SHARON NIESP: Max has a friend from childhood called Yoko. They knew each other from

Provincetown and New York also. They were running around as kids together.

MAX MUELLER: I met Yoko and his sister in my father's car; my dad was giving them a ride to New York from Ptown and picked me up before he dropped them off. We sort of became friends after that. I was about 13.

YOKO: I think it was 1984 or 1985. We first started chilling in Ptown because I had seen him around and I had always felt like I was misunderstood in that town 'cause they were just like so many light years behind. But then we would go to the city and not even speak to one another. I think maybe it was the following winter or something and some of my boys had a beef with some of his boys and the two crews got together for the beef and one of the kids had a gun so obviously there was no fight. I saw Max and since that day we just started hanging out every day.

MAX MUELLER: All these guys were Village guys and they were tough. There were a lot of kids that hung out with us but then didn't because they would just get abused and they couldn't take it. You had to be able take a certain amount of abuse to be down with the crew, and you had to be able to dish it back also.

YOKO: To be honest, most of them were a bunch of fucking assholes. They were straight-up bullies, just fucked up kids, man. And not your regular bullies, I'm talking about smoking a blunt and then putting an 8mm to your head just for shits and giggles.

I didn't really consider myself a tough guy, and I kind of got that vibe from Max, like we were both sweet kids and I was more the sharp talker but Max was the more sensitive guy. We just clicked. I was looking for a friend and I found one. I could be the one to tell you to fuck off and he could be the one who could hug you and make it alright, so it was a kind of this codependency thing. And anybody who meets Max has got to love the kid. Anybody with half a brain, at least.

MAX MUELLER: I got arrested three times when I was 14. The first time was at Janovic on Spring Street and 6th Avenue. We stole spray paint and sold it for money. The stupid thing was as soon as the money ran out, we went back. Then I got arrested for having a transit key, one of the keys that gets you into the train system. My mom had to come get me in a bad Brooklyn neighborhood.

Then I got arrested in Ptown. I talked a couple friends into coming out here and we just went buck wild. We went on a stealing mission at the A&P. I was getting a pack of hot dogs and some paper plates and my other friends were getting some steaks or something. I got caught stealing a pack of hot dogs! [laughing] It was so stupid. We had nothing better to do and they had so many people stealing from the A&P that they had some undercover cops staking things out.

After that my mother said I had to go back to school and finish but she didn't want me back in the same school with the same friends. So she found Quintano's.

ANNIE FLANDERS: Max and my daughter Rosie went to school together. It was a ridiculous school, perfect for both of them! I think it started at 10 a.m. and went until about 1 p.m. It was a professional children's school. [laughing] Quintano's School for Young Professionals.

JAMES BENNETT: You'd be at Cookie's and Gregory Corso or somebody like that would be there and then Max would come in with his friends and go in the back room and light their bong and watch professional wrestling on TV. It was like so opposite…

MAX MUELLER: I remember Gregory. He was crazy. He was always crazy. He came and stayed with us in New York and I had one of my school buddies over and we had found a canister of pepper spray—mace—and we were testing it out on each other, spraying each other in the eyes with it, just to see what it was like. Gregory came into my room and got sprayed and was all pissed off. I remember that. Gregory Corso is my godfather and Edith the Egg Lady is my godmother. Bunch of freaks, my family.

WARREN LESLIE: Gregory Corso as Max's

godfather... Gregory Corso at a church ceremony... just the thought of that scares the shit out of me.

MAX MUELLER: My mother knew all my friends. Yeah, they were just completely different worlds. My friends were thieves and graffiti writers and stuff like that, and I didn't want to combine the two. They'd come over because they had no other place to smoke pot, and my mother would allow it. Nowadays you could get in a lot of trouble for that, but I think it's better to have a safe place to hang out than be running around God knows where, especially in New York.

YOKO: A lot of kids liked Max because he's Max. The kid had a great personality, he's funny, he couldn't dress for shit, and he couldn't talk his way out of a brown bag, but he's Max! He was just different, and he was a smart kid. He read a lot. The guy definitely had a lot of potential, and that's what you look for as a kid, at least I did: you look for somebody with a future, someone to chill with. Do you wanna chill with the pathological liar kid or you wanna chill with this kid that's real? Real recognizes real.

We could go walk around Manhattan at six in the morning just kicking a box of matches across the street or something, you know, and he'll make it entertaining somehow.

DENNIS DERMODY: Max and his friends would hang out on Bleecker Street and play the pinball machines. He was always at the arcade. But where does that go? His dad hadn't been around and was sort of not really his dad—he was and he wasn't. He would come in and be really good at doing dad stuff, and then leave again, so he wasn't always to be depended on.

EARL DEVREIS: Max and I are kinda tight, you know. He don't really treat me as a father, I was never a real *father* figure. He calls me Earl, he doesn't call me dad... which is acceptable to me. And I can't force issues on him, I can't be fatherly to him, he has his own mind and his own thing. And we're just sort of friends.

MAX MUELLER: We were always really good buddies. The way my father described it to

me—it's not something my mother ever described—he said my mother wanted to have a kid and she basically picked him. They were kind of dating at the time. It was just a very cool and open thing and he wasn't officially my father on the books because of the whole legal thing, so my mother could get all the welfare and stuff without him being bothered. It was a different world back then.

DENNIS DERMODY: I thought, you can have crazy friends—all your parent's friends are freaks, and that's okay—but you can have a structured life. Go to zoos and read and do normal things. I always thought that was so much better, and he did turn out okay. He still likes all the freaks. Sometimes kids rebel, and that's what I was worried about. When you have freaks as parents, they rebel and become bankers and boring, horrible, square people! That would be the worst thing. You just make sure that you give them both aspects, so they don't rebel against yours—that was what I always thought.

EARL DEVREIS: Sharon was always a very nice person and so he was around nice people. Nice, courteous, thoughtful people. Max doesn't have a mean bone in his body; he's just a nice guy who was raised around nice people. A little undisciplined and a little wayward, but that's the way it turns out sometimes.

PATRICK FOX: Max is the epitome of "raised by a village," a village of Bohemians. Although Cookie was there for the day-to-day of motherhood, there were *always* people around. I remember thinking how fortunate Max was to know all these people, and unfortunate because he was sharing his mother with these people. She was also writing constantly or acting. She was busy. It seemed that Cookie was aware of her mortality. Like she knew that life was short, so she was doing and experiencing and *working*. We are our work, you know.

MAX MUELLER: She worked hard at it, all the writing and plays and performance art and art shows. All that art world stuff was boring to me. Being a teenager, I just wanted to be doing other things. I didn't appreciate any of that stuff at that age.

MARCUS REICHERT: She struck me as one of those parents who respects the identity of the child. I never, ever, saw her be harsh with Max. My feeling was that she provided a good home for him, the best she could, and I don't know what her financial circumstances were, but I know she wanted a better life. She wanted to be more secure in her life, especially for Max. But it's not always possible; you do what you can.

MAX MUELLER: We never had a lot of means at all. But I never really noticed that we would struggle too much. I'm certain she had trouble with the bills and such sometimes.

PATRICK FOX: Motherhood sort of drove her to earn a living, it really kept her working. It made her very aware of her need for money. The school was expensive.

SCOTT COVERT: She would make sure there were meals there for him or money for him to go and get food. I know that Max grew up young, he grew up fast, but I can't judge a mother.

BILLY SULLIVAN: I never saw it as any trouble. She was there as much as anybody could be at that point. She was a mother as much as she could be a mother. And she loved her son more than anything in the world and that was to-

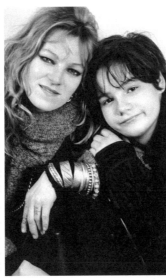

tally apparent. And she was good, sensitive, and she had to juggle a lot of shit to keep her show on the road. It wasn't easy.

PEYTON SMITH: And she wasn't the kind of woman who sat around and talked about womanly problems like that. That wasn't Cookie. She had her own way of dealing with it and that's why she was so special. I mean yes, she did have issues with Max, and we did talk about them, but I'm hesitant to say it in that way because I wouldn't want someone to construe her as most mothers that sit around and talk about, "I can't get him to do homework." It wasn't like that. I remember there

were issues about getting Max awake in the morning for school, which was a huge problem that I think mostly fell on Sharon.

PETER KOPER: Sharon was less spaced out than Cookie was.

EARL DEVREIS: Sharon was like Max's sister, almost.

LINDA OLGEIRSON: Sharon, true-blue Sharon, for all those years. Sharon was involved in his life from the time he was really, really little.

DENNIS DERMODY: Sharon, she's like the strict mother, always telling him what to do—although she shouldn't be calling the kettle black! Where does she live, in a barn somewhere out there in Truro?

MAX MUELLER: I spent a lot of time with Sharon when I was between 7 and 12. God, what a funny character. I couldn't live without her. Sharon was a big disciplinarian in my life. Sergeant Granny; that's what I always called her. And it kind of stuck. A lot of people still call her that.

SHARON NIESP: He wasn't ever raised in a conventional way. He never had a kind of family structure where you learn from it and go out and do your own thing. You'd come home and his homework would be out and he'd be asleep and the TV would be on or he'd be with the kids downstairs and we'd go get him and carry him up to bed. You know, I share a lot of that guilt. It's not even guilt, it's just the way it was. It was dysfunctional in my house, too.

JOHN WATERS: However, Max has no anger about any of that. I mean, I think Max has got some issues, but he's not angry about anything that happened.

BOBBY MILLER: I photographed Cookie and Max when he was young once for an article in a magazine. I was photographing people with their best friends, and I asked Cookie who she wanted to be photographed with and she said Max.

*Cookie & Max, NYC, 1984 (Bobby Miller)*

## ITALY, 1976: 4' 3" AND SINGING

*"Wherever we went, we were plagued with randy dandies and horny honchos. Guys were always walking along beside us whispering in a dialect about their balls and other organs. Along paths in mountains, where we thought we might find respite from all these biological urges, we would see lust areas in the underbrush where sex parties took place at night. We'd always catch a few guys jerking off in the magenta crush of bougainvillea blossoms. They followed us everywhere; the fact that we were both blondes had something to do with it. The fact that we were lesbians on a honeymoon didn't make much difference to them. Four year old Max was with us too, and that didn't deter them either. Maybe they thought he was a very short pubescent girl. Everyone is short in Sicily anyway."*

—Cookie Mueller, "The Stone Age—Sicily 1976," *Walking Through Clear Water in a Pool Painted Black*

SHARON NIESP: Paris was wonderful. I loved it. I'll always love Paris. We went to London and took the hovercraft to Paris and stayed for two weeks with this friend of ours who was a dancer, Tommy Myers. We stayed in this really great building where all these dancers lived. It was like a broken-down warehouse and they all kind of lived there and used it as a rehearsal space for their dancing and I loved it. And then I called my friend Jingles and said, "Get me outta here, Cookie's insane. Send me a Pan Am ticket. I gotta leave." I was going to leave them all there. We fought about everything. I used to go to the post office every day to see if my ticket was there. Max was five years old, so that was in '76. He sent me a ticket but I stayed with them.

MAX MUELLER: I remember going to England and making them go to castles. I wanted to see the old medieval stuff and they just wanted to check out some famous pubs and things like that. I remember that very well. In Paris, rainy Paris, it rained for two weeks and we went to a lot of museums and French movies. We were staying in a warehouse that had old hardwood floors and I got a bad splinter. I wanted to go to the Eiffel Tower but we couldn't go all the way to the top because of the lightning. Then we took a train to Italy.

SHARON NIESP: We went to Naples by train— beautiful train ride—and they sent German Shepherds to smell if we had drugs. I was in the bathroom, and they banged on the door. It was the morning and I was peeing or something. We were going through Switzerland to Italy, through the Alps, and it was all snowy and misty. They made us stand out there and interrogated us for our passports, since we didn't look like your average tourists. Bums, whores! I mean, Cookie had her little short-shorts and spike heels on and I was looking like Johnny Cash. We looked like the Romanian gypsies that got thrown out. She dressed in rags with all this bling around her neck and Max was dressed in a loincloth at that point. They didn't think we were from Kansas. They probably thought we were whoring and pimping out Max or something. They checked our makeup—Cookie's creams, too—with this little poker thing.

MAX MUELLER: We had to get off the train in Belgium to change our French francs to Belgian francs. We had a sleeper car and I remember the beautiful mountains. Then we went to Venice and Rome and we found Positano somehow.

SHARON NIESP: We got stopped everywhere you could get stopped: trains, cafés, anywhere. Going through the Strait of Messina was beautiful. We got onto the freight car at night. You wake up and all of a sudden everybody's 4' 3" and singing. This was Sicily. And Cookie once again in one of her short, raggy, mini-shorts, and Max in his rags and there's this one Italian guy with his twins, babies, in each arm and the train aisles are very narrow and they have the half windows so Cookie was leaning out the half window with her little mini shorts on and her butt was sticking right up and the Italian guy was com-

ing and with his pregnant wife right behind him and he brushes by he just goes and pushes his crotch right up her butt as he's carrying his babies and his pregnant wife behind him! And he's exclaiming in Sicilian, *"Oh yeah ye-hah yheahyyeeeeyi siiyhsiishih"* with his crotch grinding her! And she looks back and goes, *"Oh hon!"* I mean what are you supposed to do? It's Italy, so she just goes, *"Oh hon!"*

We laughed so hard. They liked her hair because it was so big and so platinum, all streaked and stuff. We were going to Central Sicily, but it was July and it was so hot. Our hair was like *sizzzz*—it was frying. We had to put oil in it and wrap rags around our heads because of the bleached hair. It was so fucking hot!

We were in the mountains. I was going to see where my family was from, in Valledolmo, and I had a letter of introduction with my grandfather's name and my mother's picture. You couldn't even ask directions cause everybody speaks Sicilian and it's a totally different dialect from Italian. You had to go up by donkey cart, but it was so hot you couldn't go even early in the morning; you had to go at night. Well, we got halfway up, Max had to pee, so Cookie tells him to go behind those rocks and he starts laughing and laughing and she's like, "Max, what's so funny hon?" and he's like, "Look, ma, look at the funny books," so we go over there and there's all these porno magazines with wads and wads of toilet paper around them. So the guys with the families with the 15 babies and 97 grandchildren and three more on the way and two wives have to go up behind the rocks and jerk off to porno magazines! Like great, that's my genealogy, right! Max thought it was hilarious.

We rented a car, and there's an old saying that to rub a midget's head is good luck. Like a genie lamp. So we rented a little Fiat, and Cookie was driving of course, and she had no sense of anything and you have to be a good driver in Italy and so we're driving and we come up to a train crossing and we have to stop 'cause there's a train oncoming and the train trestle is there—they have two arms that come down with a big heavy ball in the middle of them that weighs them down and you're supposed to stop. Well, Cookie decided she was going to beat the train with her son and me in the car. But the car was little and was having trouble getting over the track. The train was coming and the arm was down and the ball was on the roof of the car. She would go forward and couldn't get over the track and then she'd back up and every time she would go forward and backward the ball would dig deeper into the roof of the car. All these Italian farmers and workers were yelling in Sicilian, yelling and laughing and whistling and yelling, and the train was coming closer. *"GO FORWARD, NO GO BACKWARD, NO GO FORWARD, GO BACKWARD!"* They're clapping their hands in the air and raising their hands to the sky or to their foreheads because they thought this train was going to hit these stupid Americans. And Max was trying to climb out of the window.

MAX MUELLER: I was in the back of the car and I do remember some freaking out. I remember looking up and seeing the hood of the car get dented. I remember the little Sicilian woman, too. She had a limp.

SHARON NIESP: Finally we get off the tracks—*obviously*—but the ball had made a big indentation in the roof of the car. So when we brought it back we were wondering what the fuck we were going to do. End up in jail? "Cookie you asshole, why did you do that? We're going to end up in jail—have you ever been in an Italian prison? The state will take Max and put him up in a farm somewhere and we'll be in jail."

Anyway, we took the car back to the rental place and I remembered that there was a little midget that signed us out and when we brought the car in I parked the car far away from the office in the lot and so I'm thinking if we get that little midget to look over the car he won't be able to check the top of the car, cause he's little. So we go in and went straight to the midget as opposed to the other guys

and gave him the papers. We had parked away from the curb so he couldn't stand on the sidewalk to look at the top of the car. So he comes with us and he checks the car, the bumpers, the doors, the windows, he checked inside, he checked the seats, everything, he saw everything except for the big hole on the top of the roof from the big ball on the railroad track that almost killed us.

## DEADLINES

*"I am here this month to distract you. In this column, you are about to read—or skip over—some useless but interesting trivia, some topics for conversation, some well guarded but cheap baubles, some dime-store details and some insignificant information about art. All of it is worthless but all of it is true, and that is something."*
—Cookie Mueller "Art and About," *Details,* June, 1986

DENNIS DERMODY: When Cookie started writing, I just thought, what a great idea. She was turning out these really great stories, and I thought, finally these stories will be on paper, I've heard them so many times. Like the Manson family, when she almost got on the bus... typical Cookie, that *would* happen to her. And that was true; that really happened! That's how she got into John's movies—just like a story. She won a contest and ended up in *Multiple Maniacs* go-going topless! Now that's funny!

DUNCAN HANNAH: I saw her read the story about being picked up by the Manson clan somewhere—that was amazing.

PETER POMPAR: Most of the stories in her books she told to me as events in her life. Like the story about the midget and the train gate

coming down on top of the car—they were both yelling at each other while telling the story. I heard that story right when they got back from Italy. They just relived it with me sitting there. I was just spellbound.

And the story about the Canadian fire I heard several times before I ever read it. As she told it, everyone took what they could out of the burning house and then all of a sudden she looked at Max's feet—he was a little baby and didn't have shoes on—and just knew that she had to go back in and get those shoes. So the story ends with her running in with fire everywhere and then running back out with the pair of shoes. As she's telling the story, I look down and the front ends of Max's shoes are singed black. The story was only six months old.

GARY INDIANA: Cookie used to tell me stories all the time, and finally one weekend I locked her in her apartment and said, "Don't leave here until you write these down. Just write the goddamn stories down." I had to push her, she wouldn't have written otherwise. She didn't have confidence. I didn't have much confidence myself, but I knew she had stories to tell. And that's when she started writing.

SHARON NIESP: Gary was one of the first people who really prodded her into reading, who encouraged her to write and give readings. He was her total inspiration to read and be confident with her short stories. Her readings were wonderful.

MARK BAKER: We always included Cookie in our crazy *vernissages* at the loft. We'd have people like Ethyl Eichelberger doing *Medea*, like the Robinson Jeffers adaptation, doing all the parts in a Belle Époque evening gown, sort of like 1860 under my Christmas tree. And there was Cookie reading her poetry or her reactions to holidays or something from *Garden of Ashes* or just hilarious observations.

PETER POMPAR: She can narrow a story down to a few drops of water that fill up no more than a couple of pages and she does it so nicely. She told me she lived down the hall from Janis Joplin when she lived in San Francisco

and that Janis came over one time to borrow cigarettes, but the way Cookie told the story was a nice, quiet, special little episode. She wasn't banging drums like, "I knew Janis Joplin!" or anything. She told it with a bit of poignancy.

BOBBY MILLER: Even the most horrible situations she could make light of. The stories of getting raped... you don't want to laugh about someone getting raped, but the way she would convey it—she would just dust herself off and, oh well, it was another day in the neighborhood for Cookie. That was one of the great things about her; she had the kind of perspective about life that made things something to write about rather than things to be depressed about.

PETER KOPER: Yes, and some of her humor

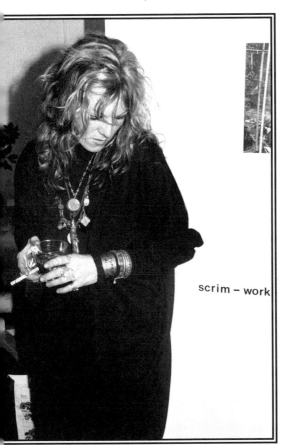

scrim – work

was to take fact and spin it into total fantasy. If there's a contradiction between fact and legend print the legend, it's a lot more fun. Like her hitchhiking trip with Mink, when they all ended up with those rednecks. You take a story and then you start spinning it and it becomes something else than it really was. There's a truth to it, but it grows in legend.

JAMES BENNETT: She wrote a story, "Another Boring Day," where she was in line with her dog at the Chase Manhattan Bank over on 5th Avenue and all of a sudden there was this smell and then a big turd on the floor. Cookie started scolding the dog, sort of that fake "bad dog, you shouldn't have done that," thing, and then the woman behind her taps her shoulder and whispers, "It wasn't your dog; it was that lady." Some lady had taken a dump in line at the bank.

PETER KOPER: Cookie was starting to write and she showed me some of her stories. I was writing at that point for the *Baltimore City Paper*. I was an editor there, basically we were all running the place, and I got her stories placed, like a front-page thing. It was some of her early stories, and I think it was among the first times she was published. I would say it was the mid-'70s—'76 or '77. I remember I wrote a little introduction and they ran Cookie's short stories and there was a photograph of her.

LINDA YABLONSKY: There was a newspaper in the '80s called *The East Village Eye*, and that was where the "Ask Dr. Mueller" letters were. That was really what started to make her name as a writer, and then the books—*How to Get Rid of Pimples* and *Garden of Ashes* and *Fan Mail, Frank Letters, and Crank Calls*. And she had the *Details* column, "Art and About." She was one of the first people I knew who got a personal computer. She would write these columns in the middle of the night after Max had gone to sleep and she had gone to some nightclub. We'd come home and get high and she'd say, "I have to write my column." And she did! Or she'd do it during the day while he was at school. I don't know how she'd do it, but those columns appeared every month—for

*Cookie at an art opening, NYC, c. 1985 (Bobby Miller)*

years. So I was both insanely jealous and completely admiring and loving the whole thing.

ANNIE FLANDERS: I wanted somebody who wasn't run of the mill. I wanted somebody who had some spark. I met Cookie and she was the one for sure. I didn't ask for any writing, I never needed that. I can always tell from a person, if it's the right person, what I'm going to get. She came to the office and a couple of people in the office knew her and loved her, and that was that. She started writing a monthly column.

DUNCAN HANNAH: The art market was really booming. I remember my opening at the Phyllis Kind Gallery: Cookie was there and people were spilling out into the street and sitting in cars. We were just like, "God, this is great." It got written up in *Vanity Fair*. It was just before the bubble burst, so it was good times. Art had never been really a mainstream preoccupation with so many people. I mean, there was that great crossover of music and art and fashion, the likes of which hadn't been around I guess since the '60s. It was exciting again. And there was a lot of emphasis on young artists, which there hadn't been in the '70s. In the '80s, it was kind of a youthquake or youth revolution. The artists were getting press and selling paintings.

RAYMOND FOYE: There was a serious change in the aesthetic ground in New York at that point which was going from minimalism to conceptualism into neo-expressionism. There were painters like Clemente and the graffiti artists Jean-Michel Basquiat and Keith Haring. They were the ones who were sort of bringing back Warhol from his obscurity. This new scene had so much energy that was connected to the streets.

PATRICK FOX: There ended up being about 100 galleries in the Lower East Side by '85. I'd say the Anderson Theatre Gallery was the fourth gallery to open. Civilian Warfare was one, Nature Morte Gallery, Fun Gallery. I showed my friends that weren't being shown in galleries in SoHo. I figured, why not? I was living at the time with an artist named Robert Hawkins.

ROBERT HAWKINS: I met Cookie in '81, when Patrick opened his gallery. I knew who she was and I'd seen John Waters's movies, and she was totally in the art world. Patrick's place was great; it was a lot of fun. She'd come over a lot and it was very bad, bad, bad. Patrick, Teri Toye, Cookie, and René Ricard? Bad, bad, bad. It was a real clique. All these art galleries opened all at once—from '80 to let's say '85—and it was a big fight to get people to recognize you and pick you out of a crowd. I mean, if it wasn't going by '85, you missed the boat. Patrick didn't know anything about art, but he didn't have to. I said, "Come on, you don't have anything else to do."

PATRICK FOX: The Anderson Theatre Gallery was a big theater in the East Village at 2nd Avenue and 4th Street. My brother and I lived there with a circus of our 20-something boyfriends and girlfriends. We lived in the offices above the lobby and rarely even bothered with the spectacular theater.

ROBERT HAWKINS: No electricity and no running water in this theater—totally abandoned. It was the last place the Yardbirds played, and it was where the Cockettes played and bombed horribly when they came to New York.

PATRICK FOX: It was often referred to as the Palace of Decadence and Decay. The boys were provided with empty water bottles and the girls were given a small fishbowl to pee in. Cookie would pee standing up and get it right into the fishbowl with perfect accuracy. She reviewed the first show I opened the gallery with. Some artists I showed there were David Armstrong, Greer Lankton, Donald Baechler, George Condo, Robert Hawkins, Carl Apfelschnitt, Sue Williams, Vincent Gallo, Scott Covert, McDermott & McGough, René Ricard, Stefano Castronovo, Alexis Rockman, Alain Jacquet, Stephen Sprouse, Kate Simon, Alan Vega, and Mike Carson. Cookie wrote about basically every show that I put on.

Afterward, I opened the Patrick Fox Gallery on Bleecker on May 5, 1984, the same day Jean-Michel Basquiat's show opened at Mary

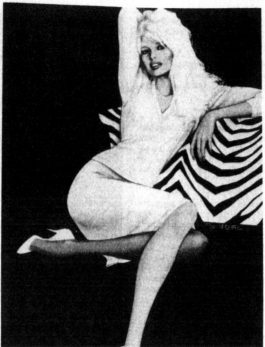

Drawing of Brigitte Bardot by Jon Mathews

# ART AND ABOUT

### Cookie Mueller

I got a ride home in a cab the other night; the driver, Johnathan Herbert, had been talking to the big doorman at the Roxy about the art show he was having somewhere on Long Island. I looked at his pad of drawings while he was driving down Seventh Avenue; most of them were comments on his life as a cabdriver: sketches of people he saw in his mirror, and of people he saw fleetingly in the street, whom he didn't stop for because of the insensitive way they hailed his cab. Herbert told me that his paintings hung in Chase Park (remember?) near the office and I did, in fact, remember them. They had made an impression but I don't recall whether I hated them or liked them. These little drawings on the pad were good, though, because these were things that had made an emotional impact on him and it showed.

I began to think of my mother, who paints almost every day. Her images were usually the same subjects: either her children or the back of the house from every angle. As a child, I would look out into the backyard and, despite the weather, there she would be sitting on an aluminum chair at her easel, rendering her interpretation of the back of the house. Obviously there was something there that she loved. The back of the house is no longer her subject matter—she has moved on to painting her renditions of ads from *Time*.

Billy Sullivan paints from Polaroid snapshots he takes of people doing eventful things. (I've also seen his wonderful paintings of pigs doing regular uneventful things.) Sometimes paintings done this way can be static, but Billy's never are. At his show at the Kornblee Gallery on West 57th Street are paintings of breakers and rappers at Negril, of children (his own and other people's), and of his friends and acquaintances—Becky Johnston hugging, Sharon Niesp singing, Chi Chi serving, Gary Indiana musing, to name just a few. I mull over the idea that Billy, as a chronologist, is anticipating the annihilation of the world and is ensuring that future archaeologists' jobs of understanding the sociology of the eighties will be expedited if only they find his work. Aside from being beyond-polychromatic, his images always look as if they've been twirled by a sagacious and enchanted eggbeater.

•

Jean Michel Basquiat's paintings (now at the Fun Gallery) are indeed, as I said in an earlier issue of this magazine, like automatic writing-painting. There seems to be some force at work that moves his hand, some futuristic yet primitive vision, as if he sees things with a weird X-ray vision from the vantage point of a UFO

Boone Gallery on West Broadway. I remember the date so well only because Cookie referred to that day as a "red-letter day for the art world" in *Details*: Basquiat at Mary Boone and Robert Hawkins at Patrick Fox Gallery. She covered every aspect of it, including the after-party, which was at the Odeon, a really motley crew.

KATE SIMON: I had a show with Robert Mapplethorpe and David Armstrong at Patrick Fox Gallery and I remember Cookie standing next to me, madly trying to get David's pictures affixed to the wall. I felt that was really a great thing to do for a friend.

PATRICK FOX: It was a smaller community within the insular world of art. We were on the fringe of that; we were a little clique. There were artists who would want a show with me specifically because they wanted a review by Cookie, so that gives you an idea of how she was viewed.

ANNIE FLANDERS: She started in 1982, in the third or fourth issue. She was free to write about anything and anybody she wanted to. There was nothing but line editing in anything that my writers did. I had a staff that understood the field better than anybody pretty much. It wasn't like we guessed when we thought somebody was very talented. We always knew. And we put a lot of people on the map. It was nightlife, it was fashion, it was music, it was art, it was any form of talent. We had a column on music from LA, we had people contribute from London. We just tried to keep up on all the latest things before other people really knew they were good.

LESLEY VINSON: I was the art director. We were writing about so many crazy things that I thought the layouts should be straight. So that's why *Details* was written in stone, because nothing in those days was written in stone. Totally boring, like every other restaurant review. And Stephen Saban would say, "This looks like a manifesto!"

STEPHEN SABAN: I was one of the founders of *Details*. We used Cookie because she was very

smart about art and she was a funny writer. She was excellent. I did almost no editing to her copy, it was so good. I actually appreciate it more now than I did then.

ROBERT HAWKINS: *Details* was underground. It was about as hip and legitimate as it gets, and Cookie... she was no art critic, that's for sure. What she was writing wasn't art criticism; it was gossip. It highlighted names of people. All she did was say, "And there was a blue painting that was really pretty," or something like that. That was as deep as she was going to get with it.

SHARON NIESP: Cookie was not a gossip. Mostly in her life, she was a factual person. Even in "Ask Dr. Mueller"—those were her facts, as she knew them. It wasn't gossip. It wasn't hearsay. I hate hearsay. All it is, is everyone trying to get their little moments in there and why?

RAYMOND FOYE: What she was writing were like news dispatches. I think she liked the immediate feedback.

DENNIS DERMODY: Cookie's art reviews for *Details* were hilarious! One time, she was writing about an artist and didn't bother going to the show. She wrote about his painting and he turned out to be a sculptor! She freaked out—"What am I gonna do?"—but Jimmy Bennett was smart; he said, "If anyone asks you about it, just say, 'I wanted to see if you were paying attention!'" And she got away with it! She wrote a whole review of art she never saw!

MARCUS LEATHERDALE: She wrote a review for *Details* of my work. I remember her phoning me up, asking me some things for the piece. She would never say anything bad about anybody. She was more an art admirer than an art critic. I don't ever recall her saying something nasty—even constructively—about anybody's work. She was a sweetie. You knew you weren't going to get ripped to shreds if she was writing about your show. Actually, I don't recall her ever being mean. I'm sure she had her knockout fights with Sharon, but publicly, I never knew her to say

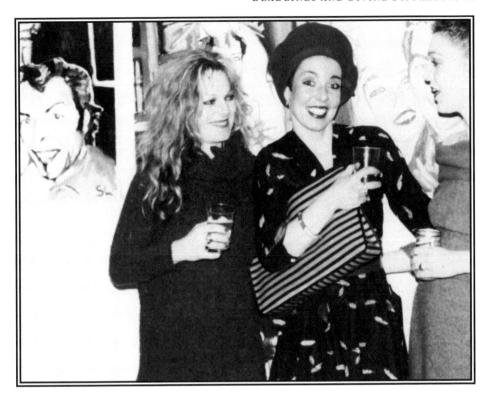

anything aggressively negative about anybody.

DUNCAN HANNAH: She was like a cheerleader, cheering everybody on in a very articulate way.

ARNIE CHARNICK: She gave me a very special review by simply writing, "Charnick's art is good medicine." I cherish that one-line review from a top-shelf *señorita*.

BILLY SULLIVAN: She wrote about my work in *Details* and I understood it. She was the first person that called me a diarist and I didn't even know what the fuck that was but then I found out that that's what I was doing. She coined that for me.

CARLO MCCORMICK: Her opinions were definitely respected. She had a good eye. She had a good sense not just for what people were trying to do, but Cookie understood the Zeitgeist, so to speak. She understood her relevance. Downtown New York wasn't the rest of the world. But the fact was, we didn't really care about the rest of the world. We only cared about what

we thought, and Cookie was a great voice for that. She was writing to the already-initiated about stuff that would probably go over other people's heads because it was a part of this art discourse that was way different than the rest of the world at that time. Art had nihilism and decadence and all sorts of things attached to it, so within her community—and I know that sounds limiting, but for us it was self-limiting because if you were famous in our world, you were famous even if no one else had heard of you—she was very well respected. Because she spoke to all of us, for all of us.

CHI CHI VALENTI: And because it was 400 or 500 people who were out all the time in these clubs and galleries, they didn't really need to reach outward. You knew there was a physical place where you could find all of these people.

SARA DRIVER: We all germinated each other among the different arts.

KATE SIMON: In a town where everybody hates everybody and where everyone is clawing

their way to the top or clawing their way to fame, Cookie Mueller was special in that absolutely everyone adored her. It's true.

RAYMOND FOYE: There were people on the scene like René Ricard, who was an extremely brilliant, witty, vicious, and overbearing person. Cookie could more than hold her own with someone like that. She was very witty and could zing it right back at somebody, but always in such a nice way. She never got vicious or mean, but she could really play that witty game. I remember Gregory Corso saying when he came to New York that wit was like a guillotine: it could cut off your head if you weren't careful.

CARLO MCCORMICK: I was writing for *Artforum* and these really *art* magazines, and there was sort of this mandate—it probably still exists—of critical distance, this notion of objectivity that I never really ascribed to. It seems that knowing an artist gives you more insight into their work. It's taking a position more of advocacy than being a person on some mountain, passing judgment on everyone else's creativity. I loved that Cookie found such a great voice really early on for that kind of thing when people weren't really doing that much yet. She was dealing with things in a kind of social way. She was writing about her friends in ways that she cared about.

DUNCAN HANNAH: It's hard to write about art without succumbing to that creepy art-speak that so many people who write about art use. She wrote about art in a very human, poetic, generous way. She didn't use theory at all. Looking at this one review she wrote about me, she talked about how it made her feel: "Looking at any one of these paintings I find myself playing out the scenario, writing the corresponding story in my head. I know these tales, I know what the weather feels like the day of the painting. I know the characters and what they're doing there, where they're going and what they're thinking. The plot is here in the present, but the future and the story resolution is anybody's guess...or Hannah's next paintings." *Artforum* definitely wouldn't let anyone

write like that. I think it's really refreshing. It was real, she was really real, totally unpretentious. My favorite critics have always written that way. Eileen Myles, who I think was a friend of Cookie's, used to write for *Art in America* and she wrote that way. But it's rare. I mean in the '50s, poets like John Ashbery used to write art criticism. They were allowed to be impressionistic in their criticisms.

RAYMOND FOYE: I always thought that a lot of Cookie's writing was coming out of the early routines of William Burroughs. When Bill would write, he would get up and walk around the room and do the voices and act it out. They were very much routines. I thought Cookie was kind of working in that same style. Very episodic.

MARCUS REICHERT: I think sometimes intelligent people have a tendency to show off and you sort of buy half of it and you don't buy the other half. But I didn't find Cookie like this at all. Her intelligence was just part of the way she was, the way she behaved. I'm sure we talked about filmmaking and what it was to be a writer. I've always been a writer. I felt very comfortable with her in that way because she spoke in a very natural way about these things.

PETER KOPER: Cookie got a high school diploma and that was it. She never went to college or anything. She would soak it up from people. I remember her asking me occasionally about historical stuff and I would fill her in and explain things to her. And then she was hungry, and she would go after it. She did research for her articles, this I know; artists, for instance. And particularly if it was for *Details*, she would do her research. She was a self-taught person.

ANNIE FLANDERS: She was the favorite of Si Newhouse, the owner and CEO of Condé Nast. He thought she was the best art writer that he had seen in his 20 years at the magazine. He was just crazy about her writing. He just thought it was incredible and fresh and different from everybody else that was out there.

RAYMOND FOYE: I had a dinner at my house and I invited Jimmy Schuyler, a great New York City poet, a friend of John Ashbery. David Trinidad had a long correspondence with him, Eileen Myles was his secretary, every young poet in New York admired him. There was Ashbery, the great public poet, and then there was Schuyler, who until the age of 65 never gave a public poetry reading. He was hard to see because he was in and out of mental institutions and was extremely erratic. There was a lot of rumor and mystique about Jimmy.

I also invited Cookie, and Jimmy and Cookie hit it off like a house on fire. He just adored her. The next day he asked me for her address and sent her a signed book. Now, Jimmy did not ever trade on his name or his reputation and he would not give out a book; he didn't like to sign. The idea that he would sign a book and send it to somebody really showed how much he thought of her. And he admired her work. He read and liked her work, which meant a great deal to her.

BOBBY MILLER: I ran into Cookie one day and was like, "What are you up to?" and she said, "I got to go write about this art show on 57th Street—wanna come?" So we smoked a big joint and went uptown. The gallery was in this building on the 5th floor, and when we got off the elevator, nobody was there. I think the opening was supposed to start at 6 p.m. and we got there at a little after 5 p.m. So we're looking at the work, and in a corner of the room was a table all set up with shaved ice and oysters on the half shell. Cookie and I are from Maryland, so we both love seafood—plus, we're stoned—so we looked at the art and the art was really bad and we just started eating the oysters and talking. The guy who had been preparing the food had gone downstairs to get to his truck or something, and meanwhile we're talking, we're eating, and finally I look and I go, "Cookie, there's no more oysters, we ate all of them!" So then we go toward the elevator and the door opens and here comes the guy with the lemon and the cock-tail sauce. We just get in the elevator and he walks over and sets it down and turns around to us, and just at that moment the doors close and Cookie lets out a little burp. We start laughing and Cookie says to me, "Don't worry hon. The art was so bad that nobody would even stay for the oysters!"

JANICE BIRNEY: I visited New York and stayed about a week with Cookie and we went to the opening of Julian Schnabel's show, which she was supposed to be reporting on. It was his antelopes and broken plates period. It was fun going around to shows with Cookie. I went with her to interview Erté when he was about 95 years old. He was a really famous artist and fashion designer in the '20s and he died when he was 98. He was my hero, so when I heard she was going to interview Erté, I said, "Oh good, I'll come!" She was doing an article for *Details* and she was completely off her head [laughing]; she was incoherent I tell you. *I* ended up having to ask him questions! We went to his office; he had this huge wonderful place, some penthouse somewhere. She taped him, but I don't think anything came out on the tape, so she was asking me, "What did he say, I can't remember what his answers were? I can't even remember what the questions were!"

PATRICK FOX: Cookie made dolls sometimes. Once, at Patrick Fox Gallery, I showed one of Cookie's dolls. It was some kind of mummified thing. It turned out really beautiful, and there was some kind of Julian Schnabel thing connected to it. He bought it or did a painting of it. It was one of the shows that Cookie didn't write about because she was involved in it and felt it would be a conflict of interest.

DENNIS DERMODY: And then "Ask Dr. Mueller," that was *preposterous!* Asking her to do health stuff was like asking the Devil questions about Jesus! It was so ridiculous. She had so many crazy home remedies; she was really funny with that stuff.

LEONARD ABRAMS: Basically people would write in and she would answer, but of course people never write enough for these things so

# ASK DR. MUELLER

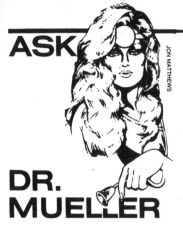

JON MATTHEWS

### By COOKIE MUELLER

I'm not going to talk about A.I.D.S. It would be unwise and presumptuous for me to try to shed some light on a subject as serious as this epidemic. But there is one thing I have a burning desire to say and then I won't ever mention it again. If you have A.I.D.S. seek help from doctors other than ones connected with the A.M.A. Like some bizarre sci-fi C.I.A. plot the A.M.A. seems to be trying, albeit unwittingly to obliterate the following groups: queers, Voodooers, drug fiends, hemophiliacs who need transfusions often and straight who share Sabrette hot dogs with gays. (But really, not only has William Burroughs thought that the C.I.A. and the A.M.A. are creating strange diseases to eliminate certain segments of society, but just about everybody I talk to.)

I've had too many beloved friends die lately from diseases contracted when the immune system breaks down. I'm tired of going to wakes. I miss these people. So after you have an accurate diagnosis and before you take any medication or therapy, try a nutritionist, a homeopath, a kinestheologist and a chiropractor/nutritionist. Go to them all. The first thing a really good chiropractor/nutritionist will do is take hair, urine, blood and nail paring samples to determine what your individual deficiencies and needs are. It's a very personal treatment. They put you on a diet that's correct only for you alone. Three of my friends who had A.I.D.S. and didn't start any A.M.A. treatments but went instead to chiropractor/nutritionists now have white and red blood cell counts back to normal. They are virtually cured. So there is some hope.

If you have A.I.D.S. write to me and I'll give you a list of some of the people who may, perhaps cure you.

---

**Dear Doctor Mueller,**
I'm an aspiring James Brown sound-a-like. I'm not saying that I'm copying his style or nothing but people have mentioned this to my face and otherwise. What I'm asking is that after a rehearsal or a show, my throat is blown. I get the nodes on the vocal chords. I can't talk for a few days and anyway it hurts. So what do I do?

**Calvin S. Flypaper**

---

Dear Calvin,
You get the nodes from screaming not singing. You ought to see a voice coach to learn how to sing from the diaphram and the head. There's three places where the sound rings from: The diaphram, the head and the throat. But if you're in pain right now, try eating fresh pineapple. It works like a painkiller on the throat. Also Slippery Elm tea is great. You can buy Slippery Elm lozenges too. Papaya eaten with lemon juice is another remedy. The Yerba Mansa root chewed slowly seems to work well.
Love,
Doctor Mueller

---

**Dearest Doctor,**
I'm a gay man and when I fart I shit my pants. What can I do about it? This is serious.

Love,
**Fossil Daulah**

---

Fossil Dear,
I'm really disturbed by this one. I mean, the idea doesn't bother me at all, it's the laundry I'm concerned about. Does it happen frequently? Where? In the crowded subway? On a date? My heart goes out to you. I guess the only response I can give is to not fart. But if you must, you might try Crazy Gluing two Huggies together and wearing them or use a simple butt plug. I remember in the heyday of Studio 54 there was this girl who always dressed minimally. She was invariably totally naked but wore her butt plug with various jewelry hanging from it. Perhaps these two suggestions will put you back in business.

Love and Concern
Doctor Mueller

---

**Oh M.D.M.**
What are these insipient, subliminal viral attacks? This Angst Vor Der Angst? This anxiety? Is it drug related? Does everyone go through it?

**Methrina Tipps**

---

Oh Methrina,
Is this viral angst? Has this Age D' Ennui spawned and weaned so many of us? Are we the Neo-Moles that have evolved to the no eye state after eons of seeing too much light?

Whatever it is, I would unequivocally say that it existed before drugs, but these drug hang-over can certainly sharpen it. So when the little dancing dolls in the jewelry boxes peter out you just have to wind them back up again. Here I am waxing poetic when I'm supposed to be talking about nasal douches and the like. There is no cure, I'm afraid. The Germans have a perfect word for it. Schwermoglichkert.

Love,
M.D.M.

---

she either got her friends to write questions or she made questions up and answered them. She would take on subjects like how to cure things that bother people, whether it was allergies or how to kick dope and keep your nose from running or various sexually transmitted diseases. Practical advice. Sexual incompatibilities. All kinds of things.

JOHN WATERS: She totally made it up and told people to do things that made people go crazy, stuff that was really bad for you!

LEONARD ABRAMS: She'd write something like: "Dear Dr. Mueller, I enjoy anal sex but whenever I fart I shit in my pants. What should I do?" And she'd answer: "Well you can get a butt plug." This is not the kind of stuff you read in most medical columns.

JOHN HEYS: I started to get these pains in my stomach on the weekend, and on Monday I called Cookie and said, "Cookie, what side is my appendix on?" She said, "Your left side," and I said, "Weird, I have this sharp pain on my right side. I don't know what it is," and she said, "Oh, just take a fleet enema and douche yourself out and you'll be alright." In America, a fleet enema is an over-the-counter enema. So that was on Monday, and by Tuesday at noon, it was so bad. Luckily, next door to my building was a doctor, and he said, "You better get yourself to the hospital, quick. If your appendix bursts, you're going to be in deep shit." And I said, "Well, a friend of mine said if I took an enema…" and he looked at me like I was nuts and said if I had taken an enema I probably would have exploded my innards completely. It's true! So I called Peter Hujar, who took me to Cabrini Hospital and they took my appendix out and told me I was lucky it didn't burst. So, in essence, I had a normal appendectomy. But if I had taken that fleet enema, I don't know. It would have been something like a John Waters movie. So Dr. Mueller really erred on that one.

LEONARD ABRAMS: Or she would write: "I have a big dick. My dick is so big that I'm wondering if I'm gonna have problems meeting or having relations with women." And

then she'd answer, "No, you're very lucky and you're equipped for life."

She kept writing about this big dick guy. At the time, not a lot of people were talking about big dicks. Dick size was mostly restricted to the homosexual community. Now all you see is dick size; there's a whole industry. I had this picture of a person in Malaysia who suffered from elephantitis of the scrotum. This poor guy had a scrotum as big as a wagon wheel. Seriously. So I replaced her column picture with this picture the next time she wrote about the big dick guy and she came in to pick up her copy and said, "Okay guys, I get it."

PATRICK FOX: She always had great advice. We would all sit around and help her with it. Mulling over Mueller!

LEONARD ABRAMS: The first issue of the *The East Village Eye* was May, 1979. The punk rock scene was coming up. It served as a catalyst for a lot of things. On the cover of the first issue was James White, also known as James Chance; he had a band called The Contortions. The story was written by David McDermitt and basically he used the subject of James White to talk about his idea: that this whole new crop of artists and musicians were kind of like the new Hollywood gods and they were there to inform the rest of the country about how outdated they were and how everybody had to change and get with the scene.

RAYMOND FOYE: The previous generation or say two generations before, let's say the Beats, Kerouac, Ginsberg, Burroughs, Corso—they were still around and that was such a hard thing for writers to follow. I think it was kind of like the abstract expressionist painters; if you compare Burroughs, Kerouac, Corso to De Kooning, Pollock, and Rothko and then the second generation people, the Lower East Side, they were just like midgets to these tremendous dinosaurs. It wasn't til the generation of Cookie Mueller, David Trinidad, Tim Dlugos, and Dennis Cooper who really got on to something new. They really got a new energy going that was not handed down from

thus the broken bones. How
did you ever bone any skiing
instructors? They've always
tell you - just fall and
roll with the punches.

Yeah I'd say, just let
yourself get right thru the
wind shield as ~~if~~ long as your
wearing a helmet or ~~strong hair~~
~~do with lots of~~ hair spray.

Love
Doctor Mueller

Dear Mueller,
You're no ~~doctor~~ real doctor
~~to~~ but something you said in your
last column impressed me. You,
like Jethro Kloss, the man who
wrote Back to Eden ~~seem~~ seem
to lean toward enemas. I believe
they work for everything. Especially
those high colonics. Where can
I get a professional one?
Signed Mister P.G.B.

Dear P.G.B.
Yes ~~you~~ wise old Jethro Kloss

will tell you that enemas
are the cure all for anything
from Asthma (~~this~~ to
Impure Blood. You know,
he's right. By God just a
hearty high colonic will
rid your body of all its
accumulated toxins. Get yourself
into position ~~on~~ with your
bag.

Use three
quarts of
water
with lemon
+
a little oil,
one
quart at a
time. allow yourself lots of time. Don't
~~try~~ ~~to~~ It's been observed that
it gets rid of facial bags ~~too~~
in no time. But don't try this
right before you go out on the town
allow yourself an hour or two
~~in the bathroom.~~ You don't want
~~away~~ to get to the party and spend
all your time in the bathroom
love Dr. Mueller

the previous generation. They broke away. They were relating to Frank O'Hara and pop art writing, very urban contemporary—like Apollinaire, sort of thing tied in with the painters.

LEONARD ABRAMS: There was a whole new energy, which was inspiring because at the end of the hippie era, it was getting kind of depressing. There was kind of a bankruptcy of ideas. I was trying to get people with new points of view, which at the time were considered bizarre, really. But these points of view became absorbed to the point where you can't turn on the TV now without seeing these points of view. Now a lot of them should be thrown out already, but they're still there, if you look at MTV. For example, the idea: I don't care what you're doing but make yourself useful. Do something interesting. Do something, or just get the hell out of the way. This snotty idea is all over MTV and everywhere else, but at the time it was a new idea or it was an idea that needed to be brought out again because people were just stuck in this no-man's land of nicey-nicey ideology on the left and on the right a whole other bunch of things that were not interesting.

LYNNE TILLMAN: There's always a tendency when thinking of the past, or history, to think that it was more cohesive... People who were called downtown writers at that time, each of us was really doing a lot of different things. If there was a similarity, I think it was in the idea that none of us was supposed to be complacent about what we were living in, and there was a sense that being a writer was a way of speaking to the time that you lived in, and not just joining the mainstream. There was the idea that we were different from, we didn't have the same values as the mainstream writers or mainstream culture. And I think that in many ways that was true, and is still true.

LEONARD ABRAMS: Cookie wrote from 1982 to 1984. A writer named Sybil Walker interviewed her in *The East Village Eye* in 1980

maybe, and later I met Cookie and she said she'd like to write the column. I liked the idea of having columns, a place where people could talk directly. Sort of like a soapbox.

Her columns were great, very clever, and at the same time, provocative. They were practical. Whether it was a sunburn or indigestion, she took it seriously. She wasn't just handing out advice like a telephone psychic. She gave thought to it. It was jokey maybe, but the cures, mostly herbal based holistic things, they were real.

CARLO MCCORMICK: Cookie and I worked together at *High Times*. She did a version of "Ask Dr. Mueller," but much more drug-related.

SHARON NIESP: I remember how she used to struggle with deadlines. Deadlines were like the demon, they were like the encroaching devil, like Satan and his footmen. You could hear them coming closer and closer... deadlines! And of course, there was hell to pay if you lived with it. Max would always go, "Cookie's writing deadlines Shar!" and I'd be, "I know, let's go out and get something to eat."

MAX MUELLER: She kept the office in the living room. You know, desk and word processor and typewriter. When she had deadlines she really kept to herself. She would hover over her word processor and it was a known thing for me to not bother her.

LINDA OLGEIRSON: But she would get them in at the last minute. I remember running with her from Bleecker Street over to Broadway in order to hand in something that was due like yesterday—or the day before.

ANNIE FLANDERS: We all looked forward to her deadlines when she'd come in with a fantastic new outfit and was always in a great mood and excited about what she had written. She was so beloved in our office, certainly more loved than any other freelance writer we had.

GLENN O'BRIEN: We had a very similar sensibility. I really liked the way she wrote, and we had the same sense of humor. We wrote

*The header for Cookie's* High Times *magazine column*

a play together, which has never been performed. I thought about it for a while, and recently I found it and did a little work on it, just cleaned it up a bit and showed it to a few people, because I would like to perform it. It's called *Drugs*. It's a comedy about two guys who are college roommates and they take amphetamines to study for a test, and then wind up using amphetamines, and then become pot dealers, and then get into acid, and just go from one drug to the next. They become coke dealers, then they become junkies, but then at the end they become outdoorsmen. We did a reading of it once with Steve Buscemi and Martin Boone Jr., who are really great actors, but that was the only time. We just did it to see if we wanted to make any changes. We had an agent, and thought we could get it into some good off-Broadway theater. It came close, but it never happened.

RAYMOND FOYE: I went to India in 1984 with Francesco Clemente and his family and Francesco and I started this small press,

Hanuman Books. I was collecting miniature books, which was a very common format all over India, and Francesco and I had been talking about doing a magazine of art and literature but I didn't really want to do a magazine because I had done magazines before and I realized how ephemeral they were. There was a monsoon and everything got flooded and when I came back to the apartment all these little books were wet, so I laid them out on the bed to dry. The entire mattress was filled with these small books and Francesco came in and was kind of amazed at this sight and we immediately realized that was the format we were going to do. So I went back to New York and started asking people for contributions.

First we did *Fan Mail, Frank Letters, and Crank Calls* and then we did *Garden of Ashes*. *Fan Mail* was a bit of a scandal because there was an illustration of a postcard of the Priapus statue with the huge phallus, and the book got seized at customs and deemed obscene.

Fan Mail, Frank Letters, and Crank Calls *(Hanuman Books, 1988);* Garden of Ashes *(Hanuman Books, 1990)*

My printer, who was a wonderful Hindu gentleman, a devout Hindu, very religious, suddenly was called up on obscenity charges. But he really stood behind us. He said, "I know this is just a lot of stupid people over here that just don't understand this is a Roman statue. I know what you're doing is serious." But it was seized in India, there was an obscenity trial, and we were found not guilty so we got the copies back.

Cookie thought it was great. There's nothing a writer would rather have than an obscenity trial. What better publicity, except the fact that it was in India. It didn't make much of a dent over here.

ANNE TURYN: Everyone downtown back then knew about Cookie's writing. I had met her before in passing, and then probably in late '83 or early '84 a mutual friend said, "Cookie wants to publish a book—*How to Get Rid of Pimples*—do you think it would be good for Top Stories?" and I said, "I think it would be perfect." The first Top Stories came out in very early '79 and my philosophy with Top Stories was to let the person, whether it was a writer or a visual artist, pretty much do whatever they wanted in between the front and back cover. And I remember she definitely wanted an index. We had never had an index before. It was just something she wanted to make it look like a real book.

So, she had the manuscript and she just told me to use these three photographers, Peter Hujar, David Armstrong, and Nan Goldin, and then she left town. It was the beginning of summer and she was about to go to Italy. She just sort of left me directions, and told me to put pimples on the photos; you'd have the same person with and without pimples, for "before" and "after". And Peter Hujar helped me a lot, I had anxiety not knowing quite what she meant about the pimples. So he ended up doing them. I think he just took out a pen and made pimples on the photos.

SCOTT COVERT: One of the last things she worked on was trying to turn a story from *How to Get Rid of Pimples*—the one about a girl named Dorothy, which was Cookie's name as you know, the nightclub story about the girl who cures people—into a screenplay. It was a good idea, a period piece about the '80s.

ANNE TURYN: Those were probably the heyday years, for Top Stories, when Cookie did it, with Jenny Holzer and Kathy Acker and Lynne Tillman, Jane Dixon—some pretty well known downtown writer types. Constance DeJong's came out a year before, then there was Ursule Molinaro who was much older and more known in literary circles. And Pati Hill.

Cookie was one of the downtown people who was doing interesting things with writing. People call it "downtown writing." I was interested in a kind of writing that was more plastic. Like what could you do with the shape and the form, coming out of Gertrude Stein, a form that is moldable. Breaking rules of how text or conventions would be.

SHARON NIESP: Cookie always wanted to be out, doing, doing, doing. She was focused on having a career. Yup, if you got it, you got to do it. Otherwise you're a miserable fuck.

BILLY SULLIVAN: She was an art critic, a health critic, she made her own clothes, she did everything, she was a walking renaissance.

CHRIS KRAUS: Somehow she could translate that presence as an actress and performer into her writing. It was such an effortless segue between her life and her presence as a writer. A manifesto for a life.

MICHAEL OBLOWITZ: She was a different kind of woman. An absolutely postmodern woman. She supported her son, she was writing for a newspaper, she was writing a book, we would hang out with Kathy Acker... I was studying with Sylvère Lotringer at Columbia University and we did an edition at Semiotext(e). It was a magazine called *Schizoid Culture Polymorphous Perversity* or maybe *Polymorphous Perversity or Schizoid Culture*, I can't remember. I'm sure there's stuff of Cookie's in those editions.

MARCUS REICHERT: Everyone's trying to find their own way of writing, and hopefully it's an honest way of writing. When what you're

**TOP STORIES**   #19-20                    $6.00

# HOW TO GET RID OF PIMPLES

## BY COOKIE MUELLER

# INDEX

doing is connected to your life—and I think that's what she was trying to do—there's a truthfulness to it. Cookie's writing could be very amusing and wry. She had a dark sense of humor, but a slice-of-life view of things that makes the writing interesting and amusing. There's a tone to it, I think, that gets to you.

PETER KOPER: What she wrote was her inner core. That real humanist sense of humor and absurdity. I think Cookie's cosmology was that warm, bemused detachment.

SCOTT COVERT: She wrote a short story, "The Mystery of Tap Water," where she talks about wanting to become invisible. You are what you eat, so she just drank water to become invisible and eventually that's why her friends put her in the nuthouse in San Francisco, which she then escaped. I once asked her, "So how did you escape the nuthouse?" She just answered, "I turned invisible." That's all she said.

PETER KOPER: As funny and crazy as her stories were, they always had these beautiful, gentle, affectionate endings, and that's what I see in her. She had this deep inside her: the sentimental melancholic, laughing at herself, laughing at the absurdity of life. This was the sort of Buddha Cookie, hovering over the situation and seeing the wholeness of it. That's her.

RICHARD HELL: I published some of her writing in a literary magazine called *CUZ* I was editing in the late '80s. Her go-go dancing piece was in the first issue of the magazine and I published our collaboration—the poems we did together. There are two that just she and I did together and three that we wrote with H. M. Koutoukas. We would just pass the paper from person to person; we used either a typewriter or wrote by hand. I had her give a reading at St. Mark's Church, at the Poetry Project.

LINDA YABLONSKY: She started doing readings in bars. There was a magazine called *Straight to Hell* that she published a few stories in, and she would do these readings at places like the Pyramid Club or places in the East Village that don't exist anymore.

LYNNE TILLMAN: I remember doing a reading

with her for Linda Yablonsky's reading series, and I think that was at the Pat Hearn Gallery. And I remember reading with her at Clarissa Dalrymple's Cable Gallery, which was on Broadway and Houston. It was a beautiful old building, the Cable Building it was called. We read together with a bunch of other people, maybe Max Blagg, maybe Gary Indiana. I think her writing was very sharp and funny. She was observant and I think she could accurately depict a scene that she was seeing.

RAYMOND FOYE: She did a wonderful reading for Hanuman Books. There's a tape of her reading the story about the guy who's into getting peed on in sex clubs. It was a benefit reading we did for the press: Allen Ginsberg, Herbert Huncke, Gregory Corso, John Wieners, René Ricard, David Trinidad, Eileen Myles, Bob Flanagan, Vincent Katz. A stunning group of people at the St. Mark's Poetry Project, in the church. Absolutely packed.

MAX BLAGG: She was a great reader of her work. Really funny and droll. She had people howling with laughter. She was a poet, too.

RAYMOND FOYE: Her voice was slightly sand papery or raspy, a very unique voice, very warm and expressive, had lots of ups and downs to it.

CARLO MCCORMICK: She was beautifully unprofessional about everything she did, and I mean that as the best compliment. There was nothing slick about it, and it was always good. She came from the same short attention span that we all did, so her readings weren't some interminable thing; she always kept them short and sweet and light and funny. She had a good sense of timing... she was a natural.

GABRIEL ROTELLO: She really built up quite a following as a writer, I think even among people who didn't know her and weren't aware of her as an actress or a figure on the downtown scene—just people in suburban New Jersey or whatever. She had a voice that was very distinct, which is something that a lot of writers don't have, even people who study writing. It's something you've got or you don't, and she had it naturally. I always thought that might

have been what she would be most famous for, ultimately.

CHRIS KRAUS: It's a gift to be able to tell a story that's a written text, a literary text but make it sound like someone is just sitting down and entertaining you by telling you a story. She's a raconteur.

CHI CHI VALENTI: Just today I was thinking of something that Cookie wrote about the homeless in one of her essays. I saw this man, and he looked like he was really wasted—I assumed from AIDS—and he was lying on the street and I was thinking of this thing Cookie said: "Pretty soon we'll be stepping over the bodies of people dying of AIDS to go out dancing." I don't know if that was something she just said when we were sitting around or if she wrote that somewhere, but it's extraordinary that you would still reference somebody who's been gone that long almost like a philosopher.

PAOLA IGLIORI: The other day I was talking about Cookie, about how she told her stories, like the one when she was little and she went travelling with her parents and she would look at everything with these giant eyes and then she realizes that the eyeballs are the only thing that always stay the same size. You're small but you already have your grown-up-sized eyes.

I don't know if that's true but I always remembered that.

SCOTT COVERT: Oh yes, in "Art and About" she talks about the sharks and the souls. She believed there were too many people and not enough souls, so a lot of people were getting other types of souls, which is why they were sociopathic. Like, a shark soul would jump into a human body. She also believed that some people didn't have souls.

RAYMOND FOYE: And often times it's ordinary women in working class situations who have this kind of wisdom in her stories. There is a strong matrilineal lineage of wisdom and knowledge that comes through in her work, I think. There's one episode in one of her books where somebody is complaining about being

depressed and she remembers this aunt of hers, who had a mentally retarded son, saying, "Well, thank God you have a brain to get depressed with."

MARCUS REICHERT: I think everyone finds their own language, some particular aspect of the person comes into their writing. It's the texture of their psychology that's manifest in the writing, and I think that's very true of her. That's what makes her writing so interesting, gets her writing so close to people. We all sense that we have that within ourselves but it's rare that somebody can connect with the reader in that way.

RAYMOND FOYE: The great works of art, it's like they unwind themselves. Like a mechanism that unwinds and they continue to have relevancy, continue to have something to say. Like what Ezra Pound says, "Poetry is news that stays news." Cookie's work remains terrifically fresh.

JOHN WATERS: Looking back on the whole thing, I wish Cookie had been a writer from the very beginning. She was a better writer than an actress, and I think she would be the first to say that. Her books are brilliant. I love her in my movies, but the books are brilliant. The acting thing she tried, and she worked with me and she worked with other people, but it never really went very far. But the writing could have. Her writing was the best to me, not as a critic or as "Ask Dr. Mueller," but when she wrote about herself and her life. It was incredibly moving, incredibly sweet, true, and funny. And she really didn't start writing until late in her life. I have all her books. *How to Get Rid of Pimples* is a great title.

JUDITH PRINGLE: There's very little about Cookie that she didn't say about herself. All her stories are so personal, you really get such a sense of who this woman was. What about Cookie could we reveal or say that everybody doesn't already know?

*Cookie's notes for her story "Brenda's Losing"*

Brenda Losing 2.

~~She sat in the living room watching a light outside. Though the window, although the glass seemed~~ indiscernable, she saw the actual shape of the light bulb itself and the ribbing on the lampost.

Some one had asked her if she wanted to leave with him. He had the car. She thanked th~~two~~ hostesses and began putting her coat on. Her ride was already waiting at the door. When shepulled herself out of the chair and brought herself to her total four feet six inch height. Small. Two years age she was ~~five feet and five~~ inches but because of a horrible and delicate operation she had had her thighs removed. Together lenghtwise thethighs measured a good twenty ~~two~~ inches,.

The worst disadvantage was not caused by being squat but by new having a vagina that began and ended at her knees.

No one really ever noticed because she were long dresse all thetime. People gossiped though but she held herself proudly and feared ~~meene larger~~. who also had no secrets. It was always the short folks that held things back. Some had hemmreids some had unsavory pasts, perhaps a few had even murdered. some one. There was absolutely no way of knowing.

So she went home. Luckily for her she had someone who had begun to live with her before she had th operation. This person who was a woman loved thighless Brenda very much. Nothing physical could change a feeling so profound. Brenda was lucky that she didn't have to search for a husband or ~~a~~ a lover to satisfy her needs new than she was so short. She could never have done it. Breda was shy evenbefore her operation.

She fought less now with her companion. They had horrible fights about money and inertia before. Things seemed less difficult now and Brenda seemed happy. When they made love things were also different. Brenda could easily bend at the vagina giving her a remote feeling of distance with her mate.

It was all fine for a year ~~and then Brenda~~ and three months and then Brenda's girlfriend found someone who had long legs but not much sense.

209

*"Dodge Lee had a secret life. It was the kind of unimaginable, unacceptable, and grisly secret life that would horrify most friends and casual acquaintances. In fact this secret life was something that horrified ninety-nine percent of the population of the world."*

—Cookie Mueller, "The One Percent," *Ask Dr. Mueller*

SCOTT COVERT: Like Richard Hell said, "When she walked into a bad party, she cured it." That was one of her miracles.

KATE SIMON: I would see Cookie at clubs and we always had this great rapport. "Hi hon." She talked to everybody like that. She always looked fantastic, so I'd say, "Cookie, you

look fantastic, where did you get that dress?" "I made it." And I'd say, "You're kidding!" I loved that about her: she'd create her own perfect

black dress. So I'd ask who she came with and she'd say she was alone. "It's a lot better," she'd say, "You don't have to think about what someone else is doing and you can leave when you want." I always thought that was so cool—and very Cookie, too.

STEVE BUTOW: We would be drinking at Boots & Saddle and we'd wanna cop so we'd go to Cookie's house and just hang out there. She'd go to some of the clubs with me sometimes. I never went to those straight clubs like Mill Bar, Area, Feron, and Danceteria too much.

PETER KOPER: We would go to the Eagle, the Mineshaft, the Glory Hole… I'm a straight guy, but some of these places were semi-hetero as well. Hellfire was one of our favorites. I went with Sharon and Cookie. John Waters and I would go to the Hellfire like it was one of our local bars every time John was in town. John would stay with me, I had a windowless first-floor apartment in Tribeca, which was completely different in those days: a construction site, totally abandoned. We would go out to these sex clubs and Van Smith would be there. I remember going with Van to the Eagle once with my girlfriend, who was turned away, and Van just went nuts, he wanted to beat up the guy when they wouldn't let a girl in. These were totally male clubs. Van was a Southern kid and he wanted to uphold the woman's honor and by God he was going to beat the shit out of this guy. Van was a smart-dressed guy in Brooks Brothers. He would wear tweeds and a duck print was his idea of something to hang on the wall. But there he was being a drunk, being a junkie, and being a low-life cocksucker, whatever they were doing in those goddamn trailers!

STEVE BUTOW: Hellfire was a bisexual S&M club. It was literally under 14th Street. Now it's a chic area, but in those days it was junkie drag queens and after-hours gay bars with back rooms. You could check your clothes

# PRIVATE CLUB
## MEMBER'S ONLY — FAGS ONLY
# 835

Straight couples would come from Queens dressed in polyester and would change into S&M outfits or walk around nude. People would get whipped. Disco had died, but you could still get high and hang out all night, just it wasn't in a disco—it was in Hellfire. One night we took Quaaludes, and I think that's the night Sharon broke a chair over Cookie. They would fight a lot and Sharon would pace back and forth.

PETER KOPER: Hellfire was three floors below street level. It was like an abandoned subway stop. It had these columns and the rainwater from above would seep through two floors and end up as these stalactites. The floor was always a little wet, as if it had been raining. There was a bar in the middle of the room—horseshoe-shaped—and the drinks were really cheap, like $1.50 or something for a Jack Daniels. The main room had some slings and there was always this guy there called Pops who kind of looked like William Burroughs. He was in his seventies or eighties and he had really shiny black shoes and pull-up socks, like over-the-calf socks, and nothing else—nude otherwise. He'd be sitting in one of those torture chairs, a leather swinging chair, beating off the entire night in a corner.

Then in another corner there would be some guy leading his gorgeous Thai girlfriend around the crowded place with a red ball in her mouth, all tied up. In the middle was a tiny stage where somebody would be whipped. In the back were these small cubicles and they had two bathrooms. I was with John once and he says, "Bathroom's over there," and he smirks and I go get in a line of men. The guy in front of me steps up to what I think

is a porcelain urinal but instead it's a bathtub with a guy in the tub and you piss on the guy. That was the men's room. Believe it or not I brought dates there. I would test their sensibilities.

JOHN WATERS: You could go to Hellfire and totally *not* participate. You could go and watch everything. It's hard to imagine, but it was straight and gay mixed together.

MICHAEL OBLOWITZ: I would go to Hellfire with Cookie and she would often wear a black German officer hat. It was almost cliché but it looked really hot on her and she'd wear a black leather biker jacket and extremely tight black leather pants.

PETER KOPER: It was wild. One time Cookie said she had to go to the bathroom but she didn't want to wait for the women's bathroom so she disappears somewhere and then Sharon tells me to come here and took me into one of the back cubicles with the little sex scenes and there was Cookie, squatting, taking a piss, surrounded by guys just watching her. She just couldn't hold it any more! Hellfire was one of her clubs. The story was that she took Francis Ford Coppola there. The most shocking thing I ever saw in Hellfire was a couple of Hassidic Jews walking around. They found out about the club and were checking it out.

MICHAEL OBLOWITZ: At that point in New York, there was this extremely deviant sexual world. Today if you go down the West Side Highway, where all those big warehouses and wharfs are, they've become sports centers and recreation centers, restaurants, galleries. But the West Side Highway, down 14th Street and Christopher Street, used to be extremely

run down, full of desolate buildings, broken-down warehouses, gaping holes reaching into the Hudson River, and rats everywhere. Those warehouses were frequented by gay men looking for anonymous sex. They were really dark sexual places; a lot of orgies would take place there among strangers. It was a radical place, something out of Genet.

DAVID ARMSTRONG: It was really fun then, particularly in the late '70s, because that was when there was that whole thing about uptown and downtown.

KATE SIMON: A time when you could say, "I'm going downtown," and that had several meanings. Now, going downtown—you're going to find a cupcake at Magnolia Bakery. Then, going downtown meant going downtown in every way. It was subterranean.

DAVID ARMSTRONG: The Mineshaft, the Anvil, and the Internationale were the biggest ones. It was endless; every day and night there was stuff to do, and at the time we were certainly up for it. They weren't really welcoming to women, but Cookie went.

MICHAEL OBLOWITZ: Cookie was one of those girls for whom nothing was too taboo. We would go to these places with 19th century bathrooms that were made of porcelain and there would be holes in the walls and you'd see penises coming through these holes and then other men would come in and give these guys blow jobs; it was fucking insane. Cookie was fascinated by all of this and I guess I was one of the few people crazy enough to go with her!

BETTE GORDON: Cookie was a feminist. I don't know anyone who wasn't—from Vivienne Dick to the Wooster Group girls, Deborah Harry… All the women around me were breaking ground all the time. Until that point, certain behavior was taboo, so we were embracing our sexuality and going into areas—into dark places—where we were told not to go. It was a defiant embrace of who we were as women. I feel like these women were living lives that were already feminist. They didn't have to be defined by anyone but them. They were writing their own playbook and not losing any sleep over it.

PLAYGIRL/OCTOBER 1984

LINDA OLGEIRSON: There was this whole group that would hang out at One U—One University Place—when that was really a hot place owned by Mickey Ruskin, who had owned Max's Kansas City. Sharon was working there, I was working there, Linda Yablonsky was working there. They had good food—crabcakes. It was the kind of place where if you were doing nothing in your apartment, you could get in a cab and go there knowing you'd see friends. You knew that somebody—if not six, seven people—you'd want to hang out with would be there, the way Max's Kansas City was.

SHARON NIESP: Mickey's was the greatest. One U had a bar in the front and dinner tables and booths in the back. People would go there and drink from the time it opened until the time it closed. You'd go in shifts—go and come back. It opened at 11 a.m. Steven Mueller would be there at 11:30 a.m. and we'd all be there by the afternoon. Helen, who was married to Brice Marden, was waitressing then; it was very early

on, before people had gotten their props. They were just young artists that were more up-and-coming. It was just a cool place. All our crowd hung out there. It wasn't inundated. It wasn't celebs and flashbulbs and "Oh, it's so fabulous!" It wasn't a celebritorium. It was more… *gurgle gurgle snort snort*. It wasn't a drug den, but it was a combination of everything without the elit-

ism. But after Mickey Ruskin died, it just fell. One of my other favorite places was Better Days. It was up in the forties and it was a black crowd. A lot of the girls—the hoes—would go there when they finished their work, and this guy Sylvester—he had a really beautiful voice, died of AIDS really early—used to go there a lot and would just sing. He'd sit in the back room, which was all mirrors, and he would sing without a mic, just sitting on one of the round stages. There was a round bar in the front and

there was red fleur-de-lis wallpaper. It looked like a real pimp bar. And then we used to go to Escuelitas, which was a tranny bar. You could dance there; it was more Latin. And then there was Sally's 1 and then Sally's 2, Sally's Hideaway. And the after-hour joints like Continental and Berlin; you could stay there till 8:30 a.m.

LINDA OLGEIRSON: At that time, there were a bunch of after-hours clubs—mafia-run—on Houston Street. I wanted to have a sunglasses concession and sell sunglasses outside the door for people who would come out and be blinded because it was 10 a.m. and they'd been up all night.

Another idea I had in the '70s was to have a bakery open between 2 and 5 a.m.: Stoned Pastries in pink neon.

SHARON NIESP: When I came back to New York from New Orleans in the mid '80s, I went to EMT school and worked on ambulances. I'd

be driving up 2nd Avenue at 8 a.m., drinking coffee, waiting for the emergency calls to come in, and I'd see people coming out of Save the Robots or some other after-hours club in the Lower East Side, and I'd put the siren on when they got in front of me—*vup vup VUP!* They would be all coked out and drunk and hung over and have sunglasses on and just scream.

CHI CHI VALENTI: I met Gennaro Palermo on New Year's Eve in 1980. He was painting the staircase of the Mudd Club gold, and if you know anything about metallic paint, that was a stink bomb. Everyone breathing in the fumes, oh, it was a gorgeous party! There were all these people who just lived to create themselves at night, and I would say that Gennaro

# XENON

was someone who took it further than anyone, just made the most incredible, elaborate personas for himself, but not in the sense of drag—always as Gennaro. To support that, he was also a bartender, a coke dealer—whatever. He is so fondly remembered. He died years ago and yet left absolutely nothing behind except what Greil Marcus called "lipstick traces." It was a time when there weren't that many photographs taken at night. If you look at the total amount of photographs that exist from the Mudd Club compared to some crappy frat-boy party now, where everybody might be photographing, there's just so little in the material world that lives from these people.

BILLY SULLIVAN: Cookie's whole life was inventing what she was going to be. She would start dressing late in the evening. You'd go by the apartment and she'd either be sewing her outfit together or coloring her hair.

RICHARD BOCH: After the Mudd Club, I worked for several years as the manager at One U so I continued to see a lot of Cookie. She was one of the biggest stars downtown and she didn't play that card *ever*. When she arrived at the door she was always patient and she never had

to wait. I never made her pay, even on nights when, allegedly, everyone had to. She was one of the most gracious people at the door. But that's how she was. I never saw her crazed or flustered. No drama. You're not going to hear a lot of people say this, but Cookie was a lady.

CHI CHI VALENTI: Gennaro and Cookie were really kindred spirits, because they loved a kind of offbeat beauty and glamour, and had no choice but to live their lives that way. We would do these party-line conversations because Gennaro was in love with three-way calling. I think he was one of the first people who wasn't a businessman who would get people on a conference call.

BILLY SULLIVAN: Bar Bar was a gay bar on 2nd Street and 2nd Avenue. I used to go there and Gary Indiana used to go there, everyone went there. It was one of your last stops on a slow night. I'd go there to see if I'd pick some-

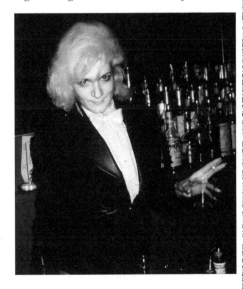

*Chi Chi Valenti at the Limelight, c. 1982 (Billy Sullivan)*

body up or see what would happen and often Cookie would be there.

SHARON NIESP: There was a restaurant I worked at right underneath our apartment on Bleecker and 7th. The owner was Argentinean; he had really long, beautiful hair and really dark eyes, was really tall, and made huge paintings. His brother was a surgeon and they used to get top-of-the-barrel cocaine, still in the lumps in plastic. So he'd set up the stuff all the way across the table and we would all go snort and then we'd be ready for the masses. He was such a good chef that people from the *New York Times* would line-up to get tables. He'd be open till 2 or 4 a.m., and of course we would stay after. They'd close the place off and people would come in—Cookie would come in—and we'd just drink at the bar. It was like a whole after-hours bar/social thing. And when the drag queens would come in, during prime time supper hours—when all the rich and wealthy were dining—they would sit at the bar and throw their raggedy furs on a table in the back cause we had no coat check. There was no supervision, so when they were leaving they'd pick up all the expensive, real ones, like minks and ermines from the wealthy clientele that'd be dining there! They'd walk out like, "Bye darling, gotta go," and then they had private detectives coming in. It was like a big, huge, scene, oh my God. Working there, we were treated really well; we all got steak dinners. It lasted for a pretty long time, and then one day the owner got so fed up with it that he just closed the doors and left. Nobody could find him and the wall was all exploded. It was like walking into a crime scene.

JOHN HEYS: One night Cookie and I were at her place, one of the rare nights we stayed in, and we decided to make a list of every nightclub we had ever been to. Some stood out easily, like Palladium, Area, Danceteria, or Mudd Club, naturally, but others opened and closed like, *snap*. We were just writing this list for hours, and it was really long. Longer for Cookie, because she went out more than I did. I don't know how she did it. But if there was a party at Area or Palladium,

WATCH

she'd need something to wear and would want to make something new, and then in the course of like three hours, she would sew a new skirt or dress—usually short. She had really good legs and a nice body and she liked to show it off. I'd pick her up and there'd be this new outfit.

LINDA OLGEIRSON: Did Sharon ever tell you when she decided she was in love with Cookie? When she opened Cookie's closet and saw all these great shoes, she decided Cookie was the woman for her! All these great high heels—Spring-o-lators. Cookie made her wedding dress, and was supposed to make mine, but she was too high all the time and never got around to it.

SCOTT COVERT: Yes, *yes,* she had a lot of shoes! Closets full. She always wore heels. She had beautiful legs, incredibly beautiful legs.

JAMES BENNETT: One time Robert De Niro cruised Cookie and followed her down the

block. I remember her telling me that. She said he was walking towards her and then he turned around and gave her that look, and then he followed her for a while. That's what she said, and that was back when he was with that gorgeous black woman. Cookie was quite... *vavavoom!*

AMOS POE: Cookie was wonderfully out there, but not in a grandiose way. She could be flamboyant: her clothes, the hair. God, her hair was crazy. There was not a hint of "fashion" about her—it was complete style.

KATE SIMON: Chic as a motherfucker.

JANICE BIRNEY: Alternative, but chic, and the hair, the hair! She used to do her own blonde streaks, and it had this ratty look, like rat's tails, but on purpose. It certainly *looked* on purpose. She had her own style, she wasn't up with the latest trends, she didn't give a shit.

JUDITH PRINGLE: One time we were going to the Christmas party at John's. We all lived in New York and were all taking the train down and Cookie had these boots that were really high-heeled, kind of pointy, almost a dominatrix style but also very low, they were around the ankle. At the moment the fashion was boots that came up mid-thigh. So she simply went out and got pieces of leather and fashioned them into a tube that she slipped over the boot and *voilà*, she had some fabulous fashionable boot that on closer inspection was just some things she cobbled together.

SCOTT COVERT: I knew Cookie from the '70s—from *Pink Flamingos*—and honey, she wasn't trendy or even part of a trend in fashion. I was always a fashion-conscious person, and I can't tell you how many times I sat in a cab next to her on the way to an opening or a club and she would be sewing a dress or working on the dress she was wearing. I'm an old drag queen from New York City, and honey, Cookie was the *real deal*.

LINDA OLGEIRSON: There was always this little theory going around; I still believe it was absolutely true. Cookie, of course, was always everywhere—at nightclubs, all over the place—and it always seemed that she'd be wearing something and then not much later, Betsey Johnson would all of a sudden have something similar. I always thought that Betsy would see Cookie around and knock her style off, as a fashion designer.

JOHN WATERS: She made deconstructed outfits way before Comme des Garçons. She had a line of clothing and a label that said COOKIE and everything, but they took ages to make. She would take orders and never finish them because the clothes were so hard to make. She didn't have anyone working for her. She did them all herself—she'd be sitting there like Betsy Ross, sewing all day!

STEPHEN MUELLER: It was kind of like hippie meets Vegas showgirl. I mean sometimes they were actually quite amazing designs. She would make a big evening coat or something. She dressed to go out. Even in the daytime, she was dressed to go out at night.

STEVE BUTOW: She could make anything look good, even with her rags and bracelets, which would make her arms turn green.

SCOTT COVERT: She was very ritualistic with her jewelry, she had incredible jewelry. She had a lot of jewelry but always had her set jewelry she always wore.

STEVE BUTOW: We used to say that Madonna ripped off her look. I mean, she was around when Cookie was running around, and Cookie was very popular.

MARK BAKER: And also—hello—she was running around with movie stars and fashion models. She was very exotic. Did you know she was an exotic dancer? She helped

*Cookie, East Hampton, 1981 (Billy Sullivan)*

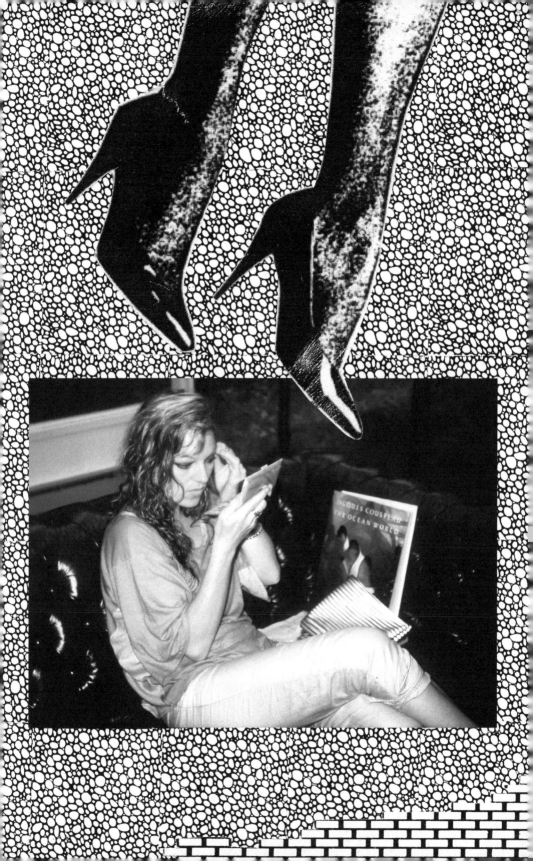

create that whole downtown look just by being herself. She was great friends with Van Smith, who designed Divine, and she knew famous fashion models but she had her own distinct look and fashion. And that wonderful exotic eye makeup.

JAMES BENNETT: Her appearance was always very important to her, although it didn't seem that way. I remember when she was in Italy, she ran out of lip liner or something and there was a forest fire so we couldn't get to a pharmacy. We were going out that night and she was really panicking, so she thought of using art pencils or oil pastels—I don't know what the hell they were; they were like colored pencils—and there in the car she's doing her whole thing and then there she was! She had her whole look.

SCOTT COVERT: She always wore makeup, that was a ritual.

LINDA YABLONSKY: She would insist on going to bed with full makeup on so she could wake up ready to hit the streets and still look good.

SARA DRIVER: I remember the first instance I saw her. It was at this Christopher Makos art opening; it must have been '77. The photo series was called *White Trash*. Cookie had on these thigh-high stiletto boots and a miniskirt. She was always wearing dresses and miniskirts. We all wore black and tried to look androgynous so that people wouldn't pick on us, but she wasn't afraid of her femininity, of her ability to manage in the world. She was fearless in that way.

BETTE GORDON: She was so elegant. That's what struck me about Cookie—while she operated in a world where everybody was kind of messy, she was so elegant. She just had a flow about her; she was like the Grace Kelly among everyone else. When everyone had short hair, hers was long and flowing and beautiful. Her skin was so translucent… she was like an angel, and was so nice to everybody.

LESLEY VINSON: She had this great cheap face; it was very sexy. It wasn't like those people who even if they're down in the gutter they have this face of an angel. There was something Stevie Nicks about her—kind of witchy.

MARK BAKER: Very exotic, like Xena Warrior Princess of Manhattan. There was that magic of her urbanity.

RAYMOND FOYE: She did wear things that were talismanic or amulet like. But more in an ancient folk way, like a wise person rather than someone who was like, let me read your tarot cards.

BILLY SULLIVAN: It would be a beehive with cat eyes; it always reminds me of this movie with Catherine Deneuve and Pierre Clementi in the late '60s, you know with pencil thin skirts but Cookie's style was always just a little wilder. She really understood the '60s and '70s and she'd just interpret it in her own way.

EUGENE FEDORKO: A captivating, charismatic demeanor like Anouk Aimée, that French actress, and an Ava Gardner glamour. She had a glamour about her that was beyond ordinary.

MARCUS LEATHERDALE: Cookie was just so diverse, so ambiguous. You never knew whether she was a girl or a boy. She was glamorous in that disheveled way. I mean, she looked amazing, but was never quite together. She might have her hair all done up, but part of it would be falling down or she'd be all made up but her makeup would be a little smudged or she'd be wearing a fucking fierce evening gown but the hem might be loose or undone.

SCOTT COVERT: If she painted her nails they would never be sloppy. They wouldn't be chipped. I don't remember sloppy fingernails. She would take care of her body. She was orderly. She knew where her clothes were in the closet. Her clothes were hung. If something wasn't there, something was wrong.

BOBBY MILLER: I used to color her hair for her: White Minx, it came in a grey bottle. I would love it when she would do her makeup. I used to go over to her place and try and give her

*Cookie, 1981 (Ileane Meltzer)*

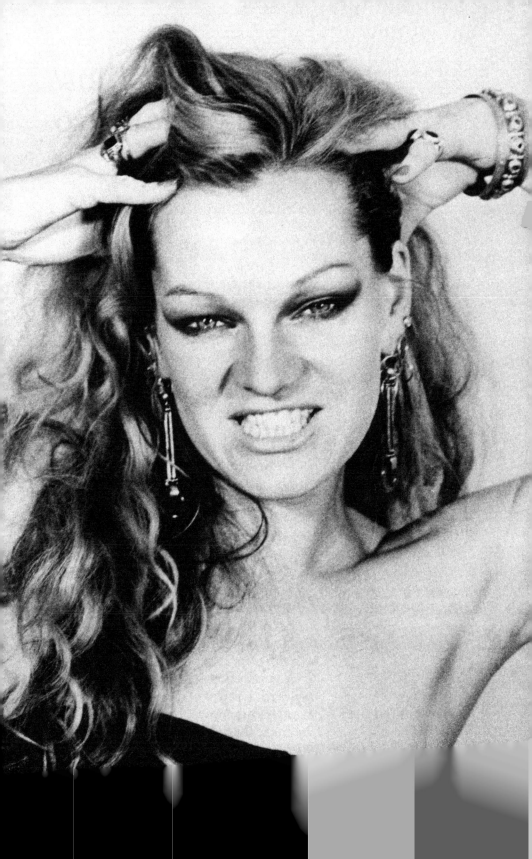

tips or ideas and she'd say nothing but give me the look, and then I'd learn something: why would you want to make her look like everybody else?

RICHARD HELL: For me, she was kind of the ideal of the attitude and the way of life I was looking to when I came to New York. When I was 17, I was looking for this fantasy of artists who rejected conventional ways of life, and she really was unconventional in the way she lived and uninhibited by anybody's attitudes towards her. At the same time, she was really sweet and actually insecure, and was very sophisticated while also being not judgmental or snobbish. People who are very sophisticated tend to be hard and cynical and sarcastic; she wasn't like that at all. She was just a sweetheart, just into pleasure and adventure with this really fun, trashy side. I completely related to that whole trailer-camp, kind of tabloid-paper thing—always entertained by and identifying with everything trashy. So we had great times, and to me she's always represented that ideal New York artist way of life.

CARLO MCCORMICK: At that time, there was a sense that you lived your art and your art was your life, and the separation was quite opaque. You conveyed who you were through your work. The way you were socially at nightclubs, the way you dressed, all these things were part and parcel of this whole invention of persona, and Cookie was one of the really good ones from that time who had the whole package.

ERIC MITCHELL: I suppose she was kind of the embodiment of the '60s, but without all the hippie things that go with it. It was more of a human thing. You actually felt like she was your mother or something, like she actually really cared.

JOHN WATERS: Cookie was always a glamour girl, but I think that was because her mother made her feel like she wasn't pretty when she was young. I think she told me that her mother would say, "Well, you aren't the pretty one," or something horrible like that. Maybe the mother didn't realize how terrible that would make someone feel. Had Cookie lived, she would have gotten facelifts. She got one when she was alive, and it didn't do one thing! She got a cut-rate one. I said, "Whatever, it looks the same to me!" She got the bags under her eyes removed, but it didn't do anything.

GABRIEL ROTELLO: Cookie was a classic example of the idea that beauty is not necessarily based in physical beauty. If you just looked at her using a technical view of female beauty, you would not necessarily say she was a beautiful woman as far as bone structure, symmetry, skin tone, all the things you look at if you're a photographer evaluating a potential supermodel. But every time she walked into a room, into a club, even just walking down the street, heads invariably turned in the way they would for a supermodel. Because, despite her physical structure, she was staggeringly beautiful. But it all came from inside. I used to think of her almost like Bette Davis, who was the same way. If Bette Davis had just had a normal personality, you would not say that she was a particularly beautiful woman. She wasn't bad looking, but she wasn't gorgeous. But because there was something bubbling up from deep inside, she was beautiful, incredibly beautiful. She blew people away. Cookie was a total head-turner, everywhere she went, no matter what she was doing. It wasn't about the makeup or her fashion sense, it was this incredible inner beauty that just exploded around her and made her the object of attention and adoration. She had about the strongest presence of anybody that I've ever met in that regard.

*Cookie, 1981 (Ileane Meltzer)*

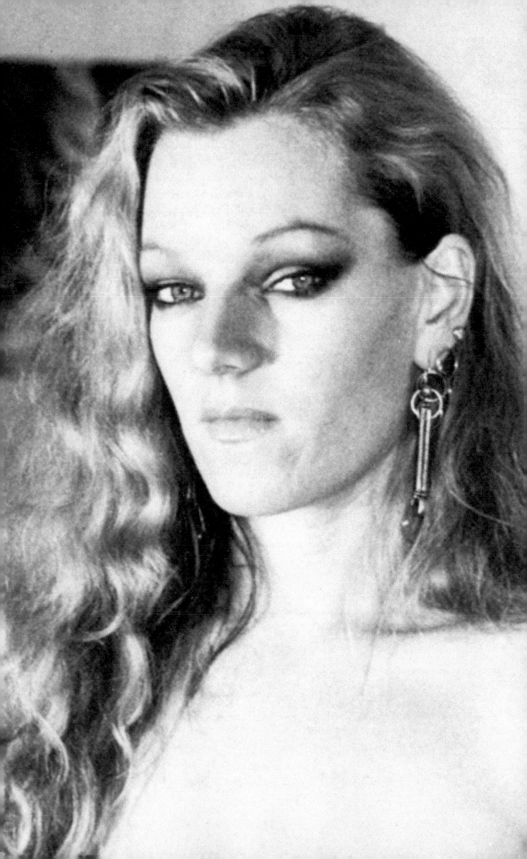

## THE PAIN PIT

*"I was so wildly miserable I was projectile vomiting at the very thought of facing another morning. I couldn't be at home for more than twenty minutes at a stretch; there were too many reminders. I couldn't eat; food tasted like rubber. I lost thirty pounds; I was skeletal. I couldn't sleep. My eyes, the proverbial mirror pools of the soul, were as mired as a peat bog. Beneath the mascaraed lashes were bags and dark circles. My crow's-feet looked like road maps. I was in pain. I was learning firsthand that one can actually die from a broken heart. What poets have always warned us about is true."*
—Cookie Mueller, "The Stone of New Orleans—1983," *Ask Dr. Mueller*

MINK STOLE: The whole time Cookie was with Sharon, she was having affairs with guys. I lived upstairs from them for a few months when I moved to New York, and I must say, living upstairs from Cookie and Sharon in '78 or '79... it was constant. They were the most volatile couple. Sharon would come running up the stairs saying, "Cookie killed herself, Cookie did something awful," and Sharon would be all upset because Cookie had had sex with a guy or something so she would come up with a story. Then Cookie would come up with her side and I never knew what to say. There was nothing to be said; they were insane.

SHARON NIESP: When I was still living on Bleecker Street, I came home one day and she had a bass in the oven. She never really cooked that much, so I say, "That's nice," and she says, "That's Richard's dinner."

RICHARD HELL: I saw her a lot during the period when she was doing the go-go dancing. She said she liked dancing because it kept her body toned. Yeah, we had a romance. I guess you could call it that, but there wasn't anything complicated about it, you know.

MARINA MELIN: Eventually Cookie was really

feeling her bisexual needs and was seeing men, which drove Sharon mad.

SHARON NIESP: We would argue a lot about dumb-ass things. We never actually really *argued* about her sleeping with guys. It would happen and it would be like, okay, well, it happened. It's a difficult situation to deal with. I had to meet the boyfriends and be the gentleman. We all remained friends, mostly, all the boyfriends. I wasn't one of those stupid-asses who whines and complains. She wanted an open relationship. She wanted to fuck whoever she wanted, and I was supposed to be nice to all the boyfriends. And then finally, *finally* when I caved in and started seeing somebody else, or a couple people, when the situation was reversed, there was this big flip-out scene. I just thought it would keep going on and on and on. We couldn't do it anymore.

JOHN HEYS: Cookie cried very easily, she was very sensitive. I can remember them having crazy hissy fits or losing their patience and Sharon stomping out like the butchest woman on the face of the earth, but they'd always reconcile.

SHARON NIESP: I'd disappear for a while. We didn't have *fight* fights every day like neurotic couples do. I would just disappear.

JAMES BENNETT: I remember one time when a lot of sex clubs were around—sometime in the late '70s early '80s—Cookie was making out with some guy and Sharon got so pissed off that she took a chair and bashed her on the head. The next day I saw Cookie when she was getting out of bed and she said, "Oh, I have such a headache. I must have had a really good time!"

PETER KOPER: I don't know, I wasn't there. It doesn't sound like Sharon. I've seen Sharon angry and worried—that worried look she always wears—but never violent. But hey, they had a tempestuous time. Sharon was deeply, *deeply* in love with Cookie.

SHARON NIESP: We were in Hellfire, where high school teachers strapped in leather used to swing on a trapeze. It was all sort of

animated. So we're hanging around with this English guy and they were getting a little *too* friendly. Whatever she did away from me, okay, but not in front of me. That's just rude. So she's sitting on his lap in this skanky room on this folding chair against the wall and he was like, "Oh, *ooohh*," and she's drunk, listening to him, and I'd had enough of the rudeness. I didn't say anything and picked up one of the folding chairs—like the ones they have in church basements—and very quietly walked up to them and smashed the chair against the wall above their heads so the wood would sort of cascade down upon them. Everybody thought it was really violent and was like *wooooohhh* and John Waters was there and laughing. I just did it casually and walked away. It was more like an action worth a thousand words. She came over to the bar and I say, "Well now I feel like a real asshole," and she goes, "Shar, I kinda *liked* it!"

JOHN WATERS: All these men ran over and started jerking off, because they thought it was part of an act, some S&M act!

LINDA OLGEIRSON: Richard Hell she was crazy about, and I don't know what that was

all about. I think he had a relationship and a child. And Joe Lewis, I don't know what it was about him. She was determined to marry Joe Lewis—and of course that never happened—but that was when she basically split with Sharon forever. They were together for a few months. It was almost like she had this whole fantasy, like she was infatuated with him or something. Cookie came by once and said, just out of the blue, "Joe and I are getting married," and it was like, *what?* And it almost felt like he was sort of trying to get rid of her, but she wouldn't be gotten rid of. She was really pursuing him, and she needed a reality check about what this was all about, but I didn't know him enough to really know what was going on, whether he was just an asshole or whether Cookie had created some sort of fantasy.

PETER KOPER: Joe was a big, powerful guy. He was tall. He struck me as being a little paunchy, handsome, maybe a little overweight. He wasn't light-skinned exactly but not completely black, either. He had kind of wild hair and I remember a beard. A nice guy, we had a good conversation about politics, he had this point that the reason conservatives

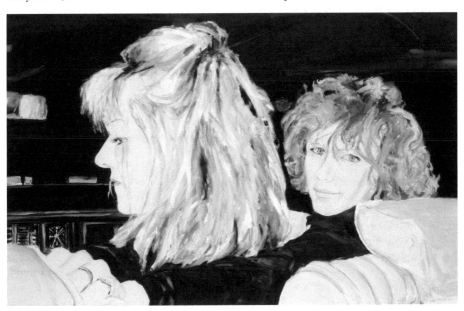

*Cookie & Sharon, 1981 (Billy Sullivan)*

have good arguments is that they are well read in history and liberals ignore history. It was an interesting point about conservatives in those days. Not the lunatics they have now. I saw him maybe two or three times with Cookie and then he disappeared.

SHARON NIESP: He was a black guy, a friend of Warren and Tutter's. They were going to get married in a Pentecostal church but never did. Then she claimed he tried to kill her with a shovel—no, he claimed that Cookie tried to kill him with a shovel... or did he try to kill her? Well, she cried about it.

SUSAN LOWE: Yes, Joe Lewis! He was an ass-hole. I didn't like the way he treated her. He was so arrogant and into himself. She was too much fun, and he was a downer.

PETER KOPER: She was in her marrying phase. It was directly after the time that *we* were supposed to get married. So she was definitely on the marriage hunt, don't ask me why. She said that she and I should get married, and we actually entertained it for a split second, but I had a different lifestyle than she did. We were much better as friends. I can remember having a conversation with her, I think on a trip to Coney Island, "Should we get married?" It was like being in the grocery store, "Should we buy this coffee or that coffee?"

DAVID ARMSTRONG: There were a couple of guys she almost married in that same period of time, like Gábor Bódy, the Hungarian filmmaker.

SHARON NIESP: God knows why. She was tired of trying to take care of herself and she wanted a man to take care of her. She was sick of working. She wanted to just stay at home and write.

PETER KOPER: I think it was more like a desperate move to get grounded, to be like other people, getting married. It seemed like that kind of life looked good to her.

BILLY SULLIVAN: It was always Cookie and Sharon and then whoever else Cookie was with. Cookie would fall in love with someone else and Sharon was always around.

MAX BLAGG: It was sort of this casual thing—

I'd go over and have sex with her, because that was okay. We both liked it. We talked about collaborating on things but we didn't end up doing anything. She lived up the street and I would just stop by. We had a funny arrangement in that sense, because we always had this kind of mutual attraction. I think that Cookie attracted special friends; she had that kind of personality, that easy way about things. She was open, had a loving way, even when she was having the same problems as everybody else, she was empathetic.

MICHAEL OBLOWITZ: She was never my girl-friend; she was just a friend that I hung out with. She was never in committed relation-ships as far as I knew. I mean we would have sex, we would go to clubs.

MARCUS REICHERT: I met Cookie through Amos. I had recently finished *Union City* and didn't really know Amos very well but I liked him and I liked what he was doing a lot. When I met him he said, "Would you have a look at the film and see if you can help me out with this?" So I went into the editing room and I saw Cookie in the film and thought she was very compelling, so I chatted to Amos about her and he said, "Oh, you guys should meet, maybe you'd like to use her in a film of yours." I don't recall where I met her first but we just hit it off and started seeing each other. I reckon it was 1981.

I didn't know her day-to-day. We only had rendezvous. Sometimes it would last for two or three days and then we wouldn't see each other for a week and then we'd get together again. I think a lot of people, to keep their life rolling, are involved with other people. It becomes part of the fabric of their life but that's not necessarily who they are or what they're about. I think we all have public lives and private lives, and to me it seemed that Cookie had a very private side to her that I cherished, because I could share that with her. We just liked being alone together. Her apartment was very homey and she made it comfortable. There was music playing and she'd cook, Max would be playing on the

carpet. Sometimes we'd go to places like the Peppermint Lounge, but mostly just be alone together, have a meal together, or be at my apartment or at hers and talk. She was a huge comfort to me, so we became very close. I think we relied on each other. It was rare to meet someone completely separated from everything else who was so intelligent, who you could talk to.

JOHN WATERS: I knew her very well as a couple with Sharon. Matter of fact, they used to come over to my house and break up. I used to say, "Why are you coming over here to fight? Fight and make up and *then* come over!" They had a melodramatic relationship, but a great one. Cookie and Sharon were a couple in our world for a long, long time.

GABRIEL ROTELLO: I remember subletting their apartment on Bleecker Street and for some reason they came back early and I would hear these *uproarious* arguments from the next room. They would just be *screaming* at each other, and then the next thing I know they'd go off arm-in-arm down the street, looking fabulous. I was like, *wow*. These people are really a-rocking-and-rolling when it comes to their relationship. They seemed to be able to just really go after each other in the most intense way and then forget about it.

SHARON NIESP: We never talked about our *issues*. I think the only time we had a conversation about anything, she threw a lamp at me and that was it. We never talked *issues*. We weren't that type.

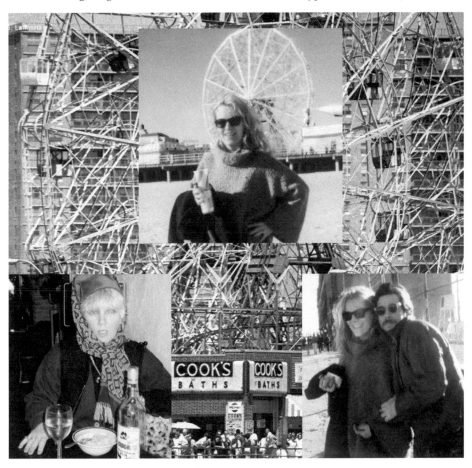

*Sharon Niesp, c. 1981; Cookie & Peter Koper, Coney Island, c. 1981*

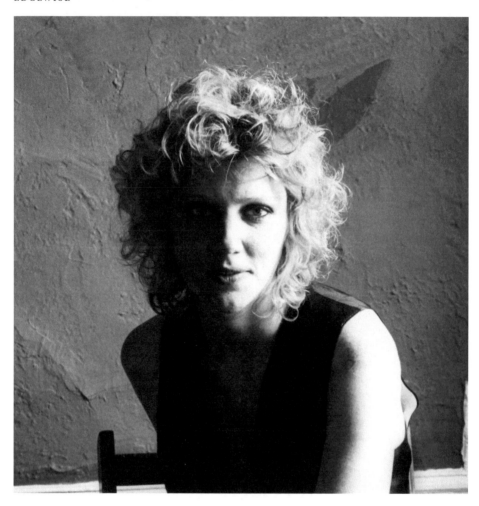

PEYTON SMITH: In a word: fucked up. [laughs] They were together so long, and I knew both of them before they knew each other. They were such an amazing couple, but it was just so difficult, they put each other through such trauma.

SHARON NIESP: She was dramatic, my God. *She* was the dramatic one. I was the sneaky one.

PEYTON SMITH: They were just so volatile. Although, I have to say, I never *saw* them volatile. I only saw the results of it: Sharon being upset. Before Sharon had her own apartment, when they would have a hard time, she would come and stay at my place. But when they were on and together and going someplace, the two of them putting on their makeup and getting ready and being two hours late and finally showing up, it was amazing. They were a force, the two of them together.

GABRIEL ROTELLO: They were a fabulous couple. They were out there and they just let it all hang out! They were my favorite lesbian couple by far in those days. Not that I really knew lots of lesbian couples, but they were really different, let's put it that way. I didn't know any other couples like that. A lot of my lesbian friends are sort of buttoned-down and serious and professional and highly organized. I didn't really know any super-hip dykes in

*Both pages: Sharon Niesp, NYC, c. 1982 (David Armstrong)*

those days and they were super-hip. They were really unusual in that regard, a little breath of fresh air. It was pretty cool.

DAVID ARMSTRONG: Cookie loved Sharon, but I don't think they wanted the same things, even if they did for a while. I think it was particularly difficult for Cookie because she had been this paragon of the free spirit—the most fun, most wonderful, most loving person—and I think she was getting scared and unhappy about the way things were going.

SHARON NIESP: In order to be in New York and do what she wanted to do, she really had to be free. It was tough enough to be in a relationship there. God, I hate that word. She wanted to be out every night and if she saw somebody she wanted to fuck, that was it. She had to do it. But it wasn't so much about her fucking men, it was just that she was under a lot of pressure, to write, to go out. She was driven, she *drove* herself. In New York in the '70s there was a lot of innovation going on; everything was all new with a new scene and just going and going and we got in right in '76, the revolution of the '70s when everything was bursting. So she had to be out and involved, and having a child and a girlfriend or a boyfriend or a husband or a whatever, there's a certain amount of friction and she didn't want to feel tied down.

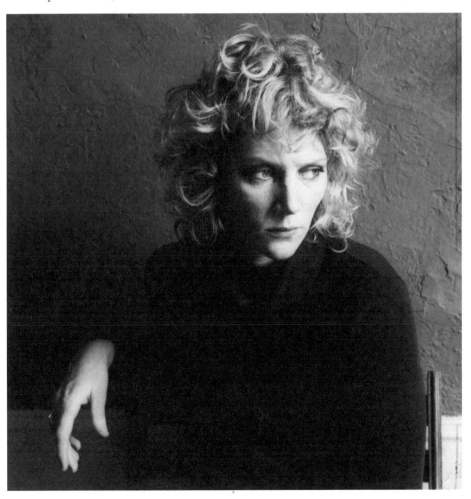

And it was really rough having a kid. I could have walked at any given point, she couldn't. She loved Max and tried to take care of him but you had to be really spontaneous at that time and she was that type of person anyway, so it just wasn't conducive to having a girlfriend anymore. Cookie was probably more hetero than she was queer, and she had to be free to do what she wanted to do with whomever she wanted to do it with. That's all I can say.

ERIC MITCHELL: There's no bullshit with Sharon—cut to the chase. She and Cookie were together for a long time, but they were like sisters and best friends as well as lovers.

SUSAN LOWE: I think the love of her life was Sharon.

MINK STOLE: Yes, it was Sharon. Sharon was her mate. Sharon was truly her mate. But Sharon's a lesbian, and Cookie was never really a lesbian. Cookie was a straight girl—I mean she and Sharon were lovers, but Cookie was a straight girl.

SHARON NIESP: In the '70s it wasn't so defined. Things are so defined right now. Political and defined. You are this or you are that. In the '70s, most of the guys we knew were gay, but we hung out with a lot straight couples. The only gay women we knew were Linda Yablonsky and her girlfriend Pat Place. It was just different then; you weren't determined by whether you were with someone. It was more a bisexual thing, although there were some real staunch lesbians. I hate that word. I fucking hate that word, it's such a blanket term.

BILLY SULLIVAN: Sharon has been the same since the day I met her. Every day I see her it's the same girl. She's in the middle of a drama and it never cuts to the chase, it just goes around and around.

ERIC MITCHELL: Sharon—an angel, that woman—she always had this incredible relationship with guys in a way I could never figure out. She was never politically or sexually affirmative, like, "I'm this," or, "I'm that." But she was so courageous. I remember she used to do these jobs to maintain her life, like work

in a restaurant and do all this really grueling work, whereas Cookie lived more like a prima donna.

SHARON NIESP: I think I was a little too raw for her. I didn't really have anything under my belt. I could do a lot of things and I had a lot of potential, but I just never followed through, so I wasn't this dynamic person. She always hooked up with somebody who really had something already conceived. Cookie did the topless dancing thing and then she did the dealing thing and that was basically where her income came from. In New York I was working at restaurants at night and helping her to pay the rent and go out. I think she needed something more than that.

GABRIEL ROTELLO: I didn't know Sharon at that time and in those days, this was probably 1980, I was producing a series of big musical revues in a big rock club called The Ritz in New York that held about 1,500 people. It was a place where people like Tina Turner and The Police would play. And I had these shows called Girls Night Out in which I would have a big band on stage and then there would be maybe 10 or 12 female lead singers who would each come out and sing one song each. Some of them were famous rock stars like Ronnie Spector, but many were just people I thought were the top local female lead singers of various rock bands in New York. It was like a big revue, almost like the *Ed Sullivan Show*, with people like Cherry Vanilla and Holly Woodlawn and Jackie Curtis. Everybody wanted to be in these shows because it was a great showcase if you were good. Cookie kept trying to get me to hire Sharon to be a singer. She kept saying, "My girlfriend is *so* great, you've gotta have her in the show," and of course everybody was saying that to me all the time and I really wasn't interested in people other than people I already knew about. Sharon didn't have a band, she wasn't really a singer, she was just somebody who sang in the shower. Then one day Cookie invites me to this show at the Peppermint Lounge, Wilson Pickett.

So I go to the concert and I'm in the audience watching the show and Pickett had a habit of pulling somebody up from the audience to sing with him for a few seconds, and he pulls up this woman from the audience to sing and she was *un-fucking-believably* good. I couldn't even believe what I was hearing, she was like Janis Joplin on steroids! I just grabbed my friends and said, "Who the hell is that?" So the second the show was over I raced backstage to find out who it was and there was Cookie with Sharon and it was Sharon! Cookie had arranged for this to happen, she had orchestrated the whole thing! There she was, sitting there smiling: "Gabriel, I want you to meet my girlfriend, Sharon," and of course I immediately hired her to be in my next show a few weeks later. She just *killed*. I mean she was *amazing!*

SHARON NIESP: I was a good performer and whenever I sang people loved it. I just didn't push it. I didn't have the commitment or the ambition. I wasn't driven like Cookie.

GABRIEL ROTELLO: That's how good she was: I *never* put people in those shows except very well-known singers because that was the thing that attracted audiences. I really hoped that she would put together a band and become a singer, because I really thought she had a very good shot at becoming a star.

PAOLA IGLIORI: Sharon was an amazing singer. We used to go a lot to Harlem, to the Baptist House of Prayer at 126th Street and Lenox and Sharon used to sing with Reverend Henry. And then we'd go out afterwards to a wonderful place called the Lickety Splits. It was full of old timers that would play their saxes and jam. It was a total jazz music place. We'd go there and have a drink and be the only non-African girls there.

JOHN HEYS: "Negro Number 4" was my nickname for Sharon. It's a scent that she probably still wears to this day that Blacks in New York wore in the '80s. Sharon could pull it off. And if you called Cookie's house but Cookie wasn't there, Sharon would pick up and—I can't do justice to it, so I won't attempt to—be this black mammy on the telephone. She'd be cooking in the kitchen—I don't know, fatback or something—and she'd start off with, "This be Miss Vicrola here," like Cookie had a maid or a housecleaner named Vicrola. "Miss Cookie not here, she be not in da house." She'd use quintessential slang and it was hysterical. You should really hear her do it—implore her to. But that would be for the edition of the book for the blind.

*Sharon Niesp (Arnie Charnick)*

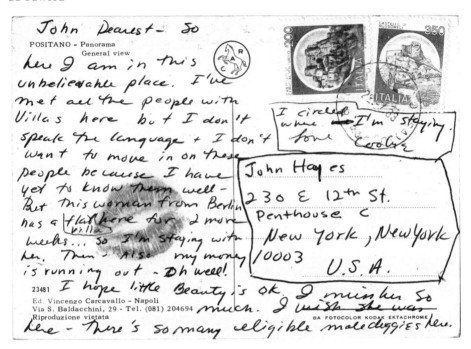

Postcard handwritten text:

John Dearest— So here I am in this unbelievable place. I've met all the people with villas here but I don't speak the language + I don't want to move in on these people because I have yet to know them well— But this woman from Berlin has a flat here (villa) for 2 more weeks... so I'm staying with her. Then — Also my money is running out — Oh well! I hope little Beauty is ok. I miss her so much. I wish she was here — There's so many eligible male duggies here.

POSITANO - Panorama
General view

I circled where I'm staying.
love Cookie

John Hayes
230 E 12th St.
Penthouse C
New York, New York
10003      U.S.A.

23481
Ed. Vincenzo Carcavallo - Napoli
Via S. Baldacchini, 29 - Tel. (081) 204694
Riproduzione vietata
DA FOTOCOLOR KODAK EKTACHROME

## DIVINE DISTRACTIONS

*"...We reached the Amalfi coastline road and it was a sight that sent me reeling. I couldn't believe what I was seeing. The road was terrifying—narrow hairpin curves wound around three-thousand-foot mountains that plunged to the blue of the Mediterranean. But it wasn't the road that was so scary; it was the beauty of the place. I was afraid my eyeballs would explode. Could a human being hold this kind of beauty in their eyes without going blind?"*

—Cookie Mueller, "The Italian Remedy—1982,"
*Ask Dr. Mueller*

SHARON NIESP: When it started getting hot in May, Cookie would get depressed and we'd be in a panic to get out of the city. It was hideous and hot for a long time; you couldn't breathe in Manhattan.

JOHN HEYS: Cookie first went to Positano on the Amalfi Coast with Sharon in the '70s, and later in the '80s she'd go back. She would be gone the whole summer, and I thought, wow,

you have a good strategy, girl, because New York in July and August is really not so wonderful. It's what we call the dog days. She would always go on the 4th of July with Beauty. I would go with her by taxi to JFK and the hardest part was after Cookie checked in and it came time for parting, because of course Beauty had to go in the cargo. It was so sad; Beauty was such a darling little dog. We'd both get down on the floor and Cookie had a cocktail—you know, from the '50s—what do they call them? A cocktail frankfurter— *total hässlich aber Fleisch*—and she put inside of that wiener a little animal tranquilizer just to placate and pacify Beauty, because this was really traumatic. So she'd stick it in there and, "Okay hon, just six hours and then we meet in Roma!" This was a ritual we did.

JANICE BIRNEY: The first year I met Cookie was 1983. We met at the historic Bar De Martino, where we all used to hang out. It's in the middle of the street, so you'd have to cross the road from the bar to get to the seats. It had the most wonderful view right over the beach. You'd just sort of hang there, go off and have

dinner, and it wouldn't end until 1 or 2 a.m., just chatting. There wasn't really any music even, it was quite an untrendy bar, nothing except the view and the sea and the people.

ELIZABETH SCIBELLI: It was an old Italian bar run by this man Ciro and his wife Eda. I can't even begin to describe it; it was really quite a scene, like the Mudd Club of Positano. You really never knew who would be sitting next to you. You'd get the local plumber sitting next to Gregory Corso and Vali Myers. It was just a really funny mix. We were dedicated Bar De Martino-goers, every night.

JANICE BIRNEY: It wasn't a clique. It was down to earth, a rough bar. That's why we liked it.

ELIZABETH SCIBELLI: It was before cell phones and Ciro would take everybody's messages. The local bricklayer and someone staying at the chicest hotel wound up going there.

EUGENE FEDORKO: I remember seeing Cookie one time in Positano. We were having lunch together at Bar De Martino and there was this German guy there, he was a nurse to some wealthy gentleman, and there was a child that was being obstreperous and the German nurse said, "Somebody should kill that baby" [laughs] and Cookie said, "Now watch out Dieter, because your German is showing." As in like, "Don't look now, but your slip is showing." Cookie was just full of repartee like that, and she carried herself with such élan and panache.

BRUCE FULLER: Did anyone ever tell you about the fistfight between Vali and Cookie at Bar De Martino? They hated each other I think, but they respected each other too. It was all very rip-her-to-shreds, a famous knock 'em, punch 'em girl fight. It wasn't a catfight; it was more like two heavy hitters. Cookie was the least catty person I ever knew, she would just tell it like it is. Men couldn't even break it up. This was a *brawl*—in dresses, rolling around in front of Bar De Martino!

EUGENE FEDORKO: Well that town was apparently too small for both Cookie and Vali.

*Elizabeth Scibelli's wedding with Cookie (top right) as a bridesmaid, 1988*

They had a very frosty relationship because each one of them had too big of a regency to be able to be contained in that one small town of Positano, Italy.

SUSAN SCHACHTER: Vali is a Leo and I think she felt excluded and she was dealing with a lot of starving animals. She was under a lot of stress…

JANICE BIRNEY: Vali used to dance at Music on the Rocks; Cookie and me would go to Privilege. Music on the Rocks cost a fortune and that wasn't our thing. Privilege was quite small.

ELIZABETH SCIBELLI: Music on the Rocks was light-years more sophisticated than Privilege. Oh my God, Privilege was the seediest place in the world. I remember never paying for a drink there, and I always had a drink. It was this older woman, Francesca, from one of the noblest families of Naples. She had this place

with her much younger boyfriend. It was a disco. Sometimes we'd go there after Bar De Martino because it wasn't very far. It wasn't the most refined crowd.

JANICE BIRNEY: Cookie and Vittorio met in Positano, maybe at the end of the summer of '83. I already knew Vittorio because he used to come for weekends to Positano. He would often be around Bar De Martino. He used to crouch at tables and talk to you. He was quite an unusual guy, a very nice guy.

JENNIE HANLON: And he was very smart. I remember spending a New Year's Eve in this little restaurant overlooking the bay with him and my girlfriend, Marion. She always said, "Vittorio has such a noble look about him… and the way he acts." He was a real intellect.

JANICE BIRNEY: He was fluent in English so I think they spoke in English all the time. I don't think Cookie's Italian was really much

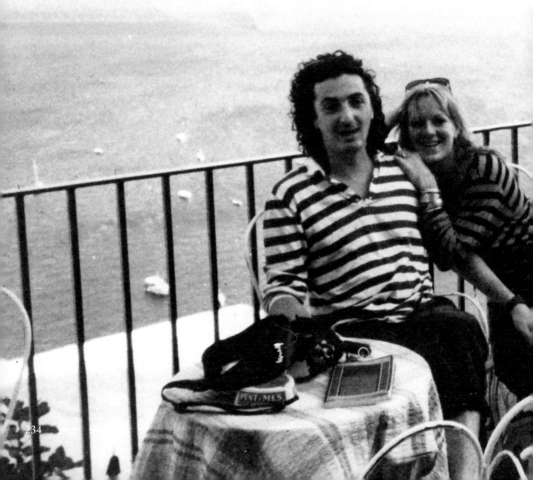

good at all. Vittorio was a graphic artist. I don't know if he was working in Naples or not. Daniele, his brother, spoke wonderful English and was quirky, funny, very elegant.

ELIZABETH SCIBELLI: Vittorio was about 10 years younger than Cookie. I don't think he was very tall; his brother was much taller than he was, tall and lanky. A lot of southern Italians can be quite short. Vittorio wasn't traditionally good-looking either but he had something. He had long, wavy, jet-black hair. He had a kind of sexiness.

PAOLA IGLIORI: Italy is a place of saints, poets, and sailors and Vittorio was both a poet and a sailor. He told me he went to Africa by boat from Naples. He was working on one of those cargo boats that brings down merchandise. He would go down there and hang out in the port cities of Africa.

MAX MUELLER: Vittorio was cool. He was a tough guy. He was a worldly kind of guy; he was a merchant marine. He had really big, strong hands. When I first met Vittorio I was 12. They were out partying all night and it was the morning, right after dawn, and she came and woke me up and I had to meet him. He had bought me a fishing set.

JANICE BIRNEY: They were great together. I think Vittorio was wonderful and I think Cookie was, too. Vittorio's family had a holiday house in Colle di San Pietro, which is very close to Positano. I remember Daniele couldn't stand up in parts of it and neither could I; the roof came down quite low on one side but it was quite a nice villa apart from that.

MAX MUELLER: It was an estate, vineyards and lemon groves. I used to just go wandering around for hours because it was so big. Being small, it obviously seemed a lot bigger then. It was so beautiful.

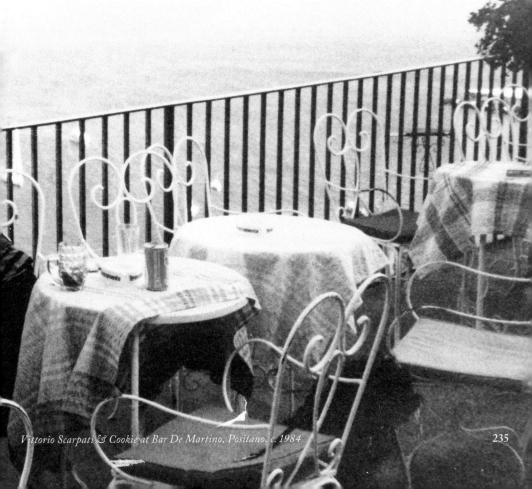

*Vittorio Scarpati & Cookie at Bar De Martino, Positano, c. 1984*

ELIZABETH SCIBELLI: They had money. I mean not by Bill Gates's standard, but they were well-to-do.

JANICE BIRNEY: Absolutely, a rich Naples family.

ELIZABETH SCIBELLI: Cookie's father and Vittorio's father both worked for Seagrams. They had met at some sort of convention when they were young men, before Cookie and Vittorio were born. Cookie showed me this old black and white photograph she had of these businessmen at a convention and there was her father and Vittorio's father. That's pretty ironic, considering Cookie was from Baltimore and Vittorio's father was from Naples.

CLAUDIO CRETELLA: Vittorio was really fun in high school. We were in a private school in Napoli and were taught by priests. He was very happy and energetic. He was very original and extravagant. Even when he was little, about 14 years old, he had a classically extravagant style.

ELIZABETH SCIBELLI: A couple of times I stayed at Janice's with Cookie. Janice had rented a home in the village above Positano called Montepertuso where they are all inbred and just weird. Every time we'd go out everybody would stare at us.

A lot of times Cookie would borrow Janice's motorino and give me a lift down to Positano. That was just hair-raising. I don't think she knew how to drive it; I think she just pretended like she knew. We'd be going around these hairpin turns!

JANICE BIRNEY: We hung out mostly with foreigners but also a lot of Vittorio's friends, Naples people, the Laurito crowd. Laurito Beach has only two restaurants—the one we would go to is Adolfo's—and they have their own boat service. That was our place. We would swim, there's a natural spring in a cave. And we'd get drunk on sangria and have long lunches and stuff like that. The last boat would come back around 6:30–7 p.m. You slowly walk back up and go home, get dressed, and go out. Vittorio would come and get Cookie on his moped and I'd take Elizabeth on mine.

ELIZABETH SCIBELLI: Positano was like if you lived in Manhattan and you had a place in the Hamptons or Fire Island. Mostly Neapolitans, some people from Rome had homes there.

MAX MUELLER: The memories are a little mixed up. The first time I went to Positano was with my mom and Sharon when I was around seven. The next time my mom went, she met Vittorio and after that she would go pretty much every year.

SHARON NIESP: Everybody used to go to Positano in those days. In '81 I moved in with some friends of mine, including a guy who was in the band The Descendants, and then he and his wife moved to Paris and I took over their apartment. Cookie was still on the West Side, and then I moved to New Orleans in '83 and she met Vittorio in Positano. Vittorio was great. I thought he was very handsome; he had the most beautiful hair and of course his big Roman nose. That was probably the best relationship she had—before me and after me. They collaborated. He was an art historian, very political in his paintings.

MAX MUELLER: I have a lot of memories of Positano from the summer of '84, when I was 12. We went with René Ricard for the whole summer, or it seemed like it anyway.

PATRICK FOX: We were outside Paul Olsen Gallery and Cookie had just come back from Italy. She mentioned Vittorio, said she was going to go again next year, and I got the thought in my head, well yeah, I should go too. Then René decided he would go and then Pat Place and Linda Yablonsky.

LINDA YABLONSKY: I remember her coming over and telling me about Vittorio. I spent part of that following summer in Positano. We stayed in the villa with Cookie and about ten other people from New York. I spent several weeks there, so I got to know Vittorio and his family very well. I liked him. He was pretty easy to like.

PATRICK FOX: Cookie had been there two weeks when I arrived. She'd rented Vittorio de Sica's house. After I arrived, Pat Place and Linda Yablonsky came. Linda was our heroin dealer at the time, and the big thing was

to wait until Linda Yablonsky would come so we could actually get some heroin. I wasn't a junkie at that stage of my life, but I did appreciate it. I was just a garbagehead, so I would take anything put in front of me.

LINDA YABLONSKY: I didn't have any plans to stay in Positano, but I ended up staying because of them for a few weeks longer. We went to Pompeii, we went to Naples... we were tourists, but we would also have these big dinner parties and we generally got to know the Amalfi Coast. We went to Vittorio's family's farm and to all the little towns around. I was on vacation—a vacation from drug dealing—and frankly what bound us together was that we were all junkies. Vittorio helped us get high every day because he had a morphine connection.

PATRICK FOX: Vittorio had an active drug habit, it seemed. He was shooting dilaudid, which is this opioid. We were all there to sort of give ourselves a break. We were drinking certainly, but no one was doing coke, although that could be just my memory. It didn't seem particularly druggy.

JANICE BIRNEY: Vittorio was very social and really *simpatico* as they say here. He had quite a history of drugs. I was never really into drugs, so for me it was a bit difficult to sympathize. I know he and Cookie used to do heroin together. And he used to do heroin before with this other girlfriend. Her name was Giovanna, a beautiful girl. I think she was in love with Vittorio; they were at school together in Naples. They were both from rich Naples families.

PATRICK FOX: There was a night when René decided he was going to pick up these boys, hustlers from Naples, and somehow he wanted me to help him. This was never my thing, but he brings several of them back to the house, and he had them on the bed. I just passed out and fell asleep and René got one excited and the kid started pissing. I woke up with this guy pissing all over me. There was a whole commotion in the house and Cookie and Vittorio woke up and Vittorio's saying, "You can come sleep in our room," and Cookie's like, "René! This is a rental!"

JANICE BIRNEY: They got kicked out of the villa. Noise, lots of people sleeping everywhere, chaos. I'm not sure if Max was there, maybe part of the time.

PATRICK FOX: Max was a little kid, I remember him catching chameleons that were running up and down the walls. René and I shared a room and Max may have had his own room and Cookie and Vittorio had their own room.

MAX MUELLER: The villa was a really nice spot, with grounds and everything. There was a scary cave on the property, and a small vineyard and a terrace. We stayed in the servants' quarters but it was still like three bedrooms and two bathrooms and a big kitchen and a huge patio. It was nice.

I remember René had gotten a lot of money, he had just put a book out or something, so he had like 50 grand or something and was having a blast. We rented a small yacht and went out to Capri. We went to the blue grotto, it's a cave on the other side of the island. You get into a little boat and go into the grotto and it's all dark but the sun shines through the water and lights up the whole pool of the cave—super, super blue water. Very beautiful. I remember my mother and René jumping out of the little rowboat and swimming in the blue grotto.

JENNIE HANLON: Cookie said Carmen, my daughter, could come with them to Capri one time. They had no money and Cookie convinced someone to let them on the boat with no ticket.

CARMEN (HANLON) SORRENTI: I was about 12 when we went to Capri with Max; we're pretty much the same age. We went with Cookie and two female friends of hers. Cookie somehow always managed to get us into places, and she gets us into this big hotel with this pool and Max and I loved it so much we decided we didn't want to leave. But we were supposed to go back the same day and the boats going back leave quite early in the afternoon. Because Cookie and the other two women didn't speak much Italian, they didn't hear the guy saying the last boat is at this time, but I clocked it. So I whisper to Max, "The last boat is at whatever

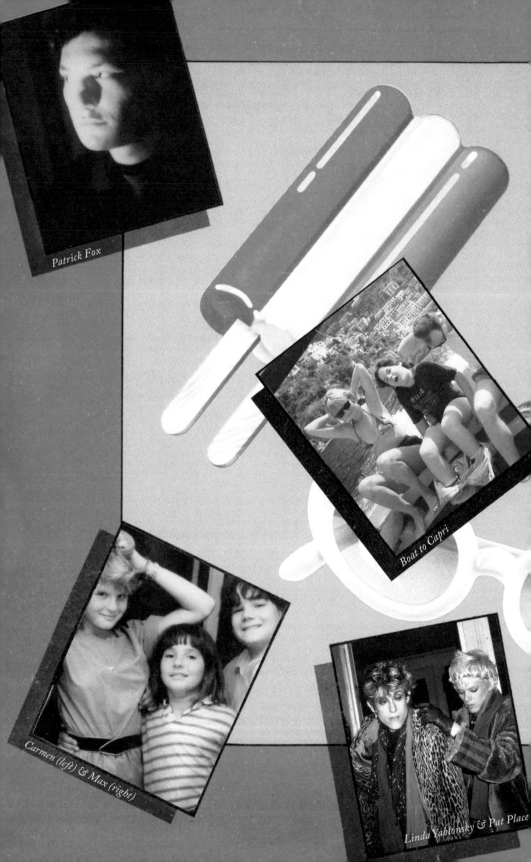

Patrick Fox

Boat to Capri

Carmen (left) & Max (right)

Linda Yablonsky & Pat Place

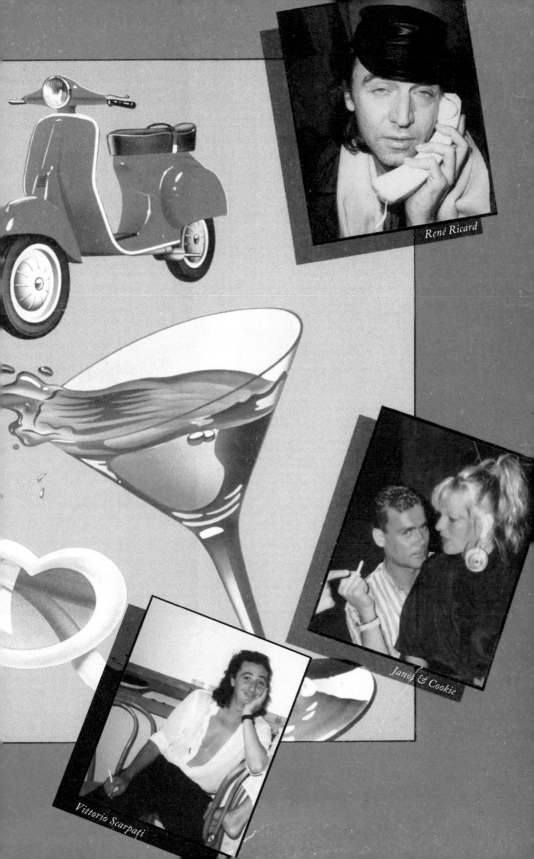

René Ricard

Janos & Cookie

Vittorio Scarpati

time, let's stay!" So at a certain point they're like, "Okay, we gotta go," and we keep delaying and pretending to fall back in the pool until I was sure we wouldn't get the ferry. Then we got out all innocent and go down to the harbor and of course the last boat is gone.

That night they wanted to go to some club. Max had fallen asleep but I wanted to come. I looked a lot older than 12, you know, fully-formed, big breasts and whatever, and earlier that day we had gone into one of those perfumeries. Cookie was unbelievable with me, I loved it, I was like her doll. She practically did a film makeup session with all the testers. She was like, "I'm just going to pretend you're my daughter!" So I really looked the age to get into this club and the club owner came out and was, "If it was 18 I'd let her in, but this place is 22," and looked at her knowingly, like it was a really heavy joint. So she had to take me back.

When they got back the next morning I wanted to hear everything. It had been a really heavy-duty club and Cookie was saying, "People were going around in all sorts of stuff. You wouldn't believe it existed in Capri. I ended up at this guy's house and he had this Jacuzzi…" and it went on and on.

So now we had to get back. The hydrofoil is quite expensive so Cookie literally begged the ticket guy, since we had no money left. She's literally on her knees pleading in this fake Italian: "Oh, pretty please, *prego prego!!*" And you know, she's dressed really sexy and she's got these tickets from the day before and she's saying we missed the boat and her sunglasses and her hair everywhere and we looked a *wreck*. So finally after a really long time this guy said, "Just get on the boat."

We eventually got back to Positano and I don't think I told any of it to my mother, except she found the switchblade Cookie had bought me and went crazy!

JENNIE HANLON: Carmen came back and said, "Hey Mom, I brought you a present, a click knife." She said, "We were in the shop and they thought it was a fun present," and I said, "Yeah, well give it to me."

CARMEN (HANLON) SORRENTI: It must have been hard sometimes for Max, kind of lonely. He didn't speak Italian. There were a lot of foreigners there, but not many foreign kids.

JENNIE HANLON: I was going home one night with Carmen and we met Max at the Bar De Martino. It was very late, like 2 a.m. and he was totally alone. He said he was waiting for his mom, but it didn't look as if she was going to turn up, so I told him to come home with us. Cookie was out with Vittorio or something.

ELIZABETH SCIBELLI: I think during the summer before she married Vittorio, Max kind of got the shitty end of the stick there. I think he was ignored.

MAX MUELLER: We were at Bar De Martino all the time. And we would hang out on the beach. I would walk up and down the steps. Positano is on a mountainside, so it's all steps. They always had festivals, it seemed like every weekend there was something. And there was a video game arcade there I remember.

I made my mom take me to Pompeii, I really liked that. I loved Pompeii, because you can walk among the ruins and you feel old, you know, you really feel the 2,000 years. It's a whole new world. You feel like you're two thousand years old.

JENNIE HANLON: Cookie was always with Max at Laurito, but he wasn't hanging around the young kids. We'd all be eating on the beach and he'd have his spaghetti and Coca Cola but he was always sort of alone. He was a great kid, and my daughter loved him, so I said to Cookie, "Look, just do your thing, get it over with, come back to earth, and then you can take Max back home. But leave him with me for the moment." It was only a couple of weeks. Because we were pretty straight, compared to them. Carmen had this other little English boy named Kerry and the three of them used to get dressed up in little suits and ties every night, even Max, and go to the cinema.

MAX MUELLER: Right off the beach there was a little area, a little rotunda, it was so beautiful. And they would show movies on the church with a projector, American movies, all kinds of films.

CARMEN (HANLON) SORRENTI: We really had a good time that summer. Positano was so free; we did whatever we wanted. Cookie had this spontaneity. She would just talk to people, beg people, persuade people. She was so wild, and I knew it even at the time. It's not like I didn't know... how she dressed and everything. I could tell that she really enjoyed pretending she had a daughter. There was something about her that was really soft and sweet and kind of romantic. I thought she was so beautiful, and kind of innocent and girlish.

JANICE BIRNEY: She was smokingly good looking. I think she was gorgeous. Smoky eyes. Cookie used to get a little tipsy—and sometimes quite drunk—at Bar De Martino, but she was never obnoxious. She would kind of hobble around on the high heels. Quite a character, definitely remembered in Positano.

## WHITE TULIPS, NOTHING MORE

*"I'm a fan of Vittorio Scarpati. I'm also his wife, so I guess you could say I'm his biggest fan, aside from his mother. I know his art so well, so I have some insight into it. I know what it looks like even before it's a gleam in his eye."*
—Cookie Mueller, "Art and About," *Details*, August, 1989

SCOTT COVERT: I remember when she was coming back to New York and Vittorio was coming with her. She was so *extremely* happy about that. She felt it was karmic that they got together.

SHARON NIESP: She was living back and forth between New York and Positano, then Vittorio came in '86. When Vittorio came to New York we became friends. I went to the house for the holidays, I'd see them out, and we'd go out together sometimes, too.

EARL DEVREIS: If I remember correctly, when she was with Vittorio, they would travel in Europe, and I thought that was so good for Max. I recall seeing Vittorio once or twice in Ptown. I liked him, he was a nice guy. And I asked Max, "Does he treat you well?" and he said he did. I always liked the name Vittorio. And that's that—that's all I really know, hon.

PETER KOPER: Nobody in New York really knew him and I don't even know how that relationship developed. I found Vittorio to be a really nice, sweet guy, just a great guy. I understand he did some drawings and stuff, but you never knew really what he was doing. I got the feeling that he came from a rich family, because we called him the "no-account count."

GLENN O'BRIEN: He would say, "I'm the count that don't count." He was a really funny person. He had trouble making money, but he was good at drawing. I think at one point he had a job making posters for supermarkets.

ELIZABETH SCIBELLI: He probably got money from his family. Cookie wrote a little bit and sold drugs. I think their major income was what she was doing. They got by.

CLAUDIO CRETELLA: Vittorio never worked. He was a bit of a snob. He always wanted to be an artist but he never really did anything about it in Naples. He did more in New York with his artwork.

PHILIP-LORCA DICORCIA: He was a tall guy, he stood out. He had long hair and an aquiline nose—big and sharp—and he looked like a slightly romantic figure from another era. He sort of dressed the part; he definitely didn't look contemporary. One of the last jobs I remember him having was working for a guy who did inlays for musical instruments.

JUDITH PRINGLE: Vittorio was wonderful. He worked with us for a while doing sculpture conservation in our little studio downstairs from the New York Academy of Art. Bob, my husband, was carving a hand in marble, but before he got to the point where he could really do the carving it had to be whittled down: that was Vittorio's job. He would come in looking very elegant and sit down in front of this piece

of marble and start whacking away at it. He was so excited. He'd say, "I'm a sculptor, carving the marble!" with his Italian accent.

PHILIP-LORCA DICORCIA: He was wry. I thought he was funny. He was also a junkie, and in a way, I was attracted to all of those things. There were a lot of drugs around those days, and that was my drug of choice. There was also the conspiratorial aspect of it. When you share an addiction, there's a lot of conversation around that subject. Those were the days when the East Village was a dump and you had to go in holes in abandoned buildings and down a black corridor and they wouldn't serve you drugs unless you had tracks. It was violent, and you were either going to get hurt by the dealers or the cops, but Vittorio was strangely innocent of all that.

PENNY ARCADE: When I met Vittorio, I fell in love with him and he fell in love with me. It was amazing to speak our dialect together; the point of view is so different. It's a very sharp way of thinking and of expressing your opinion, which you can't do in English. In English, people would think you were horrible. It's too direct and harsh—very real. Cookie had been with Sharon for so many years, so it was a real departure. She was madly in love with him; a very romantic relationship. But I don't think people liked him very much—they thought he had too much sway on Cookie. As I remembered it, people resented his influence.

ELIZABETH SCIBELLI: I think he fit in very well because he was charming. Cookie had a lot of interesting friends and Vittorio bringing his Italian style… People really liked him, and

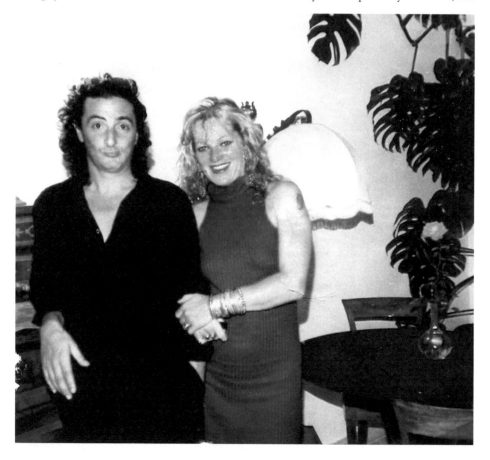

*Vittorio Scarpati & Cookie, c. 1986 (Jennie Hanlon)*

they were a really good-looking couple, an interesting couple.

PATRICK FOX: He had a fabulous introduction. He was Cookie's boyfriend, so he was instantly allowed in based on that. There was something sweet and dumb about Vittorio, like a Labrador. I'm not saying he was dumb, but he wasn't aggressive, he wasn't one of those people with a minimum of talent and a lot of ambition, and there were plenty of those around. He wasn't offensive.

LESLEY VINSON: I used to run into Vittorio a lot at the Waverly Bar. He'd be sitting there at 2 or 3 p.m. I'd walk in there because I had to use the pay phone or something before work and he'd be in there and he'd be like, "Oh hi! How are you! Sit down!" He wouldn't even know my name really and I'd sit down and have a beer with him and I think he kind of just sat in there all day. He seemed kind of lonely.

ELIZABETH SCIBELLI: They had fun, but they bickered. Cookie'd get annoyed with him. New Yorkers are much more dynamic than Neapolitans. He'd come home in the afternoon, have his nap, have his pasta. Even though he was untraditional in the sense that he was a big druggie and very artistic, his sense of tradition was very deep and she'd get annoyed with him about certain things.

PETER KOPER: There were times when Cookie would actually turn to him and say, "Oh Vittorio, that's silly or stupid!" or something like that, in public. So here was the space cadet of space cadets telling Vittorio that he was too spaced out or that he was being too idiotic or something. It was that kind of a relationship, but I mean they were close to each other, they were with each other all the time but it wasn't like the great romance of your life, or something. I didn't get that kind of feeling from them.

MAX MUELLER: They started fighting sometimes after they were married. Well, it wasn't *so* bad. I saw him slap her once and that didn't make me happy, but I just told him to back off and he put his coat on and left.

PAOLA IGLIORI: There was an Italian butcher downstairs on Bleecker Street and so I used to love to get the things that you can't normally get in New York, like rabbits and liver. So I would go beneath the house with Vittorio and then bring it up and cook something. We'd drink wine and eat and hang out until late. He loved New York and he loved the travelling, but he was very Italian, and I think his soul was always in both places.

JAMES BENNETT: My fondest memory was one day in the winter I was on my bicycle in Sheridan Square and all of a sudden there's this huge, old Cadillac, and there's Cookie, Vittorio, Sharon, and Steve Butow, and they go, "Hey, come on," so I lock my bike and got in the car and we drove to Coney Island and went to the aquarium. There was nobody there. It was a freezing day in February. Then we went to Brighton Beach where all the Russians are and had a huge meal with some carafes of vodka and then we went back into town and copped some drugs. That's when we watched Cookie's old 8mm home movies. It was pretty cool; it was all spontaneous. Cookie would do something at the drop of a hat.

PATRICK FOX: One night we were all at Area, a large group of us: Cookie, Stefano Castronovo, Teri, Nan, Robert Hawkins, Vittorio, about 10 of us. We decided to leave Area together, and we were all poor. Not only poor, but broke. So we leave the club and there's a big white limousine parked outside, and the driver sees us and says, "You guys need a ride?" We all sort of looked at each other, and before I knew it, Cookie was in the car, dragging people in with her. So we all piled into this big white limousine and he's driving up the Hudson, and we all start whispering in the back, like at some point we'll get to the Village and jump out at once, you know, free ride. So we get to the light at Broadway and Houston—and it's 3:30 a.m.—and we all start getting out; there were so many people. Cookie was in the back seat and the driver grabs Cookie's fur—she had this stole, a bunch of foxes. There's maybe half a dozen animals on this thing. She started to run and then she turns to me and says, "No, I want my fur," and she goes back and

grabs her fur and at the same time someone grabs the keys from the ignition and throws them to me. I threw them into the mail slot of the Tony Shafrazi Gallery, because I didn't want them on me. I freaked when they handed them to me. So we think we're safe, then we see the limousine backing up. He obviously had another set of keys.

ROBERT HAWKINS: We would see him cruising the streets and would run and hide behind things. Cookie got in a dumpster, because she was like, "If he calls the cops and they're shooting we're gonna need something the bullets will bounce off. We'll be safe in this dumpster!"

PATRICK FOX: Cookie was like Rambo; all she needed was camouflage. So I go back to the loft and Vittorio's gone, Stefano's gone... then the phone rings, and it's Stefano and Vittorio. Our two immigrants are at the police station with the driver, and the driver wants $35 and his keys and none of us have a fucking dime.

ROBERT HAWKINS: Vittorio had just come from Italy and Cookie was freaked out that if they took him to jail, he would get deported.

LINDA YABLONSKY: While I was in Positano, she kept asking, "You think I should marry Vittorio? It's very complicated, he would have to get his papers, but I really would like to marry him." And I thought, yeah, he's a great guy. He really liked Max and Max really liked him, so they decided to get married. One day we went into Naples to get papers for him so he could move to New York and marry her.

PATRICK FOX: I did the paperwork for him to come to the States. You know, sort of sponsored him, guaranteed to the government that he wouldn't become a burden to the American people. It was a long process.

DAVID ARMSTRONG: There was a certain franticness, I felt. I know she wanted to get married, but I wasn't sure why. I guess now I can understand why people want that kind of relationship, but I don't know what it had to do with Cookie.

PETER KOPER: I think she had reached the point where she wanted something. I mean how old was she, mid-to-late thirties? I think

she was feeling that she had a writing career going, now she just needed a little stability. I think that's what the drive was.

DENNIS DERMODY: Cookie lived by her own rules, always. When she decided to get married, it just made sense in some crackpot way.

MINK STOLE: I went to the wedding. It was sweet, it was on a rooftop. She really was in love with Vittorio. Cookie had been going to Italy every year for a couple of years.

SUSAN LOWE: And she looked for a husband over there.

MINK STOLE: She wanted to be married, and she wanted an Italian husband.

SUSAN LOWE: Yeah, that's true.

LINDA YABLONSKY: They got married on John Heys's rooftop. He had a kind of a penthouse in the East Village.

SCOTT COVERT: She had her eyes tightened before she married Vittorio—just had them tightened a little. Cookie had something like extra muscle below her eyes. It looked like she had bags under her eyes, and she wanted them taken away. It was something like $200 and she was actually looking in the yellow pages for cosmetic surgeons. Then there was somebody on television and she did it, she went and had her eyes done.

STEVE BUTOW: Her wedding dress was fabulous. It was a cocktail dress, and then like a hostess skirt that you wrap over in the front. After they got married she threw it off—took off her skirt, basically—and she had on a cocktail dress under, ready to party!

JAMES BENNETT: It was such a beautiful day, and everything worked out fine. Of course, it was supposed to be a 5 p.m. wedding and it didn't start until 8 p.m. I remember right before they were getting ready to say whatever they were saying, a siren came by and I wisecracked, "Immigration. Hurry up, marry him!"

JOHN HEYS: Francesco Clemente was Vittorio's best man. There is a beautiful photograph by Peter Hujar when Cookie is arriving late— she was always late—and René Ricard is fussing behind her. The wedding ceremony was on my terrace. The weather was nice, and the

*Cookie at her wedding, 1986 (Peter Hujar)*

terrace looked south—this is on 12th Street between 2nd and 3rd. For the wedding I said to Cookie, "What do you want?" Cookie said, "I just want white tulips—nothing more." So all I had was white gauze hanging by the windows. There wasn't much furniture, and I tied the gauze up in different lengths and the tulips cost a fortune because they were long stems—I mean, really good quality—but I'd do anything for Cookie. I just threw them on the floor, and it was beautiful. Everyone had to walk through them to the terrace.

MAX MUELLER: It was a hot day. There was so much happening, so many people. But I wasn't really involved. I was 15 and by that time I was in my own world. It was the summertime and I went because she wanted me to be there, but I left afterward.

LINDA YABLONSKY: Everybody cried when they got married, including me, and it was a beautiful ceremony. So many people who were at that wedding are dead; it's kind of upsetting. They got married and then there was a party, a big dinner party at the artist Joseph Kosuth's loft in SoHo.

PETER KOPER: Joseph Kosuth is married to a mega-rich woman, and they had this huge loft. There were bottles of frozen vodka on each table and Cookie's entire subterranean crew was there: the Baltimore people and the hanger-ons and the street people who are not connected to that society, they were all invited. The party afterward turned into a *debauch*. People drank all this vodka, and the hostess's makeup cabinet was *completely* rifled. It was like one group of people meeting another group of people. These poor artist-girls were in some rich woman's makeup counter, sweeping all the makeup into their purses!

LINDA YABLONSKY: There were about 200 people—everyone from Baltimore and half of the downtown art world. It was a great party. I was really happy for Cookie and Vittorio, really glad Vittorio was living in New York.

BILLY SULLIVAN: Cookie was dressed in this beautiful white dress that was really tight and Vittorio was in a beautiful suit. It was just ex-

quisite. Vittorio was in love with Cookie; you didn't think about anything except the fact that he made Cookie happy. At least I didn't.

JUDY (MUELLER) HULL: I remember when my mom said they were going to get married. I remember this well. I remember envisioning her in some modern-looking apartment and wearing a glamorous gown, not a white wedding gown, but a kind of modern dress, gorgeous and with a great reception. And then I saw the actual picture and she was wearing a lot of makeup, I mean *tons* of makeup, and a white wedding gown and a veil and the whole thing!

SHARON NIESP: They both loved each other, so they figured why not? He was very talented, I loved him very much, he was an amazing man. A brilliant cartoonist, a brilliant painter.

JUDITH PRINGLE: When Vittorio was working with us, I guess we had all gone out for lunch, and we came back and there was a note from Cookie on the door of the studio. It said, "Vittorio, I came to see you but I guess you're out for a while. I'll talk to you later," and it was signed "Cookie, your wife." It was like, how many Cookies could there be?

MARCUS REICHERT: When I came across Nan's book on Cookie's life with Vittorio I didn't know anything about him, so that was fascinating to me. He looked like a lovely person. Sensitive is an overused word, but he had a sort of a vulnerability to him that I could read in the photographs, and I thought, this makes sense. I can see why she fell in love with him.

SHARON NIESP: She knew from the moment she hooked up with him that it wasn't going to be any kind of conventional marriage. I think by then she just wanted a mate, somebody who could keep up with her. That seemed to be Vittorio.

*Cookie & Vittorio Scarpati's wedding party, 1986 (Mark Sink)*

247

## A HIGH WIRE ACT

*"This is a rare period in human history.
Never have so many with so little become
so big for a duration of time so short. Never
before has such a shiftless bunch of life's
lightweights hewn such formidable nests for
themselves in so many other people's minds.
Never before have the woody, meandering
paths of directionless plodders led to the
blazing floodlit clearing in the forest, the
center ring for the mini-history makers.
This is the age of the fleeting media stars.
Watch the news. Read the papers. These
stars are easy to forget."*

—Cookie Mueller, "Art and About,"
  *Details*, December/January, 1987–1988

BOBBY MILLER: New York is one of those plac-
es where you can live and be invisible. The
city's so big that you can kind of blend in and
nobody really notices you. I remember being
with Cookie one night in a restaurant having
Indian food and this girl came over and said,
"Excuse me," and Cookie had a whole mouth-
ful of food, and the girl was like, "You're
Cookie Mueller, aren't you?" Cookie said no,
and the girl said, "Yes you are," and Cookie
said, "No, this happens all the time hon. Peo-
ple are always thinking I'm Cookie, but I'm
not Cookie Mueller." The girl was just so con-
fused and walked away, and I said, "Cookie,
why didn't you just say yes?" and she said, "Oh
hon, it just builds up your ego and then you
got more ego you gotta get over!" I thought
that was really enlightened.

I remember another time being with Cookie,
walking down 7th Avenue to her house, and
this really creepy guy was following us. I said,
"Is he interested in you or me?" and she said,
"I don't know hon, you can have him!" We
were walking and walking, and I thought
we'd lost him, and we turn a corner and sud-
denly he was in front of us, just as we were
about to get to her house. He goes, "It *is* you,
Cookie Mueller!" and then all of a sudden she
started glowing and was like, "Yes, it's me,

*Cookie, c. 1982*

Cookie Mueller." This was a couple of months after the incident with the girl in the Indian restaurant and I said, "Good for you, finally you're accepting your praise. Grab it, enjoy it, there's nothing wrong with it."

DAVID ARMSTRONG: So many people that we knew in that whole art scene were getting to be successful, you know, monetarily. There was so much mixing of uptown and downtown. I don't think Cookie thought this herself, but this idea of wanting success was a conflict she would talk about. I think she kind of denied that she wanted it, but she did want all the gifts and prizes that came with it, and the recognition as a writer.

PETER KOPER: Cookie had different crowds. There was the rich art scene of famous, semi-famous, or about-to-be-famous artists, like Jean-Michel Basquiat. She always made sure she went to the right parties. It was very important for her during the club era to know where the parties were and who the people were and then she'd hob-nob. She was pretty good at social climbing, basically 50 percent of her energy was there. But it's not like she ditched her old friends, her Baltimore or Provincetown friends.

DAVID ARMSTRONG: Everyone adored her—it wasn't that—and she knew everybody—it wasn't that either—but I think there was a conflict. A lot of other people had it, too. Gary Indiana was the same way, but he managed that transfer more easily to where he was actually writing novels and having them published. The conflict was between being free and unfettered and outside the status quo or upper echelon of society but also being part of it, like hanging out with Brice and Helen Marden or Julian Schnabel and all these others who were having meteoric rises that involved a lot of dough.

CARLO MCCORMICK: Cookie was old enough to come from the time when none of the painters were making money in art. And then she hit her stride in the '80s, when suddenly there was a shitload of money, buckets of money being made around some of these art-

ists. But I think that she was schooled or had enough memory to know that that's not really the pissing contest we were all in. Some people bought into it more than others, but I don't think she did that much.

PHILIP-LORCA DICORCIA: I think also—it sounds bizarre in this age—but Cookie had the premise for success, but I don't think she ever *succeeded*. Being an actress gave her parts that never paid her anything, being an artist or a writer got her notoriety maybe, but…

PETER POMPAR: Experiencing things was very important to her, the idea of the '60s was important to her, and I think some amount of fame was important to her.

CARLO MCCORMICK: Did she want to be more famous? Did she want the scrutiny and judgments of a mainstream audience? I would doubt it. We were all ambivalent about that stuff then. Fame was like this construct that Warhol had set up and certainly John Waters pursued, but *fame* was amongst your peers, amongst the fellow freaks. So in that way, Cookie was incredibly famous.

RAYMOND FOYE: Cookie was really like a Warhol superstar. She was cut from that same cloth of Edie Sedgwick, Candy Darling, Jackie Curtis. That was the kind of figure she was.

BILLY SULLIVAN: I don't think we talked about shit like that, that didn't mean crap. She was trying to make her rent and live her life and do what she wanted to do. I think the way people talk about fame, I don't think that existed. The "superstar" concept was a joke, it was made up. She knew none of that stuff was real.

PETER KOPER: There was another side of Cookie, though, a side of Cookie that was quite calculating, because she wanted a career and when she started writing that's when she realized it was what she wanted to do. She was actually quite ambitious. She was always sussing out what party she should go to. It was a different side of her. Once she got into writing, she kind of considered it a part of the job.

JAMES BENNETT: Necessity is the mother of invention. She was very driven, but not in an aggressive way. I remember she got printed in

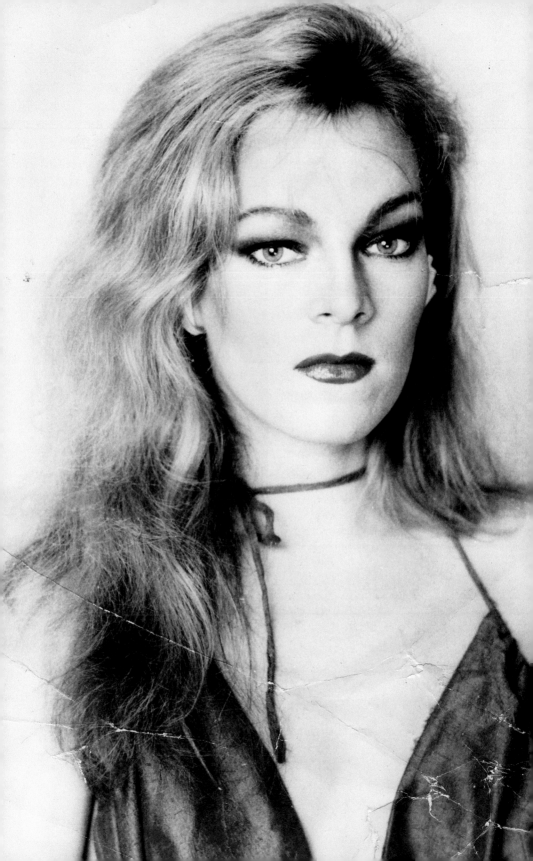

the *SoHo Weekly News*, and then she wanted to be in *The Village Voice*, and she got printed in *The Village Voice*, and then she ended up with a monthly thing in *Details*.

CHI CHI VALENTI: In the late '80s I was starting to write for *ID* and *The Village Voice*, we were both writing for *Details* and I remember Cookie coming up to me after this big article of mine came out and she said, "How do you get writing jobs, Chi?" She was dead serious. Here is this great writer and *she* wanted to know how to get writing jobs. I was like, "Well, Cookie, I'm sure they know your work..." "Oh I know hon, I just..." and as far as I know she just didn't really reach out with her writing. It was part of a generation that was, I have to say, so non-self-promotional. It was so refreshing. It was actually considered horrendous to have a press kit or something like that.

ANNE TURYN: She was ambitious with her writing in the sense that she did a lot of work on it and was serious. But there's a way to interpret that question where "ambitious" means ambitious about her career, and then I would say no. She never approached me to publish with Top Stories, there was a middle person that made it happen. There were other people who would come to me directly and say, "I want to be in Top Stories, will you put this in." Normally I did it by invitation, but I had some people who would be more aggressive.

BILLY SULLIVAN: Yeah, she wanted to get her work out, but that was just about doing your work. She would never have compromised about anything.

GARY INDIANA: Cookie wanted to be somebody. But Cookie *was* somebody. She was like a comet going across the sky once in 100 years.

JOHN WATERS: She wanted to be something, but she could never quite focus on which thing it was going to be.

PENNY ARCADE: She was kind of an actress, even though she didn't get very far with it; she had fame from *Pink Flamingos*. And she was kind of a poet but she didn't really go there. She really found her place when she started writing "Ask Dr. Mueller."

*Cookie, NYC, 1981 (Tobi Seftel)*

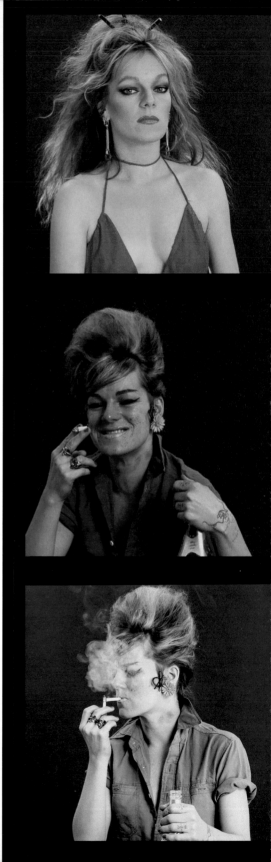

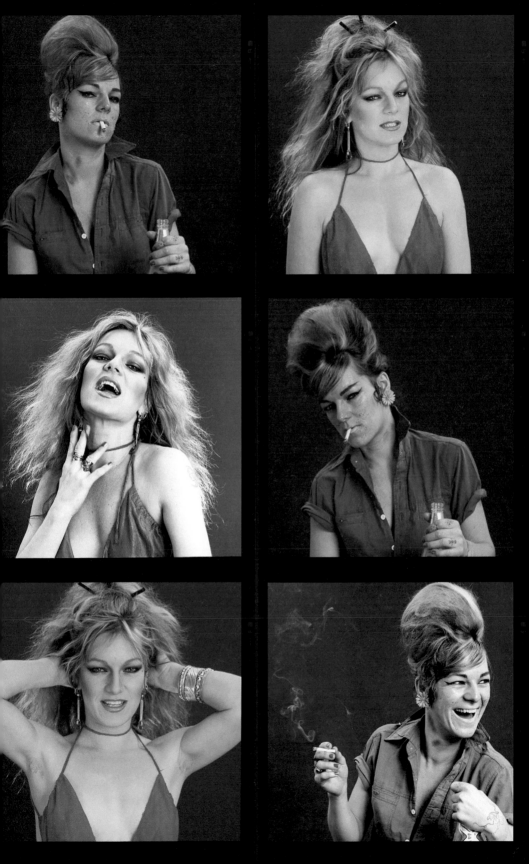

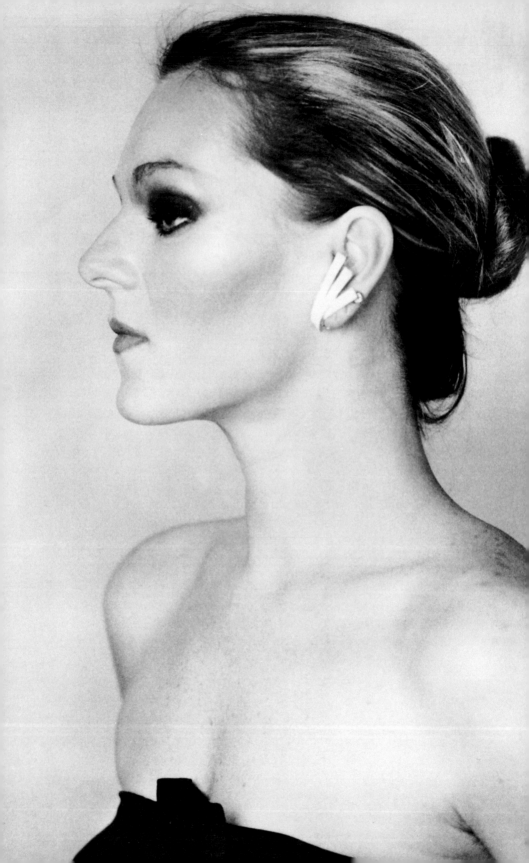

PETER POMPAR: When the punks came in and when gay writers started getting published she said, "I'll get published now. I'll have less trouble because I'm that, too." She had a lot of hopes for her writing, and she believed her poetry could ride that wave, that she could be in vogue for that reason.

WARREN LESLIE: In New York she was doing the things she had wanted to do and was doing pretty good. She had grown up. She was going to Berlin a lot; she had a lot of fans there and she had a lot of fans in Italy. She was capitalizing on her fame. She had a great job for *Details*. She was definitely more ambitious and professional when she was in New York. I suppose that was the height of her fame.

SHARON NIESP: In New York it was all business. Everything became, "I have to be on it, have to be on it." But she worked hard at getting there—as opposed to working hard at *it*. It was all a matter of timing. It was a matter of who she knew and how they all knew each other and what they could lend to each other—the minds, you know, the innovative minds of that time. It was also just being out there every day and every night, being available and accessible to people. It was all a bunch of collaboration. Whether or not it was in an after-hours club till 5 or 6 a.m., coked out of your mind, she still collaborated with people every second. And it was all based on humor.

CHI CHI VALENTI: Cookie's role in some underground movie, or a piece of her writing, or appearing in a play, or any of those things that could happen for Cookie just because of the life that she led, she never thought of those things as a career path. But it's also not like things happened to her by accident; it was about just being Cookie and what she projected and how that in turn influenced other people to create around her.

MICHEL AUDER: Did Cookie consider herself an artist? I don't think we talked about that at that time. I don't even talk about that now. I don't really have the interest to put a name on what I do, I do what I do because that's everything I know and then it comes out with

films and then the art world looks at it and that means I'm an artist. That's when you get told: you're an artist. It's just a name.

PATRICK FOX: I remember one evening in the beginning of the autumn season: after some gallery opening there was a party in SoHo. A group of us went, about five or six different artists, and I think we had a few drinks, and we ended up carrying Cookie in this refrigerator box. It was a cut-in-half refrigerator box and we were carrying her as if she were a queen—which she was—like in a sedan, you know. Cookie was being carried by a group of men on their shoulders in this box, and that's how we went to that party.

DAVID ARMSTRONG: It was kind of confusing, actually. I don't know if I acknowledged it back then; it only became clear to me when I reentered the art scene after kind of hibernating for a while and was getting major homage and was forced to look at the whole thing and what had happened. I would get asked questions like, "What was it like then?" and I would have to say it was a lot more fun, but I didn't know if that was subjective—if it really was more fun when you're young or if it was actually different. But it *was* different then. People now, it's not even that they know what they want to do, it's just that they want to be famous... without even knowing what they're doing.

MAX MUELLER: That's what everyone kind of wants, isn't it? To be famous or successful. When you don't have any money and you're struggling, of course a part of you wants to make money. But you're still trying to be more of an artist as opposed to just a greedy businessman. But I figure at some point what happens to people when they're so famous and they're making so much money is that your choice about whether the art is as important as the money becomes a moot point. Whatever you do, you just go with the flow. You can't really help it.

DENNIS DERMODY: All those people that hung out all of a sudden got famous. The only one we knew who was famous already was Gregory Corso.

LINDA OLGEIRSON: The last time I saw Gregory was in Washington Square Park and he was so fucked up. He was screaming at everybody about getting out of his park—you know, NYU students and tourists and new people who'd moved into his neighborhood and fucked it up. He was screaming and screaming and I walked up to him and said, "Gregory, *what* are you doing?" And he was like, "I'm so sick and tired of these motherfuckers."

PATRICK FOX: Cookie was driven, and it wasn't about success but accomplishment. I think it was more about the work and accomplishing something for personal or artistic reasons or to see something exist that previously didn't. It's different now. Even people who didn't have that drive to be successful 25 years ago do now. So who's to say that Cookie may not eventually have been influenced by our environment?

DUNCAN HANNAH: It's gotten so much more professional and corporate, it's become so much more about money now. This was starting to happen in the '80s, but now it's really here. New York's gotten so expensive. It's certainly harder to make a living in Bohemian circles than it was in Cookie's milieu. I suppose she could have some groovy column somewhere.

MICHEL AUDER: Everyone nowadays has credit cards. You can't be Bohemian anymore because everything is more controlled. You have to look for money all day long. Life has never been simple. It wasn't simpler than it is now, but there are so many more artists now, billions of artists. Everybody is an artist. And there's nothing we can do about it. And it's not even bad or good. Maybe it's better because there's more choice.

KATE SIMON: She was a force of nature; she didn't have anything to worry about. Nobody could possibly be as solidly grounded in Bohemian glamour as she was. Just one of a kind, it was all her own. She was too cool to be competitive.

LINDA YABLONSKY: Love her or not, it really takes a certain strength to survive the way she did, to keep going every day. Her writing, her parenting... she lived on the edge and did a lot of risky things, clearly, but she also made wonderfully imaginative things and was extremely generous to other people—that's how she drew so many people to her. You were always invited into Cookie's home, to the embrace of her world. But she was constantly promoting herself also. I mean, she wanted to meet all these people partly so that they would read what she was writing and pay attention to her. She really needed a lot of attention and she got it.

PAT BURGEE: For instance, with John Waters, you couldn't have stopped him for anything. He was like a locomotive on a track, heading where he was going to go. The people around him who facilitated that movement either fell by the wayside if their own propulsion was not strong enough or they slid into a kind of vein of their own that was also very strong. And it was interesting watching it. Trying to figure out what keeps someone alive and what makes others disintegrate. Some go up in a big bright poof and some just slowly get further and further down. We had a lot of casualties. It was a way of living that wasn't protective of the people living it. It was really risky. But folks don't have a choice. If it was the way you were, you were who you were and you lived it out.

SHARON NIESP: Cookie also had a form of depression. It just came from wherever it comes from—your past, your present, your feelings about yourself, the feelings your mother or father laid on you when you were a kid. So it took a lot for her to start getting readings, even though she wanted to do it.

JOHN WATERS: I think all of us had our own version of insecurity. That's why we hung out together as a pack. That's why we tried to scare people. Certainly she had issues with her mom, but lots of people have issues with their mom. Maybe she would have grown out of all those issues if either one of them had lived long enough.

Was she depressed? If she was, she didn't show it. I'm sure she felt trapped sometimes, but no, I don't remember her sitting around whining. Well, I mean you don't do heroin 'cause you feel good. But she kept a stiff upper lip. She was not a whiner or a complainer.

PETER KOPER: She had a tough life, some of it of her own choosing. She chose the life of an artist, a true artist. There was no safety net. I was always more in the commercial area; my big thing was I wanted to get paid with my writing, I wanted to support myself with my writing. Cookie was never really that way. There was nothing below her, she was a high-wire act, she never had a straight job in her life. I think maybe she was a waitress once for two days.

BRUCE FULLER: I think she was probably at her happiest during the summers in Positano. She liked wearing dresses and being tanned and glamorous, or, as she would say, "continental."

MARCUS REICHERT: I think she knew there had to be a balance in life. People who strive all their lives to be recognized as actors or painters or musicians and don't get that are frustrated and angry people. This craving for celebrity is such a stupid thing, and Cookie knew that. She did what she did because she wanted to. With Cookie, I don't think it was so much expressing herself as it was *living*. That's a whole different ballgame.

CARLO MCCORMICK: I learned a lot from Cookie. A lot of people learned a lot from her and probably ended up selling more books. There were all these people who were profoundly affected by Cookie, by the way she saw things and the way she dealt with things. It's sort of like the band that only 10 people went to see, but those 10 people formed bands and sold a million records. Maybe that first band is almost invisible or not so well known, but their impact is somehow genetically hardwired into our culture.

UDO KIER: I liked her attitude. She was always direct. With a lot of people it's always, "Everything is great, everything is fine," but Cookie told you her real feelings. I'm sure for some it was hard because she was so direct, but I think it was a wonderful thing that she said to people what she meant, sometimes in a very funny way.

LEONARD ABRAMS: She had this ability to be very frank, unassuming, and genuine. Today, so many people are taught or they take on this persona. It's all about personal branding. You're an entity in the world, and that's all well and good but the fact is this prevents people from real communication. Cookie had none of that. She could have presented herself as some kind of demi-star or something, but she didn't; she was completely herself. She honestly cared about people and enjoyed life. If you were interesting to her, she wanted to talk to you.

BRUCE FULLER: Once she told me something that I've always held really close to me. She just turned to me in her bathroom—I don't know why we were in her bathroom, probably doing something bad, or maybe she was putting on makeup—but she turned to me and said, "Bruce, never ever keep the company of anyone who doesn't appreciate you 100 percent."

BOBBY MILLER: Cookie was a really humble person. She didn't waste a lot of energy with people. If she liked you, you knew she liked you, she'd give you anything, she'd give you the shirt off her back. But if you treated her bad or you did her wrong, you didn't exist anymore, you know, that was the end of that.

PETER POMPAR: The magic was in Cookie. Everybody who knew her saw that, knew that. You know, the fact that she wasn't known by the public didn't change anything to us. To all of us, she was a movie star. She just fucking *was*. She was *the* movie star. And what was hard for me to believe years later was that she was under a ton of makeup! It's almost the last thing I remember about her—that she wouldn't go outside without all that makeup on. She would say, "I can put it on in 20 minutes, I'm so good at it."

SHARON NIESP: I think success for her was when she was with Vittorio and they collabo-

rated. He'd help her as an art historian, when she was writing art reviews in *Details*, and when she got her books out there. It wasn't that they were living large—an opulent-type thing wasn't their deal. I think the "success," for lack of a better word—self-fulfillment, whatever... if that ever happened—was in the fact that they were able to travel to Positano and Sorrento before they got sick. It's hard to measure what success could have been or was because everything clicked along so fast after the virus.

## PYRAMID POWDERS

*"One day she saw the sky just as it had been when she used to pretend that she was Edgar Allan Poe but this time it wasn't darkened with chemical smoke but with the impending rage of a storm. The clouds looked like rats, all the birds were flying low and the cows she saw weren't standing but lying on the grass. She knew that the animals were acting strangely because of the air pressure of a coming storm. Sure enough, it began to rain so hard that the water around her was singing with the whipping it was getting."*
—Cookie Mueller, "Case#10 Gena: I hear America Sinking," *How To Get Rid of Pimples*

LINDA OLGEIRSON: When a lot of heroin came into play, I think it affected her ambition. I think she thought she could handle it, but I don't think she had the perspective. She was hanging out more than she was working on her craft. She was always late on her deadlines and that was because there was always so much hanging out going on.

LYNNE TILLMAN: I remember she said something to me like, "I wish I were more like you." Meaning that I think she wanted to put her writing first, but there were so many other complications in her life, and I think the drugs were a big part of it. I know she hungered to be able to write more than she did, and to be able to focus better. I think that was very difficult for her given what she was involved in.

She wanted to be a serious writer, and she knew that she hadn't achieved that, and it was painful to her, I think.

MINK STOLE: We would periodically meet up, but we didn't see much of each other in the mid-'80s. I was living on the Upper West Side and Cookie was still on Bleecker. She knew a lot of people because she dealt coke, and she had a fairly large and interesting clientele, but a lot of those people were there because she was their connection. I wasn't a client, and that was a side of her life that she didn't talk to me about. I think in some way Cookie cared about what I thought about her and thought I would disapprove. So she just didn't tell me. Now, that's completely my conjecture. We would get together once every few months and go to a movie or have lunch or I'd come over and visit. We stayed in touch, but we didn't hang out. By this time she was really a club girl, and I wasn't a club girl. I couldn't keep up with her. I'm a turtle, a slow mover in life; Cookie was running with a very fast crowd.

SARA DRIVER: Cookie and I started to write a screenplay together, but she had too much going on and I ended up working with someone else. *Sleepwalk* was the film. She kept being late, and we were both pretty heavily into drugs at that point. I had to work with someone who wasn't into drugs at all to keep me in line and get some work done. But she got an incredible amount of work done. She was sort of everyone's doctor, which was a little scary.

SHARON NIESP: Cookie's meds were a little bit of this, a little bit of that, a little bit of acid, a little bit of heroin, a little joint... It was kind of medicinal for Cookie. She'd do some drugs and then meet her deadline.

PETER KOPER: Back in the early hippie days I smuggled LSD, psilocybin, mescaline, and

marijuana. I left the business, but Cookie always needed money and hounded me so I would occasionally get Cookie and Sharon some pot. Mostly the business was handled with Sharon. Cookie was not great with finances, but neither was Sharon, for that matter. I'd get them several pounds. You couldn't trust them with more because they took forever to pay and I'd have to harangue them for the money. They were terrible drug dealers.

ERIC MITCHELL: Cookie had this reputation— she had multiple reputations—and I knew she was selling drugs, but she never talked about that. I suppose she was kind of relating that to business, and a lot of it was connected to filmmakers and writers.

LINDA YABLONSKY: She was always encouraging me to write and I was always encouraging her. We kind of supported each other. I was subject to depression in a big way in those years, and she was very sympathetic. I guess she got it, having been in the same position herself. At the time I was dealing heroin, so she would come over to my house for heroin and I would go over to hers for cocaine. It was pretty much what our friends did; there was practically a track between our apartments. I was always dealing drugs on the side. She was doing the same thing. It was MDA first, a drug she had gotten from a friend of hers in San Francisco and introduced to New York.

SARA DRIVER: Linda Yablonsky was sort of at the core. She wrote a book called *The Story of Junk* and Cookie is a character in the book. Linda was our drug dealer. In 1985, we'd all see each other at Linda's house. Linda's funny—she's really thin but she talks kinda Mae West. She's got a great mind, and she's a good writer.

PAT PLACE: It was the artists, the locals—a little drug culture that we ran, and it all backfired, obviously. It's a cautionary tale, and it seems to have always been a part of Bohemian culture, but there is a certain darkness. You don't want to glamourize it. At first we were all making music and art and getting high and partying and having fun,

and then it really took over. Three or four years down the line, you're a wreck or you're dead. It just takes over, and there's nothing glamorous about that.

CARLO MCCORMICK: Like all art through drugs, it was really good and really positive and really constructive for a number of years, and then really bad. People died, years were wasted, and the art stopped being as good because the drugs were taking over. But that doesn't diminish the impact of what some of those powders did for the scene at that time.

DAVID ARMSTRONG: Cookie would want there to be a lot of fun going on, but then as things do, they would go too far and you could tell she wasn't happy. Even in the context of dealing coke on Bleecker Street, sometimes she would be furious when people would abuse the whole thing, like they'd buy something and then want to use the bathroom to get high— not necessarily with coke. She'd make rules, but then the next minute she'd be laughing.

MAX MUELLER: I didn't know the workings of all that. She didn't tell me, but there was some point when I realized what was going on. When I was a kid some of it scared me, especially the heroin, the needles. I'd see her and some of her friends. I'd make her take me with her to friend's apartments and I'd be told to go somewhere and stay but you know curiosity, sometimes I'd sneak in and stuff. I mean… I was young.

LINDA OLGEIRSON: That was the only part that was actually difficult with Cookie: you'd go visit her and want to hang out and have a nice time and talk, and then the doorbell would ring and people would come in and she'd have to take care of business. It's not that I was drug-free myself, but I didn't really care about their aimless conversation; I wanted to talk with Cookie.

CARLO MCCORMICK: Cookie kind of ran a salon at her place. That was a huge social nexus in New York. A lot of the stuff that came out of New York happened in delirious late-night moments there. So Cookie was hugely important that way. If she had only been a

drug dealer she would have been important. But thankfully, she was a really good artist in her own right and an amazing person with all these other talents.

DAVID ARMSTRONG: In the later part of the '80s, Cookie seemed very health-conscious. She struggled with wanting to do all the right things. I see it like I see myself: there's one part of me that has this optimism and positivity, but there's also a part that is incredibly self-destructive. Cookie always tried to rationalize it and cling to this thing… it's like trying to hold on to the past, and you really can't do it. I'm not saying that's specifically what it was, but she would say, "Well, I'll do this, but I'll do this, too—to cleanse this—and I'll do a colonic, because that does this." I adore Cookie, but I *hate* that, and so many people do that. Cookie was putting restraints on herself, like, "I only do this much."

PAT PLACE: She had some rule that she wouldn't allow herself to do it more than three days in a row, so I don't think she ever really got strung out. We did, but she was very controlled about it, which is interesting. She had some sense of self-preservation, more than a lot of people did at the time.

JOHN HEYS: And she's the only other person I've met in my life who did not smoke cigarettes in the daytime, other than me. I always thought that was interesting. No cigarettes until sundown and then after dinner and when night-life began.

PETER KOPER: When she was writing "Ask Dr. Mueller" I remember John saying, "She's fucking taking heroin and snorting coke and drinking and now all of a sudden she's recommending organic remedies to people!" He couldn't get over that.

SCOTT COVERT: *She* was the one keeping an eye on *us*. I was a wild drug addict, and she would be the one who would be like, "You gotta go kick for a bit, you gotta bring the habit down." She saved my life. She would tell everybody how to survive. She was the doctor.

DAVID ARMSTRONG: That period for me in New York was split into going up and then totally crashing. There were so many drugs, so much craziness, that I got so strung out. It was really Cookie and my friend Dana who were my caretakers. The last year I was in New York, 1983, Cookie was one of the three key people who kept me alive. I basically lived at her house. She was trying to figure out some way to put me back together, but there was really no way. I went to Boston to straighten up and ended up staying for about five years. Of all the people I knew in New York, there were only four who called me in Boston, and one of them was Cookie.

RICHARD HELL: We were both doing a lot of drugs, and I was really sinking deeper and deeper. She had some kind of restraint that I didn't. I was just completely destroying myself. I felt guilty, I felt like I had been exploiting her as a dealer. We parted ways in the early '80s. For me, she had a big indirect healthy influence that made me really determined to stop taking drugs. I stole her coke cache, her secret supply. I knew where it was; she wasn't hiding it from me or anything. It made me so disgusted with myself that I had fallen so low that I would steal from Cookie. I felt like such a scum, stealing from a friend. It took a couple of years of hard work trying to get out of drugs, but that was the turning point. I cleaned myself up, finally, in the mid-'80s and then I never really resumed contact with her because I was too nervous about moving in that circle again. She meant a lot to me, but I didn't even go to her wedding because it made me too uptight to be among all these people who I had this history with.

MINK STOLE: Toward the end, when she was doing all the drugs and living such a fast life, she was like the sister I didn't see anymore. She was a mess. I loved her like family—like a sister—but I didn't see her because she wasn't someone I could spend time with.

MARINA MELIN: Once I ran into her in a Village pharmacy and she was really zonked—maybe it was heroin or maybe it was something else, but it was very obvious—and all the staff and managers were watching her. I saw her and I was

like, "Cookie, hi," and she just started showing me things, this lipstick and that product… It was kind of endearing and sweet, because it was so much a part of her.

CAROLINE THOMSON: I once saw her faint completely at the sight of a syringe being passed to her. She fainted heavy; right on her back. Which is why it surprised me when she got into it in New York, but it was the fashion then, and Cookie was a great one for fashion.

BOBBY MILLER: It had a lot to do with the times, the scene. Everyone was wearing black clothing and we all had dyed hair and all the music was like that, leading people to heroin. I think a lot of people submitted themselves to it and then it became too late, the chemistry took over. By that point, some people would never get out of it.

LINDA OLGEIRSON: I think Cookie was definitely dependent, but she never looked like a junkie. Only in a few photos. Cookie felt that heroin was a preserver, that it would slow down your functioning and your heart rate to such a degree that you actually were preserved and that it made you live longer. She wrote a long letter once explaining it to John Waters. We were driving one day and he pulled out this letter. He was feeling a bit negative about Cookie, and he said, "Cookie is a close friend of mine and I'm giving you this," and he didn't say any more. I read it, and it was so crazy that I couldn't keep it. I wish I had hung onto it in hindsight. She was really pissed off at John. The whole letter was very defensive about her heroin use, and she was explaining the "preserver concept" and how she could think better.

JOHN WATERS: We were estranged a little bit toward the end, because of drugs. I was never a junkie and basically she was. But I wouldn't fight with her about it. She wrote me a letter once about how heroin is cool and I said, "No it isn't!" I did drugs, but never heroin, I never got to that point. Cookie was a drug dealer for a long time. That's how she lived. Everybody knows that. I'm not telling stories, and

she wouldn't care—she's dead, she's not gonna get busted. She sold coke and pot… and maybe heroin, I don't know. But for a while over at her house it was like an off-Broadway play about the drug world. So, during that period we were estranged. There were times when I just had to walk away and she probably had to walk away from me and yes, I think that we both did that for some kind of protection. I guess she thought I was judging her, and all I was saying is that I couldn't be around it. She wasn't my first friend who had drug issues, David Lochary died from drug issues, a lot of people did. I didn't know what to do about it—I was never a yes man. But at the end, when she was sick, we certainly talked.

PAT BURGEE: I watched Cookie change some, get a little bit harder. She was really in love with the drug thing and we'd talk about it. I said, "I know George has done it a couple of times and it's really worrying me," and she said, "What are you worried about? There's nothing wrong with that, everybody in New York does it."

It was almost like you had to step inside the aura of the drug in order to believe in it, but if you couldn't get inside that aura, what you saw were these beautiful, brilliant people spinning around in these grotesque environments that were the truth. The truth of it, for me, is a horrible, cold, grim, deprived, empty place. And I'm not privy to what makes this so magical to you, because I don't see the magic, I see the debris.

SCOTT COVERT: Sometimes Cookie got strung out. I've known Cookie to have habits, but she was always in control of them and could figure out how to get rid of them. It wasn't that she got into trouble, it was that she was lazy and would let herself do it.

SHARON NIESP: She wasn't dependent on heroin. She managed. I never knew a time when she was going through withdrawal or had a dependency so bad that she had to get up in the morning and go look for a dealer. We just did our share.

But a lot of times it does creep up on you. For a while she was doing it pretty steady, yeah.

MAX BLAGG: I didn't know how much Cookie was doing, and I didn't associate her with it, but I think in Italy, too, there was a big heroin thing.

PETER KOPER: There was a whole other world in Positano that they inhabited. I was never there with them, so I don't know, but something was going on there. Cookie and Vittorio told me there was a place in the woods where all the junkies would go to shoot up and there were these trees that were festooned with hypodermic needles. Needles stuck in the trees. I guess it was part of their relationship. They didn't seem like junkies to me, but I'm wondering if that wasn't a point of connection between them.

MAX BLAGG: It's funny to look back and say that Cookie was the life of the party. The parties were good until a certain point, and then the fun was over. It was kind of brutal. Like with cocaine. When it was around, people's behavior was fucking awful—disconnected from any real feelings.

PAT BURGEE: If you stood close you could feel the undertow, and it would be pulling and pulling you towards them and their beautifully complicated and integral way of being with each other which became what was real. I was too timid for that. But I watched people floating on that social plane that was so intense and so engaged with each other and that's what I felt like maybe Cookie was experiencing. But I couldn't see it from within, I didn't have whatever it took to withstand that. I mean it takes a really powerful person to hold their own in a drug scene like that for *so long*. It wasn't until the body broke down that they weakened.

CAROLINE THOMSON: I believe that, like a lot of us, she had a strange death wish that showed itself once she got to New York. I think she was very susceptible—she'd go for anything and do things that were definitely suicidal in some way. We all were, but we had dreams also, which is really the opposite of the death wish.

BOBBY MILLER: I don't think Cookie had a fear of dying. I think she spent a lot of time at the edge because of her heroin addiction. There's something about heroin and morphine… it's so easy when you're on those types of drugs to think, this is great, this feeling of nothing. I don't want to have to go back and work and pay rent and fight with my boyfriend or girlfriend. The psychological and emotional freedom of those drugs is the appeal for people who are miserable in life, who don't like the struggle. And yet Cookie was someone who liked life, which was what made no sense to me. I used to tell her this. I didn't understand it, even having done it myself. Toward the end, I think Cookie saw that and thought, "Okay, I did that, but that's not real life."

MARCUS REICHERT: I occasionally thought about what takes people to heroin. I think a lot of people can't strike a reckoning in life because it's not what they're about. There's a lot of excitement to the rough-and-tumble aspects of life but there's something else, a center that maybe we don't pursue but have to acknowledge and respect. There are people who want to penetrate it, to feel that it's part of themselves all the time, that they can access it. I think Cookie was like that. When I realized she was doing heroin, I thought, yeah, that's what it's about. She's working a kind of communion with something. Now, someone else could say to that statement, "Phooey, people just want to get high," but what is getting high? What is it to drift off and be in this other world? That's a pretty profound thing to do. In a way, a frightening thing to do.

*Cookie, 1978 (Robert Mapplethorpe)*

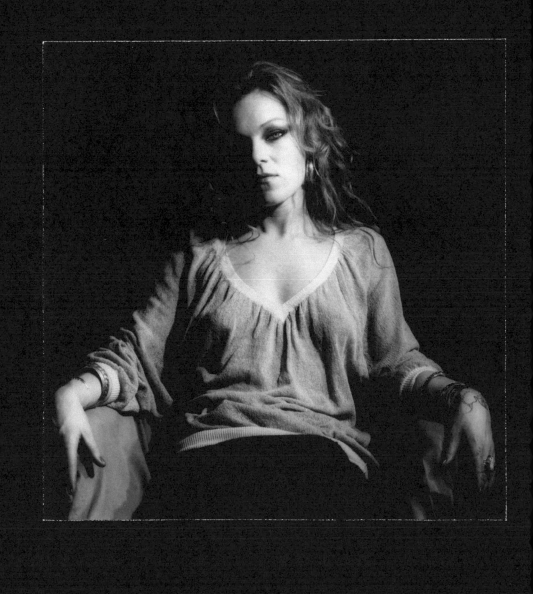

# A POOL PAINTED BLACK

New York, 1989.

New York, 1989.

## INCANDESCENT ONES

*"Fortunately I am not the first person to tell
you that you will never die. You simply lose
your body. You will be the same except you
won't have to worry about rent or mortgages
or fashionable clothes.*
*You will be released from sexual obsessions.*
*You will not have drug addictions.*
*You will not need alcohol.*
*You will not have to worry about cellulite
or cigarettes or cancer or AIDS or venereal
disease.*
*You will be free."*

—Cookie Mueller, epigraph to the anthology
*Ask Dr. Mueller*

SCOTT COVERT: It's a hard time to remember.
You block that period out.

MAX BLAGG: Looking back on that time, everything's a haze. That's the problem. Sort of a strange, very cold feeling, especially when a lot of people started dying of AIDS. I didn't feel like I was in the highest-risk bracket because I didn't shoot up and I wasn't gay, but at the same time, it was just this random thing. You just thought, okay, I guess you're just supposed to go by the time you're 40 or something. When I look back on that time, it was just dark.

DAVID ARMSTRONG: There was a crazy transition from the '60s to the '80s, and AIDS changed a lot of things. People were just dropping right and left. I really shut down... way too much.

CAROLINE THOMSON: After they all left Ptown, Cookie would still come back sometimes. I would go to New York and we'd see each other. We had all gotten Hep C, but there was this new thing coming out in '84 that nobody knew about. I was lucky because I had just met up with this couple, David and Susan Schacter, and David had been a doctor and had all these medical magazines, so we knew about this dreadful thing coming toward people. I'd go running around madly to all the places where the boys would hang out and tell them to please get married and they would just laugh at me and make fun of me. I was just frantic, knowing this thing was coming.

PENNY ARCADE: Starting in '80 and '81, everyone we knew started dying. Cookie was in the middle of that experience, and was one the first people to write about AIDS. She had a platform and she used it; she wrote about AIDS in a way that wasn't being done. Cookie's column was really important. People were reading it, she had been talking about AIDS consistently... and then she was positive.

JOHN HEYS: Gordon Stevenson was a really sweet man who I think was gay or bisexual,

and as I recall, Cookie had an affair with him. I believe he was the first friend of Cookie's who was sick, and it was in the time before its official name of Acquired Immune Deficiency Syndrome. They called it the "gay cancer." The first signs of the gay cancer before it had an official name happened in like '79 or maybe late '78. By 1980, the Gay Men's Health Crisis was founded. I was a crisis management partner at the Gay Men's Health Crisis, which you had to train for, and then you got clients. We had the first team in the East Village. We had to do this training—it was really draining and very emotional.

LINDA YABLONSKY: Gordon Stevenson was a filmmaker and a drug addict, like all of us at the time. They were sharing needles, so Cookie could have picked it up from him, although I'm not sure. The thing is, we were all constantly putting ourselves at risk. That's just one example.

SHARON NIESP: She kind of thought it was Gordon Stevenson, and in fact there's a letter in one of her books that he wrote to her. But it could have been somebody else who she had sex with. Could have been this Chinese painter—he died later on. I remember he was here in Provincetown in the summer and she had a minor fling with him. I didn't dig too much into it; that was her business. But she narrowed it down to Gordon Stevenson because he really started flaring up soon after their fling and she had been carrying on with him for a while. This has always been a grey area, and now they're coming out with all this information saying you could be infected for seven years and not know it. She could have been infected for three years, two years, one year, which would have put it back to '79 or '80. I escaped it through some miracle. I never shot drugs, I never had any blood exchange with her.

JOHN WATERS: So many of our friends died—half my friends died, really—in the '80s. Cookie… who knows how she got it? It doesn't matter how she got it. She liked heroin, she liked fucking gay guys. She liked everything! She was a bull's eye.

ELIZABETH SCIBELLI: I know Cookie and Vittorio both had it and knew it and that's why they got married. I'm sure that's not the only reason, but they definitely knew when they got married. Vittorio had travelled around for a year and I think he felt like he got it somewhere outside of Italy. Cookie told me this.

SHARON NIESP: They both loved each other and they were both positive when they met. For the longest time, Vittorio's family hated Cookie because they thought she gave Vittorio AIDS. Cookie's parents and family hated Vittorio because they thought he gave Cookie AIDS, but he didn't. He had it when he was in Naples, and she already had it before that.

When we went our separate ways in '81 and in '83 I went to New Orleans, she met Vittorio in Positano. That following year—the first year they were together, it was probably '83—we had this phone conversation and she said, "Shar, I went to see the doctor today and he looked at my blood differentials and said my immune system was compromised… you know what that means." I sort of had to think for a minute, because there were no definitions in those days—they called it everything. Then she called Vittorio and he was already sick in Rome. He had the thing called ARC—AIDS-Related Complex, which means it simply becomes symptomatic, and Cookie wasn't symptomatic at all. In Rome, they extracted a lymph node of Vittorio's and biopsied it and found out he had the virus. The doctors there were just seeing the beginning of it, the tip of the iceberg.

PATRICK FOX: I heard Cookie was sick when she first came back from Positano, the year before I went. It was the beginning of the autumn art season but the summer streets were still hot. I don't remember who, but someone said they heard Cookie had AIDS, we didn't know anything about stages or classifications yet. In the next minute, I saw Cookie approaching. I remember the evening light. She was walking into the sun and she looked more beautiful than I'd ever seen her.

SHARON NIESP: She had never gone to a medical doctor because she didn't feel bad or anything. The nutritionist discovered it. You know how they look at things holistically, well she was going there for something quite different. He figured it out. He didn't say she had this or that, he just said, "Your immune system is compromised." I don't think she ever went to a place where they gave you a test and it said she was positive, but she knew she was.

LINDA YABLONSKY: Cookie didn't want anybody to know for a long time because of Max. If people found out in those days, he would have been vilified in school. Only whores and junkies got AIDS, people thought. She was discriminated against when getting treatment; they treated her really badly at the hospital, like it was her fault. I knew she was going to die, because there wasn't any way around it at the time. I remember Cookie once telling me that Robert Mapplethorpe—who had been sick for a longer time—had told her that he wasn't going to die of AIDS, that he would seek every kind of treatment possible and that one of them would work because he was determined not to die. She said, "I'm gonna be the same way." I remember her telling me this after his memorial service at the Whitney Museum, which was a very big deal. We went to so many funerals in those years, between '87 and '89. That's what I did; I didn't go to nightclubs anymore. I saw more people at these memorial services than I did at any other time.

GABRIEL ROTELLO: Around '86, I became an AIDS activist in the group ACT UP and then later in the decade I founded OutWeek magazine. I sort of stopped being a musician and producer and became the editor-in-chief of OutWeek, which was completely and totally devoted to the AIDS epidemic and to gay rights in general, but particularly to the AIDS epidemic. OutWeek was arguably the biggest and most well-read publication about AIDS and practically any time somebody would write anything major on the subject, it would be in my magazine. I would have been thrilled if Cookie had approached me about writing something. We would have published it for sure. I was so deeply enmeshed in AIDS, and yet I didn't even know that she had it. In those days it was overwhelmingly a gay and drug thing. But there were a lot of women who had AIDS and we went out of our way to cover that aspect of the epidemic. A lot of women with AIDS wrote for OutWeek or we wrote about them, but Cookie... I just didn't know, I don't know whether she was open about it.

PETER KOPER: I was in Los Angeles and we had dinner at a sushi place and she said something about how she and Vittorio were ill. AIDS was not mentioned. Someone said she had told Divine she had AIDS and that they were going to beat it and go on special diets and clean up their act. She wasn't showing any signs at that point.

SHARON NIESP: Vittorio got the first bout of pneumonia in New York when he was doing art restoration. They thought the marble had just got in his lungs, which would have been possible cause he never wore a mask. Cookie had already had pneumonia and whizzed right through it. She was very healthy for having carried this thing for so many years.

CHICHI VALENTI: At Gennaro's funeral, which was in Ptown in October of 1986, we were up there staying with Cookie and Sharon and this other friend of ours, Costa Pappas, who had been Gennaro's boyfriend. He also died of AIDS. Cookie was one of the people who was shoveling dirt onto Gennaro's grave; it was four women: Cookie, Sharon, myself, and his friend Clara Navarro, known as Claire in those days. It was just beyond tragic. It was a very disheartening time, and nobody could believe that the most beautiful, incandescent ones were the ones being taken when there were so many boring people we could have donated instead.

MINK STOLE: I knew she was sick, but there was a whole lot of denial going on in my brain. I had been doing a lot of work in AIDS wards and hospitals. New York was a very unhappy town during the '80s, a *very* sad place to

be, because people were starting to die. If you ran into someone you knew on the street, you didn't ask, "How's so and so?" because you didn't want to know. I mean, the news was bad. Everybody was dying.

SUSAN LOWE: I didn't know who I was grieving for after a while.

MINK STOLE: It was like, "Hi, I'm glad to see you, that means you're still alive." It was literally like a plague had hit the city and was just decimating everybody. So I may have actually blocked from my mind the fact that Cookie was going to die because I just couldn't take on anymore.

DAVID ARMSTRONG: First she said her immune system was compromised. Cookie was always doing some crazy diet. I mean, at that point it just seemed to me that she was evading what she knew was true. To say that your immune system was compromised meant you were HIV positive. But in the early '80s, people didn't know what it was; a lot of people were dying of a "strange pneumonia." I only found out I was positive ten years ago, and I'm sure I have been since the early '80s.

BOBBY MILLER: I was one of the first people tested, in 1980. Almost everyone who had it from the '80s is dead now, and it's because they took that drug AZT; they didn't know better. It was really toxic and they didn't know how much to give, so they gave too much and it killed everybody who took it. They thought it was their only chance. If they had just waited just a little bit longer... I mean, how can you know? You can't know. Why am I here? I've been positive for 28 years, and it was only five years ago that I got sick. Cookie had a very holistic approach to everything. She believed in positive thinking. I remember she said to me, "If you're positive, be positive," instead of walking around with all that stress and tension. Cookie's approach was to eat healthy, fresh foods. I know it was difficult for her, because on one hand, she was trying to embrace all this positivity, and on the other hand, she was a junkie, so that was a challenge.

PEYTON SMITH: I had a dealing business myself, much smaller than hers, but we would sometimes go in on stuff together. But later when she was sick, she didn't want to do it

*Vittorio Scarpati & Cookie at John Waters's Christmas party, Baltimore, 1988*

anymore. She gave me her customers because she didn't want that happening around her anymore. Whatever money I got from clients that had been hers I gave to her.

SCOTT COVERT: It was really depressing when she had to stop selling coke because it really got hard, not having money and dealing with AIDS.

PEYTON SMITH: That was what she was living on. But when she was sick, she didn't want people in her house. I think this was maybe in '88. I remember the night when she came over and we talked about it. She didn't come to my place as much, I was always at hers, but she came to my house and we went downstairs, out on the street on St. Marks. She said to me, "I'm *angry*. People with AIDS are *angry*." I don't know why that stuck in my mind so much. I guess just to hear Cookie express something like that, because she didn't express anger. Cookie held things in; throughout all of her squalor, she was a lady.

PETER KOPER: There were times when she was depressed. Sometimes she'd just look off to the side, looking lost in thought somewhere. Having no money preyed on her all the time.

SCOTT COVERT: Cookie never borrowed money from friends, she was very proud about money. At the end, when Vittorio was in the hospital and her refrigerator broke down, it was just another thing. Her refrigerator broke and it was like, oh shit. I thought if everybody put in $10, we could buy Cookie a refrigerator. So I asked someone and they went back to Cookie because they were afraid I was buying drugs. She gave me so much hell for trying to get people to donate money. She was mad at me because she hated handouts.

When we flew to Provincetown that summer, we had had a long ride into town, and hadn't eaten. We went into a bar and there were nuts and I was eating the nuts too fast and Cookie went, "Stop eating like that, everybody's going to think that we're starving and poor!" She was very much about her image. It was embarrassing to be in that situation: to be poor and dying. She did *not* like people

to think she needed any help. She was very proud.

MARCUS REICHERT: When I met her, I was having anxiety attacks that were very painful. Things were rough; I'd have to go to the hospital. She understood this, and I would calm down when I was with her. I don't think you can recognize the turmoil in someone else and have a pacifying effect unless you know what it's like. There was an aspect of suffering to her. She wasn't demonstrative of her emotions in an exaggerated way, ever. But she was very affectionate, and sometimes I would look at her and think, this woman knows a lot about things. I've known people who are very extroverted and if they're having a bad time they're very vocal about it and they create a difficult atmosphere that you've either got to partake of or back away from. Cookie wasn't like that.

LESLEY VINSON: It was probably one of the few intimate moments I had with Cookie. I hadn't seen her in a while and she came into my office. I was the art director so I was always sitting in the dark over a light table, and she walked in and opened up her heart to me and started telling me something and crying. It was so unusual for her. It was something about this being her last chance. We weren't best friends. It was out of character. She came and started talking so seriously: "I have to stop doing this." It was something about drugs and being sick.

STEVE BUTOW: When Cookie and Vittorio got sick, I turned them on to the doctor of my friend. They started going to Dr. Jeffery Wallach, and they both ended up in Cabrini Medical Center. There were a lot of gay doctors and it had a big AIDS ward, and they were the first couple with AIDS to share a room together. It was kind that the hospital let them, because normally it was very segregated.

SHARON NIESP: People visited them jointly and there was a video made. Cookie did a reading from the bed, an interview with Vittorio happened there...

GLENN O'BRIEN: I saw a lot of Cookie and Vittorio in the hospital. That was really a

*Vittorio Scarpati & Cookie at Cabrini Medical Center, 1989 (Francine Hunter)*

# Putti's Pudding
# Cookie Mueller and Vittorio Scarpati

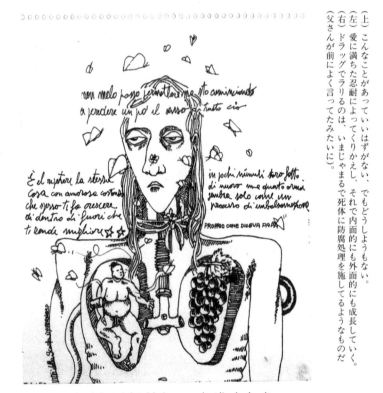

（上）こんなことがあっていいはずがない、でもどうしようもない。
（左）愛に満ちた忍耐によってくりかえし、それで内面的にも外面的にも成長していく。
（右）ドラッグでラリるのは、いまじゃまるで死体に防腐処理を施してるようなものだ
（父さんが前によく言ってたみたいに）。

(top)  I can't let this happen, but I'm losing it.
(left) It's the repetition of the thing with loving perseverance that makes you grow inside and out.
(right) Getting stoned now is just like an embalming process (just as dad used to say).

*Title page from* Putti's Pudding *(Kyoto Shoin International Co., 1989)*

tough time. Cookie would give me pills, because they had a lot of painkillers. It was a sad story; even though they were in very good spirits, there was nothing anybody could do then for people with AIDS.

JUDITH PRINGLE: I never saw her down, really. Even when she was in the hospital with Vittorio, she had a lot of optimism. They talked about going to swim with dolphins, drink their own urine, whatever might make them better.

LINDA YABLONSKY: Vittorio got sick first and had pneumonia often. In the hospital he started making these little drawings that were eventually published in a book. Cookie put it together as an art show to help pay for his medical expenses and everybody bought the drawings. They were very powerful and moving, because they were about his being sick and the kind of anger he had and the kind of love he had for her and wanting to live.

CLAUDIO CRETELLA: He was very aware of what was happening to him. He was very intellectual and he always politicized things.

PAOLA IGLIORI: Edit deAk was working with a Japanese publishing house, and she asked me to curate a book for a series they were doing, so I gathered all the drawings Vittorio was doing with Cookie's writing and we put it all together.

SHARON NIESP: *Putti's Pudding* was the book. It's the most amazing thing—he was in Cabrini Medical Center with chest tubes and morphine and he couldn't get out of bed, and somebody got a brilliant idea: "Gee, duh, maybe I should get him some crayons or colored pencils," and he created *Putti's Pudding* and she did the libretto.

PATRICK FOX: Bill Stelling was one of the founders of the Fun Gallery, and after I had dissolved my involvement with the partners of my gallery, Bill sort of took over. The drawings were shown at my old gallery, now 56 Bleecker Gallery. He did this beautiful one of himself at the gallery with all of his drawings around him. It was incredible; he did it in such detail that you could recognize each drawing he was

standing in front of, because he was in the hospital for the show—he couldn't make it.

PHILIP-LORCA DICORCIA: I took a photo of Vittorio in his hospital bed for the show at Patrick Fox's gallery. My wife Naomi worked there, and that was the first time I ever had a picture up in a show. I never took any pictures of Cookie, and I never took any pictures of my brother when he got AIDS. I always felt that it was somehow exploitative to do so. I took Vittorio's because he asked me to.

BILLY SULLIVAN: I have a drawing that Vittorio did in the hospital. They're both in bed and everybody's paying attention to Cookie; that's why I bought it from him. Vittorio said to me that everybody in the room was there to see her... and it was probably true.

JAMES BENNETT: Vittorio was getting worse and worse. He was in a lot of pain—dental pain—and back then, dentists didn't really want to work with your mouth, with all the blood and stuff. Vittorio was a lot worse off than Cookie. He was pretty much on morphine most of the time, whereas Cookie was fine, entertaining in her room all the time, everybody bringing something over.

JUDITH PRINGLE: We used to see Vittorio a lot in the hospital. I used to make him big jars of chicken soup, which he loved. I used to put chopped dill in it and he loved the little green things floating around, he just thought that was spectacular. There were always people coming and going, people bringing big juicers, making special concoctions.

ELIZABETH SCIBELLI: They needed t-shirts, they needed food. It was kind of a little party in there all the time. They were always trying to be funny and witty. They were both very charming.

PATRICK FOX: I remember rubbing his foot. I just remember sadness in the hospital. I asked Cookie about Beauty, her dog, she said, "Oh you know how dogs are, they always know when to get out of the way..." It was the last thing Cookie ever said to me.

RICHARD HELL: Cookie was always very apologetic and embarrassed when the people who were close to her came by, as she had so much

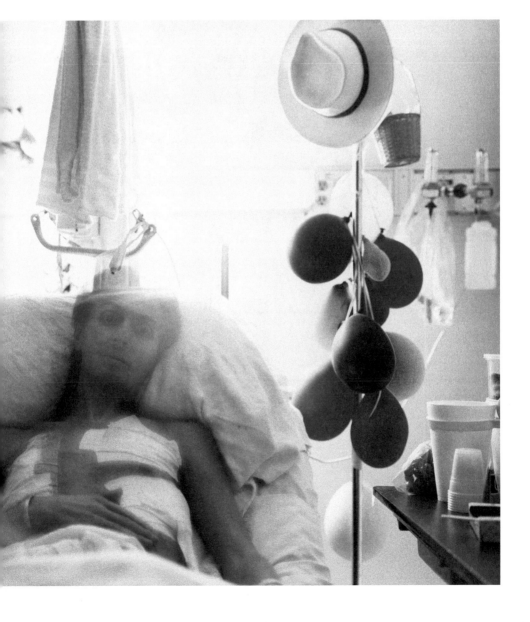

style. You know, the way she liked her hair to be, her makeup to be, and her clothes to be… she liked to present herself. But by then she was just ravaged. And she got sicker and sicker and was always apologizing. She was embarrassed that she was so haggard and she also went through the whole thing with her husband, keeping his spirits and her spirits as high as possible.

PENNY ARCADE: Near the hospital was a store that would get Bloomingdale's, Saks, or Bergdorf's merchandise on sale. One day I went and there were all these Norma Kamali bathing suits for $10, and then I went to the hospital with this bathing suit. Cookie was in bed, and here I was: "I found these bathing suits!" Cookie was like, "Can you get me a black one?" And I did, but by that point we didn't think anyone would survive.

JAMES BENNETT: The closest I got to Cookie was in the last year of her life. Practically everyone I've known is dead from AIDS, and she was one of the best soldiers in that war.

UDO KIER: The last time I saw her was in the hospital, which was a beautiful picture. Jim Jarmusch and Sara Driver were there, and there were a lot of flowers. Her hospital room looked like a flower shop. We did not talk about her illness at all. Not one word. She was just like Cookie always was: funny, all made up, sitting in her hospital bed. It looked like she was playing it in a John Waters film. And then she had to say goodbye and I turned around at the door and she waved and I have a picture I always will keep in my head: her in the bed, looking beautiful, surrounded by so many flowers. That was my last image and it's a wonderful image.

BRUCE FULLER: I always said they were like Lucy and Ricky with AIDS. She was very vocal in the hospital. Those are some of my best memories of her, even though it was very sad. I was so young I had no idea they were even going to die, to tell you the truth.

MAX BLAGG: I wrote a fictionalized piece about seeing her there with Vittorio, lying down with things coming out of his chest.

The room was filled with people, partying as if they weren't in a hospital room but in a downtown loft or something. I probably exaggerated it for fictional purposes, but it was like a big scene in there, everyone hanging out, some people even doing drugs. Like, the show must go on.

TAYLOR MEAD: My memory is kind of shot; I'm 81 years old. But I do remember visiting them in the hospital. The nurse had left hypodermic needles next to them. The nurse deliberately left morphine on the table next to her, and Cookie thought it was so she could commit suicide, because the nurse knew what was going on, knew what AIDS meant.

GARY INDIANA: It was a wonderful party, but it ended with her dying. Cookie was stronger than anybody in the world. She wrote me a letter once saying there were only one or two things that were killing her and that she would go on anyway. I was so fearful of her dying that I backed away from her, because when people are dying, sometimes people gather around them that you don't want to deal with.

JOHN WATERS: It's a tough story because it has a sad ending. A really sad ending. A lot of people had sad endings in the '80s. AIDS was something that just came through and wiped out my generation. I didn't know anyone who died in Vietnam. Everyone I knew, they knew how to get out of it, and all the people in Vietnam probably don't know anyone who died of AIDS. Cookie never led a safe life; unsafe was her middle name. She lived on the edge, always. She liked the edge, I think.

*Drawing by Vittorio Scarpati*

## CABRINI

*"The wall eyed butcher cleaves to his heart the butterflies, the fleeting and elusive beauties who live only for an afternoon"*
—Cookie Mueller, *Putti's Pudding,* 1989

SHARON NIESP: Cookie didn't take AZT. She just kept it in the medicine cabinet. She took it once and hated it and would never take it again. PML—Progressive Multifocal Leukoencephalopathy—is where the virus goes to the brain; the blood barrier to the brain is the last thing that gets infected, and she eventually got the PML. She survived pneumonia, she survived thrush, she survived all other kinds of infections, but because she had no antiviral intervention, it got to her brain. She couldn't go in the sun when she was living here in Ptown. She would go into New York to see Dr. Jeffery Wallach, who's dead now, and he gave her AZT. I told him, "She won't take it. She hates it," and he said, "Just tell her to shut up and take the fucking pills." He knew that even though it made you feel horrible, it was the only treatment out at that time. What it would do is sustain her a little bit, give her time. But she would just take minerals and vitamins and amino acids. We used to go to this nutritionist, Dr. Rodriguez, who really kept her alive because he kept pumping amino acids into her. That's why she didn't get this thing called the wasting syndrome, when people just lose weight and their hair and the skin goes. The amino acids are probably what kept her so strong, because the first things the virus attacks are your enzymes and amino acids. When she and Vittorio were in the hospital, sharing the same room, Dr. Rodriguez came in with a bag of pills and didn't even charge them. They just tried everything. He came in with this $4,000 suit—this little nutritionist—but he was great. He knew his stuff.

PAT BURGEE: She came down to Baltimore when Divine died in 1988 and Vittorio was with her. He was *really* sick. And just *so sad.* A

deeply sad man. Cookie wasn't really showing yet; she was harder, the planes in her face were a little bit more decisive and she was grieving and we all look a little bit harsher when we're grieving, but I didn't see the degradation of the disease. I could see change. I could see age, but she looked like Cookie. She looked pretty.

EARL DEVREIS: The older she got, before she died, she looked extremely beautiful. That was the best I ever seen her look, to be real honest with you. I was astounded with how good she looked. She really matured beautifully; she looked better when she wasn't into the makeup and all that weird stuff.

ALAN REESE: I think the last time I saw her may have been at Divine's funeral. I was in an upstairs room where you could hang your coat before going out to the viewing room and she just kind of appeared. We had an awkward, kind of *The Way We Were* moment and a nice conversation. That's the last memory I have of her.

PAT BURGEE: It may have been the last time I saw her also. I remember Cookie broke down. We had a place for Vittorio to sit, because he couldn't possibly stand up, but the room was crowded. Very few people could get anywhere near the front of the room. Cookie and I were standing next to each other and the poor thing just broke down. I remember putting my arms around her and noticing how skinny she was, there wasn't anything to her. Even though she didn't look bad, the bones were too close to the surface. She was sobbing, saying about Divine, "He was like the only mother I ever had." She was very badly torn up about it. It was sad for all of us.

KATE SIMON: In '89 I was doing this show at a gallery in Santa Fe called Casa Sin Nombre which was run by Steven Lowe, who I believe died of AIDS in the last year or two. He was a friend of William Burroughs. I was trying to shoot new portraits for this show and I wanted one of Cookie. So, the truth is that Cookie is the first person I photographed knowing she had AIDS. Currently I know many people

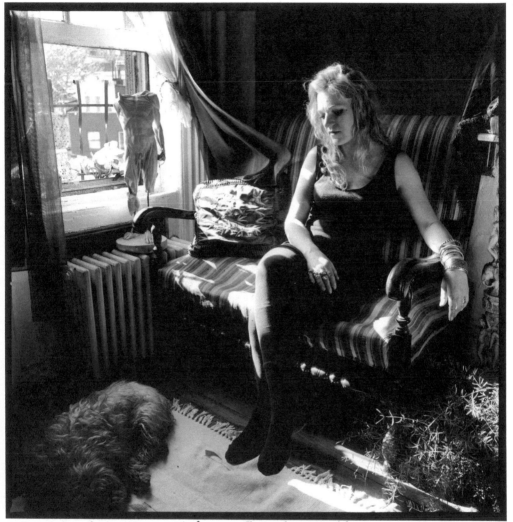

*Cookie at home, Bleecker St., 1989 (Kate Simon)*

living with AIDS. I did the shoot in March of 1989. I showed up at her apartment and she was sitting in a chair holding a bottle, and I said, "What's in your hand?" and she said, "Oh, nothing," and I said, "Come on, let me see," and it was Percodan. I said, "Give me some of those," and that's really sick of me, but it's true. She gave me three. And I mean, she needed them. It was sick of me, but that's the kind of relationship we had. So there I am, stealing her drugs!

Cookie was good friends with my best friend Carl Apfelschnitt, who was an incredible painter and who came with me to this last sitting I did with Cookie. Carl died of AIDS in May of 1990. She was an incredibly brave subject. The pictures were very intimate—she would have had to have felt a certain closeness with the photographer to be as quiet and intimate as she is in these pictures. They're very thoughtful and beautiful, and she was very collaborative. She was sitting on her couch by the window and there's a sculpture of a sinuous naked man with no head and there was this muslin fabric wafting from the window and beautiful available light and her dog was at her feet. It was magnificent, and she always had these millions of Janis Joplin silver bracelets on her arms. In the middle of the shoot she said, "Kate?" and I said, "Yeah?" and she said, "Can you give me back one of those Percodans?" But I had already taken them all.

LINDA YABLONSKY: Cookie got out and Vittorio didn't. He was in the hospital for months and months and never got out. I would go there a lot and then stop by the apartment on Bleecker and see Cookie. Sharon was dealing with her as well as she could—she was really the caregiver. And Max helped out a lot. But it was so difficult for me to watch her deteriorate that I stopped going there that often. Emotionally, I just couldn't deal with it. It was easier for me to go see Vittorio than it was to see her, and I guess I felt more urgent about seeing him because he was clearly dying.

MAX MUELLER: She wasn't in the hospital much at all. When Vittorio got really sick and his lungs collapsed and he was on the machines and stuff it was tough. I hate going to hospitals. But I'd go to Cabrini and support her and I saw how it made him feel better. She would just go and stay with him.

JANICE BIRNEY: He'd already had pneumonia earlier in the fall. Then he got really ill during the winter and the parents came.

ELIZABETH SCIBELLI: He was in the hospital for... it must have been six months. His parents were here maybe a week or something. It was when you could still smoke in the waiting rooms, and we would all go to the waiting room and smoke. When he first got to the hospital he kind of seemed okay and sometimes we'd go to the cafeteria and he'd have these tubes attached to his lungs that went into some kind of aquarium-looking thing. He was dragging all kinds of stuff with him.

JANICE BIRNEY: Cookie was a bit stressed out because his parents were coming and he was getting all hyped up about it. She felt that they disapproved of her, and they probably did. But, I mean, both the sons were drug addicts before meeting Cookie.

ELIZABETH SCIBELLI: But I think Cookie was probably very sweet to them and they got along. She was older, and—especially his mother—I got the feeling she secretly blamed Cookie for all of this. I could be wrong.

SHARON NIESP: Vittorio's brother Daniele passed away while Vittorio was in the hospital with collapsed lungs. Daniele was on a Vespa at an art opening with his girlfriend and had an accident. He hit his head, and the X-ray department was closed, so they said, "Come back Monday." So he went home, went to sleep, and never woke up. We didn't know if we should tell Vittorio, because he was in the hospital dying. It was like, maybe it wouldn't be weird if he knew his brother was already on the other side. I don't know if Cookie ever told him or not.

ELIZABETH SCIBELLI: Vittorio's mother told me that Daniele had died and they didn't want Vittorio to know. I actually made a big mistake because I told my friend Richard Turley

who told me I had to tell Vittorio. I said I couldn't because she told me in confidence and whether I thought it right or wrong, I didn't feel it was my place. I really regretted having told Richard because they told Vittorio, which made me feel like a piece of shit. His mother was so old.

It was a horrible situation for his parents. It was horrible and tragic enough to have a child die of this freak accident, and then Vittorio... I'm sure they had expectations of having a grandchild, and that obviously wasn't going to happen.

SHARON NIESP: I remember when Cookie told her mom she was sick. They were sitting at the table and her sister Judy said, "I think everything's going to be okay Cookie," and we just rolled our eyes, because we knew what was happening.

JUDY (MUELLER) HULL: I think my mother told me it was AIDS. I knew Vittorio was sick. We had been together that Christmas and Vittorio was really sick. Then in July Cookie called me or I called her and she could hardly talk. Her voice was messed up. I knew something was really wrong and it was horrible. Later, I found out that she had had a stroke. I guess I was just really in denial.

SHARON NIESP: Cookie got discharged because she survived the pneumonia—it was May, becoming June—and she wanted to come to Ptown. She came without Vittorio; he couldn't be moved and he said, "Go. You can't spend the summer in the city, it'll kill you," and she knew it would. She came here and kept in close contact with him in the hospital.

SCOTT COVERT: She was being released from the hospital and I picked her up. I had sold a painting and had cash in my pocket. We were going to Provincetown and instead of taking the bus, which would have been eight hours, I spent the $400 dollars or whatever to take a plane. We stayed in a big house on Tasha Hill. There were horses. It was an old family property and they had a couple of cabins. We rented a place there with Max.

We didn't have much money to spend so we didn't go to restaurants, but it was all about

brown rice at this point. Cookie was on a strict diet, she had her specifics and she had her food stamps. She was trying to work on her novel that summer. We had a set thing: We would get up and have breakfast and I would leave. Certain times she would come with me when she felt like it, but she was writing and I think she spent most of the time sleeping.

She had this card that I found. It had something she would repeat to herself, for some kind of visualization, like a mantra: "I will live long enough to write my novel—one year, two years..." I don't know what the novel was about; maybe her life. She wanted to dedicate it to her son.

SHARON NIESP: We were driving once on Route 6, I think to Hyannis to see a doctor. She looked at me very seriously and said, "You know Shar, I can beat this." And I just couldn't respond to that at all. No response. What was I supposed to say? I said, "Well if anybody can, you probably can." But I didn't believe it at the time. My heart was very sad, because I just didn't think she was going to.

SCOTT COVERT: When we were at Tasha Hill, we were away from everything. It was fun. We'd go to the ocean beach, we'd go to the cigarette beach on the bayside, and we'd go to the ponds. She liked the freshwater ponds a lot. She liked to swim underwater.

There was a funny point at the end because earlier she had gained weight, but now she was at the point with AIDS where she had a thin period again. She was happy that she would lose weight and look thin again. We were driving in Provincetown and she lost her ring because she was losing so much weight, and she said, "Okay, now I'm losing too much." We found it on the floor of the car. We enjoyed that last summer. We laughed a lot. We had the same sardonic sense of humor. As things were falling apart, it was okay. It wasn't a drama. It was *living* and living fully.

EUGENE FEDORKO: I remember being in Provincetown, I don't know if it was the Café Blasé or the Euro Café but anyway Cookie came

281

in and she made this very, very graceful entrance. She sat down at the table, just looking so glamorous and effortless that you wouldn't even think that there was anything the matter with her physically. And then the next day I was at my friend's house on the beach and Cookie came down to the beach with a couple of friends and they put a towel down on the sand for her, right, and she took off her chemise or whatever it was and she went to sit down on the sand and it took her *forever*. They had to help her, just to sit down onto that beach blanket because she was in so much pain. The point of it is, she was in the same amount of pain as the previous night at the Café Euro, but for appearance and for glamour's sake, she just forced herself to endure it.

SHARON NIESP: This was an okay place for her to be when she wasn't feeling well, and she wasn't. She used to come here and walk all along the meadow. She would feed the horses on Tasha Hill. While she was here she started talking slower, like a stroke victim would, and one side of her body gave out. Her mouth was just a little bit like this and then her arm went, and then her legs, so she had a cane. But she still got out every night, she would *not* lie down. She'd say, "Fuck it, let's go out." Then it got to the point where she couldn't talk. She would try and think backwards, because the words would come out backwards. She would write backwards… that was hideous.

In the fall she went back to New York because Vittorio was really bad in the hospital, and I followed shortly after. She wanted to buy a thesaurus. She wanted so much to communicate, and she thought if she could think up the thought in her head and find it in a thesaurus and circle it, she could figure it out. You think straight but you can't get it out straight—how fucked up is that for a writer!

LINDA OLGEIRSON: There was a magazine, I forget which one now, that came out and on the front cover was this galaxy with all these planets and it had all the greats of modern literature—Mailer, Capote, and these little stars further out with names on them. And one of them was Cookie Mueller. This is the cover of a major magazine! I was showing it to her, and at that point she was angry about the fact that she was so ill. She took no pleasure from it at all—it was too late.

ANNIE FLANDERS: One of Cookie's last columns for *Details* was August 1989. It was about her husband Vittorio and it was extraordinary. She wrote her column until she couldn't anymore. And I got in a lot of trouble because I refused to replace her as long as she lived.

CHRIS KRAUS: I knew that she had this incredible manuscript she was shopping around and trying to get published. Nobody seemed to want to do it. Everybody adored Cookie, but when push came to shove, all these agents and editors said, "Well, you could rewrite it *this* way, we want to see *this*." Nobody wanted to just publish the book the way she wrote it. I had already been thinking of a new series for Semiotext(e), and it just seemed so urgent and necessary to start this series with her and to do it right then.

SCOTT COVERT: When she got sick, she swore it was because she started taking the Saint John's Wort—that's when everything started to go wrong. When she was still healthy, when she could still talk, she said, "Scott, I have to talk to you." I can remember the sun was behind her. She told me about how the doctors had diagnosed her, and she says, "I'm losing my physical ability—you know how I'm a physical person. I'm not going to be able to walk, and I'm not going to like that. I'm not going to be able to talk, and I'm a communicator, I'm a writer. I really don't want to live. Why would I want to?" She did want to commit suicide, she said it to me in the hospital. She said, "The last thing in the world I want is to be lying in my bed with all these people around me making decisions for me that I'm not going to agree with but won't have the ability to tell them. The only thing that's going to happen is that I'm going to die. I don't want that nightmare."

*Nobody* could tell Cookie what to do. I promised her that. She wasn't sad, it wasn't a soap opera. It was like, this is how it is.

*Opposite and following pages: Cookie at the ponds, Cape Cod, 1989 (Scott Covert)*

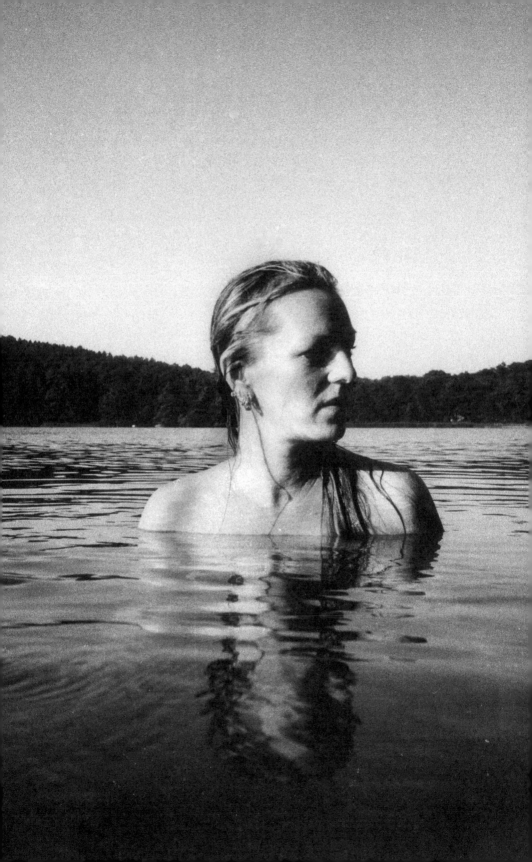

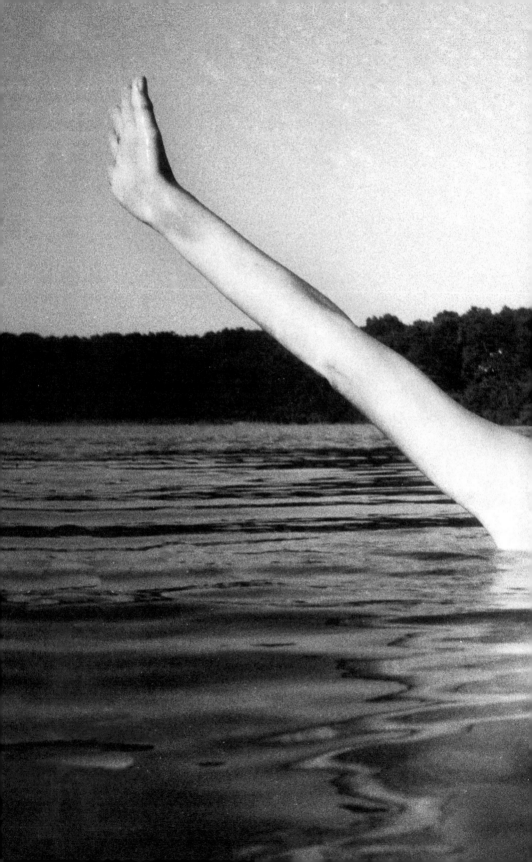

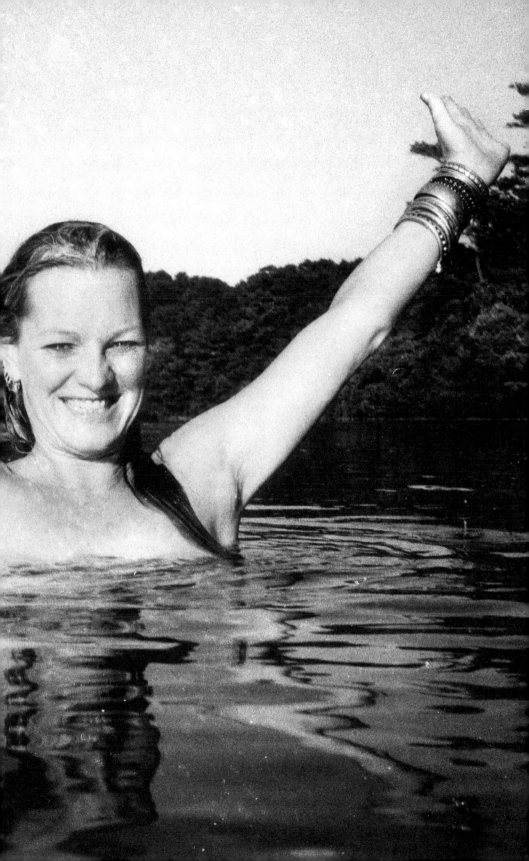

SUSAN LOWE: Cookie was stroked out; we never could tell whether she was really there and just couldn't communicate or whether she was not there. She called me up one day—we hadn't seen each other in six or seven months—and said, "Sue, I want you to come up to spend the week with me," and her speech was different. I called John and everybody else and asked if they thought Cookie's voice and way of communicating was different. Then it got worse. She knew who I was, though... she knew who we were.

GARY INDIANA: I went over to the apartment one day and she couldn't talk and I said, "Cookie I'm gonna say goodbye now because you can't argue with me." Because we used to argue all the time. She was my muse. It's frightening to talk about it. Jesus Christ. It's still hard for me to talk about Cookie.

ELIZABETH SCIBELLI: After she came back to New York from Ptown, she decided to go back to Ptown. She and Sharon were driving, and they stopped by the hospital to see Vittorio. By then, Cookie couldn't speak anymore. The nurse came out and says Vittorio is actively dying, that he would die in the next 12 hours. Obviously they were not going to go back to Provincetown that night, so we called Richard Turley and I think we stayed for a while. That's when I said somebody should call his family in Italy and tell them, because maybe they'd want to come, maybe they would make it and I don't even know how I got the phone number but I called his parents. It was the middle of the night there. I woke them up, and his father spoke to me and I told him. Cookie said she wanted to go home. She couldn't take it. So I took her home and we were in her apartment on Bleecker Street and I think she fell asleep. Then Richard Turley called and told me that Vittorio died and we had to go to the hospital and it was... so awful. It was like 3 a.m. or something and she was walking with a cane then. When she saw him she just threw herself on his body and started sobbing hysterically.

SHARON NIESP: He died on the 14th of September. She stayed with him for eight hours after he died. They closed off the room. It's a Buddha thing to stay with the body. The night shift let her stay for eight hours until the next shift in the morning and after that she went home. She went downhill from there.

I remember Amos at Vittorio's funeral; I don't know if he would want to recall it or not, because it was a hideous, horrible time, but I remember Amos was weeping. He had his little baby.

AMOS POE: That was the last time I saw Cookie, at Vittorio's funeral. My daughter was a month old. It was a Saturday, and I didn't have a babysitter. It was at the funeral parlor right up the street, and Vittorio's mom said, "You shouldn't bring babies to funerals," so I was kind of like, what should I do? I started to leave with my daughter in my arms, and Cookie came and that's when I started crying. I hugged her, and she said, "Don't worry, it's not about the body, it's about the soul."

PETER KOPER: In our last conversation she said something like, "Peter, life is more than the body, life is the mind." That really stuck with me. I knew I was having my last conversation with her. But she was still the old Cookie at that point, you could hear her voice was going, but she said that very clearly.

SCOTT COVERT: The last time I saw her was at Vittorio's funeral. She was a true believer in karma, that suicide could be fulfilling a karmic debt. She believed that. I was told I wasn't allowed to come near Cookie at the end, that if I was to bring her anything that would help her to commit suicide they would call the police on me. I just stayed away.

LINDA YABLONSKY: I haven't thought about this in a long time... It was difficult to even find a funeral home that would deal with an AIDS patient; there was only one. There was a wake, and a lot of people gave Cookie money so she could survive. Someone had started a fund for her medical expenses, and so that day a lot of people brought checks, and I think they raised quite a bit of money to keep her and Max going. Nobody had health insur-

ance. So, for all of the many gifts Cookie gave to friends in her life, nobody hesitated for a moment to do whatever they could to help her out when she really needed some kind of help.

JAMES BENNETT: I saw Vittorio's parents at the funeral. I remember his mother coming up to me. She had never been to America. She came up to me and started sobbing. "So much sadness," is all she said.

ELIZABETH SCIBELLI: I don't think Cookie was crying at Vittorio's funeral. I think she had just quieted herself. But I have this vivid memory of Chi Chi just sobbing in the corner. A lot of people were just shocked, I think. A lot of people hadn't seen her for a while. Seeing her walk in that condition, you knew she was going to die soon. It was like she was looking at her own fate, facing her own death. We all went to her place that night. Max was there… I think he was kind of in a trance, lost, just absolutely traumatized by what had happened. At that point he didn't think his mother was going to die—he said that to someone.

JAMES BENNETT: Cookie used to leave pamphlets around for Max, like, "So your mother is going to die…" Not really like that, but you know what I mean. She didn't know how to deal with Max. She never really talked about it with him, and I remember him at Vittorio's service—just so lost.

LINDA OLGEIRSON: He was watching her become more and more incapacitated, you know it wasn't over night at all, it was months. She was in and out of the hospital and he went through the whole thing with Vittorio dying. Max had to watch all of it.

JUDY (MUELLER) HULL: Max is about four years older than my son, and whenever we would get together they would play together. I remember that weekend when we were there in September, when Cookie was sick and Sharon was taking care of her, I talked to Max on the phone. I said, "Ike is here, do you want to come see him?" and he said he didn't. He didn't want to see anybody. He didn't want to be with anybody.

SHARON NIESP: Max knew, but he didn't know. She was in the bed on Halloween and he was going out with his friends. He was 17, you know what I mean? He was probably in a big sea of denial or whatever you want to call it. She died 11 days after Halloween, on November 10. So no, I don't think he realized the severity of it. She never really told him what she had. She never sat him down; that wasn't her way of dealing with things. I mean, how can you tell that to your son? But she never explained it to him. She said she had really bad pneumonia.

MAX MUELLER: No, she didn't tell me. I was in denial for a while but I had spent the summer before Vittorio passed away with my father and he had a long talk with me and then it really kind of sank in. I had an inkling that something was wrong, but I wasn't sure what. I didn't know what AIDS was; it was still not a known thing. I mean, I knew about it because my mother's friends were dying. These are such confused memories around those years.

After Vittorio died her health just went to hell. She had a stroke, so that's when she couldn't take care of herself anymore. Me and Sharon took care of her at the apartment. She wanted to stay at home.

SHARON NIESP: We were at Cookie's home on Bleecker Street. Me, Linda Olgeirson, John Heys, and Richard Turley took turns taking care of her. We'd have to take breaks… she was suffering from aphasia and she couldn't walk on that side at all. We would have to help her get around the house.

JOHN HEYS: There was no nurse, just Sharon. This is horrific to talk about, this part I don't like to talk about so much. Sharon was there in the day and would stay sometimes all night. I'd come at like 5 or 6 p.m. and stay till midnight. Max was there throughout the whole thing. He was in school and then he'd come home. My recollection of him was that he just was around. He used to come into the living room and ask his mother something or stay with Beauty or if he needed some money or something. He answered the phone. Max was a quiet young man. The nights were really quiet. Sharon would cook, she would make her

puttanesca. Cookie could see Sharon cooking at the stove from the bed.

PEYTON SMITH: At the end, they were giving her codeine. She would break the pills apart and just nibble on them and in her bed sheets there'd be little pieces of broken codeine pills. We'd be like, "Cookie, take as many as you want!"

SUSAN LOWE: I remember sitting with her by her bed. She had codeine in one hand and a Coca-Cola in the other, and she got to the bathroom by using a mirror. That's how she moved that side of her body, that's how she got out of bed—she watched in this mirror. I don't know if that was cognitive or just intuitive. She wouldn't let anyone else take her to the bathroom. This is right at the end. She got it in her lungs; that's why she was on codeine. And I remember another night sitting there with her watching television. That was the only thing she could do.

PAT BURGEE: Sue went up to see her, and I wanted to see her, but I felt like I would be more of a burden because it was Sharon and Max and Cookie who were going through this. You have to be careful when you move into that space because it's sacred and you don't want to disrupt it. You don't want to make anything harder. I knew Sue definitely wouldn't because she and Cookie were *so* close. By the time she went to visit, Cookie was already so far gone that she only wanted to watch reruns of *Star Trek*, which Cookie wouldn't have watched under any circumstance at any time that I knew her. She was going into that place where you just need the repetition of something.

PEYTON SMITH: I was at her apartment a couple days before they went to the hospice. She was not talking but she was trying to write in her book. I brought her cookies and an amaryllis plant with a big red flower. She loved it and loved the cookies and she stuffed them in her mouth and smiled and was happy... She looked like a child. Sharon had braided her hair. Sharon was taking such good care of her. Sharon was dressing her. She did such a beautiful thing, taking care of her.

LINDA YABLONSKY: I don't know how it was for Sharon, because after all, it was the love of her life. I never actually talked to Sharon about that, because we were so focused on Cookie. We never talked about how *we* were feeling.

MARINA MELIN: At the very end, Sharon was trying to make her as comfortable as possible, and they had to take the bracelets off, they had to cut them off. Cookie was like, "Oh no, not my bracelets, don't take them off!" She loved her bracelets.

JOHN HEYS: She would be demanding sometimes because she couldn't talk. It was frustrating [makes a sound]—like that.

LINDA OLGEIRSON: She knew she was saying the wrong words but she couldn't access the right ones. As it progressed, it got to the point where she had to write things. I remember the last thing she wrote while she was dying and was still on Bleecker Street was MAX. She couldn't write TAKE CARE OF MAX, but she could write MAX.

SHARON NIESP: Then it just all came to a halt. One day we had to call the paramedics to take her to Saint Vincent's because she was just shutting down. She was like way shut down, she was demented, she was confused, and all she could do was count her pills. I'll never forget that. Later, when I was really sick with the Hep treatment and I was in bed and couldn't do anything and couldn't stand the pain, I grabbed the pills and spilled them on the bed. I was counting them out and I thought, Jesus Christ, I'm counting these just like Cookie did before she died.

When the paramedics came to take her to Saint Vincent's, she was acting like someone having an overdose. She was sort of frantic, trying to push the pills under the sheets, and we were trying to pull them out. That was the only thing she could think of: to get as high as she could. That's what a lot of people do. She was experiencing pain, lymphoma... the whole lymph just swelled up. And that's not even the mental pain. The higher you can get when you're dying, the better, so that's what she did.

The paramedics said they would intubate her if she got worse—stick a trach tube down her so she could breathe and put her on a respirator, unless we could sign the DNR form. And I couldn't sign it. I know she wanted the "do not resuscitate," but for some reason, I just couldn't do it—I couldn't. Max had just turned 18 on Sept. 25, but we couldn't ask him to sign it, so they told us if someone didn't sign it, they were going to keep her alive, and I knew that's not what she wanted, so I had to call Linda Olgeirson, who was also one of the health proxies. She signed it. And they transferred her to a hospice at Cabrini and then we stayed with her for a couple days. They gave us two cots outside of her room—we camped outside. Max and me would stay overnight and Linda and Richard Turley would stay as late as they could.

MAX MUELLER: I remember being in the hospital for a couple days, just being at her side. Then somebody came—I can't remember who—and was like, "Listen, why don't you go home and get some sleep," and I went home and I wasn't home more than maybe half the day or something and then I was going back and then Sharon came in and told me.

LINDA OLGEIRSON: There's a lot that Max had to go through on his own. I don't know how prepared he was, but I never really got the feeling that Cookie prepared him. I remember being at the hospice when she was dying. I walked to the elevator with him and said, "Max, do you know what's happening, that this is the end?" He sort of mumbled, "I don't know," and then he went home. We were all still there—Max had been there for two days at her bedside and everybody was trying to convince him to go home and get some rest, take a shower, then come back. As soon as he went home, he had to turn right back, because she started actively dying, which is not uncommon. People very often wait until family members and people they love leave the room; that's when they choose to die. So he'd been there with her the whole time, and within 20 minutes or half an hour of his leav-

ing, she had died. You need to be released and you need to release them. It gets to the point where the person who's dying has to separate. He was the one she was in love with. We were there supporting her, but Max was the one she loved, he was the one she needed to have out of the room.

MAX MUELLER: Well, it was coming. It was the end of the line for sure, but of course I wanted to be by her side. But she probably didn't want me there to see that. I was a little disappointed.

SHARON NIESP: Richard Turley and I took Max home at 1:30 p.m. We just knew we should get back; all we wanted to do was drop off Max and get to the bank and make sure there was something secured for him. When we went back to the hospital, the nurses said we had better go in because she was going. So we did. She started having a tough time breathing, and when you have that and there's a DNR, the nurses in the hospice know exactly what to do. She died at 3:30 in the afternoon. Yeah, she kind of waited. As much as anyone can.

And a weird thing happened after she died. I'm sure it was just a nervous twitch or whatever, but she winked and waved. Her little fingers moved up and down like a little wave. She used to wave to people with the first three little fingers sort of, and then it looked like she winked right after she took her last breath.

the word "life" when issued
through the lips of the dead
       is uttered
in longing
     in yearning
        for something
                to be renewed
                to be brought back
the living hold life
        to a minimum of existence
    but are still afraid of death.

—Cookie Mueller, 1965

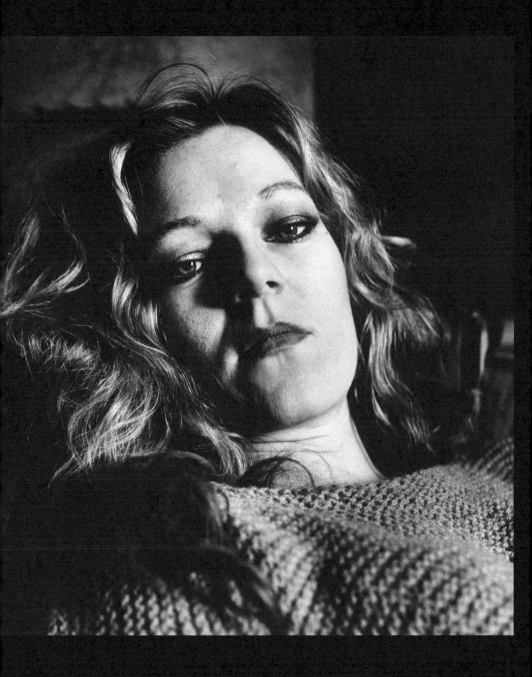

*Cookie, 1981 (Peter Hujar)*

## ST. MARK'S CHURCH

*"Maybe in the next reincarnation the wiser among us shall become dolphins. Their hearts are joyful and open and their lives are unfettered. There are no shackles. There is no cruelty or destruction. There is no technology. Only flips and dives. They smile all the time. What is the aim of life? To be content, to be happy."*

—Cookie Mueller, *Putti's Pudding*, 1989

LINDA OLGEIRSON: The night before the funeral, we were all drunk over at the apartment on Bleecker, and I remembered Cookie wearing this gold lamé dress, very fitting and beautiful, to one of John's Christmas parties. So I went through her closet and found the dress and that's what she wore for the viewing. I thought, she's got to look like Cleopatra, with the gold dress and all her jewelry on.

JUDITH PRINGLE: When we came upon these clothes in her closet, clothes that when she wore them she looked so amazing, but actually they looked like rags. Things were stapled together, held together with safety pins, maybe there'd be a little piece of tape on them, but when she'd put them on it looked like some fabulous fashion!

SCOTT COVERT: She hated to lend clothes to people, *hated* that. She believed in energies and that you'd get the energies from the person. For Cookie it was very simple. Your personality is your energy and your energy goes into whatever you have, so she didn't like to lend clothes or borrow clothes because you get involved with other energies. I'm sure she felt that her character was so strong—now, she didn't tell me this, but knowing her it makes sense—because of her energy in her stuff.

LINDA OLGEIRSON: Richard Turley and I were the executors of her will. I went with Linda Yablonsky and Richard over to St. Mark's Church to see about funeral arrangements. We put candles all over the church and it was so beautiful. There were eulogies, musician-friends played, and Sharon sang a spiritual a cappella.

SHARON NIESP: This is sick, but I love singing at funerals. Because of the Negro spirituals that I love... I believe them, and I can do them, and it's very moving. The emotions are really at a pitch, so if you can stir something in that person and let them grieve and express it through that music, that makes absolute sense to me.

DENNIS DERMODY: She can sing soul like Etta James. She's *really* amazing.

MARCUS LEATHERDALE: Sharon sings like a black woman. If you close your eyes you'd think you were listening to a gospel singer. I didn't know she sang until Cookie's funeral.

SHARON NIESP: What you do is create a whole atmosphere when you sing. You make people go to the washroom and cry, you make people want to laugh... and that's what Cookie did through her writing. She saw humor in everything. Sometimes when I'm looking for a strong rafter and I'm like, oh yeah, I can put a rope around there, I'll sit down and think about her and how she would be laughing, "Oh Shar, please get off!"

PETER KOPER: That's one of the main points about Cookie: she was *funny*. She had a *great* sense of humor. I don't really know how to characterize it... more than a deflating sense of humor. It was self-deprecating but she also brought things to ridiculous heights, sort of like in her writing—a kind of magical realism absurdity. She was an inspiration, a muse in a way, to John and to a lot of other people around her.

LINDA OLGEIRSON: It was the most amazing service. The place was packed with people. Her mother and sister were there. Her mother was just blown away by the experience, the people, the talent, and people talking about how talented Cookie was. People were leaving things in the casket, like letters and flowers.

JOHN WATERS: I remember her mother said, "God, I had no idea Cookie had this many friends or was regarded this way." It's her

fault for not knowing, but it's also Cookie's fault because Cookie never told her anything. Cookie never tried to impress her mother. Which was very sad I thought. That her mother *just didn't know.*

LINDA OLGEIRSON: Nan took a lot of photographs. She came up to me and asked if I thought it was okay, and I said, "Well, I don't think you're going to have another opportunity, Nan—this is it."

SARA DRIVER: Cookie was in an open casket and people were going up to say goodbye, but I didn't want to see her like that. For me, she was so much about life. Cookie represented the playfulness of New York, and a kind of intelligence we don't have anymore. I think everybody had a crush on Cookie.

RICHARD HELL: I spoke at her funeral. There were four of us who spoke: John Waters, myself, Glenn O'Brien, and Annie Flanders.

JUDITH PRINGLE: I remember I met Cookie's sister for the first time. I remember Sharon being up late the night before trying to figure out what music to play. I remember John gave a wonderful eulogy. And Richard Hell gave a great eulogy: he mentioned that she had great legs.

JOHN WATERS: My speech was a good one. I said, "Half of you in the audience copy her!" They did. New York hadn't seen that trashy Baltimore hippie-girl look that we specialized in.

ANNIE FLANDERS: I was one of the speakers and I think we ran everything in *Details*.

JAMES BENNETT: There was something haunting about Cookie. The images of her that flash through—and that last image of her in an open casket—she just looked so pretty. It seemed so odd, I guess because she was larger than life, but in reality she was just lying there. Everyone was putting stuff in the coffin: a silver straw for coke, flowers, whatever.

GABRIEL ROTELLO: Her memorial was incredibly well attended for a time when people were really getting tired of them. I was getting to the point where I wasn't even going to funerals or memorials unless I knew them

really, really well. There were so many that it was exhausting. But the whole world turned out for Cookie.

LINDA OLGEIRSON: Steve Butow was weeping—he's really a big teddy bear—and he went up to the casket and almost tipped it over because he was sort of holding on to it and then it kind of slid!

STEVE BUTOW: I went up to kiss her and when I bent down—the casket was on wheels—the whole thing moved!

MINK STOLE: I left New York in the fall of '89, about a month before Cookie died, and I was unable to get back for the funeral. I was in LA, I had just moved there. I was with Van Smith. We were doing some reshoots on the movie *Cry Baby* and a few of our Baltimore people were out there, Vincent Peranio and Pat Moran. We got together and had a moment of silence for Cookie; we felt really bad that we couldn't be there.

BOB ADAMS: I didn't go to the funeral in New York when she passed away. Some time later, I was outside her apartment on Bleecker Street and I just stood there and sobbed and sobbed because I was really mad at myself for not having gone up for that thing. I had forgotten the one thing my father told me when my mother died: "You've got to bury your dead." Cookie was extended family to me. I've never forgiven myself.

CHI CHI VALENTI: The funeral was completely profound. Her spirit is still very much around that church. That's the last place people saw her. I remember after, everybody was sitting in the yard there; it was like the last Cookie party.

PEYTON SMITH: Everyone behaved so well. Cookie was so beautiful at the funeral, and Max was so beautiful. At the end Max went up and kneeled beside the coffin and held her hand and kissed her. He did it in front of everyone and it was so beautiful because he never really expressed much, he was so withdrawn.

MAX MUELLER: It's a very blurry memory. I remember it was really huge, there were

thousands of people there. Yeah, I suppose I went through all the Freudian stages. I was in denial for a while and then I was... It's really hard to describe. It's not easy. It's not easy at all.

DENNIS DERMODY: That broke my heart. It was the one thing at Cookie's funeral—I couldn't look at Max. I was so freaked out. I couldn't look at him because it upset me so much to think about what was going to happen to him. I think he was always put on the spot. Cookie was always so much bigger than life—she knew everybody, was everybody's friend—and they all look at Max and he just goes, "I'm me."

LINDA YABLONSKY: I felt for Max. I don't know what happened to him after; I tried to keep in touch. I told him to call me if he needed anything. I believe Earl got married to someone else and had other children. Having no family made it much more difficult. I think Richard Turley was looking after him a bit, giving him money. It was hard to know what to do.

JOHN WATERS: I think there was some reaching out from Cookie's family, from the sister. But he didn't know that world: suburbia, Baltimore, the straight life, where they would have taken him. I don't think he ever wanted to go there and I don't think anybody ever considered it, really. I don't think Cookie would have wanted to hand Max over to that.

EARL DEVREIS: I got deported in 1991. Back to Edmonton, Canada, so I haven't seen Max in a while. I invited him up here, but he never came. I was living in the States illegally and I bought a piece of property in Tobago with my profits from the weed business I had. I was going back and forth a lot and then one time they caught a guy with a bunch of bombs and the airport went on red alert. I didn't know about it and I came in and they caught a whole bunch of us. They told me I couldn't go back to the States and that was it. I lost everything.

MAX MUELLER: After my mom died I really receded into my loner thing for a bit. I didn't see my friends for a while. I didn't see anybody. I promised my mother I'd go to college, but then I lost the apartment on Bleecker Street. It was a fucked-up situation. I wanted to go right into college after high school, but I just couldn't do it. My mother got sick and Vittorio was on his way out—too much stress.

YOKO: As kids we never talked about it, because it was like, okay she died, it's fucked up, but we were guys. I'm not gonna be like you girls and say, "Well how does it make you feel?" We never really talked about it. It was that one thing, and you know me, I would say a lot of shit, but I never crossed that line with him.

MAX MUELLER: Me and Sharon never really talked much about it. We were both there, so... I never talked about it too much. Occasionally.

After the funeral, I went to Positano. I brought my mother's ashes and put them with Vittorio's, in the family plot. I went with one of my mother's friends, Elizabeth Scibelli. It was my 19th birthday. I stayed up all night a bunch. Took some pictures of the sunrise.

ELIZABETH SCIBELLI: We went to see Vittorio's father in Positano, then the whole family invited us out for dinner in Sorrento. They were as gracious as they could be. I think the hope had been that, since there had been no grandchildren, Vittorio's family was going to help Max. And the father was very pointed about it. He said, in a very kind way, and I think he gave Max some spending money while he was there, but he said the money had to stay in their family. So there was no money for Max. I mean, Max was really just a kid. He wasn't very communicative that way. I don't remember really talking about anything.

MAX MUELLER: It was simple. Vittorio's father and mother were there, and me and Elizabeth and a preacher. We opened up Vittorio's piece of the mausoleum in the family plot and put the ashes in there, did some praying, and had a solemn benediction. I don't know if her name ever got put on the gravestone or anything. I think she might have one in Baltimore, though, on the family stone. She's never had a proper burial.

SHARON NIESP: There was a benefit at the club MK after the funeral. Everybody was there, people performed, people read, we read some of Cookie's stuff, and Max read some of her stuff. He liked that, you could tell he liked that. It was a benefit to give him something to work with. It raised $15,000 for him.

DUNCAN HANNAH: It was a celebration of her and it pulled together a lot of people that I hadn't seen in a long time. It was a great night. We were sitting around telling Cookie stories. It seemed like she was always in the room, whatever nightclub it was. It sure felt like the end of an era, the way it always does when someone pivotal like that dies.

Just her warmth and hugging and I guess the way she always said "hon." It's kind of a mother thing to say. It seemed like she was looking after all of us, which is a rare commodity in that kind of scene.

PEYTON SMITH: I remember after she died, maybe a couple months after she died, I had the most vivid dream. It was so intense, and so physical and *so* real. I was holding her in my arms and she was adult size but I was holding her like a baby and she looked up at me and she said, "Peyton why didn't you tell me it was alright to die? Why didn't you tell me? It's okay, I'm okay, it's all alright."

GARY INDIANA: We didn't just *like* Cookie, we loved Cookie. There was no one like her, ever. She galvanized people, she electrified people, she was one of the most amazing people I ever knew, and I know that's true for many people. I'd like to see that acknowledged. Not just acknowledged, but celebrated. Because part of New York died when Cookie died.

ERIC MITCHELL: What's interesting about reminiscing with you is—how do you portrait somebody who had such energy, such impact on people? How does one translate that onto words? How do you convey a portrait only through what people have said?

Because you didn't know her, the image you got of her, you got it from the writing, but there's also this other image, there's something about her journey that's kind of like...

I suppose she's the epitome of a child of the '60s, through the travels, the experiences, and the people she's met. I mean you have Baltimore, Provincetown, San Francisco, New York, Italy.

Thinking about Cookie, she's like an emblem of that freedom of being able to do what you want to do; just go here, go there.

GABRIEL ROTELLO: So many people of tremendous talent were taken away by AIDS. Charles Ludlam, think about all the plays that would have been written if he hadn't died. Or Michael Bennett and all the incredible Broadway musicals that would have happened if he hadn't died. Or Louis Falco and all the incredible modern dance that would have happened if he hadn't died. Our culture is very much poorer because a group of people died way too young, when their promise was not really fulfilled. There's a gaping hole in our culture left by the untimely death of all these people, and Cookie was way up there on that list. In addition to her being my friend and me being sorry that she died and left Max, it was a real tragedy because she had a lot more to contribute.

SHARON NIESP: I don't know what Cookie would have been like if she had lived to be in her fifties. If she and Vittorio hadn't passed away, they would probably still be together. She might have just been the same. Because she was just living fully. It wasn't like she was doing anything *that* outrageous. I think she would have been well traveled and would have been very prolific in writing. God only knows what else.

But as much as it was up to her, it wasn't, because everything changed so much from the virus. So many things got shut down—so many venues, so many people died, so many minds just went away. Other ones came up— that's good—and she probably would have collaborated with them. She wasn't dated in any way; she could be with any person of any age as long as their heads were going in the same direction, as long as there was something to appreciate.

AMOS POE: That's the whole thing about Cookie, and Sharon was right about this: it was all about timing with Cookie. It was all about immortality, not on a physical level but on a spiritual level, and Cookie had that in abundance.

SHARON NIESP: And Max is carrying it on. Max has a little daughter. Cookie has a granddaughter. Razilee is fair, she's blonde with greenish-grey eyes, just like her grandmother. We call her little Cooks.

MAX MUELLER: That's what my mother's friends call her. You can definitely see the resemblance. She's got her eyes and the same kind of facial features. But she's got her mother's round face.

Razilee was born July 2, 2002. It was great. I loved it. Having a baby was one of the happiest moments of my adult life.

It was something I was always destined to do, like a higher purpose. But we weren't planning it. And of course I was a little confused because I was wondering, how am I going to take care of her? But then somebody told me: if everybody was confused and messed up about it and thought, I shouldn't have kids, then nobody would be born. I think as long as you do the right thing—provide for your family, be kind, be intelligent, don't push prejudices on them, let them be themselves and have their free mind—there's nothing wrong with it.

YOKO: And he's a patient dad. Max has a lot of love for his kid. Max has a *big heart*. Out of anybody I know, he's got the biggest heart.

SHARON NIESP: Max is a very sweet man, a very tender father. And Razilee worships him. He has fun with her, he reads to her, his whole living room in Wellfleet where he lives is all for her. It's all paint and toys and books. Cookie loved Provincetown. She always liked it up here. Now Max lives here and he brings his little baby up here.

MAX MUELLER: There's this place we like to go to, The Chocolate Sparrow. It's cool, they make their own confections and chocolate.

I'll have a hot chocolate and she'll have hot chocolate. She loves it, we have so much fun. I bought her a guitar a while ago. It's pink rosewood with an inlaid handle, it's really nice. Finally, I got her a soft case so she can take it around with her. Now she's playing jazz. And she just won a grand prize in an art contest and got her first-degree gold sash in Pokémon. She makes so many friends wherever she goes and she just got the best report card I've ever seen in my life.

SHARON NIESP: The people who know Razilee and knew Cookie, they see the resemblance. If the people in Baltimore met Razilee, like Sue Lowe, if they ever met that little girl, they would say, "Wow look at that!" Just the way she expresses herself, her little writings, the way she sings and acts. She has the same curiosities and she holds herself physically like Cookie would. It's really amazing.

BOBBY MILLER: Cookie's granddaughter... she's a trip... she came into the joke store one day and I told her I knew her grandmother and she said, "Oh you knew my grandmother, what was she like?" and I told her, "She was a lot like you!" But it's so funny to think that that's Cookie's granddaughter, I don't think she has a clue yet who her grandmother really was but when she grows up she'll find out...

SHARON NIESP: I remember when Cookie used to do readings, she would hold her hands a certain way, like this, and when Razilee expresses herself, she holds her hands like that, too. She's a sweet girl and Cookie would have really loved her. They would have had fun together, and every grandmother says that— there's a part of her in there—but it's even more pronounced if they're dead. You see the DNA coming through, and the person isn't there to confirm it or you don't reflect off the grandmother anymore so you reflect off something spiritual.

And it's the present. You're talking about the past, but it's good to bring up something about the future, which goes on and on and on.

*Cookie, Ptown, 1976 (Audrey Stanzler)*

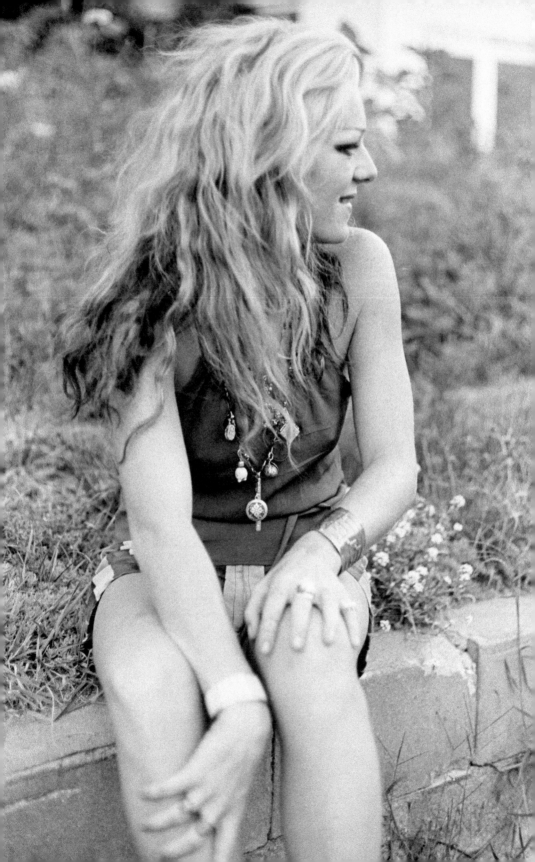

*This page and following pages: Cookie's diary, 1965*

be cultured? I guess not. ⎡March 1965⎤

You know, March is the most beautiful ~~mon~~ month of the year. (not just because my birthday is in March) but because of it's naturalness. I don't like march when it's warm out. Then it isn't really the wind-blown; free, month. It's a part of spring then. But really, I think march is the only month which stands alone; unclassified. Take any other month. It falls into class. But March—...... March has something all it's own. It has the sky especially. The sky is always full of windy; careless clouds. The fullest and deepest purples and blues and golds and whites. It is always robust and sort of lonely. When you stand out in a field in March; and the trees have no blossoms or buds— and the wind ~~way~~ whips your hair and the branches and grass — You feel like a part of nature. You feel honest, and real and lonely. ~~Don't~~ ~~feeling~~ People should feel lonely; sometimes. But not disolant loneliness without hope — but a sort of ~~its~~ thought cluttered, hopefull loneliness. The Best Kind in The World.

March is a torrent of wanting to

---

March, 1965
You know, March is the most beautiful month of the year. (not just because my birthday is in March) but because of its naturalness. I don't like March when it's warm out. Then it isn't really the wind-blown; full, month. It's a part of spring then. But really, I think March is the only month which stands alone; unclassified. Take any other month. It falls into class. But March—March has something all it's own. It has the sky especially. The sky is always full of windy; careless clouds. The fullest and deepest purples and blues and golds and whites. It is always robust and sort of lonely. When you stand out in a field in March; and the trees have no blossoms or buds— and the wind whips your hair and the branches and grass—you feel like a part of nature. You feel honest, and real and lonely. People should feel lonely; sometimes. But not disolvant loneliness without hope—but a sort of thought cluttered, hopeful loneliness. The best kind in the World. March is a torrent of wanting to

accomplish something

For the wind - it must shake
the trees and remind them to come awake.

For the human being - it makes
you realize yourself, - your potential and
your wishes - (for me anyway) Not many
people sleep in March.

(By the way - just in case I get
another low grade in English - I will
write down what I haven't done - not
handed in first copy of composition
on pet peeve type of thing - but handed
in re-done comp.) ₀ ₀ ₀ ₀ ₀ ₀ ₀ ₀ ₀ ₀ ₀

I'd like to write a novel. I'd
love to. But first I have to know
what I'm doing. The english stuff in
English class about novels will help
me - I hope to be a better writer.
All ability I have is for writing.
I would rather not live at all than
to not write.

This is a ridiculous poem but
I just felt like writing it

the word "life" when issued
thur the lips of the dead

---

accomplish something.
For the wind—it must shake the trees and remind them to come awake.
For the human being—it makes you realize yourself—your potential and your wishes—(for me anyway). Not many people sleep in March.
(By the way—just in case I get another low grade in English—I will write down what I haven't done—not handed in first copy of composition on pet peeve type of thing—but handed in re-done comp).
I'd like to write a novel. I'd love to. But first I have to know what I'm doing. The english stuff in English class about novels will help me—I hope to be a better writer. All ability I have is for writing. I would rather not live at all than to not write.
This is a ridiculous poem but I just felt like writing it.
the word "life" when issued
thur the lips of the dead

is uttered

in longing

in yearning

for something

to be renewed

to be bought back

the living hold life

to a minimum o/f existence

but are still afraid of death.

· · · · · · · · · · · · · · · · · · · · · · · · · · · ·

"~~Stating the sins of mankind is the~~
~~taught to crowd its self with a sword~~
"Stating the sins of mankind is
like piercing the snow with a
sword"

no moral or nothing
e just a passage from
my brain.

Tonight I went up the Shopping Center
to wait for Marilyn to get out of work.
We walked around for a ~~ide~~ ride up
to the Catonsville party. But guess who
came along — Joe + Chip So that's the
way it goes. I always get caught up
somewhere. I wish Frank would call or
~~something~~. But now this sounds too much

---

is uttered
in longing
in yearning
for something
to be renewed
to be brought back
the living hold life
to a minimum of existence
but are still afraid of death.

· · · · · · · · · · · · · · · · · · · · · · · · · · · · · · ·

"Stating the sins of mankind is like piercing the snow with a sword"

(no moral or nothing just a passage from my brain.)

Tonight I went up the Shopping Center to wait for Marilyn to get out of work. We walked around for a ride up to the Catonsville party. But guess who came along—Joe + Chris. So that's the way it goes. I always get caught up somewhere. I wish Frank would call or something. But now this sounds too much

AIRLINES- PAN AM 973-4000
United 867-3000 WORLD 267-7111

| NAME AND ADDRESS | TELEPHONE |
|---|---|
| Adrian (Kansas) 316-251-7805 | AREA CODE |
| michael Arien 279-5142 | NUMBER |
| Alitalia 582-8900 | |
| Astrologer - 619-297-5648 | AREA CODE |
| DAVID ARMSTRONG 617- | NUMBER 862-484 |
| Aman 247-3604 | |
| Martin Arilly 962-4399 | AREA CODE |
| 228 FRONT St. 10038 | NUMBER 276 |
| Bob Adams 1617 Shakespeare 2031 | 89 |
| ~~Bob Applega~~ Bob Applegarth balto. | AREA CODE |
| 301-747-2906 | NUMBER |
| PRTWORKS- KAREN KAYE 904-2180 | |
| Armie Charnick - 190 1st Ave. | AREA CODE 28-3 |
| marie Antoinette 966-4685 | 5 NUMBER |
| Charlie Atlas - ~~John~~ | |
| John Albano 741-1086 | AREA CODE 292 Riverse |
| ~~CARL APPLESNGHE 431-1550~~ | DR. NUMBER |
| Anne Carlise 563-0135 | |
| Adrian Milton 475-4678 | AREA CODE 512 |
| Charlie Ahearn 719- 12 36 | NUMBER |
| ANDY- 691-8789 302 W. 12 St. NY | 10 |
| ART FORUM 925-4000 | AREA CODE |
| Chuck Adams 605-3493 | NUMBER |
| A - 477-2880 | |

Bost
Coul
61

Alitalia 582-8900
Amtrack 736-4545
301.550.4121

| NAME AND ADDRESS | TELEPHONE |
|---|---|

DAVID ARMSTRONG ~~address~~ 617- 924-4339

Carl Apfelsnicht 675-4008 7-3-89

ALBA 484471 484772

michel Auder 925-6907

# BIOGRAPHIES

ASTROLOGY - Pisces 976 - 6262

Capricorn 6060 Cancer 5353
ARIES 5050

ART FORUM Ingrid Sischy

Europa offre SALITA OREGINA 11
Genoa Italia 1-16134
39(010)256-156

THomas ARANA 081-12 M 322

Leonard Abrams 673-0755

Michael Altman 977-8957

AHMAD 682-5844

PATTI ASTOR 213-816-3013

Bob Adams 327-8466 Balto.

ABC Carpets 473-3000

303

# BIOGRAPHIES:

**Leonard Abrams** was the founder and editor in chief of the *East Village Eye*. The first issue came out in May, 1979 and the publication ran until 1987. Abrams met Cookie and became friends with her after an interview with Cookie was published in the *Eye* in 1981 by writer Sybil Walker. Cookie wrote her health column "Ask Dr. Mueller" for the *Eye* from 1982 to 1984. Abrams lives in New York and was the director and producer of a documentary film called *Quilombo Country* narrated by Chuck D.

**Bob Adams** (aka the Psychedelic Pig) is from Baltimore and was a pirate disc jockey under the influence of LSD in the '60s. He is an early member of John Waters's Dreamlanders group; he worked as a set photographer and appeared in several Waters films, most notably playing Ernie in *Female Trouble*. Adams is an archivist for the Dreamlanders and his photographs have appeared in documentaries and books. In Cookie's story "The Pig Farm—Baltimore & York Pennsylvania, 1969," Cookie runs into Adams at the downtown A&P with his friend, a pig farmer, who she eventually falls in love with. Adams lived on Bond Street in Baltimore opposite Cookie and spent a lot of time at her house or his, hanging out and tripping in the late '60s. The trailer scene in *Pink Flamingos* was filmed on the commune property in Phoenix, Maryland where Bob then lived.

**Penny Arcade** is a performance artist and an actress living in New York City. Born Susana Carmen Ventura to an immigrant Italian family in Connecticut, she became Penny Arcade at age 17 while on LSD in an effort to amuse her mentor and patron Jamie Andrews. In 1990 she created her most famous work, *BITCH!DYKE!FAGHAG!WHORE!* Penny Arcade met Cookie in 1981 in New York after having seen *The Roman Polanski Story*, which Cookie starred in.

**David Armstrong** is a photographer living in New York. He attended the Boston Museum School and Cooper Union and spent time in Provincetown during the early '70s, where he met Cookie. Armstrong first received critical attention for his intimate portraits of men. Armstrong took several photographs of Cookie, including the one that appeared on the cover of her first book, *How to Get Rid of Pimples*. Armstrong and Cookie spent time together in New York City through the '80s and he lived at one point on her couch in her Bleecker Street apartment. His photographs of Cookie have appeared in numerous books and catalogues including *A Double Life: Nan Goldin, David Armstrong* and *The Silver Cord*.

**Doug Asher-Best** first arrived in Provincetown in the summer of 1968. In the early '70s he worked with Cookie washing dishes at the Mews restaurant in Provincetown. He recently retired as a letter carrier in Provincetown and is currently a member of the playwrights' lab at The Provincetown Theater.

**Michel Auder** is a French-American video artist living in Brooklyn. Auder's approach to video evolves out of the politics of May '68. In Auder's 1980 video *A Coupla White Faggots Sitting Around Talking*, Cookie plays a dominatrix named Mavis. In the film (which includes Cookie's friends Gary Indiana and Taylor Mead), Cookie goes on an out-call to pee on a lawyer's head. Cookie also plays in Auder's *The Seduction of Patrick*. The film was co-written with Indiana and is a tale of unrequited love revolving around Indiana's attraction to Patrick, a French composer and pianist. The film was shot in the studio of Swiss painter Olivier Mosset and the cast includes Indiana, Mead, Marcia Resnick, Viva, and Bill Rice.

**Mark Baker** is an actor from Maryland. He met Cookie in 1973 through Divine, who was staying with Baker in his loft on Elizabeth Street in New York. At the time Baker was starring in the Broadway revival of *Candide*, directed by Howard Prince. Baker and Cookie appeared in Susan Seidelman's film *Smithereens* and co-wrote *The Edgar Allan Poe Story*. One summer while Baker was on vacation from Broadway he visited Cookie in Provincetown and got himself a homemade tattoo. He recalls: "I said, 'Oh that's a lovely Egyptian turkey vulture you have on your wrist' and she said, 'Oh I did that myself, do you want a tattoo?' and I said, 'Sure' and she said, 'What do you want?' and I said, 'a 3' and she said, 'Why?' and I said, 'Well, Jean Cocteau said it's not just the male or the female but the third sex and I'm definitely...' and she said, 'Oh hon, me too.' So I pulled out a ball point pen and she tapped it out."

**James Bennett** was a composer living in New York City. He composed the scores for *Poison*, written and directed by Todd Haynes, and *Swoon,* written and directed by Tom Kalin, as well as numerous theater productions. Bennett met Cookie in Provincetown, where he started the Provincetown Theater Company with his boyfriend Charles Horne in the '70s. Bennett moved to New York in the late '70s, and in the mid '80s spent a summer in Positano, Italy, with Cookie and Vittorio. James Bennett died in June, 2012 of a heart attack.

**Janice Birney** lives in Positano, Italy and is a clothing designer. Originally from the UK, Birney went to northern Italy to work in knitwear factories after having completed a fashion/textiles degree in 1979. She moved to Positano in 1982, and in 1983 met Cookie at a nightclub called Privilege where they had dueling affairs with a DJ named Paolo. The two spent numerous summers zipping up and down the coast on Birney's moped. Birney also visited Cookie in New York City.

**Max Blagg** is a writer living in New York City. He left his native England in 1971 for New York, where he eventually became friends with Cookie. Blagg's 1991 poetry collection *Licking the Fun Up* is dedicated to Cookie and Vittorio. In "Gathering Bruises," a poem he wrote for Cookie in 1989, Blagg writes, "Cookie's feral eyes spelled 'Danger' despite her sweet heart."

**Roberta Blattau** is a 62-year-old government employee who is hoping to retire this year. She has been married for 41 years, has two daughters, a 5-year-old pit bull named Gracie, and has lived in Catonsville all her life. She shared a creative writing class with Cookie at Catonsville High School.

**Richard Boch** is a painter living in upstate New York. Boch worked at the door of the Mudd Club from 1979 to 1980 and then as the manager at Mickey Ruskin's One University Place.

Boch and Cookie frequented the same places and had mutual friends. One afternoon she pierced his ear with a needle and cork. Boch is currently writing a book about the years he worked at the Mudd Club.

**Steve Butow** lives in Jersey City. Originally from Brooklyn, Butow studied at the Maryland Institute College of Art with Susan Lowe and Vincent Peranio and lived with Van Smith for many years. As a part of the Dreamlanders, Butow played one of the goons in *Desperate Living*. In 1971, Butow moved to New York City. Cookie and Butow spent time together in Baltimore, Provincetown and New York. Currently he designs jeans.

**Pat Burgee** is a painter who lives just outside Baltimore. She was married to George Figgs and was a bass player in one of his bands. She has worked on several John Waters's films as a set artist and was a graphic artist on *Cry Baby*. She shared a house with Cookie on Mill Race Road in Baltimore during the making of *Female Trouble* in the fall of 1973.

**Joseph Cacace** is a chef and a filmmaker living in New York. He attended the School of Visual Arts in New York. Cookie appeared in his experimental film *Trilogy of Loneliness*, which was shot in three segments over a period of three years (1980–1983). Cookie's segment was shot at 31 Union Square West, NYC in 1983. *Trilogy of Loneliness* screened a couple times at the School of Visual Arts in NYC in 1983.

**Arnie Charnick** is a muralist who lives and works in the East Village in New York City. Cookie met Charnick in Provincetown in the '70s and the two later spent time together in New York in the '80s. Cookie wrote about Charnick a few times in her "Art and About" column and praised his mural *Luncheonette Life* on the façade of Velselka on 2nd Avenue.

**Scott Covert** is an artist who travels between cities. In 1985 he started his project The Dead Supreme, which involved grave rubbings of "seemingly incongruous couples" such as Malcolm X and Gertrude Stein, as Cookie wrote about in her "Art and About" column. Cookie told him, "This is what you should focus on." He still does. Covert met Cookie in the '70s dancing in a New York nightclub and later took a trip with her to Pen Argyl, Pennsylvania to do a grave rubbing of Jayne Mansfield's heart-shaped gravestone. Covert also accompanied Cookie to Edgar Allan Poe's Baltimore gravesite.

**Claudio Cretella** is from Naples, Italy. He is a lawyer and practices in Naples, Positano, and New York City. He was a childhood friend of Vittorio's.

**Dolores Deluxe** lives in Fell's Point, Baltimore with partner Vincent Peranio. She became Dolores Deluxe of Hollywood when she opened a boutique in Los Angeles, described by herself as "Granny takes a trip: crazy satin glittery-crappy stuff." She worked on numerous John Waters's films as assistant set designer and art director. Dolores knew Cookie from junior high school in suburban Baltimore and lived with her in a communal house in San Francisco in the late '60s.

**Dennis Dermody** managed a movie theater in Provincetown during the '70s before moving to New York City to work for The Performing Garage. He has been *Paper* magazine's film critic, "Cinemaniac," and senior editor for 21 years. Before that, he worked as nanny for the son of Willem Dafoe and Wooster Group director Liz LeCompte for 13 years. He's written for

*Details, Film Threat,* and other magazines. He has appeared in several documentaries such as *Divine Trash, The Queer Reveries Of James Bidgood,* and on the DVD of *Serial Mom,* and is currently working on his memoir, *Jesus' Nanny.* Dermody met Cookie in Provincetown in the early '70s and remained friends after they had both moved to New York.

**Earl Devreis** is the father of Cookie's only child. He met Cookie one night dancing at Piggy's in Provincetown during the summer of 1970. The following winter, Devreis says Cookie sought him out, told him she liked the way he danced, and that she wanted to have his child. He obliged, and on September 25, 1971, Max Mueller was born. Earl lived a "loose" life in Provincetown working several jobs, including weed dealer and joke shop owner, until 1990, when he was apprehended by customs coming from Tobago to the US. He currently lives in Edmonton, Canada.

**Philip-Lorca diCorcia** is a photographer who lives in New York City and teaches at Yale. DiCorcia met Cookie through his Italian wife, Naomi, who worked at Patrick Fox Gallery and was a friend of Vittorio's. DiCorcia photographed Vittorio in his hospital bed for his 1989 show at Patrick Fox Gallery. The photograph was also included in the 1989 Artists Space AIDS-themed exhibition, *Witnesses: Against Our Vanishing,* which was curated by Nan Goldin.

**Sara Driver** is an independent filmmaker born in Westfield, New Jersey. She directed a short film based on Paul Bowles's story, *You Are Not I* (1981), and the feature films *Sleepwalk* (1986), *When Pigs Fly* (1993), and the short video *The Bowery-Spring* (1994). She produced Jim Jarmusch's *Stranger Than Paradise* (1984) and *Permanent Vacation* (1979). Driver and Cookie frequented many of the same parties in New York in the '80s, and attempted to write the screenplay of *Sleepwalk* together.

**Eugene Fedorko** lives in New York City. He met Cookie in Provincetown in the mid '70s and spent time with her both in New York City and Positano, Italy.

**George Figgs** lives in Baltimore. Figgs met John Waters sitting outside Martick's, a famous beatnik hangout, in 1964. As an early Dreamland member, Figgs played numerous roles in Waters's films. He was the Grassman in the unreleased *Wizard of O.D.,* the prince in *Eat Your Makeup,* and an asylum inmate in *Mondo Trasho.* His most notable role was Jesus Christ in *Multiple Maniacs.* Figgs met a teenage Cookie while playing with his band George & Ben in the coffeehouse Boar's Head in the late '60s. He also lived with Cookie on Mill Race Road in Baltimore in fall 1973 during the filming of *Female Trouble.*

**Annie Flanders** lives in Los Angeles. Flanders was the fashion and style editor of the *Soho News* from 1976-1980 and founded *Details* in 1982. She commissioned Cookie's famed "Art and About" column for *Details* by the third issue in 1982. Flanders remembers Cookie would often take her to the Turkish baths and health food shops in the East Village. Shortly after Cookie died, Flanders wrote a moving reminiscence about Cookie in the *Details* feature "For Cookie" in the February, 1990 issue.

**Patrick Fox** opened the Anderson Theater Gallery in the East Village and then the Patrick Fox Gallery on Bleecker Street during the early '80s. Cookie reviewed nearly every show there. Fox and Cookie spent many adventurous nights in New York City together, escaping livid limo drivers and performing Cleopatra-inspired processions through downtown Manhattan. Fox

visited Cookie and Vittorio one summer in Positano. He now lives in New York, continues to sell art, and occasionally does shows with artists. He spends his free time with his partner Will, "training their Jack Russells, C'mere and C'mon, for a career in show business."

**Raymond Foye** is a writer, editor, and curator living in the States. Foye has collected the works of and written books about many illuminating literary and artistic people such as Harry Smith, Mark Di Suvero, Bob Kaufman, John Weiners, Cy Twombly, Edgar Allan Poe, and Francesco Clemente. Foye was introduced to Cookie by Beauregard Houston-Montgomery in 1983. In 1984 Foye founded Hanuman Books with Franscesco Clemente, and produced an edition of miniature books printed in India. Cookie's two books *Garden of Ashes* and *Fan Mail, Frank Letters, and Crank Calls* were both in the Hanuman series along with other writers such as David Trinidad, Eileen Miles, John Ashbery, Herbert Huncke, and Allen Ginsberg.

**Bruce Fuller** lives in New York City. Fuller became fast friends with Cookie the year she married Vittorio, 1986. Fuller remembers parading the Six Flags with Cookie while she took her top off on a rollercoaster ride in order to suntan her breasts. Fuller helped Vittorio get a job at the production company where he worked, which was producing *Pee-wee's Playhouse* at the time. Cookie took Fuller to Positano in 1987 and he returned every year for 17 years.

**Anthony Genola (aka Tutter)** met Cookie in the early '70s in Provincetown and lived with her and his friend Warren for one summer in her apartment on Railroad Avenue. Tutter lived on the Cape for years and taught Yang Family Tai Chi. He died in the summer of 2013.

**Bette Gordon** is a filmmaker who moved to New York City in 1980. Her first introduction to Cookie was at a Thanksgiving party on Bleecker Street, where "so many people came to her tiny apartment in the Village you could barely get in the door." In 1983 Gordon made her film *Variety*, about a girl working as a ticket seller at a porn theater called Variety. The film was shot in the bar Tin Pan Alley in Times Square, and Nan Goldin, Cookie, Peyton Green, and Susan Fletcher were some of the friends Gordon had play in the film.

**Jennie Hanlon**, an Australian who lives in Positano, Italy, is known as the "Aussie from Posi." Hanlon—a good friend of Vittorio's—met Cookie and her son Max in a trattoria one night, and Hanlon's daughter Carmen became a friend of Max's.

**Duncan Hannah** is a painter based in Manhattan. His work is in collections ranging from the Metropolitan Museum of Art to Mick Jagger's personal collection. He appeared as an actor in a few underground films, including *Unmade Beds* and *The Foreigner*. Hannah received a 2011 Guggenheim Fellowship. Cookie liked Hannah's paintings and wrote about several of his shows. In one of her articles she wrote that looking at his paintings was reminiscent of "the awareness of a small child who carries a storehouse of remembered incidental pictures, just little parts of the whole inscrutable adult world and all those incomprehensible secrets."

**Robert Hawkins** is an artist who was born in Sunnyvale, California in 1951. He lived and worked in Lower Manhattan from 1978 until 2001. Robert and Cookie became friends in the '80s and spent time hanging out at Patrick Fox's Gallery. Cookie praised Hawkins's work in *Details*, citing it as being "a smorgasbord, a banquet, a veritable luau of fantasies." Hawkins now lives in London.

**Richard Hell** was born Richard Meyers in Lexington, Kentucky, three months before 1950. Hell was in several early punk bands, including the Neon Boys, Television, and the Heartbreakers, after which he formed Richard Hell & the Voidoids. Since the late '80s, Hell has devoted himself primarily to writing. Hell met Cookie on the set of *Final Reward* in 1978 and became an early champion of her writing. Along with H. M. Koutoukas, he collaborated with her on several writing and art projects in the early '80s and published her work in the late '80s when he edited the Poetry Project literary journal *Cuz*.

**John Heys** is an actor and a filmmaker. In 1969 he founded America's first bi-weekly gay newspaper, *Gay Power*. Shortly after, he became a lover of Charles Ludlam's as well as a member of his Theater of the Ridiculous company. He has acted and worked with H. M. Koutoukas, Hibiscus & The Angels Of Light, The Palm Casino Review, Ethyl Eichelberger, Amos Poe, Alba Clemente, Diane Torr, David Wojnarowicz, Taylor Mead, Ondine, and other luminaries of NYC "off theater" and performance art. Heys and Cookie acted together in Gary Indiana's *The Roman Polanski Story* as well as other films, theater productions, and collaborative performances such as the *Two Chin People*. In one performance, *A Car Story*, written by Cookie and Heys and staged at Café Schmidt in New York, Cookie is driving a cardboard car and picks up a hitchhiker, played by Heys. After pointing out her dead mother in the back seat, and telling him rape stories she experienced while hitchhiking, psychotic Cookie begins to sexually attack Heys. He eventually escapes out of the car, gets covered in leeches and has Cookie administer her dead mother's excrements to remove them. The story ends with them back in the car and Cookie turning on him again by giving a toll clerk a note stating that Heys has murdered her mother, taken her hostage, and is about to kill her. Heys now lives in Berlin, where he makes films and video art.

**Judy (Mueller) Hull** lives in Maryland and is Cookie's older sister. As children, Judy recalls, "Cookie was a little skinny kid, full of energy. When she would get candy at Halloween or other events, she would not eat it right away but would hoard it in her bureau. Mine would be all gone and she'd still have chocolate bars hidden weeks later. Her favorite desert was Jell-O while mine was chocolate cake with icing. Maybe that's why I was a little chubby and she was so scrawny."

**Paola Igliori** is a writer and was born in Italy. She moved to New York in the '80s. Igliori remembers spending long evenings into nights at Cookie's house cooking and drinking wine. She compiled the drawings Vittorio made in the hospital in order to publish them in a book called *Putti's Pudding*. Her other books include *Entrails, Heads & Tails*, which is a collection of interviews with artists such as Louise Bourgeois, James Turrell, Gilbert & George, Sigmar Polke, Julian Schnabel, and Francesco Clemente. In 1990 Igliori founded Inanout Press. In 2003 she returned to her family estate Villa Lina, near Rome.

**Gary Indiana** is a writer living in New York City. Indiana wrote, directed, and acted in over a dozen plays, some of which Cookie also acted in, including *The Roman Polanski Story* and *Phantoms of Lousiana*. His collaborators were drawn from a distinctly avant-garde company of actors, artists, composers, and writers, including Bill Rice, Evan Lurie, Allen Frame, Taylor Mead, Viva, and Cookie. He has written novels including *Horse Crazy* and *Rent Boy* as well as numerous volumes of non-fiction and poetry. Along with his own stage work, Indiana and Cookie would participate together in artistic projects by other filmmakers and directors. Indiana encouraged Cookie early on to write and give readings of her work.

**Rachid Kerdouche** is a French filmmaker living in New York City. He wrote and directed *Final Reward* in 1978 and *Her Name Is Lisa* in 1987. Cookie acted in *Final Reward* as Richard Hell's masochistic girlfriend.

**Udo Kier** is a German cult movie star living in Los Angeles. Kier solidified his stardom by acting in Fassbinder films and Andy Warhol's *Blood for Dracula*. Recently, Kier "played Bella Bartok in Turkey, a pope in Prague, and a Nazi on the moon." Kier met Cookie at the Paris Bar in Berlin during the 1981 Berlin Film Festival and visited her several times in New York City.

**Peter Koper** provided the land for Mortville in *Desperate Living* and co-produced *Polyester*. Koper co-wrote Bette Gordon's film *Variety* and dropped LSD with a teenage Cookie at Pete's Hotel in Baltimore. In New York, Koper and Cookie visited Coney Island and listened to dreamy ice-skating music in her apartment. Koper arrived in the US as a stateless Polish refugee. In addition to being a writer, his background includes stints as a Good Humor ice cream salesman, a nightclub owner, a newspaper publisher, and a farmer. Koper lives in New York City and is planning a trip around the world.

**Chris Kraus** is a writer and critic living in Los Angeles. Her books include *I Love Dick, Aliens & Anorexia, Torpor, Where Art Belongs* and *Summer of Hate* among others. Kraus teaches writing at the European Graduate School in Saas-Fee, Switzerland. In 1990, Kraus began the Semiotext(e) Native Agents imprint to publish fiction, mostly by women, as an analogue to French theories of subjectivity. Cookie Mueller was the first writer in this series. She was followed by Ann Rower's *If You're a Girl*; Eileen Myles's *Not Me*; then Kathy Acker's *Hannibal Lecter, My Father*.

**Eric Lafon** lives in Rincon, Georgia and owns the contracting company Creative Coast Contracting. Originally from Baltimore, Lafon attended Catonsville High School with Cookie and was her companion in skipping class and smoking joints at Dinky Dollars.

**Marcus Leatherdale** is a Montreal-born photographer who has been exhibiting for more than 30 years. In 1993, Leatherdale began photographing exclusively in India and is currently focused on the Adivasi community. Leatherdale is now based in Portugal (Luso Studio) and commutes between Europe and the US. He first met Cookie when he visited her apartment on Bleecker Street with Robert Mapplethorpe in the late '70s. Cookie reviewed Leatherdale's work and he photographed Cookie as a part of his "Hidden Identities" feature in *Details* magazine.

**Warren Leslie** is a musician who was raised in the Bronx and followed a girl to Provincetown one summer in the late '60s. Although that relationship ended, a new one started with Cookie in the summer of 1973. Leslie lived with Cookie that summer with Max, Tutter, and Gregory Corso on Railroad Avenue in Provincetown.

**Susan Lowe** is an artist living in Baltimore. She is one of the original Dreamlanders and was a student at the Maryland Institute College of Art where she later taught as a professor. Her first role with John Waters was playing an asylum inmate in *Mondo Trasho*. She continued to play parts in many of his films, such as the lead role of Mole McHenry (according to Waters, a "super-masculine lady wrestler") in *Desperate Living*. Susan met Cookie through Dolores Deluxe while they were still in high school selling LSD in the mid-'60s. Susan and Cookie lived together periodically in Baltimore and Provincetown during the '70s and remained like sisters. Susan has three children.

**Carlo McCormick** is a critic, editor, and educator living in New York City. He has authored many books on contemporary art and artists and is the senior editor of *Paper*. McCormick was guest curator of *The Downtown Show: the New York Art Scene from 1974 to 1984* at NYU's Grey Art Gallery and Fales Library. Cookie and McCormick were colleagues at the *East Village Eye* and *High Times* magazine.

**Marina Melin** is originally from Sweden and moved to Baltimore with John Waters in the late '60s. An original Dreamlander, Melin first appeared in *Eat Your Makeup* and played numerous roles in subsequent Waters films. Melin spent one summer in Provincetown living with Cookie, Divine, and Channing Wilroy. In New York City, she worked as a barmaid in a topless bar alongside Cookie and Peyton Smith. She currently lives in New York.

**Taylor Mead** was born in 1924 and was a writer, actor, and performer. Mead appeared in several of Andy Warhol's underground films, including *Tarzan and Jane Regained... Sort of* and *Taylor Mead's Ass*. Mead performed in theater pieces alongside Cookie, most notoriously as Charles Manson to Cookie's Sharon Tate in Gary Indiana's *The Roman Polanski Story*. He also plays alongside Cookie in films such as *A Coupla White Faggots Sitting Around Talking, Seduction of Patrick,* and *Underground USA*. Mead lived in New York City until his death on May 8, 2013.

**Bobby Miller** is a poet, photographer, and makeup artist who worked in New York City for 30 years before retiring to Provincetown in 2002. He is the author of 14 books of photography and poetry. He knew Cookie for 25 years.

**Eric Mitchell** is a French No Wave actor and filmmaker living between New York and Paris. He appeared in Amos Poe's films *Unmade Beds* and *The Foreigner,* and on Glenn O'Brien's *TV Party*. He wrote, directed, and acted in the 1980 film *Underground USA*, with Cookie playing his girlfriend. Mitchell met Cookie at the Mudd Club during the beginnings of the No Wave underground filmmaking scene.

**Pat Moran** lives and works in Baltimore. An original member of the Dreamlanders, she has worked on every John Waters film as casting director and actress, beginning with his unreleased 1966 film *Roman Candles*. Says Waters, "Pat knows ugly when she sees it." She currently runs her own casting agency: Pat Moran & Associates. Moran and Cookie met when Cookie won the door prize to the Little Tavern after the screening of *Mondo Trasho*.

**Max Mueller** is Cookie's only child. He was born in Hyannis Hospital in 1971 and moved with his mother to New York City in 1976. Max currently lives and works in Cape Cod. He has a daughter named Razilee.

**Stephen Mueller** is a painter living in New York City. He was the subject of Cookie's first "Art and About" column in 1982.

**Sharon Niesp** grew up in Buffalo and met Cookie in Provincetown in the early '70s. By autumn 1973 Cookie and Sharon had become girlfriends after Cookie asked Sharon, "Why don't you just move your furniture into my house? Might as well; you're there every day anyway." The two lived together on Brewster Street in Provincetown and later moved to Bleecker Street in New York in 1976. Sharon's debut as a Dreamlander was playing Shotsie in *Desperate Living*. She

later played several other roles in John Waters's films. Sharon, nicknamed "Shaggy", appears in numerous stories written by Cookie, mostly about their comical adventures around Europe and Jamaica. Cookie and Sharon were in a relationship until 1981. In 1983 Sharon moved to New Orleans for a period of time. The two remained close friends. Sharon is a second mother to Cookie's only child, Max. Along with acting roles in Gary Indiana's theater pieces *The Roman Polanski Story* and *Phantoms of Louisiana,* as well as various other stage performances and film roles, Sharon has worked as a dough cutter at Spiritus Pizza in Provincetown since its beginning in the early '70s. She has been photographed numerous times by Nan Goldin and David Armstrong. She stuns anyone who hears her sing soulful and profound spirituals. Sharon splits her time between Provincetown and New York City. She has one daughter.

**Michael Oblowitz** is a South African filmmaker who has directed and produced a number of movies and videos. His first feature, the avant-garde 1985 film noir *King Blank,* had Cookie performing a striptease in the Pussycat Lounge. The film went on to the Berlin Film Festival and other international film festivals. Oblowitz and Cookie had a brief affair and hung out at various New York sex clubs such as Hellfire.

**Glenn O'Brien** is a writer and was an editor of *Interview* magazine and New York bureau chief of *Rolling Stone* magazine. Prior to that he worked for *Playboy* and at *High Times.* O'Brien produced and hosted *TV Party* which was a public-access television cable TV show in New York City that ran from 1978 to 1982. Chris Stein was the co-host, Walter Steding led the *TV Party* orchestra, and Amos Poe was the director. Cookie appeared in the Heavy Metal episode. He wrote and produced the film *Downtown 81,* starring Jean-Michel Basquiat. O'Brien co-wrote a script called *Drugs* with Cookie which was never produced. He lives in New York.

**Linda Olgeirson** is a licensed mental health therapist and master trainer in trauma and bereavement living in New York. Originally from Baltimore, Olgeirson is a Dreamlander, having appeared in *Pink Flamingos* as a prisoner in a baby factory and as an extra at Tab Hunter's drive-in in *Polyester.* Linda first met Cookie in 1969 when Cookie won the door prize (dinner at the Little Tavern) at the opening of *Mondo Trasho.* Olgeirson spent time with Cookie from 1970 up until Cookie's death, both in New York and in Provincetown, and was one of the executers of her will.

**Vincent Peranio** is an art director and set designer living in Fell's Point, Baltimore with his partner Dolores Deluxe. He has worked on every John Waters film to date since *Multiple Maniacs.* Peranio was a founder of the Hollywood Bakery commune in Fell's Point in the late '60s where he met Cookie. He has worked in television production design since the '90s.

**Mary Vivian Pearce** lives between Baltimore and Nicaragua. Nicknamed Bonnie, she is a childhood friend of John Waters and has appeared in all of his films to date. Her first role was in *Hag in a Black Leather Jacket* where she did the Bodie Green, an indecent dance that she and Waters were kicked out of a Catholic Youth Organization for performing. Bonnie and Cookie worked in a fish factory together in Provincetown and would see each other at Dreamlander reunions.

**Pat Place** is the lead guitarist for the New York band the Bush Tetras. She was the original guitarist and one of the founding members of the No Wave band The Contortions. Pat met Cookie in the '80s while she was living with then-girlfriend Linda Yablonsky in the West Village. She and Linda visited Cookie and Vittorio in Positano one summer and stayed in their villa for a couple weeks.

**Amos Poe** lives in New York City and teaches at NYU. He is one of the leading figures of the No Wave cinema movement that emerged out of the East Village music and art scene. In 1975, Poe and Ivan Kral (who played with the Patti Smith Group and Iggy Pop) produced, edited, and shot the now classic punk film *The Blank Generation*. In 1976, Poe began his underground film trilogy with *Unmade Beds,* an homage to Godard's *Breathless*. In 1977, he made *The Foreigner,* and then *Subway Riders* between 1970 and 1980, a film in which Cookie plays Penelope Thrash. Poe and Cookie traveled to Berlin together for the Film Festival in 1982 to release *Subway Riders* and found themselves first in a drug holdup at the German customs and then involved in an unpaid phone-bill escape. During the '80s, Poe was a director on *TV Party*. Poe's latest films are *Empire II,* a remake of Warhols' *Empire,* and *La Commedia di Amos Poe*, a meditation on the perception of motion in motion pictures, using the tools of Eadweard Muybridge to illuminate the poetry of Dante's *Divine Comedy*.

**Peter Pompar** dated Cookie's sister Judy in the '60s. He met Cookie shortly after she returned to Baltimore from San Francisco in 1968 and sometimes stayed with her on Brewster Street in Provincetown, an apartment he later subleased during the winter. He currently lives in Australia.

**Judith Pringle** and her husband Bob lived in Baltimore in the early '70s and were part of the John Waters Dreamland group. When they moved to New York City in 1986, they had an art restoration practice where they hired Vittorio to prepare marble for sculptures.

**Alan Reese** is a poet and teacher. In 1969 Cookie had a brief affair with Reese and lived with him in his basement apartment along with several other characters. He was Cookie's date for the screening of *Mondo Trasho* where she won the door prize to the Little Tavern, the event that introduced her to John Waters's world. Reese appears in numerous Waters's films and last saw Cookie at Divine's funeral. Currently, he lives in Baltimore and is an adjunct professor at Towson University and the University of Maryland, Eastern Shore. He operates a small-press publishing company, Abecedarian Books, Inc. His work has been published in *The Baltimore Sun*, *Gargoyle*, *Maryland Poetry Review*, *Passager*, *Loch Raven Review*, and other print and on-line journals.

**Marcus Reichert** is a painter and poet who has also worked in film. Reichert's film works are held in the archive of the Museum of Modern Art. In addition to contributing to and editing numerous books, he is the author of three novels: *Verdon Angster, The Miracle of Fontana's Monkey,* and *Hoboken*. In 1981 Marcus and Cookie began an intimate relationship that lasted about a year. He recalls that they spent most of their time alone. Reichert writes about Cookie in his introduction to *Art and Death,* a collection of prose and poetry. He lives and works in the south of France.

**Gabriel Rotello** is a writer, producer, director, and journalist. He was one of the founders of OutWeek, a magazine devoted to AIDS awareness in the '80s. In 1980, Rotello produced a series of musical revues called Girls Night Out at the club Ritz in New York, hosting stars such as Cherry Vanilla, Holly Woodlawn, and Jackie Curtis. Cookie was determined to convince Rotello to book Sharon Niesp and succeeded after setting up a surprise spectacle of Sharon's winning vocal talents. He now lives in Los Angeles.

**Stephen Saban** is a journalist who wrote about New York nightlife in the '70s and '80s. In 1982, he co-founded *Details* and was the editor of Cookie Mueller's "Art and About" column,

which he said almost never needed editing. Saban is now a pop-culture blogger for World of Wonder Productions in Los Angeles, where he lives.

**Susan Schachter** lives in Cape Cod with her husband David Schachter and her lover Caroline Thomson. She and her husband practice psychoanalysis.

**Elizabeth Scibelli** knew Cookie socially in New York and spent several summers with her in Positano, Italy. Cookie was one of the bridesmaids at Scibelli's wedding at the Lotus Club in New York. Scibelli spent a lot of time with Cookie in 1989 and recalls taking her to see the movie *Sea of Love* just after Vittorio died. Scibelli works in fashion, has 18-year-old twins, and divides her time between New York City and Italy.

**Kate Simon** is a portrait photographer based in New York City. She has photographed artists and writers like William Burroughs, Andy Warhol, Robert Rauschenberg, W. H. Auden, Dennis Hopper, Miles Davis, David Bowie, Iggy Pop, and her photo of the Clash appears on the cover of their debut album. Simon took Cookie as a subject numerous times, most notably with the portrait she made in spring of 1989. Simon recalls that Cookie was the first person with AIDS she photographed. To Simon, Cookie was, "Chic as a motherfucker. One of a kind. Symbolic of what New York used to be." Simon's photography has appeared on countless book jackets, record covers, in publications around the world, and is displayed in museums and galleries in Europe and the US and in many private photography collections. Her book *Rebel Music: Bob Marley & Roots Reggae* is published by Genesis Publications.

**Peyton Smith** is a founding member of the Wooster Group, with which she performed for 20 years. She lives with her husband Frank Tamburo in Bisbee, Arizona and owns the High Desert Market and Café. Peyton befriended Cookie in the late '60s in Provincetown after a hitchhiking-trip gone bad landed them in a car driven by a man with inch-long toenails. After raising a daughter and DJing at Piggy's, Smith moved to New York and began dancing in topless bars alongside Cookie while working with the Wooster Group.

**Carmen (Hanlon) Sorrenti** was raised in Positano, Italy, where she spent time with Cookie and Max in the '80s. She is the daughter of Jennie Hanlon. Carmen recalls going on a wild trip to Capri with Cookie and Max that found them stranded and penniless, resulting in Cookie pleading for a ride home. After spending time as an actress in London and Paris, she now lives in Rome, where she paints large dreamscapes.

**Walter Steding** is an American musician and visual artist. Steding made his debut in New York City during the late '70s as a one-man band (predominantly opening at CBGB for bands like Blondie, Suicide, and the Ramones.) During the '80s, Steding was an assistant to Andy Warhol, who eventually became his producer. A violinist, Steding first played with The Electric Symphony where he developed his own electronic instruments, namely a synthesizer triggered by a biofeedback device that coordinated his music with light-up goggles. Steding and Cookie worked together on *TV Party* and knew each other through mutual friends and Mudd Club events.

**Mink Stole** feels lucky to have been born in Baltimore, where, as an original Dreamlander working with John Waters, she portrayed some of the most outrageous characters in independent

film history: Connie Marble in *Pink Flamingos*, Taffy Davenport in *Female Trouble*, Peggy Gravel in *Desperate Living*, and Dottie Hinkle in *Serial Mom*. She met Cookie in Baltimore in the late '60s and became a close friend, hitchhiking and then living with her and Susan Lowe in Provincetown. After living in Los Angeles for nearly 20 years, Stole returned to Baltimore in 2007, and has since appeared in Steve Balderson's women-in-prison film *Stuck!* and Joshua Grannell's recently released *All About Evil*. Stole is also a singer, and, with her Wonderful Band, is currently recording her first album.

**Billy Sullivan** is an artist who lives and works in New York City and Easthampton, New York. Sullivan was one of Cookie and Sharon's first friends in New York when they moved from Provincetown in 1976. They spent a lot of time hanging out on Bleecker Street, the Mudd Club, and One University Place. Sullivan painted several portraits of Cookie and Sharon. Sullivan's art is in the collections of the Museum of Modern Art, New York; the Metropolitan Museum of Art, New York; the Denver Museum of Art; and the Ellipse Foundation Contemporary Art Collection, Portugal, among many other public and private collections. Cookie's last "Art and About" column for *Details* in September 1989 was a review of Sullivan's work, where she describes his work as full of "dreams, purpose and fun" and his outlook, much like her own, being "every day is a day to rejoice."

**Ben Syfu** was born in Haarlem, Netherlands and came to the US at nine months of age. Syfu became friends with John Waters in high school and was in early films such as *Eat Your Makeup* and *Wizard of O.D.* In 1968, Syfu and George Figgs formed the band George & Ben. Their shows were often in Baltimore coffeehouses, which is where he met Cookie first. In the late '60s, he left Baltimore for New York City to do studio work as a musician and sound engineer. Upon returning to Baltimore in 1975, he wrote, produced, and performed The B.B. Steele Review, starring Edith Massey, Susan Lowe, Sharon Niesp, and Cookie.

**Caroline Thomson** is an artist living in Provincetown. Originally from New Zealand, Thomson moved to London in the '60s and starred in a cult film called *Dope* about teenage heroin users. After tattooing her face and hands—inspired by Maori designs—Thomson lived in Positano and New York City, experiencing underground culture. Thomson met Cookie in Provincetown, where they became lovers for a brief period in 1973.

**Lynne Tillman** is a novelist, short story writer, and critic. Her latest novel is *American Genius, A Comedy*; her most recent story collection, *SOMEDAY THIS WILL BE FUNNY*, was published by Red Lemonade Press (2011). In January 2014, a collection of her essays, *WHAT WOULD LYNNE TILLMAN DO?* will appear from that same press. Cookie and Tillman became acquainted during the '80s, in what's called "the Downtown scene," where writing, art, film, and music mixed freely. Their work appeared in some of the same magazines and anthologies, and they were in several group readings together.

**Anne Turyn** is a fine art photographer and educator living in New York City. She is currently on the faculty of Pratt Institute and Bard High School Early College Queens. Her work has been widely exhibited including at the Museum of Modern Art, The Metropolitan Museum of Art, The Denver Art Museum, The Center for Creative Photography, the Walker Art Center, George Eastman House, and the Los Angeles County Museum of Art. Turyn

founded and edited the artists' chapbook series, Top Stories, which published Cookie's first published book *How To Get Rid of Pimples* in 1984.

**Chi Chi Valenti** is a New York City nightclub producer and writer best known for her clubs Jackie 60 and Mother. Cookie and Chi Chi shared many friends, such as Gennaro. Chi Chi wrote a piece called "The Language" that was inspired by the recordings of three-way conference calls that Gennaro, Cookie, and she would make. The piece was used as the obituary for Cookie in *Interview* magazine.

**Lesley Vinson** lives in Berlin. Vinson was the art director of *Details* magazine, where she worked with Cookie for many years and remembers her as gracious and independent.

**John Waters** has directed 16 movies, including *Pink Flamingos, Female Trouble, Polyester, Hairspray, Cry Baby, Serial Mom*, and *A Dirty Shame*. He is a photographer and the author of seven books. Waters's latest book, *Carsick*, which chronicles his hitchhiking adventure across the United States in May of 2012 was published in June, 2014 by Farrar, Straus and Giroux and appeared on bestseller lists for the *New York Times*, the *Los Angeles Times*, the *San Francisco Chronicle, The Denver Post* and *The Boston Globe*. Waters is a member of The Academy of Motion Picture Arts and Sciences and is on the Wexner Center International Arts Advisory Council. Additionally, he is a past member of the boards of the Andy Warhol Foundation and Printed Matter. After Waters and Cookie met in Baltimore in the late '60s she appeared in numerous of his films.

**Channing Wilroy** lives and works in Provincetown. He is a member of the Dreamlanders and played the inseminator in *Pink Flamingos,* the prosecutor who sends Fatso to the electric chair in *Female Trouble,* and the Captain of the Queers Goon Squad in *Desperate Living*. Prior to his work with John Waters, Wilroy was a teen star dancing to rock and roll in *The Buddy Deane Show*, a legendary television show that aired in Baltimore between 1957 and 1964. In addition to working with Cookie on Waters's films, Wilroy lived with her for a winter in Provincetown with Marina Melin, Divine, and George Tamsitt.

**Linda Yablonsky** lives and works in New York City. She is an art critic for Bloomberg News and a "Scene & Herd" columnist for *Artforum.com*. Yablonsky met Cookie the night *Pink Flamingos* opened in New York and became close with her in 1977 when they were neighbors in the West Village. Yablonsky visited Cookie and Vittorio in Positano and stayed with them for a few weeks in a rented villa. They shared concerns as writers and enjoyed going out as well as getting high. In 1997 Yablonsky published her book The Story of Junk, a novel based on the New York City heroin scene of the '80s. Cookie is loosely portrayed as the character Honey Cook.

**Yoko** is one of Max's oldest childhood friends. He lives between Cape Cod, New York City, and Poland, working as an airbrush artist. He has two children.

# ABOUT THE AUTHOR

**Chloé Griffin** is an artist, actress, and filmmaker. Originally from Canada, she has been based in Berlin since 2003. This is her first book.

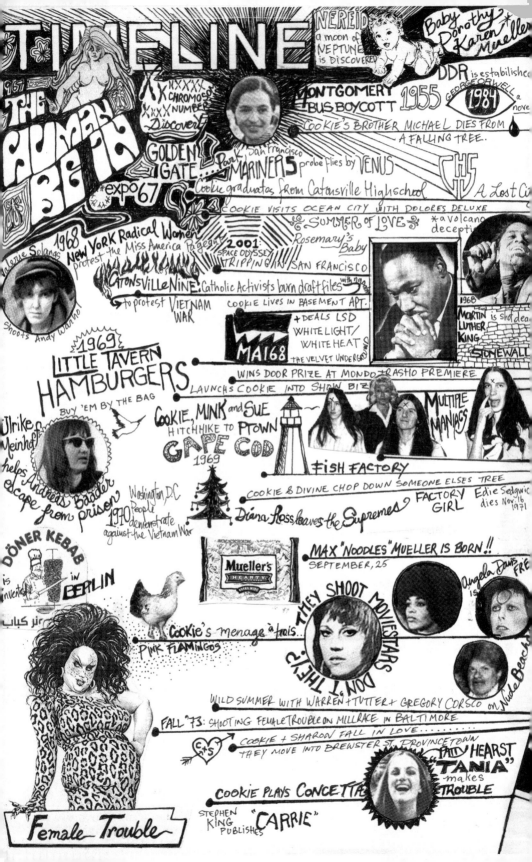

# TIMELINE

1967

# THE HUMAN BE IN

NEREID a moon of NEPTUNE is discovered

Baby Dorothy Karen Mueller

XXXXX CHROMOSO XXXX NUMBER Discovery

MONTGOMERY BUS BOYCOTT 1955

DDR is established

GEORGE ORWELL 1984 a novel

COOKIE'S BROTHER MICHAEL DIES FROM A FALLING TREE.

GOLDEN GATE Park San Francisco MARINER 5 probe flies by VENUS

CHS TV

#expo 67 Cookie graduates from Catonsville Highschool

A Lost Ci

COOKIE VISITS OCEAN CITY WITH DOLORES DELUXE

SUMMER OF LOVE

*a volcano decepti

1968 New York Radical Women protest the Miss America Pageant

2001: SPACE ODYSSEY TRIPPING IN SAN FRANCISCO

Rosemary's Baby

Valerie Solanis

CATONSVILLE NINE Catholic Activists burn draft files with na

to protest VIETNAM WAR

COOKIE LIVES IN BASEMENT APT.

1968 MARTIN LUTHER KING is shot dea

Shoots Andrea Warhol

MA168

+DEALS LSD WHITE LIGHT/ WHITE HEAT THE VELVET UNDERGROUN

STONEWALL

1969 LITTLE TAVERN HAMBURGERS

WINS DOOR PRIZE AT MONDO TRASHO PREMIERE

LAUNCHS COOKIE INTO SHOW BIZ

BUY 'EM BY THE BAG

Ulrike Meinhof

COOKIE, MINK and SUE HITCHHIKE TO PTOWN CAPE COD 1969

MULTIPLE MANIACS

helps Andreas Baader escape from prison

Washington, D.C. People demonstrate against the Vietnam War 1970

FISH FACTORY

COOKIE & DIVINE CHOP DOWN SOMEONE ELSES TREE

Diana Ross leaves the Supremes

FACTORY GIRL Edie Sedgwick dies Nov. 16 1971

DÖNER KEBAB is invented in BERLIN

Mueller's HEARTY

MAX "NOODLES" MUELLER IS BORN!! SEPTEMBER, 25

Angela Davis is FRE

THEY SHOOT MOVIESTARS DON'T THEY?

Cookie's menage à trois... PINK FLAMINGOS

Nude Beach

WILD SUMMER WITH WARREN + TUTTER + GREGORY CORSCO on

FALL '73: SHOOTING FEMALE TROUBLE ON MILLRACE IN BALTIMORE

C+S COOKIE + SHARON FALL IN LOVE... THEY MOVE INTO BREWSTER ST. PROVINCETOWN

PATTY HEARST "TANIA" makes TROUBLE

COOKIE PLAYS CONCETTA

STEPHEN KING PUBLISHES "CARRIE"

Female Trouble

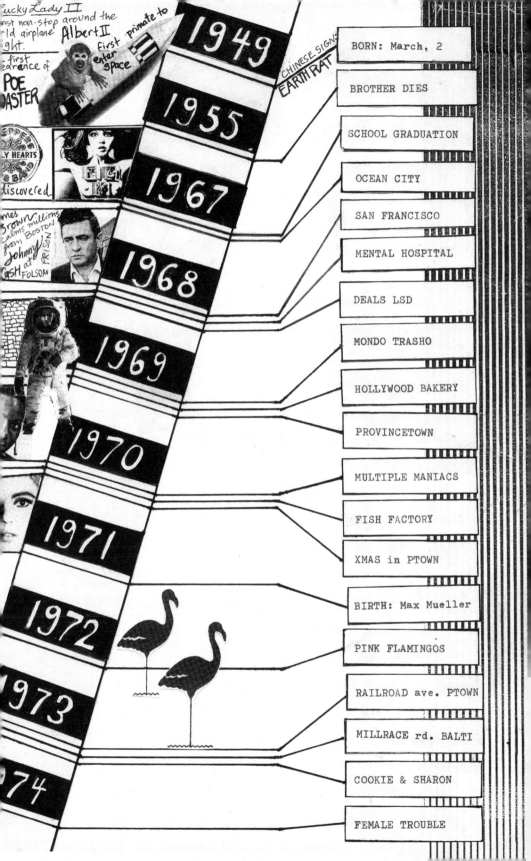

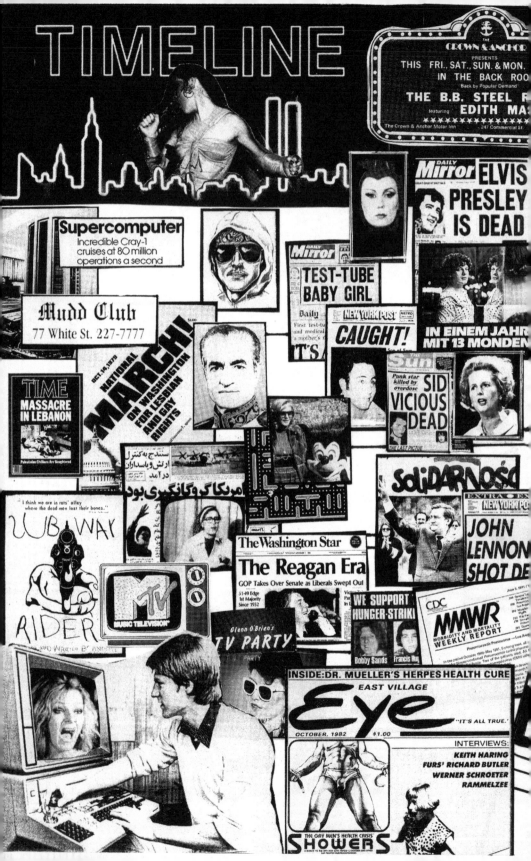

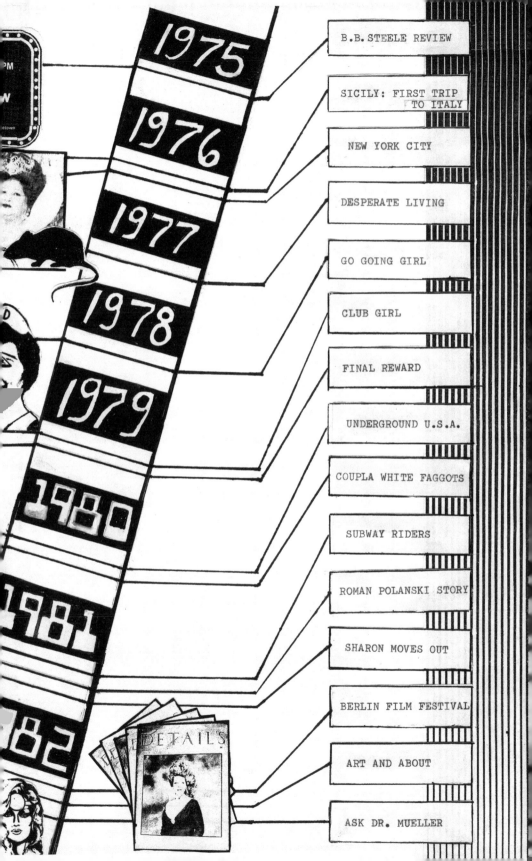

1975

1976

1977

1978

1979

1980

1981

82

B.B. STEELE REVIEW

SICILY: FIRST TRIP
TO ITALY

NEW YORK CITY

DESPERATE LIVING

GO GOING GIRL

CLUB GIRL

FINAL REWARD

UNDERGROUND U.S.A.

COUPLA WHITE FAGGOTS

SUBWAY RIDERS

ROMAN POLANSKI STORY

SHARON MOVES OUT

BERLIN FILM FESTIVAL

ART AND ABOUT

ASK DR. MUELLER

DETAILS

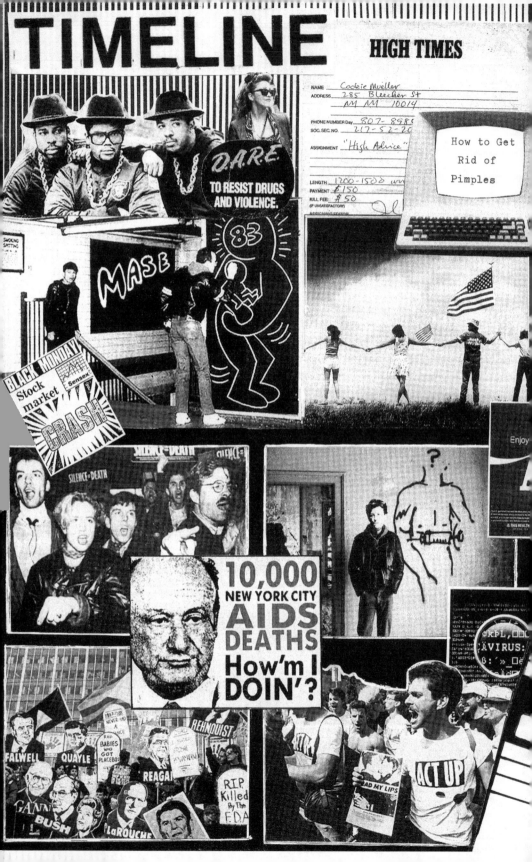

# TIMELINE

## HIGH TIMES

D.A.R.E. TO RESIST DRUGS AND VIOLENCE.

MASE

83

How to Get Rid of Pimples

NAME Cookie Mueller
ADDRESS 285 Bleecker St
NY NY 10014
PHONE NUMBER Day 807-898
SOC. SEC. NO. 217-52-20
ASSIGNMENT "High Advice"
LENGTH 1200-1500 w
PAYMENT $150
KILL FEE $50
(IF UNSATISFACTORY)
ASSIGNING EDITOR

BLACK MONDAY
Sensex
Stock market CRASH

SILENCE=DEATH

Enjoy

IS THIS HEALTH

10,000 NEW YORK CITY AIDS DEATHS How'm I DOIN'?

REHNQUIST

BABIES WHO GOT PLACEBOS

FALWELL QUAYLE

REAGAN

R.I.P. Killed By The F.D.A.

BUSH

LaROUCHE

ACT UP

READ MY LIPS

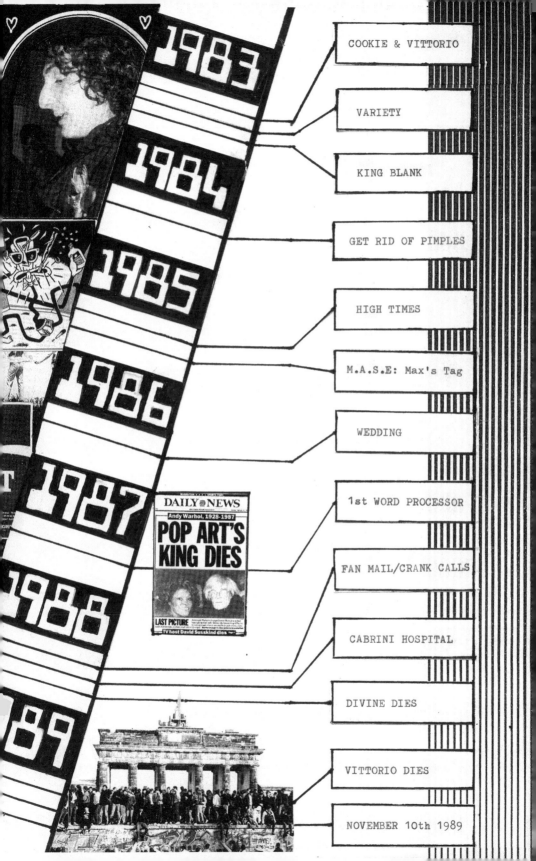

1983

1984

1985

1986

1987

1988

89

COOKIE & VITTORIO

VARIETY

KING BLANK

GET RID OF PIMPLES

HIGH TIMES

M.A.S.E: Max's Tag

WEDDING

1st WORD PROCESSOR

FAN MAIL/CRANK CALLS

CABRINI HOSPITAL

DIVINE DIES

VITTORIO DIES

NOVEMBER 10th 1989

DAILY NEWS
Andy Warhol, 1928-1987
POP ART'S
KING DIES
LAST PICTURE
TV host David Susskind dies

# BIBLIOGRAPHY

## BOOKS BY COOKIE MUELLER

*How To Get Rid of Pimples*. New York: Top Stories, 1984.

*Fan Mail, Frank Letters, and Crank Calls*. New York: Hanuman Books (no. 15), 1988.

*Putti's Pudding*. With illustrations by Vittorio Scarpati. Kyoto: Kyoto Shoin International, 1989.

*Walking Through Clear Water in a Pool Painted Black*. New York: Semiotext(e), 1990.

*Garden of Ashes*. New York: Hanuman Books (no. 34), 1990.

*Ask Dr. Mueller*. Edited by Amy Scholder. New York: High Risk Books, 1997.

## BOOKS IN WHICH COOKIE'S WRITING APPEARS

"Baltimore 1964: A True Story About Two People" and "Provincetown, Massachusetts: A True Story, 1970." In *Ferro-Botanica* no. 3. NJ: Steel Garden Press, 1982.

"Route 95 South—Baltimore to Orlando." In *Just Another Asshole #6*. Edited by Barbara Ess and Glenn Franca. New York: JAA, 1983.

"Baltimore, 1964: A True Story about Two People" and "Provincetown, Massachusetts, 1970" and "British Columbia, 1972" and "Andrew: Secrets of the Skinny" and "Randy Eros, the Sexiest Kid in Town" and "The Story of Frank the Dog and Frieda Ann the Third." In *Wild History*. Edited by Richard Prince. New York: Tanam Press, 1985.

"The Truth About the End of the World." In *Angle of Repose*. Edited by Nancy Peskin. Buffalo, NY: Hallwalls, 1986. [A collection of stories presented during the 1983-84 Fiction-Diction reading series at Hallwalls Gallery, Buffalo, NY]

"An Object Too Long Pondered." In *Thought Objects: Just Another Asshole #7*. Edited by Barbara Ess and Glenn Branca. Buffalo, NY.: CEPA; New York: JAA Press, 1987.

"My Bio: Notes on an American Childhood." In *Blasted Allegories: An Anthology of Writings by Contemporary Artists*. Edited by Brian Wallis. New York: New Museum of Contemporary Art; Cambridge, MA; MIT Press, 1987.

"It Happened on the Haight." In *Pandemonium 2*. Edited by Jack Stevenson. Cambridge, MA: Living Color Productions, 1987.

"Pink Flamingos." In *Spunky International: Translux*. Edited by Billy Miller. Independently produced artist book, 1988.

"Superior Beings." In *Your House is Mine—A Collection of Images and Texts Concerning the Broad and Essential Issue of Housing on the Lower East Side*. Edited by Andrew Castrucci and Nadia Coen in conjunction with ACT UP and Bulletspace. New York: Bulletspace, 1989–1991. [Limited edition artist book (150 portfolio copies); a newspaper edition of 10,000 copies based on the artists book was issued in 1993.]

"Sam's Party." In *A Day in The Life: Tales From The Lower East: An Anthology of Writings from the Lower East Side, 1940-1990*. Edited by Alan Moore and Josh Gosciak. New York: Evil Eye Books and Autonomedia, 1990.

"Which Came First?" In *Out of This World: An Anthology of the St. Mark's Poetry Project, 1966-1991*. Edited by Anne Waldman. New York: Three Rivers Press, 1st Edition, 1991. New York: Crown Publishing Group, 1991.

"The One Percent." In *High Risk: An Anthology of Forbidden Writings.* Edited by Amy Scholder and Ira Silverberg. New York: Plume, 1991. Reprint: Serpents Tail, 1991. Hardcover Edition: Dutton Books, 1991. [Translated into Italian: *Ad alto rischio. Antologia di scritti proibiti.* Translators: M. Garuti and S. Migx. Shake, 1997.]

"Goda" and other selections from *How To Get Rid of Pimples.* In *Top Top Stories.* Edited by Anne Turyn. New York: City Lights Publishers, 1991.

"The Italian Remedy—1982" and "Ask Dr. Mueller—Brief Tips from Italy" (September 1983). In *Ten Years After: Naples, 1986-1996.* Nan Goldin. Zurich: Scalo Verlag, 1998.

"Keep a Few Things in Mind" and "At the Hour Before Dawn" and "Those Days" and "Life Among the Alert of Europe," in collaboration with Richard Hell and H. M. Koutoukas. In *Hot and Cold.* Richard Hell. New York: powerHouse Books, 2001.

"The Birth of Max Mueller." In *The Devil's Playground.* Nan Goldin. London: Phaidon Press, 2003.

Excerpt of "Art and About" from *Details* magazine (November 1988). In *so80's: A Photographic Diary of a Decade.* Edited by Patrick McMullan. New York: powerHouse Books, 2003.

"It Happened in the Haight." In *The High Times Reader.* Edited by Annie Nocenti and Ruth Baldwin. New York: Nation Books, 2004.

"Go-Going—New York & New Jersey—1978–79." In *Up Is Up, But So Is Down: New York's Downtown Literary Scene, 1974–1992.* Edited by Brandon Stosuy. New York: NYU Press, 2006.

"Fleeting Happiness." In *The Reader.* Edited by Ali Smith. London: Constable, 2006. [Later reprinted under the title *The Book Lover.* New York: Anchor Books, 2008.]

## MAGAZINES AND JOURNALS

*Bomb*
A quarterly arts and culture magazine
"A True Story about Two People, Easter 1964."
*Bomb,* Spring (1981)
"Theatre." *Bomb,* Winter (1981–1982)
"Baltimore 1969." *Bomb,* Fall (1982)
"The Head Gargoyle." *Bomb,* Spring (1983)
"The Mystery of Tap Water." *Bomb,* Summer (1983)
"My Bio: Notes on an American Childhood, 1949–1959." *Bomb,* Winter (1985)
"The Simplest Thing." *Bomb,* Summer (1988)

*City Lights Review*
Literary Journal published by City Lights bookstore, edited by Amy Scholder
"A Last Letter." *City Lights Review* no. 2 (1988)

*CUZ*
Published by St Mark's Poetry Project
"Go-Going.", *Cuz* no. 1 (1988)
"Keep a Few Things in Mind." *Cuz* no. 3 (1989)

*Details*
Monthly magazine
"Art and About" and "Travel Guide." *Details*
(August/September 1982–September 1989)

*East Village Eye*
Monthly magazine of popular and avant-garde culture
Worked as contributing editor (1983–1985)
"Ask Dr. Mueller." *East Village Eye* (October 1982–June 1985)
"Alphaville." *East Village Eye,* July (1982)
"Video & Self Image." *East Village Eye,* August (1982)
"Film: Geek Maggot Bingo." *East Village Eye,* April (1983)

*The Gargoyle*
Literary magazine of Catonsville High School, Baltimore, MD. Short stories and poetry, late '60s

*High Times*
Monthly magazine
Worked as contributing editor (1985–1986)
"High Advisor." *High Times* (February 1985–March 1986)
"It Happened in the Haight." *High Times,* May (1986)
"Reagan." *High Times,* June (1986)
"It Happened in the Haight." *High Times,* [Reprint] March (1990)

*Long Shot*
Literary magazine edited by Danny Shot
Long Shot Productions
"Ed's Party—Lower East Side, NYC, 1979."
*Long Shot*, vol. 5 (1987)

*Lo Spazio Umano: Rivista Internationale di Scienze Umane, Arte e Letteratura*
Quarterly arts magazine edited by Enrico R. Comi
"I Hear America Sinking or A Suburban Girl Who is Naïve and Stupid Finds Her Reward"
*Lo Spazio Umano: Rivista Internationale di Scienze Umane, Arte e Letteratura*, no. 11, April–June (1984)
"The Mystery of Tap Water." *Lo Spazio Umano: Rivista Internationale di Scienze Umane, Arte e Letteratura*, no. 12, July–September (1984)

*Saturday Review of Literature*
Weekly magazine
Worked as contributing editor (May 1985–June 1986)
"New York City's 6 Best, Most Undiscovered Artists." *Saturday Review of Literature,* July/August (1985)
"Larger Than Life: The World of Robert Longo." *Saturday Review of Literature,* November/December (1985)

*Soho Weekly News*
Weekly magazine
"Champagne & Cocaine." *Soho Weekly News,* May (1981)

*Soldes Magazine*
A Brussels "tabloid New Wave graphique international"
Edited by Anne Frere, Marc Borgers, Michel Renard, Jean-Louis Sbille
*All You Need is Love* issue no. 8/9 (January 1981)
John Waters interviewed by Cookie Mueller

*The World* No. 34, 1981
The Poetry Project at St. Mark's Church literary magazine
Edited by Ann Rower
"The Third Twin" and "San Francisco, 1967: Near Easter, All True." *The World,* No. 34 (1981)

*Verbal Abuse*
A literary quarterly
"Life Among the Alert of Europe," in collaboration with Richard Hell. *Verbal Abuse,* no. 1 (1993)

---

## CATALOGUES

"A Last Letter." In *Witnesses: Against Our Vanishing.* AIDS exhibition curated by Nan Goldin at Artists Space (16 Nov. 1989–6 Jan. 1990)

*Jedd Garet*
Text for catalogue
New York: Totah-Stelling Art, 1985

# COOKIE MUELLER

HEIGHT: 5'5"
WEIGHT: 110
HAIR: Blonde
EYES: Green

TELE: 924-2126
285 Bleecker St.
NYC 10014

| FILM and VIDEO | | STAGE and CLUB | |
|---|---|---|---|
| role | title | role | title |
| Cookie | PINK FLAMINGOES | Jury, Member | LA JUSTICE |
| | John Waters | | John Vaccaro |
| Concetta | FEMALE TROUBLE | Miss Doberman | BUTTERFLY ENCOUNTER |
| | John Waters | | H. M. Koutoukas |
| Flipper | DESPERATE LIVING | Lady O | PROMENNADE |
| | John Waters | | M.I. Fornes |
| Penelope | SUBWAY RIDERS | Lady Godiva | THE LIFE OF LADY |
| | Amos Poe | | GODIVA |
| Cookie | MULTIPLE MANIACS | | P.town threatre Co. |
| | John Waters | BeBe | GRAVITY |
| Betty | UNDERGROUND U.S.A | | Victor Hugo |
| | Eric Mitchell | Madame X | NIGHT SCHOOL FOR |
| Belle | P.I. CAPPRIO/ for T.V. | | JUNGLE REDD |
| | Carlson International | Mavis | PAPER BAG |
| Alice | THE GOAT/ for cable | Sharon Tate | THE LIFE OF ROMAN |
| | Bob Biggs | | POLANSKI |
| Veronica | FINAL REWARD | | Gary Indiana |
| | Rachid Kerdouche | Miss C. | SHOE |
| Mavis | A COUPLE OF WHITE FAGGOTS | | Dancerteria |
| | SITTING AROUND TALKING | Cookie | ULTRA VIXENS |
| | Michel Audaer/ Gary Indiana | | Snafu |
| Barmaid | NEW YORK BEAT | One manshow written and performed | |
| | Global Wave Productions | La Petite Armeggedon | |
| | Edo Bertoccio | | |
| Victim | POLYESTER | EDGAR ALLAN the Story Of Poe | |
| | John Waters | Co written and Co directed | |
| Wife | AMERICAN ODYSSEY | for the Dance Theatre Workshop | |
| | American Odyssey Films | | |
| Barmaid | UNTITLED/ in post pro. | BB STEELE REVIEW toured Boston, Phila. | |
| | Micheal Oblowitz | NYC, P. town, Balto. | |
| guest | THE TEMPEST | THE JETS Provincetown, NYC | |
| | Paul Mazursky | TOGETHER AT LAST Two person performance | |
| Victim | SMITHEREENS | written by myself and | |
| | Domestic Films | John Heys | |
| | Susan Siedelman | Cafe Schmidt | |
| Hairdresser | TEXAS CHAINSAW MANICURIST | Dance Performances: THE HOUSE OF JEWELS | |
| | for t.v. | Md. Ballet | |
| | Lauie Frank | WINTER FLOWERS Md. Ballet | |
| Scheduled: | NEW YORK ON TEN DOLLARS | WHISPER LICKS Ashford Dance Co. San Fra. | |
| | A DAY | Guest on Cable T.V. Talk Show FAST TALK | |
| | Becky Johnston | | |

VOICE OVERS
THE RETURN    American Can Co.
THE BIRTH     Butterick Publish,

TRAINING: Mira Rostova, Matt Beaky     Jim Raitt, Daivd Foreman
              acting                       voice, music
     Maryland Ballet, Joffrey Ballet, Alvin Ailey, Morelli    dance

## ILLUSTRATIONS & PHOTOGRAPHS

**p. 8** Tobi Seftel: *Cookie, 1981* © Tobi Seftel, used by permission

**p. 10** *First days in NYC & Tony the taxi driver,* super 8 film stills by Chloé Griffin, 2006

**p. 11** *Research & Sharon Niesp in Ptown,* super 8 film stills by Chloé Griffin, 2006

**p. 12** *Tasha Hill,* super 8 film still by Chloé Griffin, 2006

**p. 13** *Sharon Niesp & Peg on the dunes,* super 8 film stills by Chloé Griffin, 2006

**p. 14** Clockwise: *Miss Maryland girls; AABus ticket; Sue Lowe's house; Sue in Fell's Point, Baltimore,* super 8 film stills by Chloé Griffin, 2006

**p. 17** *Max Mueller in Ptown,* super 8 film still by Chloé Griffin, 2007

**p. 18–19** *Razilee & Max Mueller, Red Maple Swamp Trail, Cape Cod,* super 8 film stills by Chloé Griffin, 2007

**p. 20–22** Illustrations by Chloé Griffin & Gwenaël Rattke, 2013

**p. 23** Drawing from a flyer for *Mondo Trasho,* 1967

**p. 26** *The Whole Story:* illustration by Gwenaël Rattke, 2012

**p. 27** Photographer unknown: *Cookie & Frank, Baltimore, c. 1969,* courtesy of Max Mueller

**p. 31** Bob Adams: *Cookie, Baltimore, c. 1969,* courtesy of Bob Adams

**p. 33** Above: *Divine,* film still from *Multiple Maniacs,* 1970 © Dreamland Productions, used by permission; right: photographer unknown: *Fell's Point local,* illustration by Chloé Griffin & Gwenaël Rattke, 2013

**p. 34–35** Drawing by Cookie Mueller, c. 1972, courtesy of Max Mueller

**p. 37** *Sue Lowe Sniffing Glue:* photo by Lawrence Irvine, courtesy of Susan Lowe, illustration by Chloé Griffin & Gwenaël Rattke, 2013

**p. 38–39** Lawrence Irvine: *David Lochary, Divine, John Waters, Mary Vivian Pearce, Howard Gruber, Cookie, Rick Marrow,* © Dreamland Productions, used by permission

**p. 40** Above: *Mary Vivian Pearce;* below: *Sue Lowe,* film stills from *Multiple Maniacs,* 1970 © Dreamland Productions, used by permission

**p. 41** Above: *Mink Stole;* below: *Cookie Mueller,* film stills from *Multiple Maniacs,* 1970 © Dreamland Productions, used by permission

**p. 42** Above: *Divine;* below: *George Figgs,* film stills from *Multiple Maniacs,* 1970 © Dreamland Productions, used by permission

**p. 43** Above: *Angry crowd;* below: *Cookie with joint,* film stills from *Multiple Maniacs,* 1970 © Dreamland Productions, used by permission

**p. 45** *Pink Flamingos à la carte:* illustration by Chloé Griffin & Gwenaël Rattke, 2013

**p. 46** Nelson Giles: *Divine, Channing Wilroy & John Waters, c. 1970* © Dreamland Productions, used by permission

**p. 47** Drawing by Anton Garber, 2013

**p. 50** Drawing by Anton Garber, 2013

**p. 51** Photographer unknown: *Mink & Sue, 1969,* courtesy of Susan Lowe

**p. 52–53** Illustration by Gwenaël Rattke, 2013

**p. 55** Greg Everett: *Cookie at the Blessing of the Fleet, c. 1970,* courtesy of Greg Everett

**p. 56** *Sue at the Beach:* photo courtesy of Susan Lowe, illustration by Gwenaël Rattke, 2013

**p. 57** Photographer unknown: *Cookie, Steve Butow & Richard Heitmanick, Ptown, c. 1972,* courtesy of Steve Butow

**p. 58** Below: *Divine in Morning Attire:* illustration by Chloé Griffin & Gwenaël Rattke, 2013; above: George Fitzgerald: *Linda Olgeirson & Howard Gruber, Ptown c. 1972,* courtesy of George Fitzgerald

**p. 60** Gary Goldstein: *David Lochary, Cookie & Max outside The Movies, Ptown, 1971* © Gary Goldstein, used by permission; from the collection of Dennis Dermody

**p. 61** Photographer unknown: *Baby Noodles,* courtesy of Max Mueller

**p. 63** Audrey Stanzler: *Cookie & Max, Ptown, 1976* © Audrey Stanzler, used by permission

**p. 64** Clip art from 1950's magazine

**p. 65** Audrey Stanzler: *Warren Leslie & Max, Ptown, 1973* © Audrey Stanzler, used by permission

**p. 66** Photographer unknown: *Cookie & Sharon Niesp, Ptown, c. 1973,* courtesy of Marina Melin

**p. 69** Photographer unknown: *Cookie & Sharon Niesp, Ptown, c. 1973,* courtesy of Marina Melin

**p. 71** Ron Illardo: *Cookie as Lady Godiva, Ptown, c. 1973,* courtesy of Doug Asher-Best

**p. 72** Audrey Stanzler: *Cookie, Ptown, 1976* © Audrey Stanzler, used by permission

**p. 75** Audrey Stanzler: *Max, c. 1973,* © Audrey Stanzler, used by permission

**p. 76** *Divine, Susan Walsh & Cookie,* film still from *Female Trouble,* 1974 © Dreamland Studios, used by permission

**p. 79** Photographer unknown: *Cookie at a picnic, c. 1974,* courtesy of Susan Lowe

**p. 81** *Cookie's astrological chart,* courtesy of Max Mueller

**p. 83** Audrey Stanzler: *Cookie & Max, Ptown, 1976* © Audrey Stanzler, used by permission; border drawing by Anton Garber, 2013

**p. 84–85** Audrey Stanzler: *Cookie & Max, Ptown, 1976* © Audrey Stanzler, used by permission

**p. 88–89** George Fitzgerald: *Dennis Dermody, Pat Moran, Sharon Niesp, Cookie, Seymour Avidor, Channing Wilroy, John Waters at the Provincetown premiere of* Female Trouble, *1974,* courtesy of George Fitzgerald

**p. 90** Bottom left: photographer unknown: *Susan Lowe,* courtesy of Susan Lowe; above: photographer unknown: *Edith Massey, The B.B. Steele Review, c. 1975,* courtesy of Susan Lowe

**p. 91** Bottom left: photographer unknown: *Cookie;* above: *Sharon Niesp, The B.B. Steele Review, c. 1975,* courtesy of Susan Lowe

**p. 92** Photographer unknown: *Cookie, The Backroom at the Crown & Anchor, Ptown, c. 1975,* courtesy of Susan Lowe

**p. 93** Photographer unknown: *Edith Massey, The Backroom at the Crown & Anchor, Ptown, c. 1975,* courtesy of Susan Lowe

**p. 94** Photographer unknown: *Ben Syfu, Sharon Niesp, Sue Lowe, Cookie & Edith Massey, The B.B. Steele Review, Ptown, c. 1975,* courtesy of Susan Lowe

**p. 96** Photographer unknown: *Edith Massey & Sue Lowe, c. 1975,* courtesy of Susan Lowe

**p. 97** Photographer unknown: *Edith Massey & John Waters, 1976,* courtesy of Susan Lowe

**p. 99** *Sharon & Cookie in Mortville:* photograph courtesy of Max Mueller, illustration by Chloé Griffin, 2014

**p. 100–101** Steve Yeager: *Liz Renay, Sue Lowe, Mary Vivian Pearce, Cookie, Sharon Niesp*

*& Marina Melin* on the set of *Desperate Living,* 1976 © Charm City Productions, used by permission

**p. 102** Don Herron: *Cookie Mueller—Actress, NYC. Oct. 26th, 1978,* courtesy of The Estate of Don Herron

**p. 105** Newspaper clipping, *The Provincetown Advocate,* c. 1976, courtesy of Dennis Dermody

**p. 107** *They Really Were All Criminals!:* illustration by Gwenaël Rattke, 2013

**p. 108** Photographer unknown: *Brewster Street backyard, Ptown, c. 1975,* courtesy of Susan Lowe

**p. 109** Photographer unknown: *Ptown, c. 1975,* courtesy of Susan Lowe

**p. 110–112** Illustrations by Chloé Griffin & Gwenaël Rattke, 2013

**p. 113** Marcus Leatherdale: *Cookie, NYC, c. 1978,* courtesy of Marcus Leatherdale

**p. 114** *Go-Go Girl:* illustration by Gwenaël Rattke, 2013

**p. 115** Clip art from classified ad from a 1970's magazine

**p. 118–119** George Fitzgerald: *Divine entering the NYC premiere of* Female Trouble, *1974,* courtesy of George Fitzgerald

**p. 120** George Fitzgerald: *Seymour Avigdor, Mink Stole, John Waters, Edith Massey & Channing Wilroy at the premiere of* Female Trouble, *NYC, 1974,* courtesy of George Fitzgerald

**p. 121** George Fitzgerald: *David Lochary, Mark Baker & Cookie, Midnight Show Poster, Pat Moran & Susan Walsh at the premiere of* Female Trouble, *NYC, 1974,* courtesy of George Fitzgerald

**p. 122** Billy Sullivan: *Cookie, May 1979* © Billy Sullivan, used by permission

**p. 123** Billy Sullivan: *Cookie, May 1979* © Billy Sullivan, used by permission

**p. 124** Gary Indiana: *Cookie Mueller as My Ex-Boyfriend, NYC, 1980* © Gary Indiana, used by permission

**p. 126–127** *Richard Hell & Cookie,* film stills from *Final Reward,* 1979, courtesy of Rachid Kerdouche

**p. 128–131** *Taylor Mead, Eric Mitchell & Cookie,* film stills from *Underground U.S.A.,* 1980, courtesy of Eric Mitchell

**p. 132** *Smithereens Silver Screen:* illustration by Chloé Griffin & Gwenaël Rattke, 2013

**p. 134** Sheyla Baykal: *Cookie backstage, c. 1981,* courtesy of The Estate of Sheyla Baykal; from the collection of John Edward Heys

**p. 135** *Poster for the stage production of* The Roman Polanski Story, *1981,* designed by Jon Matthews, courtesy of Billy Rose Theater Division, The New York Public Library for the Performing Arts, Astor, Lenox and Tilden Foundations; from the collection of John Edward Heys

**p. 136** Allen Frame: *Cookie & John Heys, NYC, 1981,* courtesy of Gitterman Gallery; from the collection of John Edward Heys

**p. 138** Top left: Billy Sullivan: *Gary and Cookie, Bar Bar, 1981* © Billy Sullivan, used by permission

**p. 138–140** Drawings by Ken Tisa: *Together at Last: Cookie Mueller & John Heys, 1981,* courtesy of Ken Tisa; from the collection of John Edward Heys

**p. 141** *Berlin Stories:* illustration by Chloé Griffin & Gwenaël Rattke, 2013, original photo: photographer unknown: *Cookie on the set of* Subway Riders, *1981,* courtesy of Amos Poe

**p. 143** Photographer unknown: *Cookie on the set of* Subway Riders, *1981,* courtesy of Amos Poe

**p. 144** Photographer unknown: *Susan Tyrell & Amos Poe, 1982,* courtesy of Amos Poe

p. 216–217 Montage by Chloé Griffin & Gwenaël Rattke, 2013

p. 219 Billy Sullivan: *Cookie, East Hampton, July 1981* © Billy Sullivan, used by permission

p. 221 Ileane Meltzer: *Cookie, 1981*, courtesy of Ileane Meltzer

p. 223 Ileane Meltzer: *Cookie, 1981*, courtesy of Ileane Meltzer

p. 225 Billy Sullivan: *Cookie & Sharon, June 1981.* 2003. Oil on linen, 36 x 64 in., © Billy Sullivan, used by permission; from the collection of Dr. Thomas J. Huerter, Omaha, Nebraska

p. 227 Photographer unknown: *Sharon Niesp, c. 1981*, courtesy of Sharon Niesp; photographer unknown: *Cookie & Peter Koper, Coney Island*, c. 1981, courtesy of Peter Koper

p. 228 David Armstrong: *Sharon Niesp, NYC, c. 1982*, courtesy of David Armstrong

p. 229 David Armstrong: *Sharon Niesp, NYC, c. 1982*, courtesy of David Armstrong

p. 231 Arnie Charnick: *Sharon Niesp*, courtesy of Arnie Charnick

p. 232 Postcard from Cookie Mueller to John Heys, courtesy of Max Mueller

p. 233 Photographer unknown: *Elizabeth Scibelli's wedding with Cookie* (top right) *as a bridesmaid, 1988*, courtesy of Elizabeth Scibelli

p. 234–235 Photographer unknown: *Vittorio Scarpati & Cookie at Bar De Martino, Positano, c. 1984*, courtesy of Max Mueller

p. 238 Top: Mark Sink: *Patrick Fox*, courtesy of Mark Sink; middle: Janice Birney: *Boat to Capri*, courtesy of Janice Birney; bottom right: Billy Sullivan: *Linda & Pat, 1982* © Billy Sullivan, used by permission; bottom left: photographer unknown: *Carmen (Hanlon) Sorenti & Max*, courtesy of Jennie Hanlon

p. 239 Top: Mark Sink: *René Ricard*, courtesy of Mark Sink; Jennie Hanlon: *Janos & Cookie*, courtesy of Jennie Hanlon; Jennie Hanlon: *Vittorio Scarpati*, courtesy of Jennie Hanlon

p. 242 Jennie Hanlon: *Vittorio Scarpati & Cookie, c. 1986*, courtesy of Jennie Hanlon

p. 245 Peter Hujar: *Cookie at her wedding, 1986* © Peter Hujar Archive, used by permission; from the collection of John Edward Heys

p. 247 Top: Mark Sink: *Cookie & Vittorio*, courtesy of Mark Sink; below: *Cookie & Vittorio Scarpati's wedding party, 1986*, courtesy of Mark Sink

p. 248–249 Photographer unknown: *Cookie, c. 1982*, courtesy of Max Mueller

p. 251 Photographer unknown: *Cookie, c. 1982*, courtesy Max Mueller

p. 252–253 Tobi Seftel: *Cookie, NYC, 1981* © Tobi Seftel, used by permission

p. 254 Photographer unknown: *Cookie, c. 1982*, courtesy Max Mueller

p. 263 Robert Mapplethorpe: *Cookie Mueller, 1978* © Robert Mapplethorpe Foundation, used by permission

p. 264–266 Illustration by Chloé Griffin & Gwenaël Rattke, 2013

p. 269 Photographer unknown: *Vittorio Scarpati & Cookie at John Waters's Christmas party, Baltimore, 1988*, courtesy of Judith Pringle

p. 269 *Vittorio Scarpati & Cookie at Cabrini Medical Center, 1988*, video stills by Francine Hunter © Francine Hunter/Jungle Red Studios, used by permission

p. 272 Title page of *Putti's Pudding* (Kyoto Shoin International Co. 1989), courtesy of Paola Igliori

p. 274–275 Philip-Lorca di-Corcia: *Vittorio Scarpati, 1989*, courtesy of the artist and David Zwirner, New York/London

p. 276 Drawing by Vittorio Scarpati, courtesy of Billy Sullivan

p. 279 Kate Simon: *Cookie Mueller at Home, Bleecker St., 1989* © Kate Simon, used by permission

p. 283 Scott Covert: *Cookie at the ponds, Cape Cod, 1989*, courtesy of Scott Covert

p. 284–285 Scott Covert: *Cookie at the ponds, Cape Cod, 1989*, courtesy of Scott Covert

p. 291 Peter Hujar: *Cookie Mueller, 1981* © The Peter Hujar Archive LLC, courtesy of Pace/MacGill Gallery, New York and Fraenkel Gallery, San Francisco, used by permission

p. 297 Audrey Stanzler: *Cookie, Ptown, 1976* © Audrey Stanzler, used by permission

p. 298–301 Cookie's diary, 1965, © The Estate of Cookie Mueller, used by permission

p. 302–303 Page of Cookie's address book, courtesy of Max Mueller

p. 318–323 Timeline illustrations by Chloé Griffin, 2014

p. 327 Cookie's curriculum vitae, courtesy of Max Mueller

**All attempts have been made to obtain permissions for all copyright-protected images. If you have copyright-protected work in this publication and you have not given us permission, please contact the author or the publisher.**

# INDEX

## IMPRINT

**Edgewise: A Picture of Cookie Mueller**

Author/editor: Chloé Griffin

Assistant editors:
Nick Stillman, Charly Wilder

Art direction and design concept:
Chloé Griffin and Gwenaël Rattke
www.rattke.com
www.instagram.com/gwenaelrattke

Typography & typesetting:
Wolfgang Schneider
www.berlinwolf.de
www.instagram.com/berlinwolf

Cover design:
Chloé Griffin and Gwenaël Rattke

Cover photograph: Audrey Stanzler
Cover inside photograph: Nelson Giles

Published by:
b_books Verlag
Lübbener Straße 14
10997 Berlin, Germany

Printed by:
ITC Print
Nicgales Street 4
Riga, LV-1035
Latvia

The design of this book was realized using *manual* layout techniques: all visual materials were first laid out by hand by Chloé Griffin and Gwenaël Rattke in a full-scale model of the book. It was then adapted for printing in InDesign by Wolfgang Schneider.

No parts of this book may be reproduced for any reason without written permission from the author or publisher.

Third edition 2022

ISBN: 978-3-942214-20-9

Available through:
ARTBOOK | D.A.P.
155 6th Avenue, 2nd Floor
New York, NY 10013
www.artbook.com

b_books
www.b-books.de
www.cookiemuellerbook.com

Copyrights belong to the author and artists.

# ACKNOWLEDGEMENTS

This book relies on the conversations I have had with those who loved and appreciated the many talents of Cookie Mueller. I am indebted to each person who gave their time and interest to help me reach a better understanding of this unique individual. My deepest gratitude goes to Max Mueller, Sharon Niesp, Susan Lowe, and John Waters whose sincere contribution, trust, and encouragement has been invaluable.

In addition there are those involved with the production of the book whose role was especially important: Nick Stillman and Charly Wilder for their assistance in reading and editing the manuscript; Gwenaël Rattke and Wolfgang Schneider from the design team; and Gemma Quomi for her commitment and generous help with so many tasks.

My profound thanks to everyone whom I spoke with and who generously contributed visual, literary, and other material: Leonard Abrams, Bob Adams, Penny Arcade, David Armstrong, Doug Asher-Best, Michel Auder, Mark Baker, The Estate of Sheyla Baykal, James Bennett, Janice Birney, Max Blagg, Roberta Blatteau, Richard Boch, Allen Brand, Steve Butow, Pat Burgee, Joseph Cacace, Charm City Productions, Arnie Charnick, Scott Covert, Claudio Cretella, Dolores Deluxe, Dennis Dermody, Earl Devreis, Philip-Lorca diCorcia, Dreamland Productions, Sara Driver, Greg Everett, Fales Library, Eugene Fedorko, George Figgs, George Fitzgerald, Annie Flanders, Patrick Fox, Raymond Foye, Bruce Fuller, Allen Frame, Anthony Genola, Nelson Giles, Gary Goldstein, Bobby Grossman, Bette Gordon, Jennie Hanlon, Duncan Hannah, The Estate of Don Herron, Robert Hawkins, Richard Hell, John Heys, Judy (Mueller) Hull, Peter Hujar Archive, Francine Hunter, Paola Igliori, Ron Illardo, Gary Indiana, Lawerence Irvine, Rachid Kerdouche, Hedi El Kholti from Semiotext(e), Udo Kier, Peter Koper, Chris Kraus, Eric Lafon, Marcus Leatherdale, Warren Leslie, The Estate of Robert Mapplethorpe, Carlo McCormick, Marina Melin, Taylor Mead, Ileane Meltzer, Bobby Miller, Eric Mitchell, Pat Moran, Stephen Mueller, Michael Oblowitz, Glenn O'Brien, Linda Olgeirson, Vincent Peranio, Mary Vivian Pearce, Pat Place, Amos Poe, Peter Pompar, Judith Pringle, Alan Reese, Marcus Reichert, Gabriel Rotello, Stephen Saban, Susan Schachter, Elizabeth Scibelli, Anthony Scibelli, Tobi Seftel, Kate Simon, Mark Sink, Peyton Smith, Carmen (Hanlon) Sorrenti, Audrey Stanzler, Walter Steding, Mink Stole, Billy Sullivan, Ben Syfu, Town of Provincetown (MA History Project), Caroline Thomson, Lynne Tillman, Ken Tisa, Anne Turyn, Chi Chi Valenti, Lesley Vinson, Channing Wilroy, Linda Yablonsky, Steve Yeager, and Yoko.

Special thanks to Richard Turley, the Executor of the Estate of Cookie Mueller, and to Stephan Geene and the team at b_books Verlag.

For additional editorial assistance, I am grateful to Daniel Hendrickson, Janie Yoon, Damian Rogers, Caroline Bankoff, and Elizabeth Gumport.

I would also like to give my special thanks to: Susan Allenbach, Françoise Cactus, Donny Cervantes, Martin Deckert, Anton Garber, Kyra Griffin, Pati Hertling, Harlene Hipsh, Sarah MacLachlan, Gascia Ouzounian, Paul Paulun, Anne Presting, Dominic Sidhu, and Paul Tasha.

Lastly, my heartfelt thanks to Sam Wilder, النور نورك, and Scott & Krystyne Griffin for their immeasurable love, support and patience over the last eight years which it has taken me to produce this book.